James Gillray
The Art of Caricature

James Gillray
The Art of Caricature

RICHARD GODFREY

WITH AN ESSAY BY MARK HALLETT

TATE PUBLISHING

Exhibition supported by The Economist

Exhibition organised in association with The British Museum, London

Published by order of the Tate Trustees by
Tate Gallery Publishing Ltd
Millbank
London SW1P 4RG

© Tate Trustees 2001

This catalogue is published to accompany the exhibition at Tate Britain,
06 June – 02 September 2001

A catalogue record for this book is available from the British Library

ISBN 1 85437 364 1

Designed and typeset by Susan Wightman at Libanus Press
Printed by Arti Grafiche Amilcare Pizzi S.p.a.

Dimensions of works are in centimetres, height before width. The abbreviation BMC refers to
the *Catalogue of Political and Personal Satires in the Department of Prints and Drawing in the
British Museum*. For prints, measurements indicate the size of the mark left by the original copper
plate during printing (the 'plate-mark'), and for drawings, the size of the whole sheet unless
otherwise stated. Catalogue entries marked with the initials RM are by Rachel Meredith.

Cover: James Gillray **Presages of the Millenium** (detail, no.109)

Contents

Sponsor's Foreword

The Economist is delighted to support *James Gillray: The Art of Caricature* – an exciting exhibition displaying the works of the outstanding eighteenth-century caricaturist. *The Economist*, known for its incisive and in-depth political reporting, has long been associated with political sketches and cartoons since it was first published in London in 1843. There is, therefore, a certain natural synergy in helping to bring an artist such as Gillray to greater public attention.

The Economist is a weekly international news and business publication – also covering world affairs, politics, finance, science, technology, culture, society, media and the arts. It is printed in six countries and published on the Internet.

This is the first time *The Economist* has worked with Tate. We hope that this outstanding exhibition will introduce the clever, witty and acerbic works of Gillray to a wide audience.

HELEN ALEXANDER
Chief Executive
The Ecomomist

Foreword

The etchings of James Gillray (1756–1815) are much more than brilliantly incisive and comical commentaries on the politics and manners of his day. They are also among the greatest prints of the eighteenth century. This exhibition, curated by Richard Godfrey, aims to bring a wider appreciation of his achievements as satirist, technician and draughtsman, and to re-affirm his importance, and that of caricature, in the history of British art.

Gillray has been the subject of previous exhibitions: an Arts Council project in 1967; a British Museum touring show in 1985; another at the Willhelm-Busch Museum, Stuttgart, in 1986. He also featured strongly in the 1984 exhibition *English Caricature 1620 to the Present* (Yale Center for British Art; Library of Congress; Victoria and Albert Museum; National Gallery of Canada), in *The Shadow of the Guillotine* (British Museum, 1989) and in the recent William Blake show at Tate Britain, where his work helped to conjure the surrounding context of the French Revolution and its aftermath. The present exhibition, however, focuses squarely and in unprecedented depth on the full range of his career and output.

Today, his works are sometimes used to embellish books on social and political history, for they brilliantly distil often complex events and personalities into graphic images which are both memorable and accessible. For instance, Martin Rowson's illustrations to Paul Langford's book *Englishness Identified: Manners and Character 1650–1850* (2000) pastiche Gillray to great effect: he represents both a distinct historical period, when many of our national institutions and ideas about national character were formed, and a style of humour (robust, even vulgar, cynical and cruel) that is identified as peculiarly British. Yet his art has long been appreciated abroad. Goya and David knew and admired his work, and the publication of new Gillray prints was reported keenly in the German literary magazine, *London und Paris* (1798–1806). Moreover, the topics of his art – tyranny, sleaze and corruption within public life, scandal and foolishness amongst society at large – rise above history and remain the driving force behind much satire today.

The exhibition has been mounted in association with the Department of Prints and Drawings at the British Museum, which has loaned nearly half the total number of exhibited works. The Department's Keeper, Antony Griffiths, and I would like to thank the other lenders to the exhibition: Andrew Edmunds, who has also been generous at every stage in sharing his great expertise in and knowledge of Gillray's work; the Library of Congress, which has provided an exceptional loan of 38 works once owned by the Prince of Wales, later George IV; the Pierpont Morgan Library; the New York Public Library; The Yale Center for British Art; the Victoria and Albert Museum; the Fitzwilliam Museum; Brooks's Club; the National Portrait Gallery; the Ashmolean Museum; and a number of private lenders. This extraordinary body of work has been brought together with exemplary care by the exhibition's organiser, Martin Myrone, who also did much to shape the concept and form of the show itself. He was ably assisted by Rachel Meredith at Tate Britain and Sheila O'Connell at the British Museum. We are very grateful to

them, and to many other staff at both institutions, for bringing a surprisingly complicated project so effectively to fruition. The advice and input of Mark Hallett, author of 'James Gillray and the Language of Graphic Satire' in this catalogue, has also been much appreciated; further thanks are due to Steve Bell and Roger Law for their many and various contributions.

Tate Britain is truly delighted to have *The Economist* as the exhibition's sponsor. Their offices in St James's are built on the site of Hannah Humphrey's shop at 27 St James's Street, above which Gillray lived from 1797 to 1815 and whose shop window was portrayed in *Very Slippy Weather* (no.183). I know that Helen Alexander of *The Economist* would like to join me in warmly thanking all those who have participated in the making of this exhibition – especially Richard Godfrey, whose industry, commitment and the versatility of his scholarship lie at its heart.

STEPHEN DEUCHAR
Director
Tate Britain

Acknowledgements

Many people have been involved in the realisation of this project. In addition to the comments made in the Foreword, we would like to acknowledge the contributions of some of the individuals who have helped make this exhibition possible.

The exhibition is founded upon the scholarship of the late Mary Dorothy George, whose immense efforts at cataloguing the British Museum's collection of graphic satires put every student of the subject eternally in her debt. It would be inconceivable without the work of the distinguished American cartoonist Draper Hill, who organised the first major exhibition of Gillray mounted in London by the Arts Council in 1967. His groundbreaking publications, including *Mr Gillray the Caricaturist* (1965) and *Fashionable Contrasts: Caricatures by James Gillray* (1966) remain a constant point of reference for any study of the artist.

We are grateful for the support and direction of Stephen Deuchar, Director, Tate Britain, and Sheena Wagstaff, Head of Exhibitions and Display. The interpretation of the exhibition has been overseen by Joanna Banham, Head of Public Programmes, and Sarah Hyde, Interpretation Curator. Rachel Meredith has been an essential member of the team from the outset. Without her patience, professionalism and attention to detail, the exhibition (and we ourselves) would have taken on a quite different shape. Gillian Buttimer and Barbara Huband co-ordinated the transportation of works for the exhibition with their usual, exacting professionalism. We are also grateful to Andy Shiel, Terry Warren and their team of art handlers who were responsible for the installation of the works, and David Dance and Mark Edwards for managing the building work. Richard Cottrell and Brian Vermeulen designed the installation of the exhibition, and we would like to thank them for their enthusiasm and invention. Piers Townshend, Brian McKenzie and their

colleagues in Paper Conservation took on the very considerable task of preparing works for display. Within Tate Publishing, Mary Richards, Fran Matheson, Katherine Rose and Tim Holton, together with the designer Susan Wightman, have edited and produced a handsome catalogue that does the exhibition, and Gillray, proud. Ben Luke, Sarah Briggs and Catherine Turner have worked on the press and publicity relating to this show.

Norman Ackroyd, one of England's most distinguished printmakers, kindly spent time in the British Museum with Richard Godfrey giving valuable insights into Gillray's etching techniques. Andrew Edmunds' knowledge of Gillray, particularly such complex subjects as technique and the intricacies of eighteenth-century print publishing, is seemingly inexhaustible and he has been unstinting in sharing it with us. The staff at various print rooms have given invaluable assistance; they include Roberta Waddell and her staff in New York Public Library, Sara Duke at the Library of Congress, Cara Denison at the Pierpont Morgan Library, Scott Wilcox at the Yale Center for British Art, Liz Miller at the Victoria and Albert Museum, and Jane Munro at the Fitzwilliam Museum. Above all, however, it has been Antony Griffiths and all the staff at the Department of Prints and Drawings in the British Museum who have been immensely helpful at every stage, even when great demands have been made upon them in the locating and collation of such a large loan. Ever patient and welcoming to visitors, the staff of this department are one of London's great assets.

Richard Godfrey would like to thank Caroline Elam, who has been a constant source of encouragement, and his colleagues at Sotheby's, who have been patient and forbearing of his preoccupation and frequent absences. In particular, Jonathan Pratt has been greatly supportive, and Marie-Christine Seigneur was of invaluable practical assistance. Nicholas Stogdon is owed a great debt of gratitude for his enthusiasm from the inception of the exhibition, and, not least, for his hospitality and stimulating conversation in Somerset, and latterly in Oxford. He also suggested the possible identity of the old man in Gillray's *A Corner, near the Bank* (no.205). Many others have contributed to the formation of this show, and risking the possibility of unforgivable oversights, we would like to thank Margaret Brown, David Bindman, Mark Bryant, Thomas Buhler, Sionaigh Durrant, Peter Funnell, Barthélémy Jobert, Diane Perkins, Judy Rudoe and Marjorie Trusted.

One of the joys of preparing this exhibition has been the opportunity to talk to and work with Gillray's heirs, the cartoonists and satirists of today. Among them, we would like especially to thank Steve Bell, Roger Law and Ian Hislop, also Felix Bennett, Dave Brown, Peter Brookes, Wally Fawkes, Charles Griffin, Kevin Kallaugher, Nicola Jennings, Martin Rowson, Gerald Scarfe, Posy Simmonds and Ralph Steadman. All the contemporary cartoonists and graphic satirists who have allowed examples of their work to be included in the show are greatly to be thanked. If this exhibition sets out to demonstrate that Gillray's caricature art is as vivid and engaging today as it was over two hundred years ago, it can do so only because it is an art kept vigorously alive by their artistry and imagination.

RICHARD GODFREY AND MARTIN MYRONE

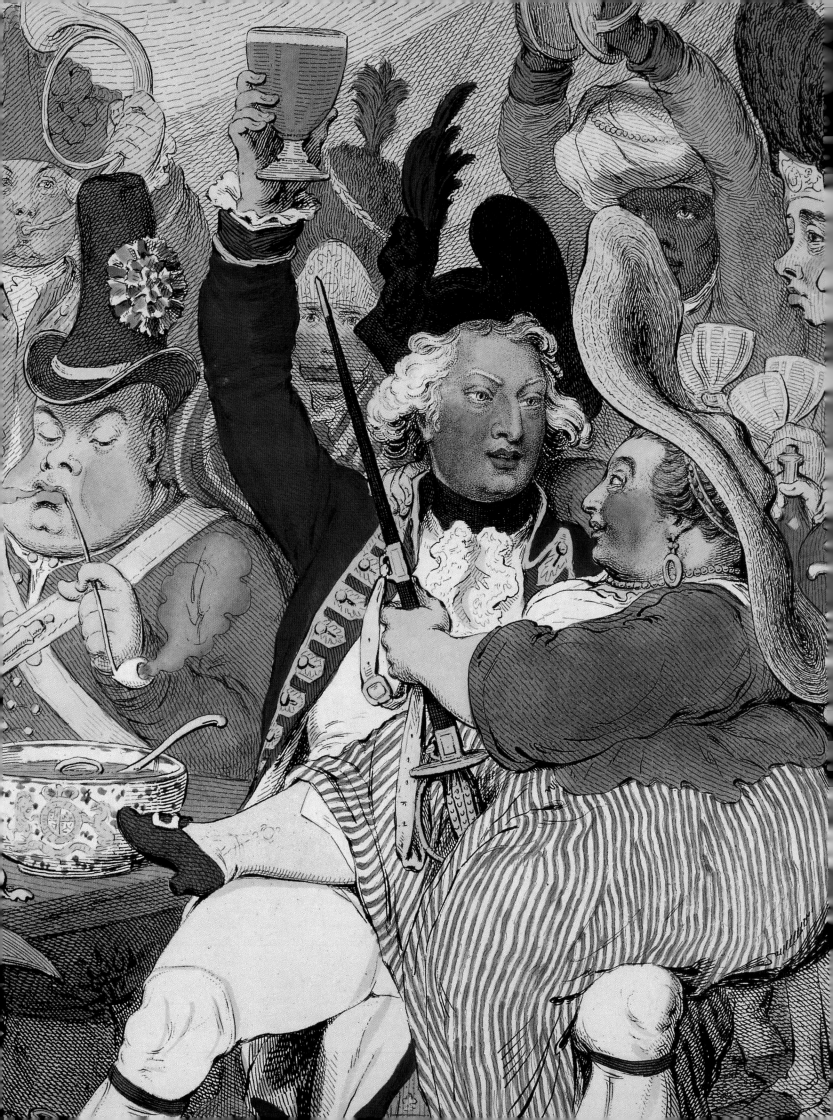

RICHARD GODFREY

Introduction

Sometime between 1792 and 1794 the young engraver John Landseer attended a supper for artists at the end of which 'we drank toasts; and when it came to his [Gillray's] turn to name a public character, the Juvenal of caricature surprised those who knew him but superficially by proposing that we should drink "DAVID" . . . [Gillray] was by this time a little elated, having become pleased with his associates, and having drowned his reserve in the flow of soul, and kneeling reverentially on his chair as he pronounced the name of the [supposed] first painter in Europe, he expressed a wish that the rest of the company would do the same.'[1]

 Proposed in drunken irony or not, this must be one of the most incongruous toasts in the history of art.[2] The two artists stood at the furthest extremes of style and purpose. Jacques-Louis David (1748–1825), painter of vast classical and Napoleonic epics – James Gillray, etcher of vituperative caricatures, teeming with grotesque figures; David, who drew like a Public Committee of One – Gillray, who scratched and scrawled like a fallen angel. We do not know the works by David that Gillray knew, but it has long been recognised that amongst the sources for the central group of figures in *The Intervention of the Sabine Women* (1799) (fig.1) was Gillray's savage print *Sin, Death, and the Devil* (1792) (no.105).[3]

 Two portraits illustrate these extremes of art: David's great painting of *Antoine Laurent Lavoisier and His Wife* (1788, Metropolitan Museum of Art) (fig.2) and Gillray's elaborate etching *Lieut Goverr Gall-Stone, inspired by Alecto* (1790) (no.43) targeting the corrupt lieutenant governor of Landguard Fort, Philip Thicknesse. Lavoisier was a noted experimental chemist and a very wealthy, sinecured man – a tax farmer. The picture is about logic, about clarity of thought – reflected in the great glass retorts – about marital fidelity and classical restraint. Thicknesse was a rogue and a charlatan; he sits on a close stool, a withered hag tipping his pen with venom. The print is about infidelity, nightmares and torment, the expulsion of reason and the reign of chaos. The portraits are a world apart, yet as a very perceptive critic noted of Gillray in the *London and Westminster Review* of 1837, 'He shows us that the ludicrous is not divided by a step from the sublime, but blended with it and twined round it.'

detail, no.73

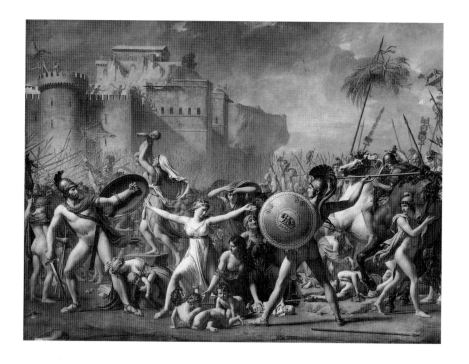

fig.1
Jacques-Louis David,
*The Intervention of
the Sabine Women*
1799
385 x 522
The Louvre/RMN

James Gillray was born in Chelsea on 13 August 1756.[4] His father was a Scot who enlisted in the British Army and lost an arm at the Battle of Fontenoy in 1745. At the time of Gillray's birth he was the sexton of the burial plot belonging to the Moravian community in Chelsea. The Moravians were an austere and unattractive religious sect. They deplored all joy and pleasure. They continually contemplated death, and when taken ill they pleaded to be released from their earthly shackles. Their children were forbidden all games. We cannot be sure of the precise nature of Gillray's education, but it was sufficient to produce a very literate and intelligent man. He was surely also marked by the grim nature of his upbringing, and by the early demise of his four brothers and sisters. His elder brother Johnny departed this life in true Moravian style, pleading, 'Pray don't keep me. O let me go, I must go . . .'

From childhood Gillray was set on a career as an artist, but the nature and circumstances of his background precluded entry into the profession in any elevated manner. Details are few, as they are about much of his life, but he spent some time apprenticed to Harry Ashby, whose shop produced trade cards, cheques, certificates and other prosaic engraved items.[5] From about 1775 a small number of etched caricatures began to appear, unsigned, like all his early prints, but clearly by him. They are sometimes pornographic, showing perverse scenes in and around brothels, or other aspects of low life. However, the most significant moment in his early career came in 1778, when he was admitted to the Royal Academy schools to study as an engraver. At this stage in his career, and indeed for another ten years, Gillray had no intention of becoming a full-time professional caricaturist. He made a sustained and determined attempt to establish himself as a 'serious' engraver, copying the works of others, notably James Northcote, and engraving his own designs, both pastoral and dramatic, in a delicate stipple technique of the kind personified by the work of Francesco Bartolozzi.

Engravers were kept firmly in their place by the painters of the Royal Academy, who for decades denied them full membership. By way of compensation engravers could make a very handsome income. At the top of the ladder were line engravers

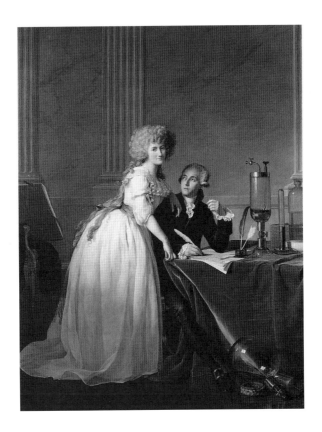

fig.2
Jacques Louis David,
Antoine Laurent Lavoisier and His Wife 1788
259.7 x 194.6
The Metropolitan Museum of Art, Purchase,
Mr and Mrs Charles Wrightsman. Gift,
in honor of Everett Fahy, 1977. (1977.10)

such as William Woollett, Robert Strange and James Heath, who engraved vastly popular historical subjects after such painters as Benjamin West and John Singleton Copley. Mezzotint engravers also prospered, particularly if they secured the prized contracts to copy portraits by Joshua Reynolds. There was a huge market in England and abroad for stipple engravings of portraits and vapid sentimental subjects. At the bottom of the ladder, indeed with scarcely a foot on the bottom rung, were the caricaturists.[6]

A prime requirement of the reproductive engraver was that he should copy the works before him faithfully, and not allow his own personality to intrude. One of the reasons given for their exclusion from the Royal Academy was that they were only a set of 'ingenious mechaniks'. This was largely Gillray's undoing. He could scarcely approach a subject without twisting a neck here, extending a nose there, or in such a supposedly sublime work as his own *The Nancy Packet* (1784) (no.37) make the doomed victims' eyeballs roll and their twisted bodies flounder ludicrously in a cauliflower sea. Likewise in his laboured portrait of William Pitt (1789) (no.102), a project that he took with great seriousness, the Prime Minister ends up with a nose so sharp that he could chip ice with it. Not surprisingly he was increasingly rejected by print publishers, most importantly by the omniscient Alderman Boydell, and was forced inexorably into the ranks of the caricaturists.

By the time Gillray commenced his career the tradition of visual satire was old, but the art of personal caricature was still in its infancy. In the seventeenth century and the early part of the eighteenth century, satirical prints were emblematic in character, with conventionally depicted figures seen in bizarre circumstances or configurations, or represented by stylised symbols such as animals. Personal caricature by contrast is the art of seizing upon a person's outstanding physical characteristic and exaggerating it to the point of ridicule. Thus if the subject has a long nose, stretch it by a foot; if his belly is large, make it elephantine.[7]

An early exponent was, surprisingly, Reynolds, who painted several caricature groups when he was in Rome between 1750 and 1752, before wisely abandoning the practice when he returned to London. Thomas Patch made the art his main activity, and from 1755 it was part of the itinerary of many smart British visitors to Florence to be included in one of his comic groups. This comprehension of caricatures and submission to them by an educated and sophisticated class are principal buttresses to the traditional Golden Age of English caricature. Such an attitude is embodied in a letter of 15 August 1775 from Geoffrey Bagnal to his friend James Boswell, then in Florence, about a picture now regrettably lost: 'Patch has by this time encanvass'd you, and I dare say has made us look as ridiculous as his Genius will admit of. After all 'tis absurd enough for a man to sit seriously down to be laugh'd at, in a copy of his figure, who at the same time would cut one's throat for laughing at the original.'

No such good nature and polite approbation attend the work of George Townshend, who in the 1750s translated previously genteel conventions of caricature into a vicious activity, the stuff of vendettas, not parlour games. His particular target was the Duke of Cumberland, under whom he had served in the Army. His pen drawings were free and abusive, and his prints, many of them published by the Darlys, introduced caricature to the political arena.[8] Matthew Darly and his wife Mary were very active as artists and publishers from the 1750s, firstly with political prints, particularly attacks on Lord Bute, and latterly with social satires where they solicited the ideas of amateurs. Social caricature was for the amateur, in the cajoling words of Mary Darly, an art suited to 'keep those that practise it out of the Hipps and vapours'.

William Hogarth, who had died in 1764 when Gillray was 8 years old, is central to the tradition of English satirical art, and Gillray was surely familiar with his engravings from an early date. *The Morning after Marriage* (1788) (no.31) is clearly indebted to the second plate of *Marriage à la Mode* (1745). Gillray, too, understood the distinction between character and caricature which had so exercised Hogarth's mind, but came to realise that the two could blend and cohabit. Yet Hogarth's influence on Gillray was limited. Hogarth composed in a rational, balanced manner that owed something to the paintings of Jan Steen. Gillray was an ardent disciple of Rubens and High Baroque excesses of movement and form. Hogarth was a moralist who believed that his art could improve the condition of mankind. Gillray scarcely knew the meaning of the word 'morality', and appears to have believed that mankind was beyond redemption. The Hogarth prints which seem to have most interested Gillray were not moralising series such as *The Harlot's Progress* (1732), but flamboyant single subjects such as *Strolling Actresses Dressing in a Barn* (1738), *The March to Finchley* (1750), or the *Midnight Modern Conversation* (1732/3), where moralising is largely absent.[9]

His period at the Royal Academy schools greatly strengthened Gillray's powers as a draughtsman, and he surely attended life classes, albeit with unorthodox results. His figures crackle with vitality, and he particularly delighted in rather sinister emaciated male figures. He was never a man to fudge the issue when it came to drawing the figure – bony fingers and twitching toes are always as resolved as the face. All this is evident in the numerous etchings of 1782 and 1783, many of them attacking the Administration of Lord North and his alliance with

Charles James Fox. They are mainly rapidly drawn and etched with the facility required of a caricaturist who had to respond swiftly to events in a constantly changing political scene. Many seem to have been etched by a single immersion in the bubbling corrosive acid. Although by this time none of his plates had been signed, there can be little doubt that their authorship must have been known to many, since he had quickly emerged as the wittiest and most accomplished artist of his kind. His only rival was James Sayers, an etcher in the pay of William Pitt, whose lively use of personal caricature certainly influenced Gillray, but who was rapidly eclipsed by Gillray's superior draughtsmanship.

In mid 1783, perhaps sensing that it was now or never, Gillray practically abandoned caricature and for two-and-a-half years devoted himself to serious engraving. His commercial failure was absolute and ignominious, yet it is paradoxical that his laborious hours cutting and notching with his engraver's burin and stippling tools should have immeasurably strengthened his hand as a caricaturist. Unlike his fellows he combined trained draughtsmanship with a formidable range of printmaking skills. He could etch, he was a master of stipple, his experiments with aquatint were bold, he was at ease with the line engraver's burin; he made a lithograph, and even experimented with white line metal engraving. Some of his experimental techniques, for instance those used in *The Injured Count..s* (*c.*1786) (no.25) were not used again until the middle of the twentieth century. The constraints of reproductive engraving may be seen as a barrier against which his creative energy pushed and shoved until it burst through in a torrent of innovation and vitality. Nowhere is this more evident than in the epic large prints of the late 1780s which include such important subjects as *Wife & no wife* (1786) (no.20), *Monstrous Craws* (1787) (no.142), *A March to the Bank* (1787) (no.30), *The Morning after Marriage* (1788) (no.31) and *Shakespeare Sacrificed* (1789) (no.41). These are not just comic subjects, they are some of the greatest prints of the eighteenth century. Floods of aquatint in *Monstrous Craws* accommodate scribbled etched lines, delicate stippling in the faces and clusters of wavy etched lines in the background. In this and other plates, dense finish contrasts with the most abbreviated and hurried lines suggesting a wall, a curtain or a bed. The compositions are flooded with light, full of space, and Gillray has learned how to describe a principal figure in detail and then suggest a subsidiary character with a few rapid but telling scratched lines. Some of these prints were first issued uncoloured, and it is in this state that they can often be best appreciated. It is a curious fact that for the rest of his career Gillray must have known that much of his technical wizardry would be concealed by the bright hand colouring which became the norm for a published print.

When Gillray began work on his first prints of 1790, including the sensational *Lieut Goverr Gall-Stone, inspired by Alecto* (no.43), there can never have been a period that offered such tempting subjects to the caricaturists. The French Revolution was still provoking violent debate in Britain. The two principal politicians, Pitt and Fox, presented not only political opposites, but a comic physical contrast: the former tall and skinny, the latter fat, short and hirsute. George III, hovering between sanity and madness, hated the Prince of Wales, whose dissolute life-style was a subject in itself. Political debate was rancorous and public. In Bond Street and St James's fashionable men and women paraded in outlandish costumes. The appetite of

the public for scandal and calumny was insatiable, and Gillray's opportunity to satisfy it was almost unlicensed.

To fulfil his obligations as London's prime caricaturist Gillray needed, and possessed, a formidable number of attributes, critically the ability to respond at breakneck speed, perhaps within a day, to some political crisis or private scandal. The Georgian public was impatient, and news quickly became stale. This required him to snatch up a visual idea and scratch it into the copper in a few hours before a print run was made. The prints needed to be titled and elaborate speech bubbles composed. It is easy to take Gillray's titles for granted, but in fact he devoted immense pains to them, drafting and redrafting words on the same sheets of paper where images were emerging. However, Gillray was not always in a hurry; throughout his career he devoted time to large and elaborate satires where the labour was time consuming, but the meaning and topicality allowed publication to be prolonged. A significant part of his time was devoted to perfecting and etching the ideas of amateurs, a frequent task and a very important source of income.[10] Crucially he had to obtain a likeness, the emergence of a new figure on the political scene requiring a hasty trip to the visitor's gallery at the House of Commons. For this purpose he carried in his pockets a supply of little cards that he could hold in the palm of his hand and, unobserved, make rapid pencil sketches of his prey. For the most important and frequently recurring characters it was important from the beginning to define a prototype that could be used again and again, allowing instant recognition.

It was not only Parliament that furnished Gillray with his subjects. The small area of central London that was his working habitat, firstly Bond Street and then St James's, was also the area perambulated by the rich, the famous and the notorious. A caricature of 3 December 1796, *Sandwich-Carrots!* (no.204), shows the lecherous Earl of Sandwich groping a compliant barrow girl at the corner of Little Maddox Street and New Bond Street. This was about 20 yards from 37 New Bond Street where Gillray then lived and worked in Mrs Humphrey's shop, and the print is inscribed 'ad vivum' (from the life), a form of words that Gillray used to denote a particularly close level of observation.[11] There must also have been encounters with his subjects in the shop itself.

On one memorable day Gillray even came face to face with George III himself. Shortly after France declared war on Britain in February 1793, a British Army, led by the Duke of York, was sent to the Netherlands. Valenciennes was besieged by the British and their allies and surrendered on 28 July. This early but short-lived triumph encouraged the mezzotint engraver and publisher Valentine Green to commission Philippe-Jacques de Loutherbourg to paint a large picture of the subject, which could then be engraved with great profit and honour to all concerned. In his turn de Loutherbourg engaged Gillray to accompany him to the scene of battle to make figure and costume studies. It was an interesting appointment, showing that at least one eminent artist had a high opinion of Gillray's powers of observation. This was Gillray's first and only trip abroad. On their return to England both artists were summoned by the King to show him their drawings – a rather surprising invitation considering the number of Gillray caricatures of the royal family that then existed. De Loutherbourg received royal approbation. Gillray did not. In the words of his acquaintance Henry Angelo,

'The only reward obtained by Gillray was a look which seemed to express, –
Mr. Gillray, you might as well have remained at home; in short his majesty freely
confessed that he could not read the likenesses, as he did not understand the
stenography of the painter's art. Gillray, not overpleased with his reception,
observed "I was a fool for going abroad, and a greater fool for going so far out
of my way", but consoled himself with uttering a determination to try whether
the great King of the isles would know himself.'[12]

From his beginnings as a printmaker Gillray had worked for a variety of London
print publishers, Wilkinson publishing most of his 'serious' engravings. Caricatures
were published by S.W. Fores, William Humphrey, William Holland and others.
In 1791 there was a brief period of intense rivalry for his services between Fores
at 3 Piccadilly and Hannah Humphrey (the sister of William Humphrey) at 18 Old
Bond Street. Both issued prints in rapid succession, but from September that year
he worked almost exclusively with the latter, a spinster who preferred to be known
as Mrs Humphrey.

This was a decision of cardinal importance for his life, not only professionally
but also domestically. Until 1793 it seems likely that he was still living with his
parents at Millman's Row in Chelsea. He now lodged with Mrs Humphrey at 18
Old Bond Street, and made the same arrangement when she moved to 37 New
Bond Street, and finally to 27 St James's Street. The advantages for both were
great. Gillray acquired a degree of stability and his simple domestic needs were
looked after. He had a secure platform from which he could work in peace, but
he was also making a firm commitment to the business venture and took his turn
helping out in the shop. The advantage to Mrs Humphrey was that all could see
that she now had exclusive rights to the work of the world's leading caricaturist.
For Gillray's reputation was not confined to England. Johann Christian Huttner,
the correspondent of the sophisticated Weimar journal *London und Paris,* wrote
with enthusiasm of 'His extensive literary knowledge of every kind; his extremely
accurate drawing; his ability to capture the features of any man . . . his profound
study of allegory; the novelty of his ideas and his unswerving, constant regard for
the true essence of caricature: these things make him the foremost living artist in
his genre, not only amongst Englishmen but amongst all European nations.'[13]

There were print-sellers in London who sold cheap, cheerful caricatures aimed
at a fairly undemanding audience. Mrs Humphrey was not among them. Gillray's
prints were not cheap, and they were aimed at a sophisticated, educated and
monied class. The Prince of Wales became the shop's most elevated client, opening
an account in July 1803 and subsequently buying as many prints as he could.[14]
Politicians, including Fox and Sheridan, were also keen customers. Huttner noted
that 'it is only in Mrs. Humphrey's shop, where Gillray's works are sold, that you
will find people of high rank, good taste and intelligence'.[15] Many of Gillray's
prints, particularly the social satires and certain of the political prints, such as *The
Plumb-pudding in Danger* (1805) (no.98), have an inspired simplicity of design that
is universal and allow instant comprehension. Many others required the spectator
to have a good literary background, an up-to-date knowledge of politics, an
appreciation of the international situation, and familiarity with the visual arts.
It helped, too, if his audience had its ear to the ground for the latest social and

sexual scandals in Town and at court. There was also much to read: visual and verbal puzzles, allusion and counter-allusion – all were there to be deciphered.

Of Gillray himself, his appearance, character and behaviour, we have only tantalising glimpses, many of them from posthumous sources. Curiously it was the aforementioned German journalist, Huttner (1766–1847), who left some of the most reliable contemporary descriptions. He wrote of Gillray that 'outwardly, indeed, in his manners and conversation, he gives the appearance of such everyday simplicity, such a straightforward, unassuming character, that no one would guess this gaunt, bespectacled figure, this dry man, was a great artist'. He also observed that Gillray 'doesn't talk very much about things . . . He doesn't explain himself about anything . . . he is of such an exterior, his appearance, manner and conversation are so ordinary and unassuming.' Henry Angelo, who was acquainted with Gillray, described his 'slouching gait and careless habits', and noted that Gillray seemed 'scarcely to think at all and to care no more for the actors in the mighty drama nor for the events which he so wonderfully dramatised, than if he had no participation in the good or evil of the day. Such a character eludes philosophic enquiry.'[16]

Gillray was a lifelong bachelor, and there are no records of any romantic or sexual attachments. There is evident in the prints a certain fascination with voluptuous, sour-faced and dominant women – viragos – but some of the most obviously glamorous and appealing women to be found in his prints are barrow girls and tarts patrolling the streets. Vain old ladies he scarified in etchings that anticipate Goya.[17]

On the evidence of such prints as *Titianus Redivivus* (1797) (no.47), Gillray had an intimate if embittered understanding and knowledge of the London art world, yet we know very little of any friendship with other artists. He had worked with de Loutherbourg and Northcote; he evidently admired Henry Fuseli, and he seems to have been on friendly terms with Thomas Rowlandson. For the most part however he was detached from what was a garrulous and social artistic scene. He seems to have been content with the company of neighbours, local shopkeepers and the like. We are indebted again to Henry Angelo for a vivid glimpse into his uneventful private life: 'and although the convives he met at such dingy rendezvous (pubs such as The Coal Hole, or the Coach and Horses) knew he was that Gillray, who fabricated those comical cuts, the very moral of Farmer George, and Black Charley, he never sought . . . to become king of the company. In truth, he never exacted, nor were they inclined to pay him any particular homage. With his associates, neighbouring shop-keepers and master manufacturers, he passed for no greater wit than his neighbours.'[18]

Inevitably the 1790s were dominated by news of the French Revolution and the subsequent war with France. Initially Gillray seems, like many others, to have been sympathetic to the Revolution, and marked its first anniversary by engraving after Northcote a large plate of *Le Triomphe de la Liberté en l'élargissement de la Bastille* (no.53) dedicated 'à la Nation Françoise – par leurs respectueux admirateurs James Gillray and Robert Wilkinson'. As events grew bloodier and more threatening, culminating in the execution of Louis XVI on 21 January 1793, so do Gillray's Frenchmen turn into sans-culottes, demons of violence and depravity, skinny, hyperactive, hairy, with their teeth filed to points.[19]

Hitherto independent and detached, Gillray was now stalked by agents of the Government, who realised that he was potentially a powerful instrument for propaganda. On 21 August 1795 the young George Canning wrote in his diary that 'Mr. Gillray the caricaturist has been much solicited to publish a caricature of me and intends doing so. A great point to have a good one.' Canning, who became Prime Minister at the end of his life, was then a young Tory on the make who had attached himself to the coat tails of Pitt. It is a measure of the part that Gillray's prints played in the hurly-burly of party politics that an appearance in one of his prints, however undignified, should be the object of a young politician's ambition, desperate to make his debut in Mrs Humphrey's window. Indeed, on 10 January 1796, shortly after he had come into minor office, Canning wrote to his friend The Reverend John Sneyd: 'I had seen in the window of Mrs. Humphrey, the very morning on which I had received your letter, the print of the death of the Wolf; and have looked with trembling anxiety for something that I might acknowledge as a resemblance of myself. But not finding such a thing, I had concluded the project in my favour to be abandoned, and for this winter at least I was at large.'[20]

Sneyd had been acquainted with Gillray and Mrs Humphrey for some time, and had probably sent an idea for the artist to etch as early as 1791. He was to be a major contributor of ideas and designs for the rest of Gillray's career, his most famous offering being the famous *Very Slippy Weather* (1808) (no.183). He was Canning's principal medium of communication with Gillray, a friendly and persuasive go-between who was charged with luring the artist firstly into Canning's presence, and ultimately into the Tory camp – a project that had the approbation of the Prime Minister himself. It was a long, drawn-out courtship, but finally, on 7 December 1797, Sneyd was at last able to write to Gillray, 'It would be difficult to me to express the pleasure I received from hearing that what I had so long wished, has taken place, and I congratulate you sincerely upon an event which (agreeable as it is) is solely owing to your own merits.'

Gillray had accepted an annual pension from the government, £200 according to a later report by William Cobbett. Thenceforward caricatures of the King and Queen diminish. A torrent of vitriolic prints assail the Whigs, who are represented as bloody-handed traitors in league with the French, dressed as sans-culottes, red bonneted, scampering behind the arch-fiend Charles James Fox as he strives and schemes to bring down Britannia and reduce the nation to a vassal state of France.

No event more than the acceptance of Tory money has caused such unease to friends and later commentators on Gillray, from Northcote and William Hazlitt to, most recently, Diana Donald.[21] In conversation with Hazlitt, Northcote remarked that 'Gillray was a great man in his way . . . yet it was against his conscience, for he had been on the other side, and was bought over'. Gillray certainly knew Northcote, since he had engraved several of his pictures, so this remark bears careful examination with its assertion that Gillray was a natural Whig and that he had a political conscience. Northcote's opinion was no doubt coloured by the fact that Gillray had engraved his melodramatic Bastille picture, but this is not the most significant of Gillray's prints, and he had almost immediately turned his graphic invective against the French revolutionaries. He had been attacking Fox, depicting him as a traitor, even as a regicide in such a brutal print as *The Hopes of the Party* (1791) (no.54), long before he received his Tory pension. As to Gillray's

conscience, the whole nature and tenor of his life's work surely testifies to its absence. The financial incentive itself was considerable for a professional caricaturist, and given his commitment to Hannah Humphrey's business it seems likely that she was party to the agreement. In 1798 Gillray was asked by the correspondent of *London und Paris* for the reason of his new direction. With studied cynicism he replied that 'now the Opposition are poor, they do not buy my prints and I must draw on the purses of the larger parties'.

Attempts by others to harness Gillray to specifically propagandist series of prints were not a success. A patriotic Scot, Sir John Dalrymple, commissioned a set of four prints of the *Consequences of a Successful French Invasion*. These were published in March 1798 in a direct attempt to rouse the British public against the French, the prints being priced cheaply to increase their circulation. The government distanced itself from the project; Gillray wearied of Dalrymple's interference and snappishly severed the connection. Another propagandist venture, a de luxe illustrated edition of the *Anti-Jacobin Magazine and Review* again foundered on the rock of Gillray's intransigence and resentment of attempts to control him. It seems that he made a distinction in his mind between being pointed at a target and being controlled from behind the scenes. The *Anti-Jacobin* was a government-inspired, polemical weekly journal, founded in 1797, with Canning a major contributor, and with significant contributions by Gillray. In May 1800 the publisher John Wright signed an agreement whereby the latter would etch 'in the best manner he was able, a series of Engravings for an Edition of the *Anti-Jacobin*'. Gillray devoted a great deal of time and trouble to this project for which handsome payment was promised. However, interfering hands were never far away, notably those of Canning and his associate John Hookham Frere, who absurdly objected to Gillray's use of personal as opposed to 'moral' caricature. This stipulation, which would have drawn the artist's teeth, was clearly the cause of the project's demise. A striking oil sketch of Voltaire and three prints, known only in unique impressions, are all that survive.

Gillray was never one to allow the graver events of war and politics to distract him from the follies of the Town, and a chief delight of the hurried procession of his work is the alternation of passing social scandals with great events, all drawn and etched with equal concentration – the world as a masquerade in which Bond Street had as large a role to play as Westminster or Windsor. His preoccupation with the art world remained, expressed in the most carefully planned print of the 1790s, the great *Titianus Redivivus*, the ultimate statement of his natural ability to deploy his figures between heaven and earth in glorious mock-historical sagas.[22] Most of the historical paintings of artists such as West, Reynolds or Northcote seem in comparison to be made of cardboard and glue with a dash of cheap greasepaint.

The only artist in Britain who could match his inventive powers was, with the occasional exception of Fuseli, another outcast from Somerset House, William Blake. Born in 1757, Blake was an almost exact contemporary of Gillray, and they may well have overlapped at the Royal Academy schools which Blake entered in 1778. It is difficult, however, to imagine any meeting between the two being anything but uncongenial. Blake was a high-minded student of Dürer and Michelangelo. Gillray preferred the coarser fare of Brueghel, Rubens and

Rembrandt. Yet a juxtaposition of their works is one of the supreme delights of English art. Blake's angelic figures soar into the air singing hymns and spouting Milton. Gillray's grotesques tumble on the clouds, farting and blaspheming.

In the final phase of his career Gillray's work was inevitably dominated by a single figure – one whom he never saw in the flesh – Napoleon Bonaparte. From 1799 when he came to power, Napoleon becomes a constant butt. As his threat to Britain increased so did Gillray reduce his physical stature until he becomes Little Boney, a little black-haired guttersnipe, an upstart who splashes in the water in *The Apples and the Horse-Turds* (1800) (no.93), a raving lunatic, and, most memorably, as the overdressed urchin in *The Grand Coronation Procession of Napoleone* (1805) (no.97). Yet Gillray never loses sight of the real menace of Napoleon, notably as a sinister skeletal figure in *Britannia between Death and the Doctor's* (1804) (no.121). The most celebrated image, however, is from *The Plumb-pudding in Danger* (no.98), arguably the most famous political caricature of all time. It is a dispassionate and neutral view; Pitt and Napoleon carve up the globe, the moral high-ground desired or attained by neither.

Gillray's world began to change early in the nineteenth century. Pitt and Fox both died in 1806, the latter pursued to his very death bed in the pitiless *Visiting the Sick* (1806) (no.129). In 1810 the old King lost his reason and never regained it. The next year the Prince of Wales was appointed Regent. From 1807 Gillray's output faltered, his health suffered, and in 1807 the considerate Mrs Humphrey dispatched him for a convalescent trip to Margate, where he briefly kept a sour and misanthropic journal. In his last years Gillray had increasingly relied on contributions from amateurs, and his last plate was a dispiriting copy from a feeble drawing by Henry William Bunbury of *A Barber's Shop in Assize Time* (1811).

From 1810 he was incurably insane, and was cared for by Mrs Humphrey in St James's Street. In 1811 he attempted to kill himself: the *Examiner* noted on 21 July that he 'attempted to throw himself out of the window of the attic story. There being iron bars his head got jammed and being perceived by one of the chairmen who attends at White's and who instantly went up to give assistance, the unfortunate man was extricated.' George Cruikshank, a caricaturist who acquired Gillray's work-table, described his youthful encounter with the artist: 'poor Gillray said "You are not Cruikshank but Addison; my name is not Gillray but Rubens" . . . Though insane, it was but seldom that his paroxysms were very violent, consequently he was allowed to wander at leisure over the house . . . it was only during his aberrations from his right mind that he was kept close in an upper room in Mrs. Humphrey's shop. The excellent lady was unremitting in her care of him.'

Gillray died on 1 June 1815, shortly before the Battle of Waterloo. His death passed unnoticed save for a brief notice in the *Gentleman's Magazine*.

For a brief period the legacy of Gillray flourished in hard-hitting caricatures by Cruikshank, William Heath, C.J. Grant and others. By the 1830s the tolerance allowed to such prints was rapidly diminishing, and by 1840 it had ceased. By the time that Victoria came to the throne the savage attacks sustained and shrugged off by cabinet ministers, the insults received – and collected – by royalty, were completely unthinkable.

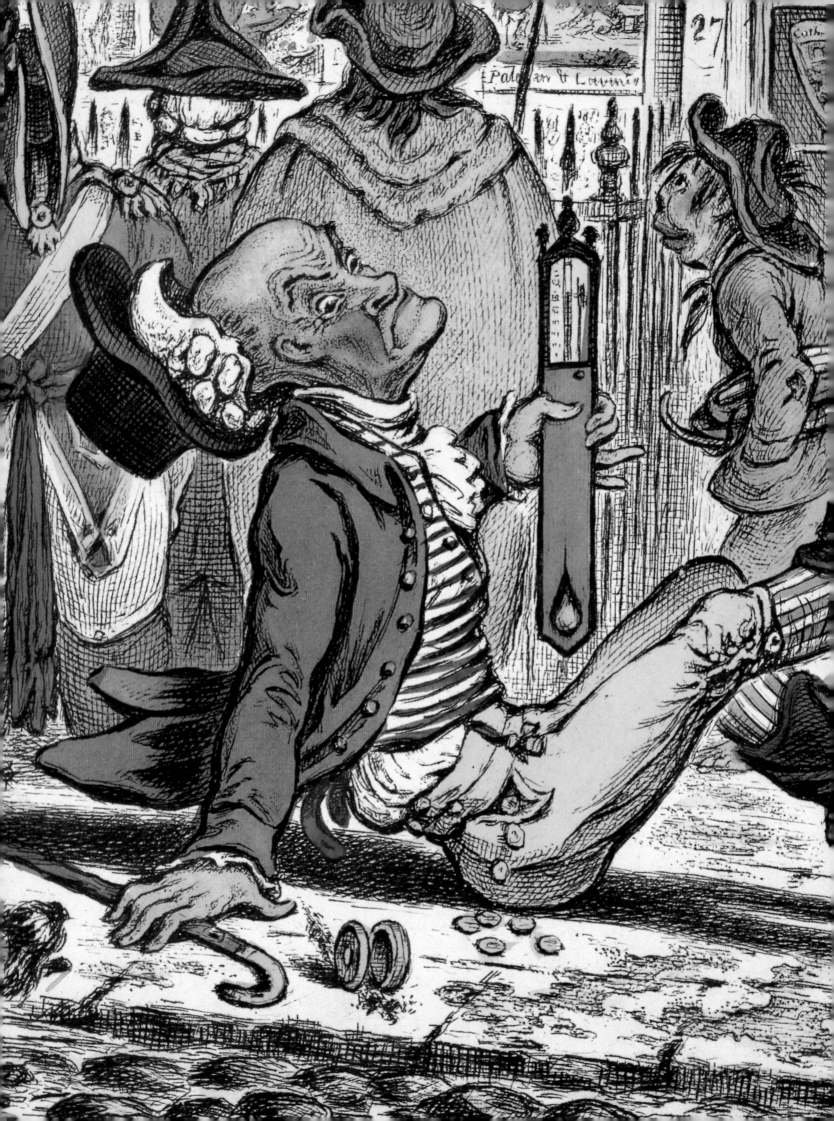

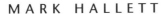

MARK HALLETT

James Gillray and the Language of Graphic Satire

In early April 1782 the London print publisher William Brown issued a political satire entitled *A Warm Birth for the Old Administration* (no.8), the work of the 25-year-old James Gillray. The young artist's print offers a scathing commentary on both the English King and the recently installed government at Westminster, and does so through a witty mix of biting caricature and mock-heroic references to high art and literature. While the plump figure of King George III snoozes on his throne, the Whig politician Charles James Fox, his head turned into that of his animal name-sake, introduces his vanquished opponent Lord North to the dandified figure of the Devil; in the distance, other members of the outgoing ministry are being taken towards a hellish gateway. On a wall, a picture of 'The Wisdom of Solomon' – which alludes to a long tradition of paintings of this subject by such Old Masters as Nicolas Poussin (fig.1) – offers an ironic comment on George's political ineptitude and neglect. As well as gesturing to a particularly elevated category of history painting, *A Warm Birth* is laden with literary references – 'PANDAEMONIUM', for instance, the word inscribed over the gateway on the right, is the capital of Hell in John Milton's great seventeenth-century poem *Paradise Lost*, while the subtitle of the print – 'Take the Wicked from before the King, & his Throne shall be establish'd in Righteousness' – is extracted from a section of the Old Testament (Proverbs 25:5) that is directly linked to the figure of King Solomon, and to the dangers of changing government.[1] Meanwhile, the name 'Boreas' given to North by Fox as he pulls him towards the Devil is also that of the Greek God of the North Wind, which not only plays on the politician's name, but also helps pictorially transform him into a ludicrous facsimile of an ancient mythological figure, who is shown expelling wind wherever he travels.[2]

Looked at in this way, it becomes abundantly clear that *A Warm Birth* is a precocious and sophisticated example of graphic satire. This term usefully describes a distinct and venerable branch of printmaking, in which an eclectic range of pictorial and textual materials are mixed together in order to make acidic and often humorous commentaries on social or political life. The most familiar technique of modern graphic satire, of course, is that of caricature, by

detail, no.183

fig.1
Nicolas Poussin,
The Judgement of Solomon 1649
101 X 150
The Louvre/RMN

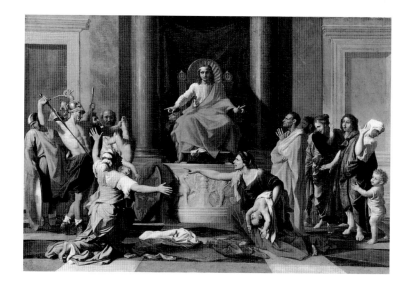

which I mean the systematic distortion or exaggeration of personal appearance for comic or polemic effect. But it is important to remember that in the late eighteenth century caricature was merely one of a variety of instruments used by the satirist to attack his targets – in the words of Gillray's contemporary Francis Grose (for whom 'painting' clearly covers all kinds of pictorial art), caricature 'is *one of the elements* of satirical painting'.[3] Gillray, in the three decades after the appearance of *A Warm Birth*, was going to establish himself as one of the most complex and imaginative artists ever to have worked in the genre of 'satirical painting', producing prints that simultaneously functioned as biting pieces of criticism and as experimental and often highly learned combinations of word and image. A better understanding of the contemporary identity and appeal of these works, however, requires looking at them a little more closely, tying them to the traditions and conventions of pictorial satire, placing them in the context of the contemporary art world, and recovering their involvement within the turbulent realms of political and social commentary in Georgian London.[4]

In such images as *A Warm Birth* we can see Gillray beginning to pursue a particular kind of satiric practice, built around a playful interweaving of historical and contemporary narratives and pictorial and literary materials. Increasingly, this kind of practice was supplemented on Gillray's part by the flamboyant demonstration of technical skill and formal refinement. Viewers of *A New Way to Pay the National Debt* (1786) (no.21), for instance, were not only expected to smile at the sight of the miserly George III loaded with bounty, or to appreciate the bitter parodies of classical statuary offered by the figures of the invalid beggar in the foreground and the ragged Prince of Wales on the right, or even to enjoy reading the fragments of published text that litter the wall, but also to revel in the delicacy and virtuosity of Gillray's draughtsmanship, itself a legacy of the artist's time at the Royal Academy drawing schools. Such viewers were invited to appreciate the fine, flowing outlines with which Gillray encloses each depicted body, and the rippling linear rhythms he sets up between the trio of faceless buglers on the left. These qualities, when aligned with a subtle control of tone and light, and the careful application of watercolours by a specialist colourist, increasingly gave Gillray's prints particular value as works of graphic art, and allowed them to be marketed

as luxury products by London's print-sellers. More particularly, his etchings provided viewers and consumers with a compulsive combination of the crude and the erudite. Thus, in *Monstrous Craws, at a New Coalition Feast* (1787) (no.142), a closely related successor to *A New Way to Pay the National Debt*, we are invited to be both repulsed by the grotesque bodies and excessive actions of the royal family – here shown devouring the money earned through the spilling of 'John Bull's Blood', and framed by the familiar sight of the Treasury gateway – and visually seduced by the technical brilliance and artistic refinement with which these bodies and actions are represented. The line that marks out the cross-dressing King's profile; the calligraphic swirl of strokes that pattern the Queen's dress; the tracks of stipple that shade the Prince of Wales's face – these were all fit for the most stringent print connoisseur's eye, and were clearly designed to be so.[5]

Gillray continued to execute these kinds of pictorially complex and visually luxurious satires on a regular basis. Another good example is *Sin, Death, and the Devil* (1792) (no.105), which transforms the current Prime Minister, William Pitt the Younger, and the recently dismissed Lord Chancellor, Edward Thurlow, into the warring figures of Death and the Devil from *Paradise Lost*. Gillray depicts them being kept apart by the 'Snaky Sorceress' Sin, herself a repulsive portrait of Queen Charlotte, scurrilously rumoured to be Pitt's secret lover and protector. As the grotesque figure of Thurlow – hyper-muscular, winged and be-wigged – approaches the Gate of Hell, bearing a fractured mace and a shield decorated with the seal of his old office, Charlotte's withered torso rises from the ground, and her right hand slyly reaches back towards the Prime Minister's penis, itself brilliantly evoked by the heavy, exaggerated shadow that falls between his bare and emaciated legs. Alongside its elaborate fusion of politics, poetry and caricature, Gillray's etching made an explicit pictorial reference to William Hogarth's painting of *Satan, Sin and Death*, executed many decades earlier, but recently reproduced as an engraving by Thomas Rowlandson and John Ogborne (no.107). Furthermore, as a sentence that slithers along the bottom of Gillray's image makes clear, *Sin, Death, and the Devil* also offered a satiric response to modern pictorial translations of Milton's poem being produced by artists like Henry Fuseli (no.106). And even as they brooded over these links and overlaps, those viewers who regularly perused the windows of the capital's print-shops would have recognised that Gillray's image offered a diabolical pendant to his etching on the same subject published a fortnight earlier, *The Fall of the Wolsey of the Woolsack* (fig.2), which this time compares Thurlow to Henry VIII's infamous Lord Chancellor, Cardinal Wolsey.

It is important to remember, however, that alongside these self-consciously intricate kinds of satiric work, Gillray was constantly busy creating a far greater number of prints that responded to political and social events in a more immediate way, that were clearly executed in minutes rather than hours or days, and that tended to be economical in both their form and content. Indeed, it can be said that Gillray's output divides quite clearly between two kinds of satire, distinguished not so much by their themes, but by the amount of time they demanded of both artist and viewer. A print such as the *Hanging. Drowning* (1795) (fig.3), for instance, which depicts two very different responses on the parts of Fox and Pitt to the news of France's contemporary military misfortunes, is a rapidly produced and absorbed satire whose power and appeal resides in its immediate

25

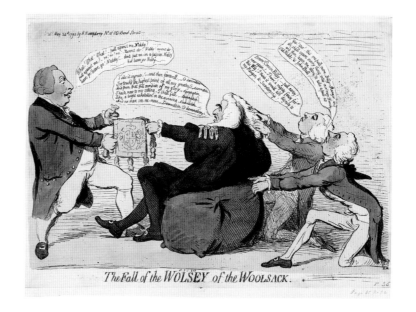

The Fall of the WOLSEY of the WOOLSACK.

visual impact and the humour of its caricature, rather than its ability to sustain extended contemplation. But even if we, as Gillray himself no doubt did, might assign this kind of image a secondary aesthetic status within his output, it is also important to grasp that he often exploited the constraints of time to brilliant effect, and made a virtue of pictorial economy. Thus, in his famous *Fashionable Contrasts* (no.161), published by his long-term employer Hannah Humphrey in January 1792, Gillray shows only two pairs of feet, but in doing so slyly invokes the wedding-night lovemaking of the new Duke and Duchess of York and simultaneously ridicules the idealisation of the overweight Duchess's 'dainty' feet and jewel-laden shoes in the contemporary London newspapers.

Fashionable Contrasts, when looked at alongside such etchings as *A New Way to Pay the National Debt* and *Sin, Death, and the Devil*, exemplifies the range and variety of Gillray's satirical output. In producing such images, however, he was not working alone, or without precedent, but participating in a well-established branch of the graphic arts. Ever since the rise of copper-plate printmaking during the Renaissance, European artists had used the medium to attack religious, political and cultural figures and institutions, and had often done so with considerable pictorial wit and inventiveness. In Britain, however, the satirical print was very much a product of the seventeenth century, and of an expanding demand amongst an early-modern metropolitan population for printed forms of both art and news. In this period, a number of renowned engravers working in London, such as Wenceslaus Hollar and Francis Barlow, had begun fusing acidic political and social commentary with a strikingly elaborate form of pictorial practice.[6] The topical and polemical prints they produced, such as Hollar's *The World is Ruled and Governed by Opinion* (1641) and Barlow's *The Happy Instruments of England's Preservation* (1680), were already forging a distinct satiric aesthetic, in which the viewer's engagement with contemporary events and debates is mediated through the playful artistic assemblage of visual and textual matter drawn from a wide variety of sources, ranging in these cases from emblem-books to portraiture, and from biblical texts to polemical pamphlets.[7]

fig.3
James Gillray,
Hanging. Drowning 1795
24.1 × 34.3
BMC 8683
The British Museum, London

fig.4
George Bickham Senior,
The Whig's Medly 1711
42.6 × 37.5
BMC 1570A
The British Museum, London

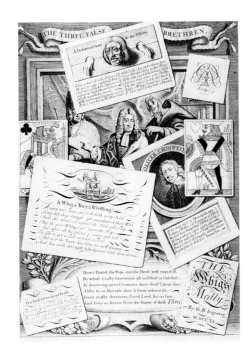

In the eighteenth century, satirical engravings were produced in ever greater numbers. George Bickham senior's *The Whig's Medly* (1711) (fig.4) demonstrates the aesthetic ambition and political punch characterising graphic satire early in the century. In this print a wide-ranging attack on the Whig journalist and propagandist Daniel Defoe – whom we see depicted as a treasonous conspirator sitting between the Pope and the Devil at *The Whig's Medly*'s centre – is mounted through pictorially juxtaposing a miscellany of printed materials, including a second, repulsive portrait of Defoe as 'A Deformed Head in the Pillory', a likeness of the notorious anti-monarchist Oliver Cromwell, two playing-cards, a trade card, and illustrated fragments of political poetry. As well as flaunting the satirical print's engagement with the language and materials of contemporary politics, *The Whig's Medly* promotes its creator as a highly skilful graphic artist, a 'penman' who could manipulate his engraving tools to produce either the most grotesque kind of portrait or the most exquisite calligraphy, and whose works revolved around the imaginative and ironic play of high and low cultural forms.[8]

Bickham and his successors were part of a burgeoning community of engravers producing graphic satires in the English capital. These men catered to the scores of print-shops, large and small, that dotted the centre of eighteenth-century London, where the satires they created might be hung in windows or pinned to boards standing outside the shop.[9] The makers of satiric prints also supplied the owners of city-centre coffee-houses and taverns, who frequently displayed satirical engravings and etchings in their premises, or made them available to be handed around by customers. In addition, those engravers who produced satires would often have their own print-shops, which typically adjoined their workrooms, and which gave them a showcase to display their own offerings to the urban public. Finally, satires were in demand outside as well as inside London, and would often be posted to out-of-town collectors and regional print-shops. All of this meant that the Georgian satirical engraving, far from being an obscure or little-regarded art form, was a regularly encountered and widely discussed product of urban culture. Furthermore, it was one that appealed to a public that extended beyond the traditional patrons of the fine arts, the landed gentry and aristocracy, and took in that 'middling' class of individuals drawn from the commercial and professional classes. While certain satirists – and Gillray was to

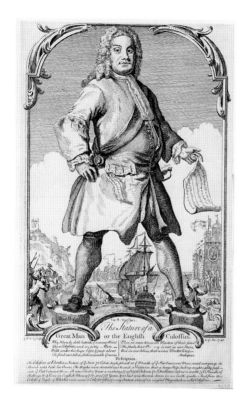

fig.5
George Bickham Junior,
The Stature of a Great Man, or the English Colossus 1740
29.2 x 18.4
BMC 2458
The British Museum, London

be a prime example – made sure they appealed to an elite as well as a 'middling' audience, graphic satire, like printmaking more generally, was very much a phenomenon linked to the emergence of a recognisably bourgeois audience for artistic goods. As such, it is perhaps not surprising to find that individual satires were constantly advertised – sometimes at great length – in that other great organ of eighteenth-century middle-class culture, the daily and weekly newspaper, where they were typically lauded as both highly topical and aesthetically compelling or, to use a contemporary term, 'curious'.

The public served by the London satirists defined itself as much by its political as its aesthetic literacy, and satiric engravings concentrating on individual politicians and ministers were a particularly familiar sight in Georgian print-shops, coffee-houses and taverns, offering those who visited scathing pictorial commentaries on these men's corruption, stupidity or hubris. Thus, *The Stature of a Great Man, or the English Colossus* (1740) (fig.5), which was produced by George Bickham's son, George Jnr., portrays the current prime minister Robert Walpole as the Colossus of Rhodes, arrogantly bestriding the international scene, his pocket full of cash from the national coffers, but ultimately doomed to collapse and ruin.[10] Just as Gillray was to do in his images of later politicians, Bickham draws upon a variety of images and texts to make his point – his print parodies a far more flattering mezzotint portrait of Walpole by Thomas Gibson and Gerard Bockman, adapts a woodcut depiction of the Colossus of Rhodes from Henry Peacham's famous seventeenth-century text *Minerva Britannia*, and, at its base, quotes from Shakespeare's *Julius Caesar* in order to link Walpole's government to the corrupted politics of ancient Rome.

If Bickham's mid-century engraving offers a particularly suggestive precedent to those produced by Gillray some fifty years later, the artist of mid-century with whom he most closely identified was William Hogarth, famous as the greatest satirist of the early Georgian era. With such hugely successful print series as *A Harlot's Progress* (1732), *A Rake's Progress* (1735), *Marriage à la Mode* (1745) and *Industry and Idleness* (1747), Hogarth was seen to have given graphic satire a new artistic and commercial credibility, producing engravings that spoke to contemporary urban society's greatest anxieties and desires whilst appealing to the most

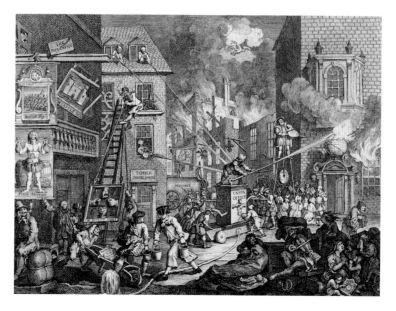

fig.6
William Hogarth,
The Times, Plate 1. First State 1762
22.7 x 29.5 (24.9 x 30.8)
BMC 3970
The British Museum, London

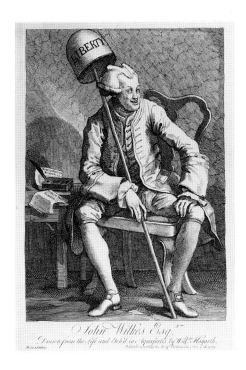

fig.7
William Hogarth,
John Wilkes, First State 1763
31.1 x 22.2 (35.7 x 23.2 in.)
BMC 4050
The British Museum, London

discerning of print-buyers as fascinating and complex works of art. Although Hogarth's fame in the genre was linked in particular to his social satires, he also produced a number of celebrated political prints over the course of his career, including *The Times* (1762) and *John Wilkes Esq* (1763). These variously dramatised the riotous mobs and the corrupted individuals involved in the contemporary political process, and did so in a pictorial language that moved confidently between dense allusiveness and pointed caricature: *The Times* (fig.6), for instance, is crowded not only with the figures, flames and burning buildings that allegorise the state of contemporary Europe, but also with a mass of pictorial and textual signs that demand deciphering by the viewer. Hogarth's etching of Wilkes (fig.7), meanwhile, offers a far more direct and individualised attack, turning the celebrated journalist and politician into a leering, Satanic rake, carrying the misappropriated cap of liberty traditionally associated with the figure of Britannia.[11]

While such images provided celebrated pictorial models for later political satirists, it is also clear that Gillray's identification with Hogarth's work went much further than this. Frequently, we find him either directly quoting from or subtly invoking the earlier artist's images in his own satires. To give just one example, a print such as *Search Night* (1798) (fig.8), which pictures Pitt as a night-watchman, surprising the Whig opposition in a squalid garret as they plot a revolutionary uprising against the government, unmistakably evokes the many scenes of forced entry and civic surveillance that we find throughout Hogarth's output, including the discovery of Moll Hackabout by the magistrate John Gonson in the third plate of *The Harlot's Progress*, the surprising of the illicit lovers in the fifth plate of *Marriage à la Mode* and, perhaps most pertinently of all, the image of the delinquent Tom Rakewell being startled in his garret in the seventh plate of *Industry and Idleness* (fig.9), convinced he has heard the sound of constables and night-watchmen beating against his barricaded door. While such comparisons deepen the satire on the cowering Fox and his colleagues – who become even more powerfully defined as low-life criminals or slumming aristocrats fleeing from the law – they must also have helped reinforce Gillray's own widespread status in late eighteenth-century London as Hogarth's natural successor, and as the artist who was most brilliantly maintaining the pictorially elevated kind of satire with which the earlier man was so closely associated.

fig.8
James Gillray,
Search Night – or – State-watchmen, Mistaking Honest-men for Conspirators 1798
24.1 x 35.2
BMC 9189
The British Museum, London

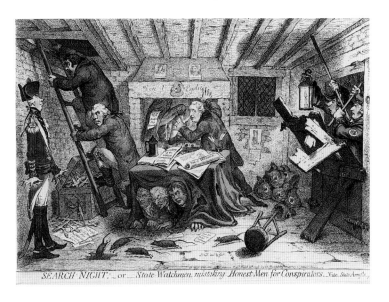

SEARCH NIGHT:_ or _ State Watchmen, mistaking Honest Men for Conspirators.

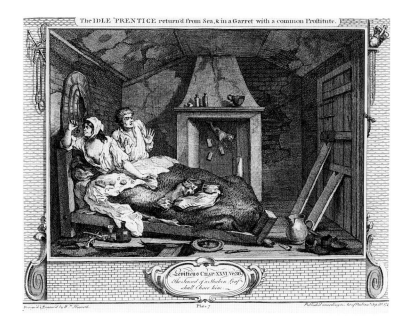

fig.9
William Hogarth,
Industry and Idleness. Plate 7, 'The Idle
'Prentice Returned from Sea and in a Garret
with a Common Prostitute' First State 1747
25.7 × 34.1
BMC 2954
The British Museum, London

In the decades since Hogarth's death in 1764, however, a new community of
satirists, and a modern form of graphic satire, had emerged in the workrooms and
print-shops of London. Significantly, this period saw the establishment of the Royal
Academy of the Arts, which quickly established itself as the central public forum
for artistic training and display in the capital. The Academy publically defined its
role as that of furthering a high-minded school of British painting, built upon a
strict hierarchy of genres in which the most elevated kind of history painting and
portraiture, focussing on the heroic actions of the past and the most celebrated
individuals of the present, was granted a pre-eminent position. Even as it
promoted itself as an all-inclusive public body that represented the interests of
every kind of artist, many observers perceived that in actuality the Royal Academy
was pursuing a highly divisive institutional politics. It explicitly disallowed
engravers from joining its ranks, for instance, and regularly blacklisted the
productions of artists who exhibited with rival exhibiting societies. This meant
that in the years after the Academy's founding in 1768, London's art world, even
as it was increasingly dominated by the royal institution and its activities, also
fostered a host of semi-independent artistic factions and groupings, made up
of men who saw themselves existing on the fringes of an authoritarian and
exclusionary central institution of the arts, and pursuing forms of practice that
operated outside the pictorial and aesthetic categories being encouraged within
the Academy itself.[12] Such was the case for graphic satire and its producers, and
in the last decades of the eighteenth century we can trace the emergence of a new
kind of satiric counter-culture within the London art-world, existing increasingly
independently of the Academy, but always working in its shadow, and, despite its
non-institutional basis, generating its own hierarchies, standards and conventions.

Gillray's work needs to be understood in the context of this wider satiric
counter-culture and community of satirists. More particularly, his work competed
with, and constantly responded to, the satires produced by a group of particularly
gifted artists within this community, who were capable of producing similarly
complex and technically assured images, and who defined their works as offering –
in an ironic echo of the artistic hierarchies in place at the Academy – a more

artistically sophisticated product than the mass of jobbing satires produced for the marketplace. These were men such as John Hamilton Mortimer, Thomas Rowlandson, Johann Ramberg, Richard Newton and the two Cruikshanks, Isaac and George. When we look at Gillray's prints in relation to the graphic satires produced by these artists, we are made constantly aware of the overlaps and continuities between them, and the extent to which he both absorbed and stimulated these other artists' work. Mortimer, for instance, had already established himself as the producer of a particularly refined brand of satire when he died at the age of 39 in 1779. In his prints, an acute eye for physiognomic exaggeration and social comedy was combined with a nonchalantly elegant graphic manner. Such images as *Iphigenia's Late Procession from Kingston to Bristol – By Chudleigh Meadows* (c.1776) (fig.10) are both vicious and technically exquisite, in this instance targeting the Duchess of Kingston, recently convicted for bigamy, and seen waddling at the head of a motley procession of servants and professional hangers-on.[13]

In the early 1780s this mode of satire was expanded and developed by Thomas Rowlandson, who produced a stream of brilliantly inventive and formally accomplished satires, culminating in a succession of prints that responded to the infamous Westminster election of 1784, including the famous *Covent Garden Nightmare* (fig.11), which, ingeniously, adapted Fuseli's 1781 painting *The Nightmare* in order to depict Fox as an effeminised, debauched and dream-plagued nude.[14] Looking at these images by Mortimer and Rowlandson makes it clear that Gillray began his career at a time when a particular brand of sophisticated satiric print was being marketed in the capital, and was being produced by some of London's most talented draughtsmen and engravers. Gillray both aligned himself with this work and, increasingly, competed with it. Thus, Gillray's *La Belle Assemblée* (1787) (no.192), which offers a stinging but thoroughly elegant critique of aristocratic femininity, fashion and self-delusion, stands as an elaborately etched and allegorically weighted successor to Mortimer's *Iphigenia*, while his *Duke William's Ghost* (1799) (fig.12) not only ironically evokes Fuseli's pictorial precedent, but also that of his great rival, Rowlandson. Meanwhile, in his great series of satires dealing with the execution of the French King Louis XIV in January 1793, culminating in the horrific *The Blood of the Murdered crying for Vengeance*, published on 16 February

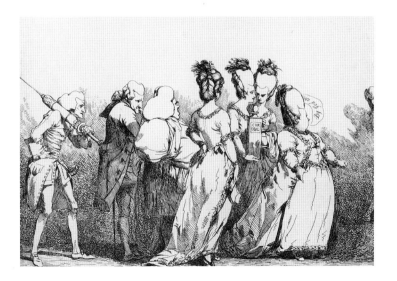

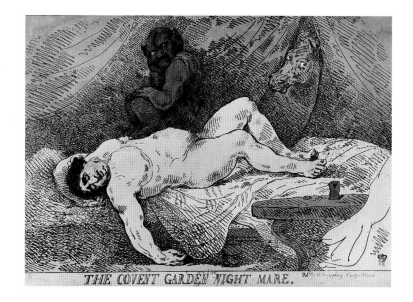

fig.11
Thomas Rowlandson,
The Covent Garden Nightmare 1784
22.2 x 33
BMC 6543
The British Museum, London

(no.61), Gillray can be seen to have worked in close pictorial dialogue and compe-
tition with those images of the same event being produced by Isaac Cruikshank,
which included *The Martyr of Equality*, published only four days beforehand.[15] At
such moments, we become more fully aware of Gillray as an artist who, contrary
to a venerable mythology that pictures him working in isolation in his garret
studio, was continually responding to the other works and individuals who
populated that modern satiric culture of which he was a part.

Gillray's works also depended for their power on the implicit or explicit compari-
son they offered to more conventionally respectable kinds of image. Throughout
its eighteenth-century history, graphic satire constantly played off more polite
and decorous forms of representation. Indeed, satire can be said to have indulged
in a two-way dialogue with 'high' art, on the one hand parodying, misappropriat-
ing and perverting its forms, and on the other raising its own aesthetic status
through this gesturing to, and absorbing of, more highly regarded forms of
pictorial representation. Gillray's prints offer a particularly insistent example of this
dialogue, as we have already seen in *Sin, Death, and the Devil's* direct reference to
the work of the Royal Academician Henry Fuseli. Similarly, *La Belle Assemblée* not

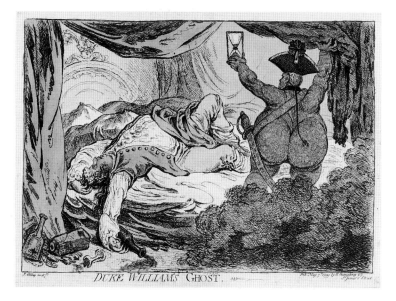

fig.12
James Gillray,
Duke William's Ghost 1799
24.5 x 34.6
BMC 9381
The British Museum, London

only maintained the format and perspectives of earlier graphic satire, but also parodied the kinds of allegorical portraits of aristocratic women associated most closely with the President of the Royal Academy, Joshua Reynolds, and in particular with such images of his as *Lady Sarah Bunbury Sacrificing to the Graces* (no.193).[16] In gesturing so frequently to the works of the Academy's most celebrated practitioners, and subjecting them to various kinds of satirical iconoclasm, Gillray was, on the one hand, ridiculing the institution's members and its products and asserting his independence of the artistic norms they promoted. On the other hand, however, this very process both confirmed his and graphic satire's dependence upon, and ultimate deference to, the Academy, and the kinds of art that it sponsored.

This process can again be seen in action in one of Gillray's numerous responses to the paintings of another leading member of the Academy, Benjamin West. At the end of 1795 Gillray produced *The Death of the Great Wolf* (no.111), an elaborate satiric critique of William Pitt that shows the Prime Minister as a military leader expiring in the arms of his colleagues and confidants on the field of battle, while, in the background, British forces overcome a tiny band of French soldiers. This print offers an ironic comment on the passing by Pitt's government of a series of draconian 'Treason and Sedition Bills' that were ostensibly designed to maintain national security during the war with France, but which came under widespread attack for their infringement of civil liberties and the threat they mounted to any meaningful political opposition. Gillray implies that Pitt, having won this parliamentary battle, can now die happily: '"I'm Satisfied" – said the Dying Hero, & Expired at the Moment of Victory.' Gillray's depiction of Pitt does not only take its cue from recent parliamentary events, however. As a line at the bottom of the print makes clear, *The Death of the Great Wolf* is also an extended, obsessively painstaking parody of West's 1770 painting of the death of General James Wolfe (no.112), shown dying at the moment that British troops were defeating the French in Quebec in 1759.[17] Here, even as he pretends to be acting in a spirit of emulation and deference, declaring that the print is 'respectfully submitted' to West, his adaptation of *The Death of Wolfe* clearly represents a sustained form of pictorial vandalism and satiric distortion, in which West's sentimental and patriotic hero and his loyal supporters are transformed into a series of caricatured and subtly ridiculed politicians. Yet at the same time, the print's mock-heroic mimicry of the forms and storylines of contemporary history painting, and the sheer skill and scale of Gillray's response to West, were clearly designed to earn both *The Death of the Great Wolf* and its producer a particularly distinguished reputation within urban graphic culture.

While this kind of comparison playfully exploited the discrepancies between the heroic protagonists, narratives and environments found in the most prestigious forms of history painting and the corrupted, perverse and excessive imagery tradi-tionally associated with satire, we also find Gillray responding to an alternative kind of high art to that represented by West and Reynolds's decorous canvases. By this I mean a brand of distinctly fantastic, grotesque and exaggeratedly violent painting that emerged in the supposedly genteel environment of the Royal Academy during the last two decades of the century. Artists such as Fuseli, as has already become apparent, were regularly exhibiting paintings at the Academy that

fig.13
Johann Zoffany, engraved by R. Earlom,
Invasion of the Cellars of the Louvre 1792
56.7 x 64
BM 1856–10–11–106
The British Museum, London

offered sensational explorations of the supernatural, the melodramatic and the eerie.[18] In his numerous parodies of such pictures, Gillray was both satirising the taste for this new kind of gothic imagery, and using that imagery to bolster satire's own concentration on the dark side of the human and political psyche. Meanwhile, during the war years of the 1790s, the Academy exhibited numerous pictures that depicted the reported atrocities of the French Revolution in brutal detail, including Johan Zoffany's shocking painting *Invasion of the Cellars of the Louvre* (1792) (fig.13), which was both exhibited at the Royal Academy and published as an engraving in 1795.[19] When we turn from Zoffany's work to a print such as Gillray's *Promis'd Horrors of the French Invasion* (no.83), issued in the following year, we quickly realise that both artists are trading in the same imagery of decapitated heads, swinging bodies, flaming buildings and physical assault. Indeed, at first glance, the gap between the products of high art and those of satire suddenly seems almost to have disappeared, and we become aware instead of a powerful form of artistic cross-fertilisation, in which Academic history painting aligns itself with the gross forms and narratives of satire, and vice-versa. Even here, however, everything is not as it seems. For while, at one level, Gillray's picture, just like Zoffany's, dramatises the contemporary threat of anarchy and destruction represented by the Revolution, and turns this threat to powerful aesthetic effect, at another *Promis'd Horrors* – through its cheerful satire of figures like Fox and Pitt, through its relentless caricaturing of the aristocratic protagonists who swarm around the fashionable gambling clubs of White's and Brooks's, and through its laughable image of an invading French army – makes the 'promised horrors' of revolutionary violence seem both exaggerated and comic, and in doing so calls into question the hyperbolic pictorial and political language that was currently being used to denounce what was happening on the other side of the Channel. Yet again we find Gillray, in his engagement with the art being generated within the Academy, trying to have it both ways.

The 1st of August 1798 saw the publication of another satire dealing with the French threat, Gillray's remarkable *New Morality* (fig.14), a particularly lengthy and crowded print which was designed to be inserted as a fold-out illustration into the *Anti-Jacobin Magazine and Review*, a political journal set up to combat what its editors dramatised as a powerful pro-revolutionary Jacobin movement in English politics: 'The existence of a Jacobin faction, in the bosom of our country, can no longer be denied. Its members are vigilant, persevering, indefatigable, desperate

fig.14
James Gillray,
New Morality: - or – the Promis'd Installment of the High-Priest of the Theophilanthropes, with The Homage of Leviathan and His Suite 1798
20.3 x 61
BMC 9240
The British Museum, London

in their plans and daring in their language. The torrent of licentiousness, incessantly rushing forth from their numerous presses, exceeds, in violence and duration, all former examples.'[20] Gillray's etching, which illustrates a poem by the government politician and journalist George Canning, depicts a fantastic procession of opposition Whig politicians, monsters, poets, writers, frogs, crocodiles and snakes, all shuffling forward to worship at a French Revolutionary altar. Near the head of the procession, we see a 'cornucopia of Ignorance' spewing forth a torrent of pamphlets, and a number of figures carrying copies of some of London's leading Whig newspapers. Noticing this concentration on printed political texts, and remembering the location of Gillray's image within yet another explicitly political publication, make it clear how his satires have to be understood not only in relation to the worlds of engraving and of high art, but also, crucially, to those of journalistic commentary and political propaganda.

As we have seen, graphic satire, from its beginnings, enjoyed a powerful status as a vehicle of social and political critique. In this role satire functioned as an adjunct to the expanding realm of journalism in the English capital, taking its place alongside the newspapers, pamphlets, broadsides, and journals that proliferated in ever greater numbers within urban culture. Indeed, Gillray, like the other producers of graphic satire in the Georgian period, continually responded not so much to political and social events in themselves, but to their representation in the contemporary press. The satires he and others created, even as they flaunted their allegiance to the world of the image, thus functioned as powerful supplements to, and interventions in, the predominantly textual sphere of political journalism and printed social commentary. By the last decades of the eighteenth century this field of literary production had become an increasingly partisan, vitriolic and competitive arena of reportage and opinion. Particularly significant here is the fact that the London newspapers, and many of the capital's journals, were frequently subsidised by either the government or the opposition, and consequently functioned as propagandist mouthpieces for their policies. In the parliamentary reports, printed letters, satirical poems and gossip columns that filled their pages, the leading political personalities of the day were relentlessly idealised or ridiculed, and the policies and fortunes of the main parliamentary parties were scathingly contrasted. In this environment, particularly during the 1790s, journalism and propaganda continually merged, and the rhetoric of the press – as the above quote from the *Anti-Jacobin* confirms – became ever more florid, violent and extreme.[21]

Gillray's relationship to this journalistic and political sphere shifted throughout his career. Up until the late 1790s, he remained someone who typified the satirist's traditional role as a respondent to, and not a collaborator with, the London newspapers, and as someone who exposed and condemned the pretension, hypocrisy and corruption of all politicians and political parties. For a short period in the late 1790s, however, Gillray's works aligned themselves with the journalism and propaganda found in pro-government and pro-establishment newspapers and journals, and with the policies and personalities of Pitt's government. Between 1797 and 1801 Gillray was in receipt of a secret annual pension of £200, and began regularly producing images for such vitriolically anti-Whig publications as the *Anti-Jacobin*.[22] This alliance between Gillray's satire and the purposes of

journalistic propaganda has often been dismissed as a regrettable and diminished phase of his life and career.[23] On the contrary, it generated some of Gillray's most artistically brilliant and inventive images. Looking at the other prints he produced for John Wright's *Anti-Jacobin*, for instance, we come across such startling works as *'Two Pair of Portraits'* (no.71). This print, published in December 1798, ridicules the recent conversion of the journalist and politician John Horne Tooke to Fox's Whig party through evoking a pamphlet Tooke had written in 1788, also called 'Two Pairs of Portraits', in which he had attacked Fox and his father, Lord Holland, by systematically comparing their corrupted and criminal politics to the virtuous examples of the younger and elder Pitt. A transcript of the pamphlet was published alongside Gillray's engraving, and its final lines are shown in the speech bubble emerging from Tooke's mouth, which takes its place alongside the mass of other pictorial and textual details that are so artfully distributed across the print as a whole.

Gillray's image, as well as offering an extended attack on Tooke's political recidivism, and on his revolutionary leanings – dramatised by the references to Wilkes, Robespierre and Machiavelli found scattered across the wall – can also be seen to offer a fascinating meditation on the practice of political satire itself. For, of course, Tooke is depicted doing precisely the same thing that Gillray himself was doing as he executed this image: producing satirically contrasting images of Pitt and Fox, and their fathers, and drawing upon a mass of politically and artistically disreputable materials in order to do so. Seen this way, the target of the satire and its producer suddenly become difficult to disentangle, and we realise that we are looking at yet another 'pair' of portraits – a portrait of Tooke on the one hand, and on the other a masked self-portrait of Gillray himself, who, through this conceit, seems to acknowledge surreptitiously his own complicity in producing precisely the same kind of propagandist political satire. Given such ironies, it is perhaps unsurprising that Gillray's alliance with the government was only a brief one, and that his pension seems to have stopped on the fall of Pitt's government in 1801. From this point onwards until his death, we find Gillray resuming the satirist's traditional practice of subjecting both government and opposition politicians to ridicule, and disavowing any obvious journalistic loyalties or connections.

For much of his working life, Gillray worked for one employer, the print-seller Hannah Humphrey, who would display his works in the window of her shop in Old Bond Street, then as now one of the most dignified thoroughfares in the capital's fashionable West End. Imagining this window, and remembering its status as a kind of frame or platform for an ever-changing display of political and social satires commentating on contemporary events and issues, offer one last insight into Gillray's work and its modernity. For in Mrs Humphrey's window – as in the other print-shops of the city – the most celebrated personalities and the most topical controversies of the period were constantly being pictorially recycled, replaced or removed, as one set of satires took over from another. In this process, such windows, and the images by artists like Gillray that were produced to hang in them – the colours of which must have shone out onto the street like eighteenth-century neon – became the sites of an ephemeral, exaggerated, vibrant, up-to-date and highly entertaining form of urban spectacle. As such, they took their

place alongside, and competed with, the shimmering, continually changing displays of consumer goods to be found in the other shop windows that surrounded them on the London streets.

There seems something very familiar about this role of satire as a quickly disposable component of a commercialised, urbanised and visually spectacular culture. For today, of course, graphic satire – when equated with the cartoons found in our daily newspapers and weekly magazines – is understood very much in these terms, and because of this is often treated as a second-class category of the arts, unworthy of sustained critical attention. Even the works of such great living practitioners as Steve Bell (fig.15), Ralph Steadman and Ronald Searle, which deploy many of the same satiric techniques as their eighteenth-century predecessor, are conventionally treated as witty, fast-moving, but ultimately ephemeral forms of art. In front of Mrs Humphrey's window, we can now suggest, this perception of satire as an attention-grabbing but fleeting art form, part of the ebb and flow of modern urban life and journalism rather than of high-minded cultural or aesthetic practice, would already have been placing a great deal of stress on the very different pattern of looking also invited by Gillray's works, in which the spectator was invited to peruse the image at length, and to appreciate the satirical etching as an enduring example of ambitious printmaking. The tensions and contradictions between these two ways of looking, between these two kinds of interpretation, and, ultimately, between the two different kinds of viewer they imply, help explain graphic satire's traditionally ambivalent art-historical status, and the uncertainty with which Gillray himself has often been viewed by scholars and critics. Today, however, we can suggest that it is precisely because of such tensions and dualities that his work is so interesting. For Gillray produced an art that belonged to the street *and* to the connoisseur's study, and in doing so enabled us in turn to enjoy his satire as both a remarkable index of late Georgian urban society and a fascinating realm of aesthetic interest and pleasure.

fig.15
Steve Bell,
Introducing the Single European Cow 1996

Notes

INTRODUCTION

1 *The Athenaeum*, 15 October 1831, p.667. John Landseer (1769–1852) was an engraver, well known for his opposition to the Royal Academy, and for his attack on the memory of John Boydell in his *Lectures on the Art of Engraving* (1807). He was the father of Sir Edwin Landseer.

2 It is reasonable to assume that this toast was accompanied by drunken hoots and catcalls, since David's name in England was a byword for bloodthirstiness.

3 It is unlikely that Gillray had more than a sketchy knowledge of David's work, since very few of the latter's paintings were engraved.

4 See Draper Hill, *Mr Gillray the Caricaturist*, London 1965. This outstanding biography is indispensable for all studies of Gillray.

5 Although Gillray seems to have wearied of his tutelage under Ashby, engraving calligraphy amongst other tasks, one legacy was his brilliance as a lettering engraver.

6 See David Alexander and Richard Godfrey, *Painters and Engraving: the Reproductive Print from Hogarth to Wilkie*, Yale Center for British Art 1980.

7 For a general introduction to British caricature see Richard Godfrey, *English Caricature: 1620 to the Present*, Victoria & Albert Museum 1984.

8 See Diana Donald, '"Calumny and Caricatura": Eighteenth-Century Political Prints and the Case of George Townshend', *Art History*, vol.6, no.1, March 1983, pp.44–66.

9 The standard catalogue of Hogarth's prints is Ronald Paulson, *Hogarth's Graphic Works*, revised edn, London 1989.

10 A number of letters from amateurs suggesting ideas are to be found in the miscellaneous collection of Gillray's papers, British Library, Add.Mss. 27,337.

11 Although sometimes he seems to have used the words with his tongue in cheek.

12 Henry Angelo, *Reminiscences of Henry Angelo*, 1828, vol.1, pp.382–3.

13 *London und Paris*, 18 July 1806, pp.7–10. See *Gillray Observed: The Earliest Account of his Caricatures in London und Paris*, trans. and ed. Christiane Banerji and Diana Donald, Cambridge 1999. This exceptionally important publication contains an introduction and translations of 23 articles about Gillray. It is a vital tool for understanding the sophistication of Gillray's work as seen by a cultured foreigner, and has many direct observations of the artist's character and behaviour.

14 The great bulk of the Royal Collection of caricatures, excluding prints by Rowlandson and Hogarth, was deaccessioned and sold to the Library of Congress in 1920.

15 Op. cit. p.246.

16 Op. cit.

17 For the relationship of Goya to English caricatures, see Reva Wolf, *Goya and the Satirical Print in England and on the Continent 1730 to 1850*, Boston 1991.

18 *Somerset House Gazette*, 3 April 1824, p.411.

19 See David Bindman, *The Shadow of the Guillotine: Britain and the French Revolution*, British Museum, London 1989.

20 See Draper Hill, op. cit., p.60. Draper Hill gives particularly detailed and enlightening analysis of Gillray's relationship with Canning.

21 See Diana Donald, *The Age of Caricature: Satirical Prints in the Reign of George III*, New Haven and London 1996.

22 See John Gage, 'Magilphs and Mysteries', *Apollo*, LXXX

Notes

JAMES GILLRAY AND THE LANGUAGE OF GRAPHIC SATIRE

1 King James Authorised Bible. For their help in making sense of this print, I would like to thank my colleagues at the University of York, Christopher Norton and Michael White.

2 This print is no.5970 in the *British Museum Catalogue of Political and Personal Satires* by Frederick G. Stephens, vols.I–IV, and M. Dorothy George, vols.V–XI, London 1870–1954. This famous catalogue is the first port of call for any student of eighteenth-century graphic satire.

3 Francis Grose, *Rules for Drawing Caricatures: With an Essay on Comic Painting*, (2nd ed.), London 1791, p.4 (my italics).

4 The best discussion of late eighteenth-century graphic satire is Diana Donald, *The Age of Caricature: Satirical Prints in the Reign of George III*, London and New Haven 1996. Donald discusses Gillray at length and with great sensitivity in this book.

5 For an extended discussion of this image, see Lora Rempel, 'Carnal Satire and the Constitutional King: George III in James Gillray's *Monstrous Craws at a New Coalition Feast*', Art History, vol.18, no.1, Mar. 1995.

6 Both artists are discussed in Richard Godfrey, *Printmaking in Britain*, London 1978.

7 For more on the engravings of this period, see Antony Griffiths, *The Print in Stuart Britain 1603–1689*, London 1998.

8 I discuss *The Whig's Medly* at length in Mark Hallett, *The Spectacle of Difference: Graphic Satire in the Age of Hogarth*, London and New Haven 1999, pp.46–55.

9 For the printmarket of eighteenth-century London, see Timothy Clayton, *The English Print 1688–1802*, London and New Haven 1997.

10 This print is analysed at greater length in Hallett, *The Spectacle of Difference*, pp.151–4.

11 For Hogarth, see in particular Ronald Paulson's magisterial study *Hogarth*, 3 vols., London 1991–3. For modern introductions to the artist see David Bindman, *Hogarth*, London 1981, and Mark Hallett, *Hogarth*, London 2000.

12 For the best recent discussion of the Academy's early years, see David Solkin, *Painting for Money: The Visual Arts and the Public Sphere in Eighteenth-Century England*, London and New Haven 1993, chs. 6 & 7.

13 For Mortimer, see John Sunderland, 'John Hamilton Mortimer: His Life and Works', *Walpole Society*, 52, 1986.

14 Rowlandson's image is reproduced and discussed in Donald, *The Age of Caricature*, pp.70–1.

15 For a recent study of English satires dealing with the French Revolution, see David Bindman, *The Shadow of the Guillotine: Britain and the French Revolution*, London 1989.

16 Reynolds's picture is discussed in Nicholas Penny (ed.), *Reynolds*, exh. cat., Royal Academy, London 1986, pp.224–5.

17 The best discussions of West's painting are to be found in Edgar Wind, 'The Revolution of History Painting', *Journal of the Warburg and Courtauld Institutes*, vol.2, 1938–9, pp.117–23 and Solkin, *Painting for Money*, pp.209–13.

18 For a survey of Fuseli's work, see the Tate Gallery exhibition catalogue, *Henry Fuseli 1741–1825*, London 1975.

19 For this painting, see William L. Pressly, *The French Revolution as Blasphemy: Johan Zoffany's Paintings of the Massacre at Paris, August 10, 1792*, London 1999.

20 *Anti-Jacobin Review and Magazine*, London 1799 (vol. for 1798), p.1.

21 For the press in this period and its political persuasions, see Arthur Aspinall, *Politics and the Press 1780–1850*, London 1949.

22 For this episode in Gillray's career, see Draper Hill, *Mr Gillray the Caricaturist*, London 1965, pp.56–72.

23 Donald reviews early nineteenth-century criticisms of Gillray's ties to Pitt's government in *The Age of Caricature*, pp.41–3.

Cast of Characters
& Chronology

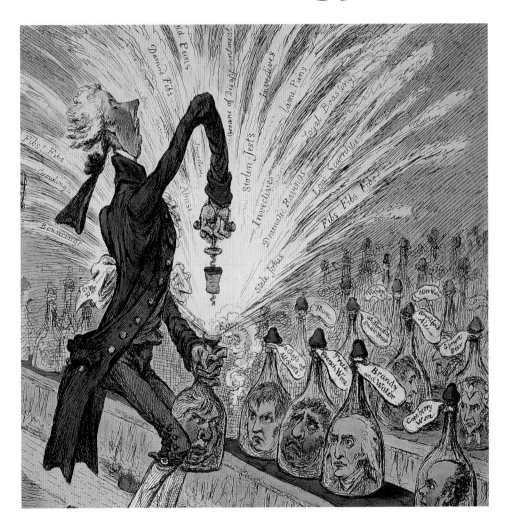

detail, no.122

Cast of Characters

Addington, Henry,
1st Viscount Sidmouth (1757–1844)
Prime Minister, succeeding Pitt in 1801. Son of a court doctor, and intimate friend of Pitt from childhood, Addington entered parliament in 1783 and became Speaker in 1789. He was much occupied with the impeachment of Warren Hastings. As Prime Minister, he negotiated the short-lived peace with Napoleon of 1802. When Pitt formed a new government in 1804 he returned as Lord President. Addington was not highly regarded, and operated in the shadow of Pitt. As Canning witticised: 'Pitt is to Addington, as London is to Paddington.'

Boydell, John
(1719–1804)
The leading print publisher of his time. In 1789 he opened the Shakespeare Gallery in Pall Mall, a collection of newly-commissioned paintings of Shakespearean subjects by many of the most famous British artists of the day. He was thus established as the most important patron of new British art, though his intentions were commercial as well as patriotic. However, the French wars hit the print export market, and a series of failed publishing schemes forced Boydell to put the Gallery up for sale by lottery. The lottery took place in 1805, shortly after his death.

Burke, Edmund
(1729–97)
Statesman and man of letters. Born in Dublin, son of a Protestant lawyer father and a Catholic mother, and educated a Quaker, Burke was a life-long Anglican, though a fierce supporter of the Irish Catholic cause. After studying at Trinity College, Dublin, he went to London in the 1760s to read law. Embroiled in literary society, he entered parliament in 1765, and emerged as a leader of the Foxite Whigs. With them he strongly opposed the war against revolutionary America. Although he lacked ordinary administrative skills, his political and philosophical writings were of tremendous importance. His lasting fame is for his book *Reflections on the Revolution in France* (1790), a hugely influential statement of anti-revolutionary

feeling and a founding text of modern political conservatism. In 1791 he broke with Fox, who was far more sympathetic to the Revolution, and joined the ministerial party. In these later years he became notorious for dull and over-long speeches: 'Burke's eloquence always appears to me like a torrent pouring down and carrying all before it, overwhelming friend and foe, without any one being able to guess which way it tends, or where the ravage will stop' (Lady Bessborough). Burke retired in 1794.

Canning, George
(1770–1827)
Statesman. His father, who died when Canning was only a baby, was the disinherited heir to a family of Ulster gentry. Raised by his mother, a kindly uncle sent him to university. Canning entered parliament in 1794 and was allied to Pitt against the French Revolution, becoming Under-Secretary for Foreign Affairs in 1796. In 1797 he helped found the ferociously reactionary *Anti-Jacobin Review and Magazine* (and recruited Gillray's sevices for the magazine in 1798). He resigned with Pitt in 1801 and remained out of office until 1807. He then returned as Foreign Minister until 1809, when the occasion of a duel with Lord Castlereagh obliged him to resign. He came back as Foreign Secretary in the 1820s, and had a brief period as Prime Minister, cut short by his death.

Charlotte Sophia,
Princess of Mecklenburg-Strelitz
(1744–1818)
German-born Queen of George III. She arrived in England on 7 September 1761, and was married the next day. At the time of her marriage Horace Walpole noted: 'She is not tall nor a beauty . . . her forehead low, her nose very well, except the nostrils spreading too wide. Her mouth has the same fault, but her teeth are good.' Charlotte gave birth to fifteen children. Seven sons survived into adulthood, and the many scandals and misadventures they were involved with were to prove a great embarrassment. Six daughters survived, suffocated by the dullness of court life. Three remained

unmarried. With George she established a new, domesticated model of monarchy. Gillray cruelly exploited the Queen's homeliness and plain features for comic effect.

Derby, Edward Smith-Stanley,
12th Earl of (1752–1834)
Member of Parliament 1774–6, when he succeeded his father as Earl of Derby. The obituary in the *Gentleman's Magazine* noted that it was 'in the character of a sportsman that the late Earl made himself most conspicuous'. A very prominent Whig, he is now best remembered as the lover, and later husband, of Elizabeth Farren.

Dundas, Henry,
Lord Melville (1742–1811)
Lawyer and statesman. Came from a long line of Scottish judges, and rose through the ranks of the Scottish legal profession, to enter parliament in 1774. Dundas supported the war against America, and allied himself to Pitt. Appointed President of the Board of Control, a post he kept until 1801. He was also Home Secretary 1791–4, and Secretary of State for War from 1794. Dundas resigned with Pitt in 1801 and returned with him in 1804. In 1805 he was impeached for financial misdemeanours and, although acquitted, retired from politics.

Farington, Joseph
(1747–1821)
A pupil of the painter Richard Wilson, and a landscape painter and draughtsman of modest talent. He became a Royal Academician in 1785 and thenceforward played a highly influential role in the affairs of the Academy. He was one of the principal dupes in the affair of the so-called Venetian Secret. He is best remembered for his extensive *Diary*, a wonderful source of information and gossip about the London art world.

Fitzherbert, Mrs Maria Anne
(1756–1837)
Unofficial wife of George, Prince of Wales. Born Maria Anne Smythe, she was twice married and twice widowed prior to meeting George. Her widowhood brought her a substantial income, and she settled at fashionable Richmond. In 1785 she met the Prince, and rather reluctantly agreed to marry him. As a royal prince under the age of 25, he needed the King's consent to marry, but did not seek it. Furthermore, Mrs Fitzherbert was a Catholic, and as such not a legitimate bride for a British prince. Rumours of the marriage arose, and in 1787 Fox denied the reality of the marriage in parliament. In 1795 the Prince of Wales married Caroline of Brunswick, legitimately, and for a time Mrs Fitzherbert stopped living with the Prince, though they remained companions until 1803. Despite the circumstances of the marriage, Mrs Fitzherbert seems to have been well-liked and accepted by the rest of the royal family.

Fox, Charles James
(1749–1806)
The great political character of his age, a democratic Whig and individualist, whose robust demeanour and outrageous lifestyle contrasted comically with his severe Tory opponent, Pitt. Fox's drinking, gambling and carousing were encouraged by his indulgent father, the politician Henry Fox. C.J. Fox entered parliament while still in his teens, and was a member of the Board of Admiralty when he was 21. An advocate of parliamentary reform, he strongly opposed the war with America. In 1784, after the collapse of his cynical political alliance with Lord North, Fox came head-to-head with Pitt at the Westminster election. With the King's madness in 1788 he conspired with the Prince of Wales to establish a Regency. He greeted the French Revolution enthusiastically, and remained the most famous parliamentary supporter of revolutionary principles through the 1790s. Gillray made much of Fox's 'democratic' physical appearance, with his unshaven chin and wigless head. By the end of the 1790s Fox had no real political support, and led the opposition into effective retirement. With the death of Pitt in 1806 he

returned to office as Secretary of State, but died very shortly afterwards. Ten days before his death he moved a bill, the last of many, which ended the slave trade in the British Empire.

Frederick Augustus,
Duke of York (1763–1827)
The least embarrassing of George and Charlotte's children, although that judgement is, of course, relative. Frederick received a superior education in Hanover from 1780–7. A professional soldier – in command of an army at the age of 30 – he was involved in a series of infamous defeats, barely escaping with his life. He was nonetheless raised to 'Field-Marshal of the Staff', and proved surprisingly effective in administration, countering corruption and introducing innovations (including the college that would become Sandhurst). Frederick was married to a Prussian princess, but was not faithful. One former mistress accused him, in 1809, of corruption. Though acquitted, Frederick resigned, but took up the post again from 1811 until the last year of his life. Remembered as 'the grand old Duke of York' in the nursery-rhyme.

George III
(1738–1820)
George ascended the throne in 1760. Although his scholarship was limited (he did not learn to read until he was 11) he had practical interests (taking drawing lessons from the architect Sir William Chambers). During his long reign Britain was established as a major industrial and imperial power, as well as a centre of cultural innovation. During the 1760s he deployed his favourite, the Earl of Bute, to destroy in effect the reigning ministry, leading to accusations of tyranny. In 1768 he lent his royal authority toward the new Royal Academy of Art in London, though his patronage of art was largely taken up with commissions from his favourite, Benjamin West. In the 1770s he backed North as Prime minister. The loss of the American colonies in 1782, and with them his favoured minister, came as a great blow. A saviour emerged in the figure of Pitt, whom George

made Prime Minister in 1784. In 1788 he suffered the first of his breakdowns, now usually diagnosed as the result of porphyria (an inherited disease that attacks the nervous system). A national crisis ensued, with the Prince of Wales and his political supporters waiting hungrily in the wings. By early 1789 George had recovered, although he was subsequently to play a lessened role in national affairs. Domesticated and bumbling, and at least pretending to an interest in the common people, George's popularity grew, though he still had enemies, the poet Shelley referring to the ageing king as 'old, mad, blind, despised'.

George, Prince of Wales
(1762–1830)
The eldest son of George III and Charlotte, famed for his debauched lifestyle. He ruled as George IV 1820–30. A close friend of Fox, he established his London palace, Carlton House, as the centre of opposition intrigue. With Fox he conspired to establish himself as Regent during the King's madness (1788–9). Although already married to the older, Catholic widow Mrs Fitzherbert, in 1795 he married Caroline of Brunswick, in part to help pay off his ever-mounting debts. George's luxurious lifestyle was a constant embarrassment for the monarchy, and was richly sent up by Gillray. He was a very dedicated collector of caricatures by Gillray, now in the Library of Congress, Washington.

Grenville, William Wyndham,
Baron Grenville (1749–1834)
Son of George Grenville – Prime Minister 1763–5 – and first cousin to William Pitt, whom he resembled. Grenville entered parliament at the age of 23, and served as Paymaster-General under Pitt, then Home Secretary and Foreign Secretary 1791–1801. He was strongly opposed to the French Revolution. After the death of Pitt in 1806 he led 'the Ministry of all the Talents', but did not long maintain power.

Hastings, Warren
(1732–1818)

The defendant in the longest political trial in history, Hastings was an administrator in the East India Company, the commercial and military organisation which established Britain's political authority on the sub-continent. For entirely political reasons, in 1787 Burke, Fox and Sheridan moved to impeach Hastings, making him carry the can for British abuses in India. The trial lasted from February 1788 until 1795, and was the cause of much discussion and debate. Hastings was eventually acquitted.

Paine, Thomas
(1737–1809)

Radical writer. Paine was the son of a Quaker, and pursued careers as a stay-maker, seaman and excise-man before going to America to work as a journalist. During the American wars, he worked in intelligence (on the rebels' side), but had to resign in 1779 having revealed (although not maliciously) secrets regarding the French–American alliance. His great fame came with the publication of his *Rights of Man* in two parts (1791–2) which celebrated the Revolution in France and forecast further revolutions. The book became a virtual textbook of radical views, and helped stimulate a ferocious political reaction in Britain. Escaping the threat of arrest in England, Paine was welcomed enthusiastically in France in 1793, but following his opposition to the execution of Louis XVI was denounced and imprisoned. He narrowly escaped execution and was claimed as a citzen of the United States. He eventually went to America in 1802.

Pitt, William, 'the Younger'
(1759–1806)

With Fox, the most famous and visible statesman of the era, as both leader of the Tories and Prime Minister. The second son of William Pitt, Earl of Chatham, he suffered from delicate health as a youth and was educated at home, but became a precocious student at Cambridge. He entered parliament in 1780, and was Chancellor of the Exchequer in 1782. With the collapse of the Fox–North political coalition in 1783–4, Pitt was made Prime Minister, not having yet reached the age of 25. Pitt viewed the coming of the French Revolution as a largely domestic matter, and even predicted peace in Europe for fifteen years as late as 1792. Following war with France from 1793, Pitt introduced repressive laws against political radicalism in Britain, and severe economic measures. He resigned in 1801 when George III refused to pass Catholic Emancipation to accompany the Act of Union with Ireland. Pitt formed another ministry in 1804, but with little success: 'Nothing was ever more disastrous in every way than the second *career* of Mr Pitt – as much so as his first was brilliant' (Lady Bessborough). Although much addicted to port and plagued throughout his life by debts, Pitt's personal reputation was spotless. He died in 1806, his doctor reporting that he 'died of old age at forty six, as much as if he had been ninety'.

Sheridan, Richard Brinsley
(1751–1816)

Politician and playwright, author of *The School for Scandal*. Son of an Irish actor and playwright and an actress, Sheridan had a successful career as a playwright and theatre manager before entering politics in 1780. He supported Fox, and was a member of the social circle of the Prince of Wales. Sheridan was a master of rhetoric, and was considered a great speaker in parliament, but in reality his administrative skills were limited. In later years he suffered from the effects of his drinking and became a figure of fun.

Thurlow, Edward, 1st Baron (1731–1830)

Skilful, hard-nosed, but ultimately corrupt lawyer. In 1770 he was made Solicitor-General, and in 1771 Attorney-General. He became famous, as according to Fox: 'No-one was ever so wise as Lord Thurlow looked.' He intrigued with the Prince of Wales over the Regency Bill in 1788, and so, with the recovery of the King, lost his reputation. Following a power struggle, Pitt helped ensure that he was removed from office in 1792.

Tooke, John Horne
(1736–1812)

Clergyman and political radical. Tooke became famous in the 1760s for his support of the reformer John Wilkes. He was largely excluded from officialdom for his radical outlook. In 1790 he opposed Fox at the Westminster election. With the reactionary feelings of the 1790s, Tooke came under suspicion and was tried for treason (and acquitted) in 1794. Tooke was not a new-style democrat, but rather an old-fashioned patriotic reformer upholding the rights of merchants and businessmen in opposition to aristocratic privileges.

Windham, William
(1750–1810)

War Minister during the first phase of the conflict with France. Windham entered parliament in 1784, and supported the impeachment of Warren Hastings. With the French Revolution, he followed Burke in condemning republicanism. In 1794 Pitt made him War Minister. He held the post until 1801 when he resigned over the issue of Catholic Emancipation. In 1806 he returned to government as Secretary for War and Colonies.

Chronology

	Gillray's life	Home affairs	International news
1756	Born on 13 August in Chelsea, the third child of James Gillray and Jane Coleman Gillray. James was a former soldier, a house painter and the sexton of Chelsea's Moravian Community.	Thomas Rowlandson born (1756–1827).	Start of the Seven Years' War. Mozart born (1756–91).
1757		William Blake born (1757–1827).	
1759		The British Museum opens to the public.	
1760		Accession of George III (1760–1829).	
1761		George III marries Princess Charlotte (1744–1818) in September.	
1762	Educated at Moravian academy in Bedford.	Birth of George, Prince of Wales (1762–1830). Earl of Bute (1713–92) becomes Prime Minister.	Rousseau publishes *Du Contrat Social*. Library of the Sorbonne founded. Catherine the Great becomes Empress of Russia.
1763		Bute resigns in April and is succeeded by George Grenville (1749–1834), who retains the premiership until 1765.	Seven Years' War ends. Franco-British Treaty of Paris. Britain remains supreme in North America and India.
1764	Leaves school.	Death of William Hogarth (1697–1764).	
1766		Fall of the Marquess of Rockingham's (1730–82) first ministry.	
1768		Duke of Grafton (1735–1811) becomes Prime Minister. Royal Academy founded, with Joshua Reynolds (1723–92) as its first President.	
1770	Apprenticed until 1771 to Harry Ashby (1744–1818), a London writing engraver specialising in banknotes, certificates and cheques.	Lord North (1732–1792) succeeds the Duke of Grafton as Prime Minister in February.	James Cook discovers New South Wales.
1771		Benjamin West (1738–1820) exhibits *The Death of Wolfe.*	
1773			Boston Tea Party.
1774		Warren Hastings appointed first Governor-General of India.	Accession of Louis XVI of France (1754–1793).
1775	Returns to London after reputedly travelling outside the city for one year. William Humphrey publishes Gillray's first engravings and etchings, including satirical prints.	Thomas Girtin (1775–1802) and J.M.W. Turner (1775–1851) born.	War of American Independence begins, with British defeat at Lexington.
1776		John Constable (1776–1837) born.	American Declaration of Independence (4 July).
1778	Enters Royal Academy schools in April to study as an engraver under the direction of Francesco Bartolozzi (1728–1815).	William Pitt the Elder dies in May (1708–78).	France joins America in war against Britain.
1779	Etches his first work for the publisher Hannah Humphrey (1745–1818).	William Blake enters the Royal Academy schools. Death of John Hamilton Mortimer (1740–79).	
1780	Engraves two illustrations for Henry Fielding's novel *Tom Jones,* published by Thomas Macklin.	Gordon Riots in London. Royal Academy moves to Somerset House.	
1782		North resigns as Prime Minister in March and is succeeded by Rockingham and by Shelburne in July. Charles James Fox (1749–1806) resigns as Foreign Secretary under Shelburne. William Pitt the Younger (1759–1806) becomes Chancellor of the Exchequer. Henry Fuseli exhibits *The Nightmare*.	Posthumous publication in France of Rousseau's *Confessions* (composed between 1764 and 1770)

	Gillray's life	Home affairs	International news
1783	Attempts to establish himself as a 'serious' reproductive engraver.	North forms a coalition with Fox in April. Pitt succeeds in December after the dismissal of the coalition and the defeat of Fox's East India Bill. Fuseli exhibits *The Weird Sisters*.	America granted independence. Treaty of Versailles.
1784	Published *Love in a Coffin*, 30 December.	Dissolution of Parliament. Fox re-elected for constituency of Westminster in the March General Election. Pitt is made Prime Minister.	
1785		George, Prince of Wales, marries Mrs Fitzherbert.	In Paris, Jacques-Louis David exhibits *Oath of the Horatii*.
1786	Resumes satirical work. Published primarily by William Holland and Samuel W. Fores.	Edmund Burke (1729–97) introduces an impeachment process against Warren Hastings (1732–1818) of the East India Company after concern about the moral standards of the British in India are raised.	
1787	Publishes *Ancient Music*, 10 May, and *Monstrous Craws*, 29 May.		Anglo-French commercial treaty.
1788		George III's madness is announced provoking a political storm. Fox conspires with the Prince of Wales to establish a Regency. Hastings sent to trial before the House of Lords.	
1789	Publishes *Shakespeare Sacrificed*, 20 June.	George III recovers. John Boydell (1719–1804) opens the Shakespeare Gallery in Pall Mall.	The French Revolution begins in June; Fall of the Bastille on 14 July. George Washington elected first President of the United States of America.
1790	Publishes *Lieut Goverr Gall-Stone, inspired by Alecto*, 15 February.	Publication of Burke's *Reflections on the Revolution in France* in December.	
1791	Begins to etch almost exclusively for the printseller and publisher Hannah Humphrey, the younger sister of his first publisher. This partnership lasts for a further twenty years. Publishes *Weird-Sisters*, 23 December.	Publication of Thomas Paine's (1737–1809) *The Rights of Man*, part I, in March.	
1792	Begins to sign his satirical prints and dedicates his work to the profession of caricature. Publishes *Sin, Death, and the Devil*, 9 June, and *French Liberty. British Slavery*, 21 December.	Publication of Paine's *Rights of Man*, part II, in February. George III's proclamation against seditious publications issued in May. Death of Sir Joshua Reynolds. Benjamin West becomes President of the Royal Academy.	In August the Tuileries are captured and the King of France is suspended. Formal abolition of the French monarchy the following month and proclamation of First French Republic. Robespierre (1758–94) elected to head the delegation to the National Convention. The French army defeat the Prussians in the Battle of Valmy. The Louvre opens as a public museum.
1793	Moves into rooms above Mrs Humphrey's shop at 18 Old Bond Street. In August and September, travels to France with Philippe-Jacques de Loutherbourg (1740–1812) to assist on a large commemorative painting of the battle at Valenciennes. Publishes *The Zenith of French Glory*, 12 February.		Execution of Louis XVI in January. In February, France declares war on Britain in Holland. Britain, led by Pitt, goes to war with France, after forming a coalition (The First Coalition) with Austria and Prussia. Reign of terror begins in France.
1794	Moves with Mrs Humphrey to 37 New Bond Street.		British naval victory over France in 'Glorious 1st of June' battle. Arrest and execution of Robespierre in July.
1795	Establishes a friendship with the Rev. John Sneyd (1763–1835), an amateur caricaturist. Publishes *Light expelling Darkness*, 30 April.	Marriage of Prince of Wales to Caroline of Brunswick (1768–1821). Warren Hastings is acquitted after a seven-year-long trial.	Death of Dauphin Louis XVII and the Comte de Provence proclaims himself Louis XVIII (1755–1824).
1796	Charged, but probably never tried, by a Bow Street magistrate for selling blasphemous print. Sneyd introduces Gillray to George Canning (1770–1827), a member of Pitt's ministry, who later engaged him to produce prints for *The Anti-Jacobin* journal.	Birth of Princess Charlotte (1796–1817) to Prince of Wales and Princess Caroline.	Beginning of Napoleon Bonaparte's (1769–1821) Italian campaign. December: beginning of abortive French attempt to invade Ireland under General Hoche.

Gillray's life	Home affairs	International news
1797 Moves with Mrs Humphrey to 27 St James's Street, where he lives until his death. Receives an annual pension of £200 for his co-operation with *The Anti-Jacobin*. Publishes *Midas Transmuting all into [Gold] Paper*, 9 March, and *Titianus Redivivus*.	*The Anti-Jacobin* founded in November. Miss Provis's 'Venetian Secret' causes a scandal in the art world. Death of Edmund Burke.	
1798 Publishes *The Tree of Liberty*, 23 May.	Fox dismissed from Privy Council for reaffirming the doctrine of the sovereignty of the people. *Anti-Jacobin Review* published in July. William Wordsworth and Samuel Taylor Coleridge publish *Lyrical Ballads*.	Napoleon presents plan for invasion of England to Directory. Lord Nelson (1758–1805) destroys French fleet in Battle of the Nile. Second Coalition formed by Austria, Russia, Turkey and Great Britain against France.
1799 Publishes *The Gout*, 14 May.		Napoleon establishes a Consulate with himself as First Consul, seizes power of France and proclaims the end of the Revolution. In Paris, David exhibits *The Intervention of the Sabine Women*. In Spain, Goya produces *Los Caprichos*.
1801 Pension ceases. Publishes *Dido, in Despair!*, 16 February.	Political union with Ireland. Pitt resigns and is succeeded by Henry Addington (1757–1844) in March.	
1802		Treaty of Amiens signed by Britain, France, Spain and the Batavian Republic on 27 March.
1803 Publishes *Dilettanti Theatricals*, 18 February.		War resumed; widespread fear of cross-channel invasion.
1804	Addington surrenders premiership to Pitt in May.	Napoleon is proclaimed Emperor.
1805 Publishes *The Plumb-pudding in Danger*, 26 February.	Princess Caroline acquitted of the charge of giving birth to a son by another man by a committee of the Privy Council.	Formation of Third Coalition against Napoleon's France. Nelson is killed in the Battle of Trafalgar where the French and Spanish fleets are destroyed.
1806	Death of Pitt on 23 January. Succeeded by Baron Grenville (1759–1834), head of the coalition 'Ministry of all the Talents'. Fox is accepted by George III as Foreign Secretary. Fox dies on 13 September. Slave trade in the British Empire abolished by Grenville.	British army under Sir John Stuart comprehensively defeats French army at Maida in Calabria.
1807 Suffers a mental and physical breakdown.	Fall of the 'Talents' coalition in March.	
1808 Publishes *Very Slippy Weather*, 10 February.		The Peninsular War begins in Spain.
1809 Signs a print of his own invention for the last time in September.		
1810 Lapses into a state of insanity after sporadic achievements in early part of the year. His mental illness persists and he is cared for by Mrs Humphrey until his death.	Death of Princess Amelia provokes King George III's illness, which leads to acknowledgement of his insanity in 1811.	
1811	Prince of Wales appointed Regent.	
1813 Mrs Humphrey begins to commission work from the young caricaturist George Cruikshank (1792–1878).		Napoleon is defeated in the Battle of Leipzig, marking the end of the French Empire east of the Rhine.
1815 Gillray dies on 1 June, aged 58. Buried in the churchyard of St James's, Piccadilly.		Battle of Waterloo on 18 June. Following defeat, Napoleon abdicates.

Catalogue

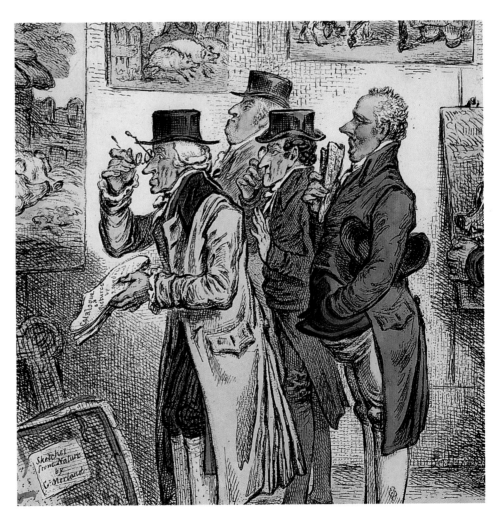

detail, no.182B

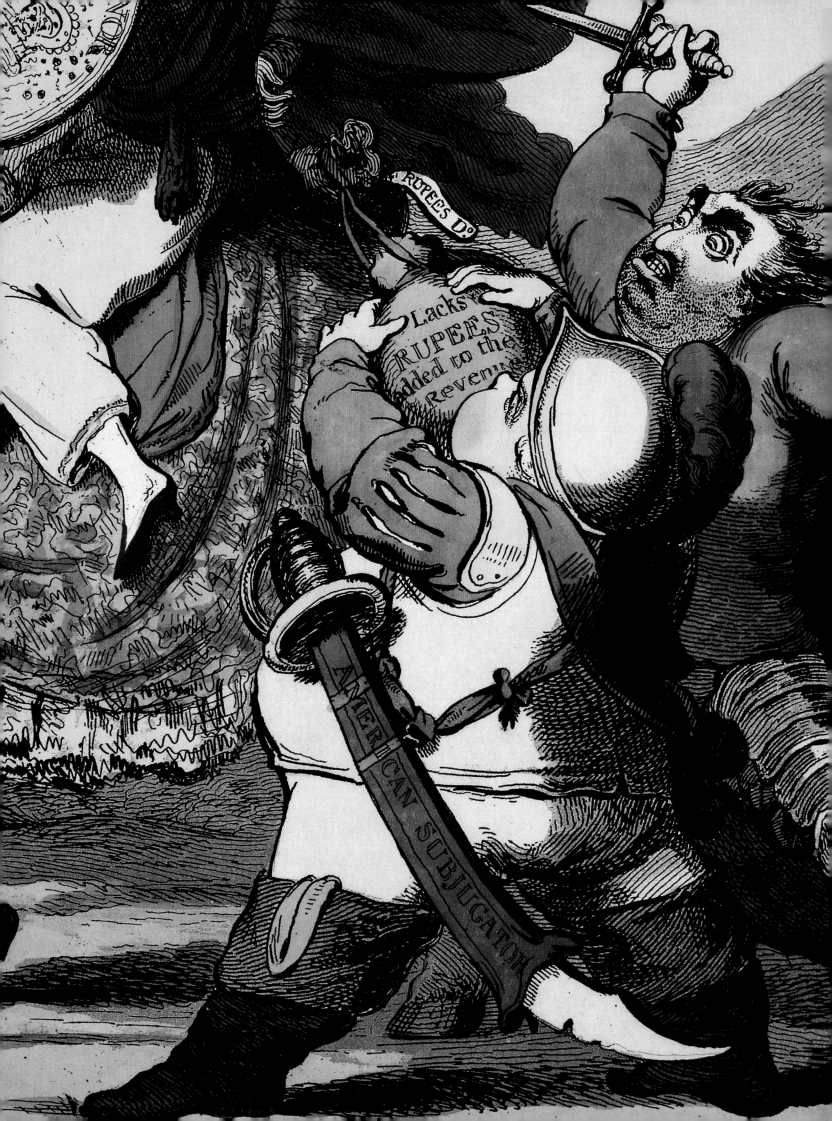

Early Works

Gillray was born a caricaturist, yet a substantial part of his early career was spent in an attempt to escape this role and establish himself as a serious engraver. This was a failure, but his mastery of the difficult modes of engraving, and his training at the Royal Academy schools, gave him an immense technical advantage over other caricaturists. His early caricatures are unsigned, and he worked as a freelance, with his prints being issued by numerous different publishers. They are mainly uncoloured at this time, which allows for a greater appreciation of the vitality of his line work and his adventurous printmaking technique. Printmaking for Gillray was seldom a routine, but often a sustained attempt to increase his range, from hastily-etched plates – probably the work of an hour or two – to large, complicated prints utilising different techniques. These, and the brilliance of his drawing, placed him from an early stage in a class of his own.

detail, no.22

Gillray emerges as a caricaturist: his sources and techniques

Gillray started producing satirical prints in the late 1770s. His early etchings were originally uncoloured, and show a refined style of draughtsmanship shaped by his training at the Royal Academy (where he enrolled as a student in 1778), by a knowledge of French book illustration, and perhaps most of all by the example of John Hamilton Mortimer, a brilliant draughtsman and history painter who tragically died in 1779. Gillray's prints ranged across scandal and social issues, as well as politics, where the hot topic was the war with revolutionary America. The unlikely and self-serving political alliance of Charles James Fox and Lord North which emerged from the political chaos following the loss of the American colonies in 1783 provided rich subject-matter for Gillray and other satirists. Some of his most incisively caricatured figures, including Fox (at first shown literally with a fox's head) and Edmund Burke, make an appearance around this date. Already, with prints like *Gloria Mundi* (no.9) and *Cincinnatus in Retirement* (no.13) Gillray was demonstrating the graphic flair and the unfailing grasp of character that were to single him out.

1

FEMALE CURIOSITY.
London. Publiſh'd Dec.ʳ 1ˢᵗ 1778. by W. Humphrey.

1 Female Curiosity

Etching 35.8 × 25.5
Published 1 December 1778 by W. Humphrey
Library of Congress
Not in BMC

This bizarre and mildly pornographic print is typical of a number of early unsigned Gillray prints depicting scenes of low life, including brothels and their environs. The phallic bedposts reveal the room's purpose, while a comely tart playfully balances a monstrous wig on her bottom and admires the view in a mirror held up by her bawd. The print comes towards the end of a whole genre of caricatures mocking the exaggerated fashions of the 1770s.

This example, like all other exhibits from the Library of Congress, Washington, was formerly in the Royal Collection. It is unlikely that it was purchased at the time of issue, but was probably acquired later by George IV when he was Prince of Wales.

2 Sawney in the Bog-House

Etching 35.5 × 25.2
Published 4 June 1779 by Mrs Holt
The British Museum, London
BMC 5539

Although he was half-Scottish, Gillray's attack on the insanitary, kilted innocent is brutal. Caricatures of Scots in England had been published with great regularity from 1745, and this print is based on another with the same title of about that date (BMC 2678). Like many of Gillray's early plates, this was reprinted by subsequent publishers.

3 The Liberty of the Subject

Etching 25 × 35
Published 15 October 1779 by W. Humphrey
The British Museum, London, Banks Collection
BMC 5609

A horrified London tailor has been seized by the determined sailors of a press-gang. His feebleness is contrasted with the furious activity of the hag-like women who assault the sailors. This is amongst a number of prints concerned with aggressive methods of recruitment during the American War of Independence (1775–82).

The graphic and decisive draughtsmanship owes something to the prints and drawings of John Hamilton Mortimer (nos.5,6), which had great influence on Gillray's early work.

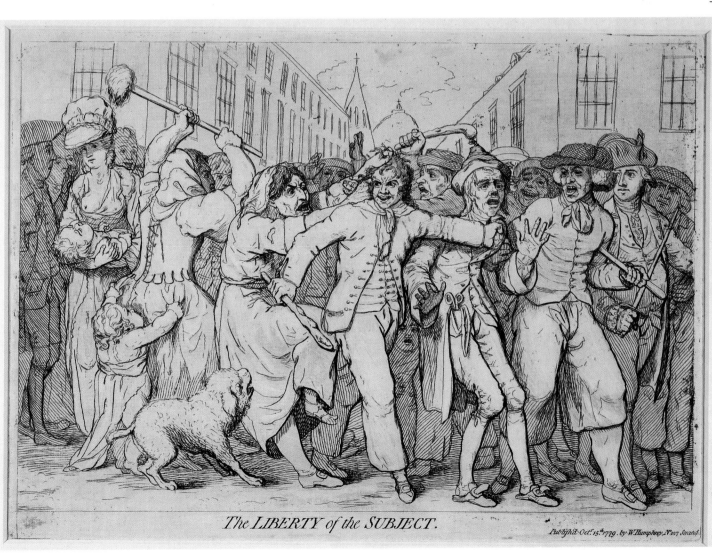

53

4A

A Peep into LADY W!!!!!Y's Seraglio.

No 6112

4A A Peep into Lady W!!!!!y's Seraglio

Etching 26 × 36.5
Published 29 April 1782 by W. Humphrey
The British Museum, London
BMC 6112

Technically this is a very simple plate which
was probably bitten in the acid in a single
session to produce clear, even lines. The deli-
cacy of the etching is at odds with the gross
and libellous subject. Lady Worsley is shown
coupling with one man, whilst her previous
partner has scarcely pulled on his breeches.
A procession of prospective lovers lines the
staircase to her bedroom, their words denot-
ing lust and impatience.

Lady Worsley had eloped with one Bisset,
against whom her husband Sir Richard
Worsley brought a legal action. The case was
considered farcical as it transpired that
Worsley had connived with his wife's adultery
and had encouraged Bisset to peep at her
when she was taking a bath. The scandal
inspired a number of prints.

4B A Peep into Lady W!!!!y's Seraglio

Original copper plate 26.7 × 37.1
Published 29 April 1782 by W. Humphrey
The Victoria and Albert Museum, London
BMC 6112

Only a handful of Gillray's copper plates
survive, and the existence of this early and
rather obscure example may owe something
to its obscene subject matter. Copper was a
fairly expensive commodity, and in this case
Gillray's publisher was exercising economy,
since the other side of the plate had already
been used in September 1779 for another
Gillray print, *Apothecaries, Taylors . . .
Conquering France* (BMC 5614).

5 John Hamilton Mortimer (1740–79)
Caricature Heads

Pen and ink and wash 25.1 × 16.2
*Tate. Purchased as part of the Oppé Collection
with assistance from the National Lottery through
the Heritage Lottery Fund 1996*

6 John Hamilton Mortimer (1740–79)
Literary Characters Assembled Around a Medallion of Shakespeare 1776

Pen and ink 20.8 × 28.6
Yale Center for British Art, Paul Mellon Collection
B.1975.4.1346
See John Sunderland, 'John Hamilton Mortimer:
His Life and Works', *Walpole Society*, 52, 1986,
cat. no. 122.

The drawing's title comes from an early
inscription on its panel support which
further states that the drawing was made
in 1776 for John Kenyon, who commissioned
a companion sheet, also at Yale, of *A
Choral Band*.

A number of figures have been tentatively
identified. To the right of the grotesque pillar,
hands clasped, is Samuel Johnson, and further
to the left, clutching a manuscript, is the poet
William Cowper, a Buckingham neighbour of
Kenyon. The sleeping man is probably Dr
George Hoarse who became President of
Magdalen College in 1768. The identities of

4B

the other figures are less clear, but it seems likely that the despairing man clutching his head is intended for Shakespeare himself.

Mortimer, a brilliant draughtsman and an occasional caricaturist, was the single most important influence on the early work of Gillray and Rowlandson. His work could be readily studied through the numerous prints that were etched from his drawings by himself and others. His draughtsmanship was characterised by whiplash speed, a contrast of high finish with sketchy areas, and close definition of salient features. The grotesque and fantastic subjects in which he specialised must also have been congenial to Gillray.

6

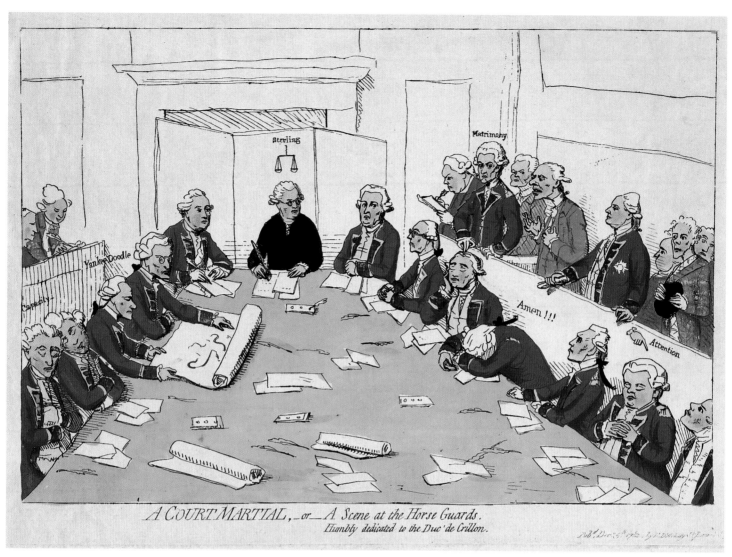

A COURT MARTIAL, _ or _ A Scene at the Horse Guards.
Humbly dedicated to the Duc de Crillon.

7A

7B

7A A Court Martial, – or – A Scene at the Horse Guards

Etching and engraving 25 × 35, with publisher's watercolour
Published 5 December 1782 by E. D'Archery
Andrew Edmunds, London
BMC 6041

Lieutenant-General James Murray was court-martialled, and acquitted, after he had been accused of misconduct during the siege of Minorca. He nervously clutches the barrier before him and the word 'matrimony' is inscribed above his head. His accuser, whose personal malice was recognised by the court, is seen further to the right, his garter star prominent. The episode is now obscure, but the image remains topical because of Gillray's sly depiction of the behaviour of a weary committee, some still alert, others bored, at least three sleeping or nodding off.

7B Preparatory Drawing for A Court Martial 1782

Pencil, pen and grey and brown ink, with touches of wash and watercolour 21 × 32, laid onto an early wash and line card mount
Private Collection

This appears to be Gillray's earliest known preparatory drawing for a print. The print is in the same direction and follows the drawing carefully, but a small but crucial element of caricature is added to the figures.

8 A Warm Birth for the Old Administration

Etching and engraving 22.5 × 34.5
Published 2 April 1782 by W. Brown
Andrew Edmunds, London
BMC 5970

The portly King is lost in deep sleep, slumped back on his throne, indifferent to events going on before him. The centre is occupied by an unholy trio: Fox, seen from behind with a fox's head, Gillray's early and old-fashioned mode of depicting him. He grasps Lord North by his collar, whilst with his other hand he holds the Devil in a friendly gesture. The Devil, with a powdered wig and a pitchfork, stands in a relaxed and insouciant manner.

The King's outgoing advisers are bundled – in the case of Lord Sandwich and Viscount Sackville, tied back to back – quite literally, by a clutch of demons. The Earl of Bute, in Highland dress, is prodded by a demon who says 'Gee up lazy Boots'.

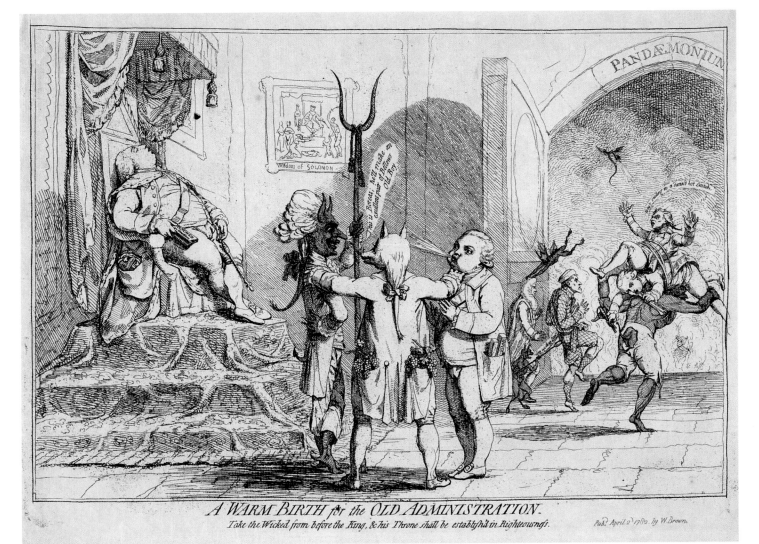

A WARM BIRTH for the OLD ADMINISTRATION.
Take the Wicked from before the King, & his Throne shall be establish'd in Righteousness.

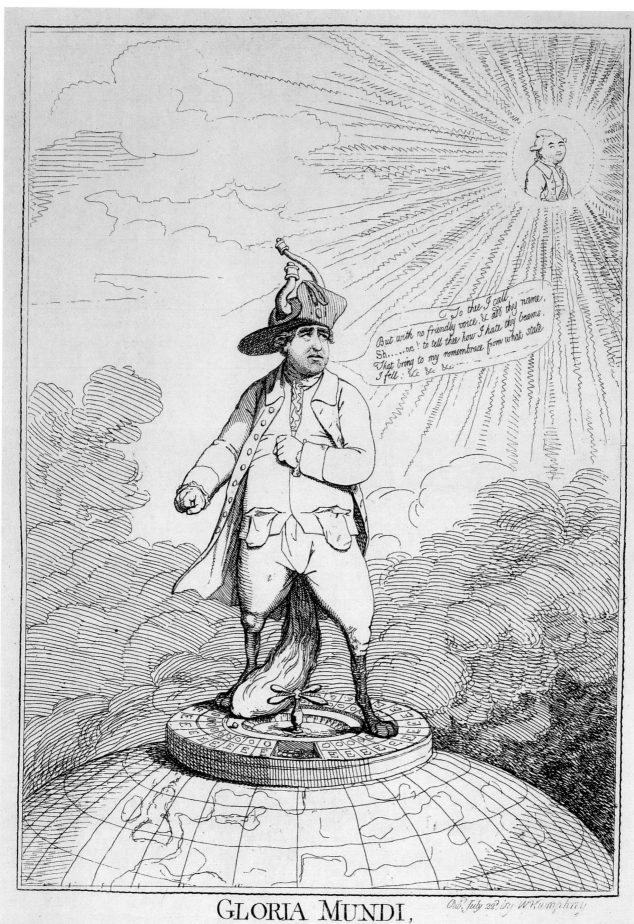

GLORIA MUNDI,

or — *The Devil addressing the Sun.* *Par.ᵗ Loſt. Book IV.*

9 Gloria Mundi, or – The Devil addressing the Sun

Etching 35 × 25
Published 22 July [1782] by W. Humphrey
Library of Congress
BMC 6012

With his empty pockets turned out, the gambling spendthrift Fox stands on a globe, above the North Pole. The sun is represented by the smiling Lord Shelburne, Fox's deadly rival. Gillray's response to Sayers's Miltonic satire (no.10) came rapidly and is extremely imaginative – one of his first iconic images, which much later served as the source for a George Cruikshank caricature of Napoleon in exile. The face is represented quite natural-istically, but he is given the emblematic attributes of a fox's legs and brush.

Much confusion has previously surrounded the mechanics of publishers of Gillray's early prints when he was effectively a freelance artist. This print initially bore the publication line of E. D'Archery.

10 James Sayers (1748–1823) Paradise Lost

Etching 20.5 × 22
Published 17 July 1782 by C. Bretherton
The British Museum, London
BMC 6011

James Sayers was a talented caricaturist who later became a strong supporter of Pitt. He was for a while the only serious rival to Gillray, who often responded to his competi-tion with great vindictiveness. The Marquess of Rockingham, the Prime Minister, died on July 1 1782, and shortly afterwards Fox and Edmund Burke resigned from the govern-ment, supposedly on a point of principle about the peace negotiations with America, but in fact because of internal rivalry with Shelburne who had become First Lord of the Treasury. The subject is a parody of Milton; Fox and Burke stand miserably outside the 'Gates of Paradise' beneath a keystone supporting the smug face of Shelburne.

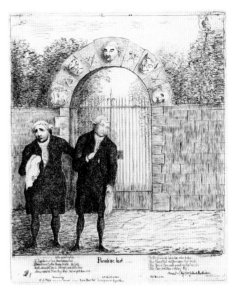

10

11

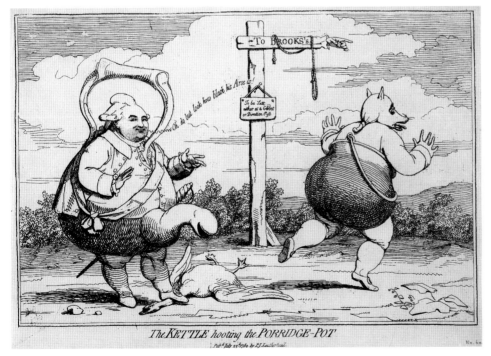

The KETTLE hooting the PORRIDGE-POT

11 The Kettle Hooting the Porridge-Pot

Etching 22.5 × 31
Published 23 July 1782 by P.J. Leatherhead
The British Museum, London
BMC 6013

This was published the day after *Gloria Mundi* (no.9) as Gillray eagerly pursued the topic of Shelburne and Fox, but using gross imagery and a cruder style of etching. Fox is now represented with a fox's head, his body in the form of a porridge pot. Shelburne as a kettle points complacently at Fox saying, 'Oh do but look how black his Arse is!' A sign-post points to Brooks's, Fox's club, where he mounted up large gambling debts. This is a particularly telling example of Gillray's ability to turn a popular saying into vivid graphic imagery.

12 John Jones after George Romney
(1734–1802)
Edmund Burke

Mezzotint 51 × 35.6
Published 1776
National Portrait Gallery, London

12

13 Cincinnatus in Retirement

Hand-coloured etching 22.5 × 31.5
Published 23 August 1782 by E. D'Archery
Library of Congress
BMC 6026

Drawn and etched with great sensitivity and lightness of touch, this is one of Gillray's most brilliant early prints. The little hobgoblins who prance, dance and skip beneath the table are new creations who will reappear. Edmund Burke is not making his debut, but this is the first time that Gillray has really set his hat at him, establishing a ridiculous type on which he will play scores of variations.

The parody works on a number of levels. Burke, as well as Fox, had resigned from government, and the title makes an ironic comparison with the nobility of the Roman dictator who had returned to his plough after saving his country. Malicious rumours had circulated for some time that Burke was a Jesuit. This was a damaging claim at a time when anti-Popery was a virulent strain in British life, and when Burke's sympathy for Irish Catholics was an established fact. For the first time he appears in a Jesuit's gown, to which in subsequent prints Gillray often adds a biretta. The poverty of the Irish is mocked by the shabbiness of the room and the unappetising meal of potatoes, steaming hot, which Burke peels with his long bony fingers. He takes them from a chamber pot, inscribed 'Relick No 1. Used by St.Peter'.

The brilliance of the caricature lies not only in the depiction of Burke, but in the accumulation of telling and witty details around a strong, simple central theme.

This impression is coloured with the heavy opaque pigments which are to be found on early impressions of a number of prints of this period, and Burke's gown has been extensively worked with the tip of a brush.

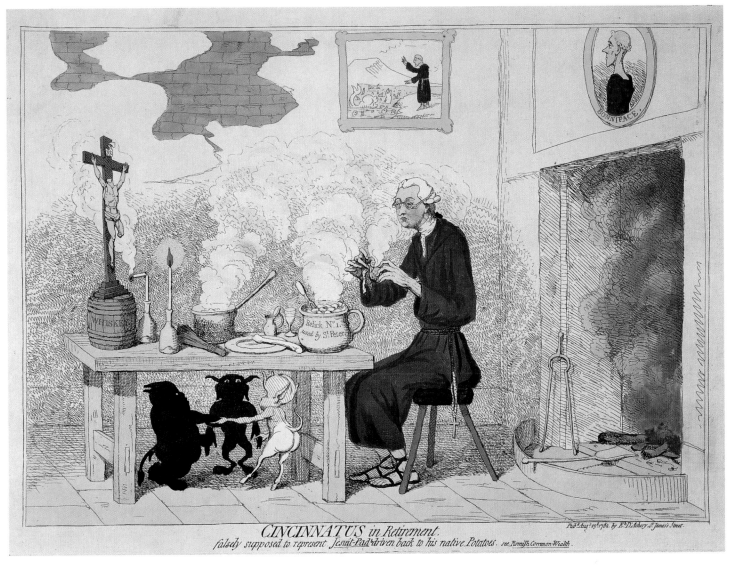

CINCINNATUS *in Retirement.*
falsely supposed to represent Jesuit-Pad driven back to his native Potatoes. see Romish Common-Wealth.

13

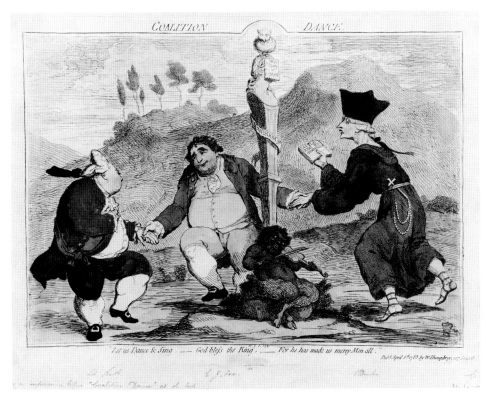

COALITION DANCE.

Let us Dance & Sing. ___ *God bless the King!.* ___ *For he has made us merry Men all.*

14

14 The Coalition-Dance

Hand-coloured etching 24.7 × 34.7
Published 5 April 1783 by W. Humphrey
The British Museum, London, Banks Collection
BMC 6205

In 1783 Fox and North formed a short-lived
and unnatural coalition under the Duke of
Portland. This was very ill received by the
King and this print, one of many satirising the
coalition, mocks his opposition. They dance
around a terminal which is surmounted by
a bust of the King covered by a copy of the
Whole Duty of Man. They are joined by
Burke, garbed as a Jesuit. This is the second
state of the print, in which Gillray has made
a change of particular significance to his
development as a caricaturist. Fox's face is
here represented in fairly mild caricature.
In the preceding state he is shown with a
fox's head. Thenceforward emblematic
representation of Fox was abandoned.

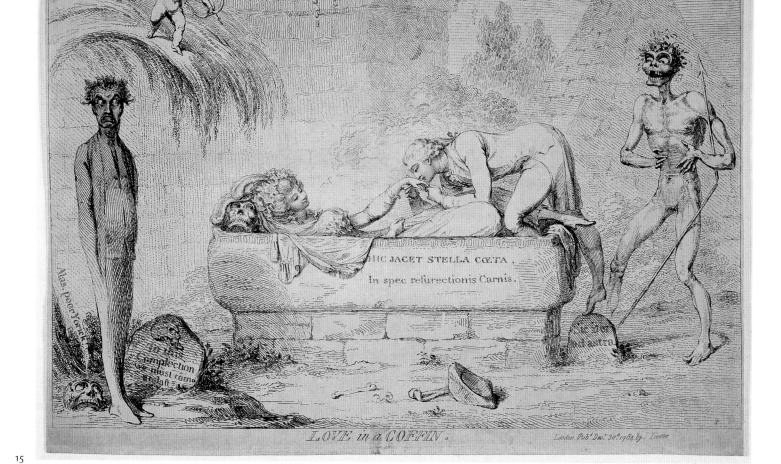

15

15 Love in a Coffin

Etching 23.5 × 41
Published 30 December 1784 by T. Trotter
The British Museum, London
BMC 6699

Gillray seldom drew more elegantly than
in this rare print, which is at once a
sophisticated parody of the courtly love
scenes in French Rococo book illustration,
and a vicious and blasphemous satire. The
subject, although trivial, was treated by a
number of other caricaturists, and refers to
a scandal in Ireland in which a Lady C.
(possibly from the Charlemont family) had
a liason with an Irish military volunteer –
presumably in a churchyard using the best
available accommodation. She reclines in
bliss in a stone coffin as her lover, his foot
daintily poised on a gravestone inscribed
'Sic iter ad astra' ('This way to the stars')

kisses her hand. His position is ambivalent –
he could be advancing or withdrawing. Her
coffin is inscribed 'Hic Jacet Stella Coeta . . .
In spec ressurectionis Carnis', which trans-
lates loosely as 'Here lies Stella after coition,
in hope of bodily resurrection.'

At the lower left is a skull, emitting the
words 'Alas poor Yorick', an obvious reference
to Chapter 12 of Laurence Sterne's *Tristram
Shandy* (1760–7). Yorick's tombstone was of
such pathos that 'not a passenger goes by
without stopping to cast a look upon it, –
and sighing as he walks on Alas poor Yorick'.
The name of Stella, given the Irish context, is
clearly a lewd allusion to Jonathan Swift's
letters to Stella. The literary allusions are
augmented by bizarre visual iconography,
the horrified figure at the left recalling
Charles Le Brun's *Treatise on Expression*, with
its slightly ridiculous simplifications of facial

expressions. Most original, however, is the
beautifully drawn figure of Death, clutching
a broken spear, his horrid skull crowned with
roses, his remaining teeth bared in a grin,
and his hands clutched to his side as he
laughs. His side is pierced, just beneath his
ribs, in an unmistakeable reference to the
wound sustained by Christ's body after His
death. This grisly figure, partially inspired by
similar figures in prints after Mortimer, will
reappear in different guises in a number of
important prints by Gillray, and, moreover,
the attenuated figure of the male lover is not
at a far distance from Gillray's early depictions
of Pitt.

This is the only Gillray print published
by Thomas Trotter (c.1750–1803), who was
a gifted engraver, and had been a fellow
student of Gillray at the Royal Academy
schools.

16 After Charles Le Brun (1619–90)

Heads Representing the Various Passions of the Soul

Plate 18 *Terrour or Fright*
Line engraving 27.5 × 19.2
Published by R. Sayer, c.1760
The British Museum, London

This well-thumbed copy represents the kind of textbook Gillray may have seen at the Royal Academy and intended to parody in the alarmed figure at the left in *Love in a Coffin* (no.15).

17 Jean Michel Moreau, called Moreau le Jeune (1741–1814)

Illustration to J.B. La Borde, **Choix de Chansons** 1773

Plate 24 *Ses Yeux sont fermés au jour*
Engraving 25 × 17
Syndics of the Fitzwilliam Museum, Cambridge

It is probable that Gillray had in mind such refined French illustrations of courtly flirtation when he etched *Love in a Coffin* (no.15).

16

17

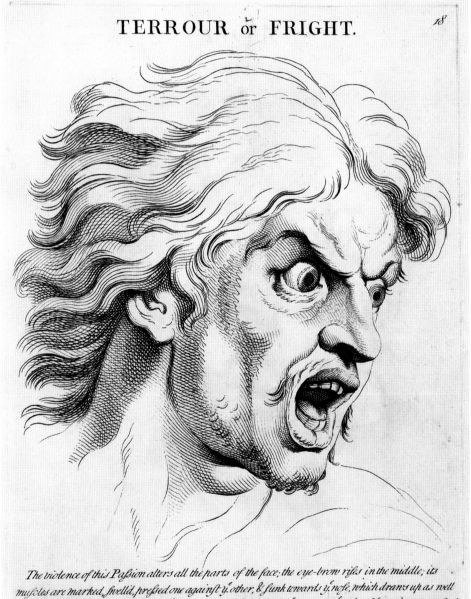

18 William Austin (1721–1820)

The Merits and Defects of the Dead by their Ingenious Secretary

Etching 29.4 × 38
Published 1 May 1773
Andrew Edmunds, London
BMC 5122

This is probably a caricature of Lord Lyttelton (1709–73), author of *Dialogues of the Dead* (1760), who died a few weeks after this print was published. It may well have been remembered by Gillray when he etched *Love in a Coffin* (no.15).

Austin was a minor, though varied artist, who began his career as a reproductive line engraver. However, he is best remembered for a mannered but very original set of twelve satires, of which this is one.

Gillray matures as a caricaturist: the emergence of the 'Baroque' style

From the middle of the 1780s Gillray's work develops rapidly, with an increased sophistication of technique and bold exaggeration of draughtsmanship. He was evidently a student of the art of the past as well as a sardonic observer of the work of his contemporaries, and the exuberance of his designs shows an affinity with the High Baroque of the seventeenth century. The same may be said of many designs by Rowlandson, but in such a print as *A March to the Bank* (1787) (no.30) Gillray pushes dramatic exaggeration and pell-mell motion to even greater limits. So great was his identification with the Baroque that late in his life, when he was hopelessly insane, he was known to identify himself with Rubens.

19

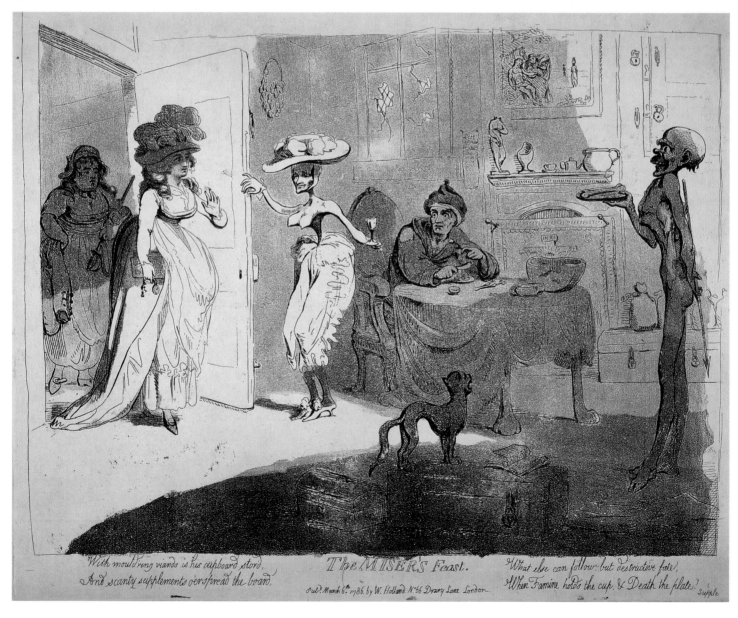

With mould'ring viands is his cupboard stor'd,
And scanty supplements o'erspread the board.

The MISER'S Feast.

Pub.ⁿ March 6.ᵗʰ 1786. by W. Holland. Nᵒ 66 Drury Lane London.

What else can follow: but destructive fate,
When Famine holds the cup & Death the plate.

Supple

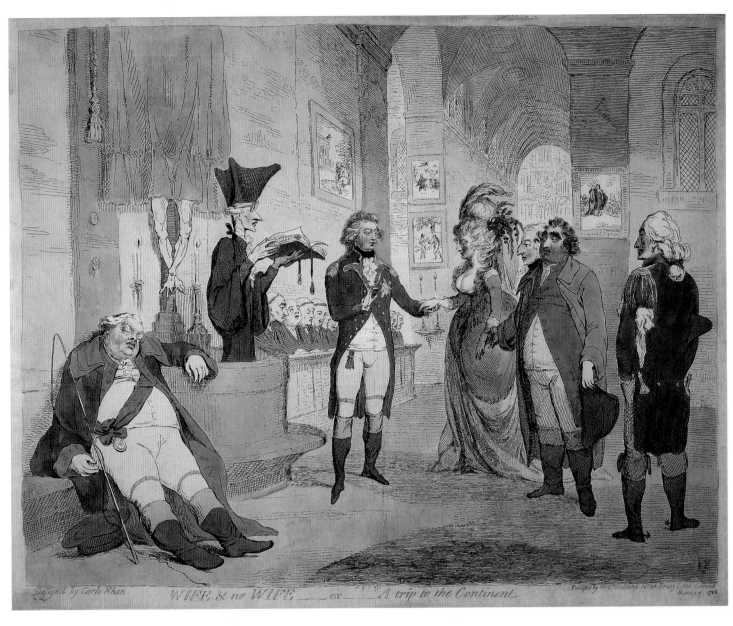

Defigned by Carlo Khan. WIFE & no WIFE ____ or ____ A trip to the Continent. Publifhed by Wm Holland Nº 50 Drury Lane London March 27 1786

19 The Miser's Feast

Etching with aquatint 26 × 40
Published 6 March 1786 by W. Holland
Library of Congress
BMC 7083

This macabre subject is etched with a bold although as yet rather crude use of aquatint. A miser is faced with the grim skeletal figure of Death, holding a bone on a plate. A flamboyantly dressed prostitute enters the room with a burly female companion. Both appear to bring stolen goods to the miser. The real interest and originality of the print lies in another female figure, probably representing Famine. Her naked torso is revolting, sharpening abruptly to a point at her waist. Gillray is now prepared to subject the human figure to the most extreme distortions.

20 Wife & no wife – or – A trip to the Continent

Hand-coloured etching 37.6 × 47.6
Published 27 March 1786 by W. Holland
The British Museum, London
BMC 6932

The Prince of Wales secretly married his mistress, the twice widowed Mrs Fitzherbert, in December 1785. The marriage – as suggested by the title – had no validity, since not only was Mrs Fitzherbert a Roman Catholic, but the Prince needed the King's sanction to marry. The ceremony was performed furtively in her house in Park Lane.

Gillray's print is a mischievous travesty of the truth; the scene is moved abroad, and the men wear boots so as to suggest a guilty journey. Burke, in Jesuit's robes, performs the ceremony, while Fox – who had opposed the union – holds the bride's hand, and Lord North slumbers at the left. Many prints associating Fox and the Prince were to follow, since the Prince's attachment to the Whigs was a natural consequence to his personal antipathy to the King, who favoured the Tories.

The faces are only mildly caricatured and are carefully worked up in stipple, the exception being Burke's with its elongated nose. Gillray has signed the print with the facetious pseudonym 'Carlo Khan'.

21 A New Way to Pay the National Debt

Etching and engraving 42.7 × 52.2
Published 21 April 1786 by W. Holland
Library of Congress
BMC 6945

On 5–6 April 1786 parliament debated Pitt's motion for a grant of £210,000 to discharge debts on the Civil List. The Prince of Wales's crony, Fox, pleaded for money for him, since his debts were huge. Gillray's response shows the King and Queen Charlotte emerging from the Treasury, heralded by mass bands and laden with gold. The King complacently accepts more gold from Pitt without even favouring him with a glance – perhaps for the better, since the fawning Prime Minister slyly conceals with his hand his own little pocketful. Gold cascades from the various flaps of the King's breeches as he eyes the adoring Queen, herself laden with an overflowing pouch of coins. At the further reaches of the design are a horribly mutilated sailor, his begging hat empty, and a tattered, half-shoeless Prince of Wales, who hesitates before accepting a dubious cheque for £200,000 from a dandified Frenchman who acts for the Duke of Orleans.

Gillray again adopts a very effective graphic mode, contrasting plain linear passages with high finish, and blank areas against a wall defined by a multitude of agitated lines.
This is the first Gillray print to satirise the parsimony of the royal couple. The Queen, who toys with her snuff box, is given a little tilted nose but is handled quite gently – for the moment. A terrible fate awaits her at Gillray's hands.

Gillray's pseudonyms are 'Designd by Helagabalis . . . Executed by Sejanus'.

22 The Political Banditti assailing the Saviour of India

Hand-coloured etching with aquatint 31 × 42.3
Published 11 May 1786 by W. Holland
The British Museum, London
BMC 6955

The impeachment of Warren Hastings was the subject of a great many caricatures over a long period, since the trial began on 13 February 1788 and lasted for seven years. Burke and Fox were among the most virulent of Hastings's accusers. Gillray shows Hastings grandly mounted on a camel repelling the furious onslaught of Burke, North and Fox. Hastings is not caricatured, but his opponents, especially Burke, are brutalised. This contrast between caricatured and normal features is a device used by Gillray throughout his career, and helps to enhance a sense of the ridiculous. Gillray creates a strong sense of space by showing Fox's outstretched hand thrusting towards the spectator. Hastings's elevation and superiority is suggested by raising his turbaned head just above the borderline.

23 A Sale of English Beauties, in the East Indies

Hand-coloured etching with aquatint 43.8 × 54.8
Published 16 May 1786 by W. Holland
The British Museum, London
BMC 7014

India was much in the public mind at the time of this print. The first Governor-General of British India, Warren Hastings, had been accused by Burke of misconduct and after his return to England in 1785 had been impeached from 1788–95. More pertinent to the subject of this large print were criticisms of the lax and immoral behaviour of British inhabitants of Madras.

A batch of courtesans have just disembarked and are being unceremoniously examined by potential clients before they are auctioned by the fop at the left. He stands on a box which sports crossed birch rods. Another box evidently contains books, including *Fanny Hill*, *Moral Tales* and *Female Flagellants*. Barrels in the foreground are labelled 'Leake's Pills', referring to a remedy for venereal disease produced by Walter Leake.

The design is open and free and the curvilinear forms are unusually reminiscent of Rowlandson. The etched work is comparatively sparse and is heavily reliant on hand colouring for its effect.

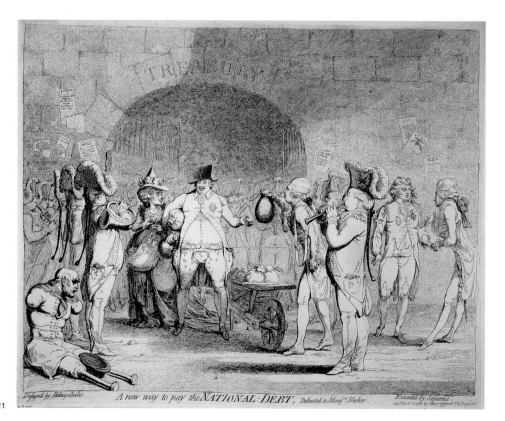

21

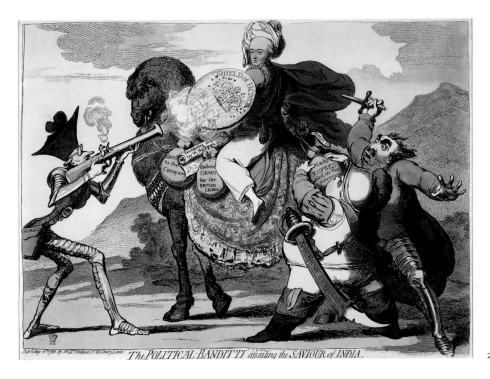

The POLITICAL BANDITTI assailing the SAVIOUR of INDIA.

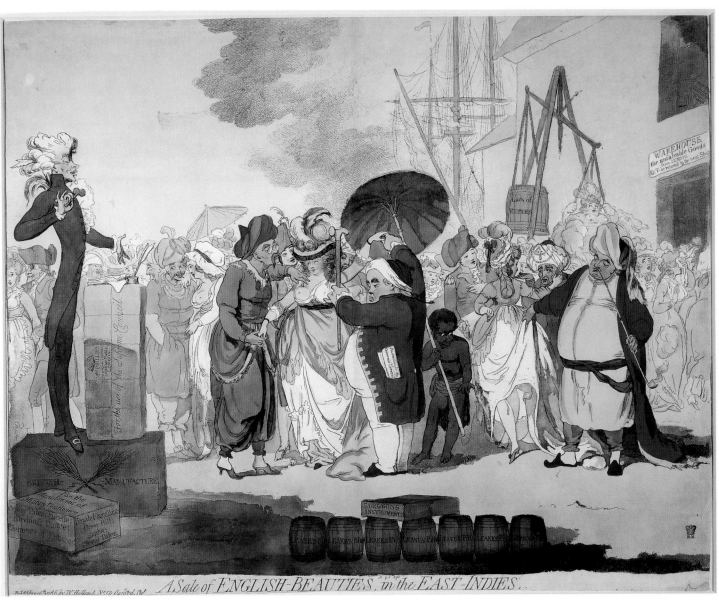

A Sale of ENGLISH-BEAUTIES, in the EAST-INDIES.

24 Lady Termagent Flaybum going to give her Step Son a taste of her Desert after Dinner, a Scene performed every day near Grosvenor Square to the annoyance of the neighbourhood

Etching 43.5 × 54.5
Published 25 May 1786 by W. Holland
The British Museum, London
BMC 7011

Gillray enthusiastically deploys a Baroque excess for this scurrilous social scandal. Lady Strathmore, widow of the 9th Earl, entered into an unfortunate marriage with Andrew Stoney, a fortune hunter. She fled from him, and at the time of this print she was living under the protection of the law. Later, under pressure from Stoney, she admitted to an 'unnatural dislike of my eldest son' (John, 10th Earl of Strathmore). Gillray, possibly commissioned by Stoney, gleefully twists the facts. The weeping 'stepson' who is being prepared for a flogging did not exist, but is here made to stand in for the son she had by her first husband.

The faces are highly finished, in the dotted manner, in contrast to the freely drawn lines elsewhere. This adds frisson to the subject, since it was an accepted convention of 'polite' stipple engraving of portrait and other subjects.

A number of Gillray's earlier prints evince a keen interest in the subject of flagellation.

25 The Injured Count..s

Soft-ground etching 27.5 × 40
Published c.1786 by C. Morgan
The British Museum, London
BMC 7013

Nothing could be more trivial than the subject of this print and nothing more remarkable than its style and technique. It is undated, but seems to be a sequel to *Lady Termagent Flaybum* (no.24). Lady Strathmore, her breasts bared, suckles two cats. Beside her a crying boy says, 'I wish I was a cat my Mama would love me then.' Some squalid servants in the background guzzle liquor. Half hidden by a screen is an obscene picture of Messalina – one of numerous references by Gillray to disreputable characters in Roman history.

Lady Strathmore is conceived as a grotesque parody of a traditional depiction of Charity. It is possible that Gillray had in mind Joshua Reynolds's portrait of *Lady Cockburn and Her Children* (Exh. R.A. 1774; now in the National Gallery), which is a sophisticated transposition of the Charity theme to portraiture. Most remarkable, however, is the fantastic figure of the woman on the right. Her face is speckled like a toad, and her upper body with a curving stem-like waist almost detaches itself from her hips as she leans forward to clink glasses with Lady Strathmore. She is developed from the figure

of Famine in *The Miser's Feast* (no.19), but stretched and distorted even further.

Gillray constantly looked to extend his technical repertoire, and the dark ground of the print has been produced in a very novel way. He has prepared a copper plate with a soft ground, and then laid a material, probably gauze, across it. When run through the press the ground adheres to it, and lifts with those parts that apply to it, and when subsequently bitten the plate will acquire the texture of the material. This technique was not used again until the middle of the twentieth century, and Stanley William Hayter in his pioneering book *New Ways of Gravure* (1949) reproduces this print as an example of technical innovation.

26 The Legacy

Etching 31.5 × 42
Published 10 November 1786 by W. Holland
The British Museum, London
BMC 6991

The royal family, miserable and disappointed, stands in a group in the middle distance. They had expectations from the will of the King's aunt, Princess Amelia, who had died on 31 October 1786, but the legatees had been her nephews, Princes of Hesse-Cassel. The white horse of Hanover (perhaps deriving from Reynolds's portrait of the Prince of Wales, Exh. R.A. 1784) trots off laden with riches, accompanied by hobgoblins, and crapping copiously in the direction of the royal family.

Directly and vigorously etched, this design is best remarked for the group of the Prince of Wales, Burke, Fox and North seen behind the bars of a debtor's prison at the left. Conjured up from simple hatchings, Burke's nose jutting prominently, they are the *reductio ad absurdum* of caricature, but by now Gillray expected his audience to recognise his major characters from basic simplifications.

LADY TERMAGANT FLAYBUM going to give her STEP SON a taste of her DESERT after Dinner, a Scene performed every day near Grosvenor Square, to the annoyance of the neighbourhood.

24

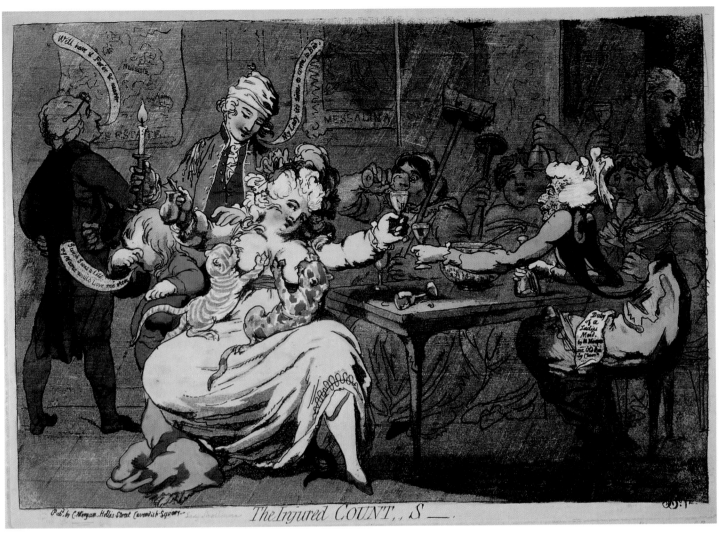

The Injured COUNT..S —

25

The LEGACY.

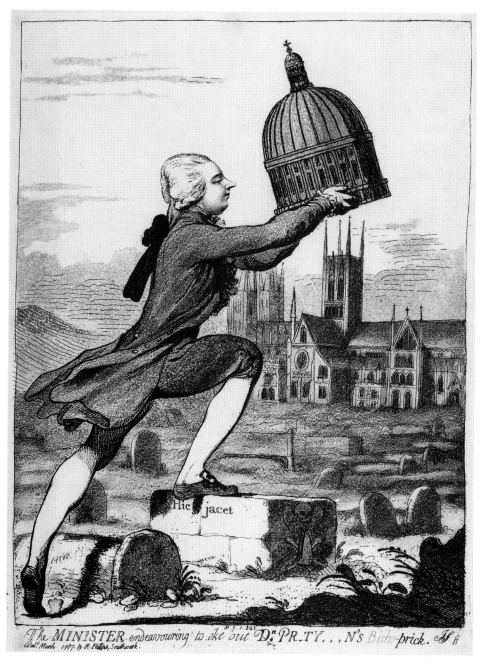

28 **Ancient Music**

Hand-coloured etching 42.7 × 55.1
Published 10 May 1787 by S.W.Fores
The British Museum, London
BMC 7163

The summer of 1787 was a joyous time for Gillray; his mind was teeming with ideas, and his powers of execution grew ever more vigorous as plate after plate was plunged into the acid. This elaborate satire is at the expense of the King's well-known enthusiasm for music of an earlier period – above all that of Handel – 'Handel! Handel and yet more Handel!' 'The Concert of Ancient Music' had been founded in 1776 by Joah Bates (here represented by an ox with a music book on its hoofs) and the King first attended a concert in 1785. From 1784 there were Handel Commemorations held in Westminster Abbey with an ever increasing host of performers. In 1787 an assemblage of no fewer than 806 performed the *Messiah*, and the Italian composer Felice de Giardini said sarcastically that 'He would go 2 or 3 miles from the town, as He could then sufficiently hear the effect.' The year before, Horace Walpole had enjoyed a performance but remarked ruefully that 'the chorus and kettle drums for four hours were so thunderfull, that they gave me a head-ache'.

The King and Queen listen with rapture as a grotesque ensemble of men and animals, Pitt, with a rattle, prominent among them, create a dreadful cacophony. The sound effects range from two wailing cats, strung up by their tails – a reference to plate 1 of William Hogarth's *Four Stages of Cruelty* – to two boys having their naked buttocks thrashed by 'Ch.n.ll.r' Thurlow. The verses beneath, 'Monarchs, who with Rapture wild, Hear their own Praise with Mouths of gaping Wonder, And control each Crotchet of the Birth-day Thunder', are a direct and acknowledged quotation from the satirist 'Peter Pinder' (John Wolcot), a good example of Gillray's awareness of literary satire.

This is the second state of the print with explanatory inscriptions and numbers. Gillray has also taken advantage of the plate's re-immersion in the acid to add to the Queen's face a few disgusting bristles, and a filthy drop falling from her nose. This is a notable stepping-up of his attacks on the Queen.

27 The Minister endeavouring to eke out Dr Pr*ty***n's Bisho-prick

Etching with aquatint 32.5 × 24.5
Published March 1787 by R. Phillips
The British Museum, London
BMC 7146

Dr George Pretyman (1750–1827) was a close friend of Pitt, and had been his tutor at Cambridge. His appointment as Bishop of Lincoln at the age of 37 was thus seen as blatant favouritism by the Prime Minister. Pitt stands in a graveyard, reminiscent of that in *Love in a Coffin* (no.15), and prepares to cap the central tower of Lincoln Cathedral with the dome of St Paul's. This is one of a number of satires which Gillray has signed with a convincing imitation of the signature of his rival caricaturist, James Sayers. It seems likely that in this case it was a mischievous attempt to damage the latter's reputation by the gross sexual nature of the print.

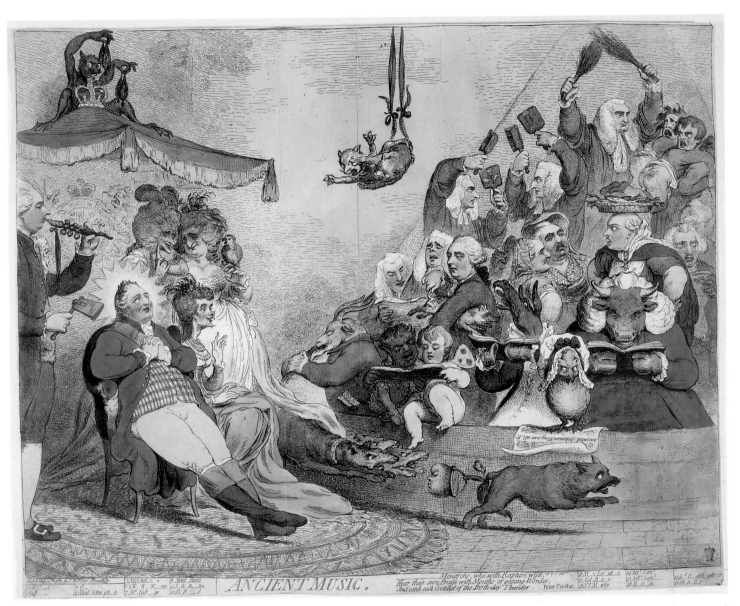

29

29 After Joseph Goupy (died 1782)

The True Representation and Character

1754

Etching and engraving 46.7 × 31.4
The British Museum, London

A contemporary satire of Handel's greed
and the intolerable loudness of his music,
symbolised by the firing cannon and the
braying ass. Goupy's original pastel is in
the Fitzwilliam Museum, Cambridge. The
braying ass is adapted from a detail in Jusepe
de Ribera's etching *The Drunken Silenus*.

Although the design is certainly by
Goupy, the execution of the print is unlike
his known work, and is probably the work
of a professional engraver.

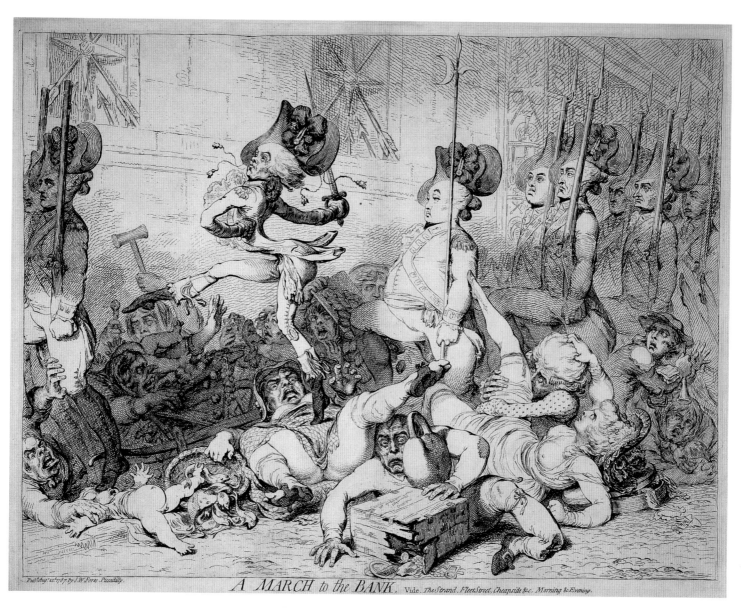

30A A March to the Bank

Etching 42.4 × 54.5
Published 22 August 1787 by S. W. Fores
Library of Congress
BMC 7174

The Gordon riots of 1780 led to fears for
the security of the Bank of England, and the
consequent introduction of a daily guard.
This was regarded by the public as a
nuisance, since the soldiers marched two
abreast along the Strand, Fleet Street and
Cheapside, showing little consideration for
pedestrians.

All of Gillray's enthusiasm for the High
Baroque is shown in the sprawling mass of
bodies trampled down by the high-stepping
soldiers. A skinny popinjay of an officer
plants his boot on the belly of a gross
fishwife. A French barber takes advantage
of the situation to put one hand between
the legs of a fallen beauty, while he caresses
and kisses her exposed right leg. More
shapely upturned legs can be seen at the
far right. The most extraordinary figure is
the petrified man at the centre below, for,
not content with distorting his features and
body, Gillray has brutally snapped his leg
below the knee. Throughout the design
there is a virtuoso alternation between highly
finished areas, and other details scratched in
at breakneck speed.

30B A March to the Bank

Hand-coloured etching 42.4 × 54.5
Published 22 August 1787 by S.W. Fores
The British Museum, London
BMC 7174

This is the second state of the print. Probably
at his publisher's insistence Gillray has
covered the modesty of the fallen fishwife
with additional folds to her skirt. He has
however slyly added to her basket an eel
which nips at the tiny penis of the fallen boy.

31 The Morning after Marriage – or – A scene on the Continent

Hand-coloured etching 42 × 51.2
Published 5 April 1788 by W. Holland
Private Collection
BMC 7298

A natural and flamboyant sequel to *Wife & no wife* (no.20), this print, first published in 1786 by William Holland, shows the couple dressing as a maid enters with their breakfast. Their respective postures are clever variations on those of the couple in the second plate of Hogarth's *Marriage à la Mode* (1745), and would have been recognised as such by most of Gillray's public. She is reluctant to dress, and gestures suggestively at the bed while eyeing the Prince seductively. He stretches and yawns, his eyes half closed, and on the table a drooping candle and an overturned decanter spilling wine indicate his sexual exhaustion.

Gillray's drawing sizzles with vitality; the figures are carefully worked up, their faces just pushed one degree beyond the inanities of fashionable portrait prints. Mrs Fitzherbert is one of the most seductive women in all of Gillray's work, reminiscent of the charmers in J.R. Smith's prints. Gillray has indicated the wall with the agitated chopped lines which he favoured in the 1780s, while the bed hangings are a bedlam of rapid unsorted marks and dashes.

This time 'Plenipo Georgy' is the ridiculous pseudonym used by the artist.

32 John Raphael Smith (1751–1815) Lady Sleeping in a Chair *c*.1782

Etching and aquatint 27.4 × 210
The British Museum, London

The seductive figure of Mrs Fitzherbert in *The Morning After Marriage* owes something to Smith's prints of languorous women, which were immensely popular at the time. Ellen D'Oench has suggested that this could be a portrait of Smith's wife. (*Copper into Gold: Prints by John Raphael Smith*, New Haven and London 1999, pp.109–10.)

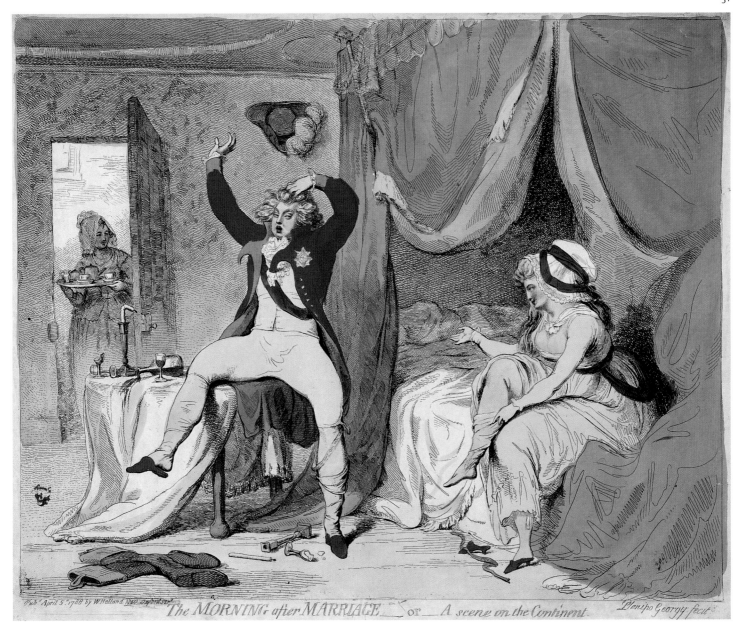

The MORNING after MARRIAGE __ or __ A scene on the Continent.

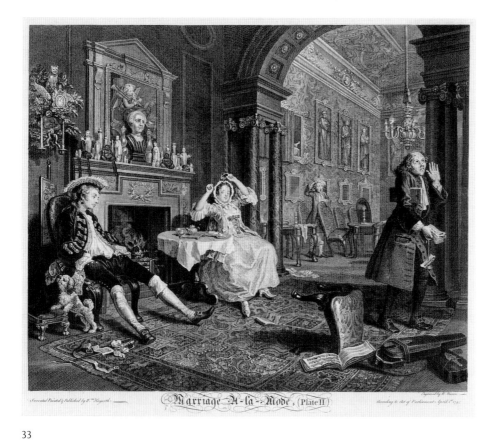

33

33 Bernard Baron after William Hogarth
(1697–1764)
Marriage à la Mode

Plate 2, June 1745 (Paulson 229)
Etching and engraving, second state of five
38.6 × 46.4
The British Museum, London

34

34 **The Bubbles of Opposition**

Etching with aquatint 35.2 × 23.5
Published 19 July 1788
The British Museum, London
BMC 7342

One of seven prints executed for the Tories
by Gillray at the time of the Westminster
election. Fox blows soap bubbles, which
emit from the pipe being the face of John
Townshend, the Whig candidate. The
Prince of Wales and numerous prominent
Whigs float upwards, including Burke, with
spectacles, and facing him Sheridan, shown
here for the first time with a face blotched
by drink.

35 Election-Troops bringing in their accounts

Etching 25 × 35
Published 14 August 1788 by H. Humphrey
The British Museum, London, Banks Collection
BMC 7369

This is the first political satire that Gillray signed and it was evidently a print to which he attached much importance. Diana Donald (*The Age of Caricature*, New Haven and London 1996, p.26) has emphasised the ambivalence of Gillray's position relative to the Whigs and the Tories. He was working for different publishers, attacking both parties, accepting fees from both sides – but publishing anonymously or under pseudonyms.

The print is an epilogue to the bitterly contested Westminster election in which the Whig candidate, Lord John Townshend, narrowly defeated the Tory, Admiral Hood. This was mortifying for Pitt and the Tories, who had spent considerable sums on hiring

persuaders and propagandists of various kinds. Gillray had been amongst them, etching seven prints attacking the Whigs.

Pitt now faces the reckoning as his former hirelings, ranging from soldiers with dripping bayonets to ragged street cryers, gather at the Treasury gates to collect their dues. They are led by Major Topham, editor of the pro-government *World*, who proffers a paper inscribed 'For Puffs & Squibs and for abusing opposition.' Pitt takes refuge behind the bars, whispering furtively, 'I know nothing of you my Friends, Lord H (Hood) pays all the expences himself – Hush! Hush! Go to the back door in Great George Street under the Rose!' This is an allusion to George Rose, Treasury Secretary, who had handled the election funds.

It appears likely that Gillray had not received his promised fee, and that this sophisticated print is his very public revenge. This is the first state of the print, before the price of 1/6d was removed.

Election-Troops, bringing in their accounts, to the Pay-Table.

Gillray's attempts at 'straight' printmaking

The 1780s saw the publication of some of Gillray's finest caricatures, but it was also a period when he made a sustained and determined attempt to distance himself from caricature, and establish himself as a 'serious' engraver, copying the works of artists such as James Northcote, but also engraving his own designs.

The publication, distribution and exporting of prints was a very large and profitable industry in eighteenth-century England. Sometimes these engravings, mezzotint and stipples were original designs, but more usually they were skilled translations of paintings by West, Reynolds and many others. The financial gain to publishers and engravers could be enormous – a considerable inducement to the ambitious Gillray.

His efforts, although technically very skilled, were doomed to failure. His tendency to introduce his own tricks of exaggeration, his irresistible individualism, were an increasing deterrent to publishers.

36 The Village Train

Stipple engraving 43 × 50.8
Published 4 June 1784 by R. Wilkinson
Andrew Edmunds, London
Provenance: Furst zu Oettingen – Wallerstein

One of a pair, the other being *The Deserted Village*, both deriving from Oliver Goldsmith's poem bemoaning the erosion of traditional village life. Gillray was determined to establish himself as an engraver of both serious subjects and sentimental rustic genre, the latter being best represented by this exquisitely refined print. The scene is idyllic, the rustics well soaped and elegant, but there is still an element of caricature in the elongated necks of the girls. Gillray was not a student of landscape, and the central tree, although beautifully drawn, is a generalised type which was to make a reappearance in rougher form fourteen years later in *The Tree Of Liberty* (no.124).

37 The Nancy Packet

Line engraving, etching and stipple 44.2 × 56.2
Published 19 October 1784 by R. Wilkinson
The British Museum, London

Gillray attempted in the mid-1780s to establish himself as an engraver of serious subjects by engraving his own designs and those of others. This is his own design, a melodramatic depiction of the shipwreck of 25 February 1784 when all on board perished in a storm off the Scilly Isles. It is an early example of the dramatic prints of shipwrecks, focusing on the desperate plight of the victims, that were so popular in England. His engraving technique is virtuoso, his drawing animated and highly finished; his Baroque construction of the figure group, culminating in the calm and affecting figure of Mrs Cargill the actress, is sophisticated; the figure of the tumbling negro is almost heroic. Indeed,

Benedict Nicolson cites this print, and specifically the negro, as amongst possible sources for Théodore Géricault's *Raft of the Medusa* (1819). ('The Raft from the Point of View of Subject Matter', *Burlington Magazine*, August 1954, pp.240–9.)

High farce is only a whisper away, however. The goggle eyes and thrashing limbs of the victims are Baroque burlesqued, and the sailor with striped trousers bending to rescue a drowning woman is waiting to be transformed into the Duke of Clarence entering the actress Dorothy Jordan in *Lubber's-Hole* (no.159). Gillray was no landscapist, but he did have a genuine feeling for the sea. Even here though, the raging waves, the foam and the spray are exaggerated to the point of caricature, and the forms with which they are about to engulf the figures anticipate the threatening spectres that appear in his later caricatures.

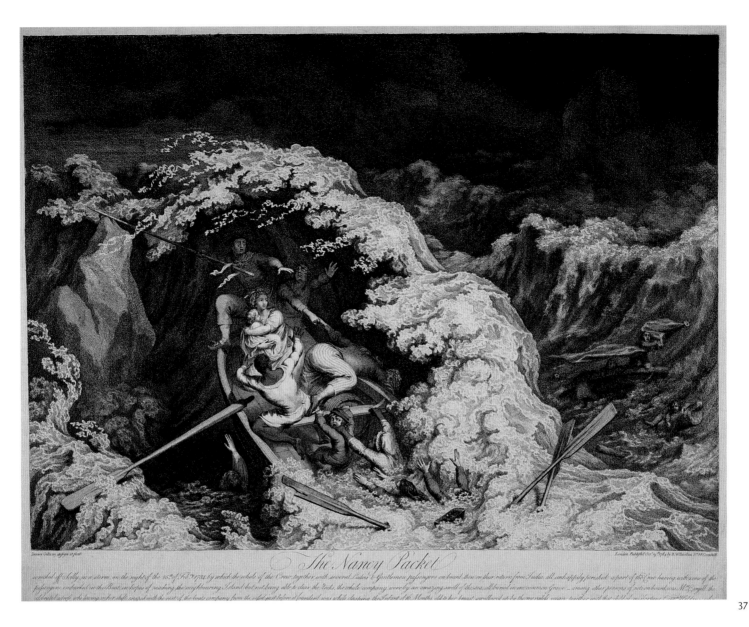

The Nancy Packet

wrecked off Scilly in a storm, on the night of the 25.th of Feb.y 1784. by which the whole of the Crew, together with several Ladies & Gentlemen passengers on board, then on their return from India all unhappily perished. a part of the Crew having with some of the passengers embarked in the Boats in hopes of reaching the neighbouring Island, but not being able to clear the Rocks, the whole company were by an amazing swell of the sea, all buried in one common Grave. among other persons of note on board was M.r Cargill, the devoted wretch who having in her chest inspired with the rest of the boats company from the cold just before it foundered, was while clasping the Infant of 10. Months old to her breast swallowed up by the merciless ocean, together with that child at one instant [...]

London Publishd Oct.r 19. 1784 by B.Wilkinson N.º 58 Cornhill

James Gillray delin.t et sculp.t

38 James Gillray after James Northcote
(1746–1831)
The Loss of the Halsewell East Indiaman

Line engraving, etching and stipple 51.5 × 63.3
Published 4 June 1787 by R. Wilkinson
Andrew Edmunds, London
Provenance: Northcote's own collection

Northcote and Gillray seem to have been
friendly, and Gillray engraved a number
of the painter's melodramatic subject
pictures. Northcote's painting is an out
and out attempt at the Tragic-Sublime, but
Gillray's participation introduces more than
a hint of caricature. Technically this is a *tour
de force*; the lines have been so deeply and
emphatically bitten in the acid that the strong
corrugated relief they produce adds even
more drama to the effect of the raging waves.

39 **The Triumph of Benevolence**

Line engraving with stipple 51 × 62
Published 21 April 1788 by R. Wilkinson
Private collection

The benign prison reformer John Howard
is depicted visiting a distressed family in a
gloomy prison cell. Gillray's print, which he
designed and engraved, was almost certainly
inspired by Francis Wheatley's painting of
Howard, *Visiting and Relieving the Miseries
of a Prison*, which was engraved by James
Hogg in 1790.

This densely worked plate is purportedly a
high-minded sentimental and moral subject,
but it is difficult to take it very seriously. The
grim gaoler lurking with his keys makes it all
too clear that 'The Triumph of Malevolence' is
only minutes away. There is an undercurrent
of malign eroticism. The prisoner's wife is of
the domineering virago type who appears

frequently in Gillray's earlier work. She
holds her husband's chains and pulls them
suggestively across his groin, whilst with her
other hand she accepts a purse, typical of
the period and of a very suggestive shape.
The print almost becomes a parody, and the
question does arise whether this was indeed
Gillray's intention.

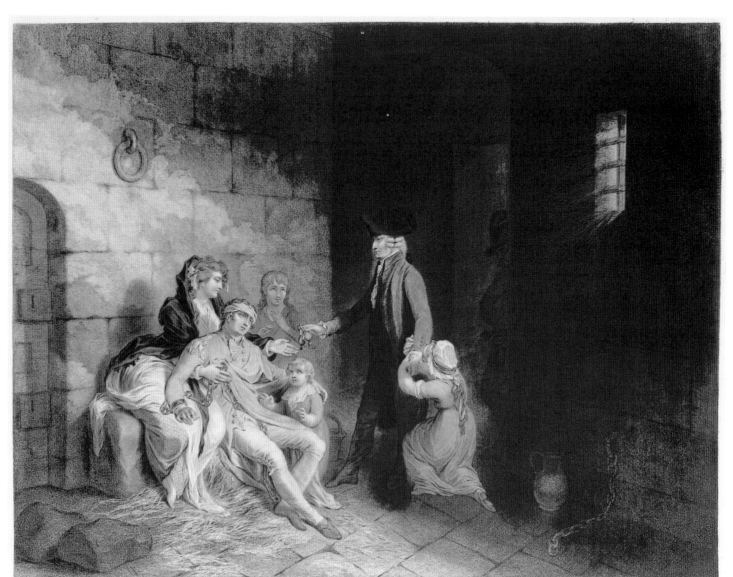

The TRIUMPH of BENEVOLENCE.

39

40 Mendoza

Etching and aquatint, touched with white body
colour 44.5 × 34.7
Published 24 April [1788] by I. Lewis and sold by
J. Aitken
The British Museum, London

Although a year is not given in the publica-
tion line this was clearly published just
before Mendoza's famous fight with Richard
Humphreys on 6 May 1788. Daniel Mendoza
(1763–1836) was the first celebrated Jewish
boxer, and noted for the science of his
pugilism which made up for his comparative
lack of stature.

Prints of boxers constitute a small but
distinct genre, being typically mezzotints
showing single figures posed alone in a
landscape. The originality of Gillray's print
lies not so much in the figure, monumental

though it is, but in the astutely observed
group of spectators, eagerly anticipating
violence and blood.

This impression, like those in the Pierpont
Morgan Library and New York Public Library,
has been touched by Gillray with white
paint to lighten some of the shadows in the
body. It seems likely that he did this to every
impression that he could, a measure of his
perfectionism, and also of his practicality
since this was probably quicker than
burnishing down the offending areas
of the plate.

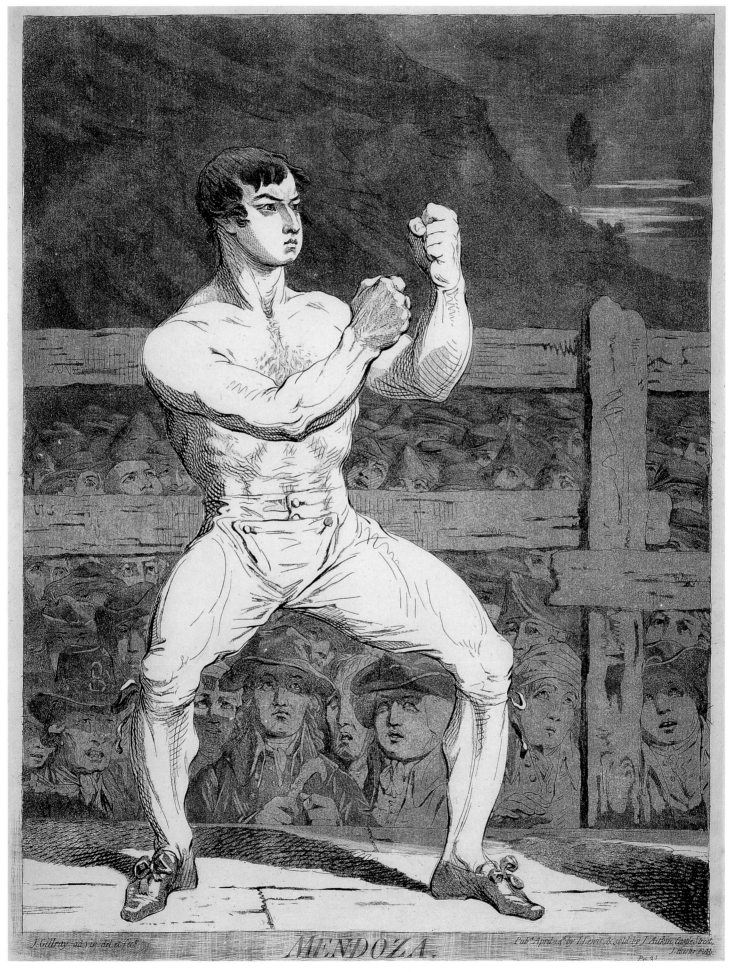

J. Gillray ad viv. del. et fect. MENDOZA. Pub.d April 2.d by H. Lewis & Sold by J. Aitkin, Castle Street,
 Leicester fields.

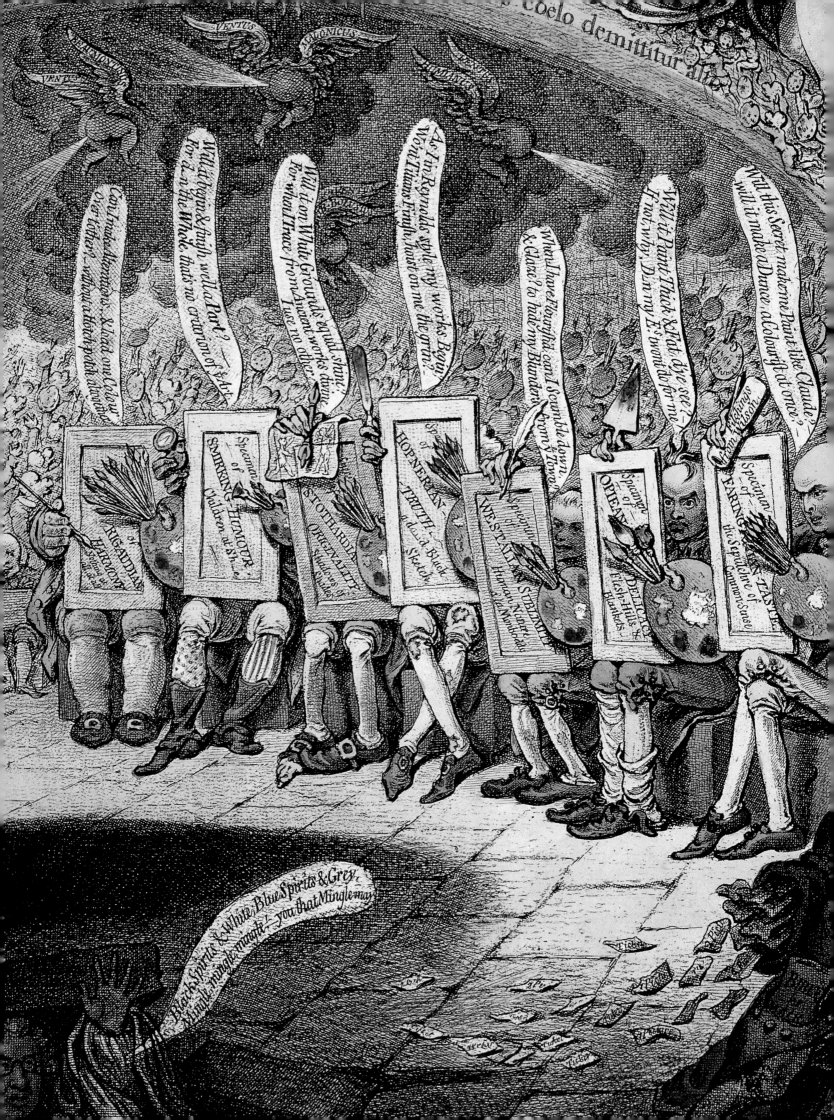

A Grotesque Trilogy

These three great prints, *Shakespeare Sacrificed* (1789), *Lieut Goverr Gall-Stone* (1790) and *Titianus Redivivus* (1797), were not planned as a programme, nor as a trilogy, but in retrospect they have something of that effect. They are some of his largest and most elaborate prints, teeming with grotesque figures. Amongst the infinity of details one is common to all three, a classical temple in the background, seemingly home to a winged ass.

The subjects are not political, but rather the follies of the London art world, the greed of Alderman Boydell, the credulity of Royal Academicians and, away from the art world, the iniquity of Philip Thicknesse. All three prints were aimed at a fairly small but sophisticated audience.

They were also surely a declaration of intent by Gillray, demonstrations of his status as an exponent of the comic sublime, as a draughtsman and printmaker, and as an unlicensed scourge of the complacent art establishment that had rejected him.

detail, no.47

Shakespeare Sacrificed

41A Shakespeare Sacrificed; – or – The Offering to Avarice

Etching, uncoloured proof before letters
50.5 × 38.5
The British Museum, London
BMC 7584

41B Shakespeare Sacrificed; – or – The Offering to Avarice

Etching, published state, uncoloured 50.5 × 38.5
Published 20 June 1789 by H. Humphrey
The British Museum, London
BMC 7584

Some of the aquatint in the clouds has been burnished away, thus accentuating Boydell's profile.

41C Shakespeare Sacrificed; – or – The Offering to Avarice

Hand-coloured etching, published state
50.5 × 38.5
Published 20 June 1789 by H. Humphrey
The British Museum, London
BMC 7584

According to John Boydell's nephew Josiah, the idea of the Shakespeare Gallery was first mooted in his house in 1786. The gallery opened in May 1789 with thirty-four pictures, increasing to sixty-five the next year. The Gallery was to be made profitable by engravings from the commissioned pictures, and in 1802 a set of nine volumes with one hundred engravings was published.

This ambitious venture was patriotic, an attempt to rival the French, and Boydell sought out the best-known painters and engravers. The engravings were strongly criticised. Ultimately it led to his ruin, as the export market for English prints was destroyed by the war with France.

Gillray was not amongst the engravers invited to participate, and he took a savage revenge on Boydell in this brilliant print – arguably the most imaginative and vivid work of art to come out of the whole venture.

Gillray's basic premise is that it was greed not patriotism that motivated Boydell. Wearing his Aldermanic robes Boydell stands before a pile of Shakespeare's plays which are burning fiercely, the flames fanned by bellows wielded by the Fool – deftly adapted from the figure in Benjamin West's painting of *King Lear* (see no.42). He gestures towards an immense book – a list of subscribers – on which is perched a grotesque, bearded, grinning little figure with twitching toes, who holds two bulging bags of money. On the shoulders of this depiction of Avarice is a tiny figure with a head-dress of peacock feathers, indicative of Vanity, who blows a little bubble enclosing the word 'Immortality'. Louis-François Roubillac's statue of Shakespeare is obscured by smoke billowing from the fire. On the clouds of smoke are numerous figures abstracted from paintings in the gallery and turned into grotesque parodies. The most vivid of them include (above Boydell's head) Bottom, from Henry Fuseli's *Midsummer Night's Dream*, a laughing man with an outstretched arm from Joshua Reynolds's *Death of Cardinal Beaufort* (Henry VI, part 11), and above him an old man with windswept white hair from James Barry's *King Lear*.

Boydell stands within a circle inside which is a Greek inscription that translates as 'Let no stranger to the Muses enter.' Gillray here takes a sideswipe at the Royal Academy, for this was the legend inscribed above the Great Exhibition Room at Somerset House. At the left of the circle a little boy with a palette and brushes roughly obstructs the entry of a little boy with an engraver's burin, a reference to the exclusion of engravers from membership of the Royal Academy. Also excluded from the charmed circle is a portfolio labelled 'Ancient Masters', over which crawls a snail. However, a portfolio of 'Modern Masters' is within the circle.

According to the *Somerset House Gazette* (18 September 1824) many of Boydell's artists 'could neither eat drink nor sleep till they had procured this print'. Coloured impressions were not issued until 1800.

42 William Sharp, after Benjamin West (1738–1820)
King Lear, Act 111, Scene 1v

Line engraving 48.5 × 63.5
Published 1793 by John and Josiah Boydell
The British Museum, London

Gillray has deftly parodied the figure of the Fool, fitting him with a pair of bellows to fan the flames. This was one of the few engravings from the Shakespeare Gallery to be considered a success.

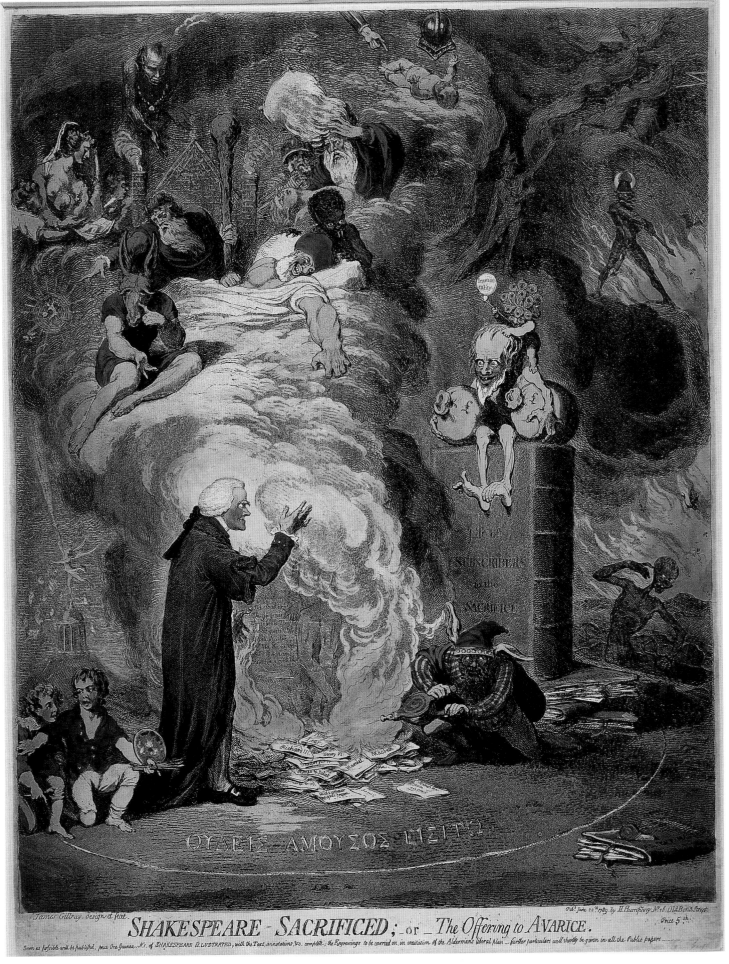

James Gillray, design et fecit.

Pub.d June 28.th 1789 by H.Humphrey N.o 18, Old Bond Street.

ΟΥΔΕΙΣ ΑΜΟΥΣΟΣ ΕΙΣΙΤΩ

SHAKESPEARE - SACRIFICED; _or _ The Offering to AVARICE.

Price 5.s

Soon as possible will be publish'd, price One Guinea. N.o of SHAKESPEARE ILLUSTRATED, with the Text, annotations, &c. compleat; the Engravings to be carried on, in imitation of the Alderman's liberal plan – further particulars will shortly be given in all the Public papers.

43A Lieut Goverr Gall-Stone, inspired by Alecto; – or The Birth of Minerva

Aquatint proof before all letters 54.4 × 41
The British Museum, London
BMC 7721

A working proof before the addition of the letters. The effects of light achieved by Gillray's use of aquatint are extraordinarily dramatic. However, he seems to have considered them too strong and perhaps unsuitable for colouring, because he has touched some of the shadows with white wash, indicating areas to be lightened by burnishing. Other areas seem to have worn very quickly, which is not uncommon for this technique.

43B Lieut Goverr Gall-Stone, inspired by Alecto; – or The Birth of Minerva

Etching with aquatint 49.5 × 38.8
Published 15 February 1790 by
H. Humphrey
The British Museum, London
BMC 7721

The finished state with the lettering added. Lettering prints (which of course had to be done in reverse) was a very skilled task, particularly in such a complicated print as this, but Gillray relished it, often adding pithy little notes on books or scraps of paper in his compositions.

This epic portrayal of Philip Thicknesse (1719–92) is one of the most sustained, complex and savage visual attacks ever sustained by a single individual. It is pictorially also one of Gillray's finest achievements, in which the legs of Thicknesse, his table, and the skeletal figure at the left, engage neurotically with the ground, while billows of clouds fill the sky, and a jet of steam explodes from Thicknesse's head. In size, ambition and dynamism it is a direct successor to *Shakespeare Sacrificed* (no.41) from the preceding year. Here too, pictorial conventions are sent tumbling. Portraitists such as Reynolds frequently depicted gentlemen as learned, serious, seated or standing, pen in hand. Here, Thicknesse's filthy muse, Alecto, looses a serpent from her head, which twines round him and tips his pen with bile and venom.

Thicknesse was an exceptionally rancorous and unpleasant man. In early life he travelled to Georgia, and later served as a lieutenant in Jamaica – where he hunted down runaway slaves. He remained an ardent supporter of the slave trade. In 1766 he bought the Lieutenant-Governorship of Landguard Fort. He was an early friend and biographer of Thomas Gainsborough. He became a prolific author, but both his work and character were motivated by greed and malice. He was by nature a blackmailer, a lecher and a sadist. Many of these attributes, and incidents and events in his life, are illustrated in this print.

A pile of his publications is on his desk, pranced upon by a monkey-like figure brandishing a whip, with one foot snapping the spear of Death, who made his debut in *Love in a Coffin* (no.15). Thicknesse had travelled in France with a pet monkey dressed as a postilion. Beneath the bony foot of the Death figure is a dead dog. A pamphlet beside it is lettered 'Elegy on the death of my favourite Dog – Horsewhipped to death for Barking while I was kissing my Wife'. The close-stool (portable toilet) on which he sits is labelled 'Reservoire for Gall Stones' – in his *Memoirs* Thicknesse recommended as a cure for gall stones large doses of laudanum, and exercise on a trotting horse.

Thicknesse himself is not caricatured, the careful drawing of his face instead defining an obviously vicious character. His physical entanglement with Alecto is a particularly memorable coupling of figures. With one hand she caresses his arm, with her skeletal right foot she rubs his sturdy ankle in a sinister game of footsy-footsy. Another serpent sucks at her withered breast. She was a creation Gillray was not prepared to waste, and she reappears several times in later prints, notably transformed into Queen Charlotte in *Sin, Death, and the Devil* (no.105) – where indeed the figure of death also reappears in the form of Pitt.

Above Thicknesse's head, springing into the sky, is Minerva, whose hair – in a brilliant passage of drawing – turns into clouds. With her left hand she holds a cracked stone tablet, framed with serpents, on which are inscribed the principal accusations against Thicknesse, many no doubt exaggerated. With her right hand she clutches a wooden blunderbuss which bears the inscription 'The Coward's delight or, the Wooden Gun'. While he was at Landguard Fort in Suffolk, Thicknesse had quarrelled with a colonel of the Suffolk militia, Francis Vernon, and had sent him the insulting present of a wooden gun.

In his large epic compositions Gillray was adept at utilising every inch of space, whilst allowing the design to 'breathe' by judicious intervals of space. He uses the corners of his plates to particular effect. The upper right corner is here occupied by a little vignette showing Thicknesse, hands raised in admiration, standing behind his wife who is playing musical glasses to an audience of pigs. This was Thicknesse's third wife, formerly Ann Ford (1737–1824), a famous beauty and a talented musician, who in 1761, the year before her marriage, published *Instructions for playing on the Musical Glasses*. In 1760 she had been the subject of a ravishing full-length portrait by Gainsborough (Cincinnatti Art Museum). Thicknesse had not been so fortunate, since he had quarelled with Gainsborough, who never finished his portrait. Gillray shows it at the upper left beneath the rump of a demon playing a viol da gamba. The canvas is labelled 'Portrait of an ungrateful Madman left unfinish'd by Gainsborough'.

The print abounds in further allusions. One more may be noted here: an obelisk at the centre showing a skeleton eating an infant holding a pen and a book, Rowley's *Poems*; the inscription reads 'To the Memory of the Immortal Chatterton who wrote 400 years before he was born – a Stranger erects his Monument'. Thicknesse had erected a memorial to the poetical forger in his garden in Bath.

Thicknesse had many enemies alarmed and revolted by the publication of his *Memoirs* (1788–90), and it must have been this which provoked such an elaborate attack. The design and execution are of course Gillray's, but surely other minds are at work here, with enemies of Thicknesse coming and going from Mrs Humphrey's shop at 18 Old Bond, armed with yet more scurrilous material for the artist to accommodate. The monument to Thomas Chatterton, for instance, might well have been suggested by George Steevens, an enemy to literary forgeries, who also had a hand in *Shakespeare Sacrificed*. Such an ambitious print, with probably a fairly limited audience, must also have been sustained by outside financing. Indeed it was the culmination of a concentrated and sustained attack;

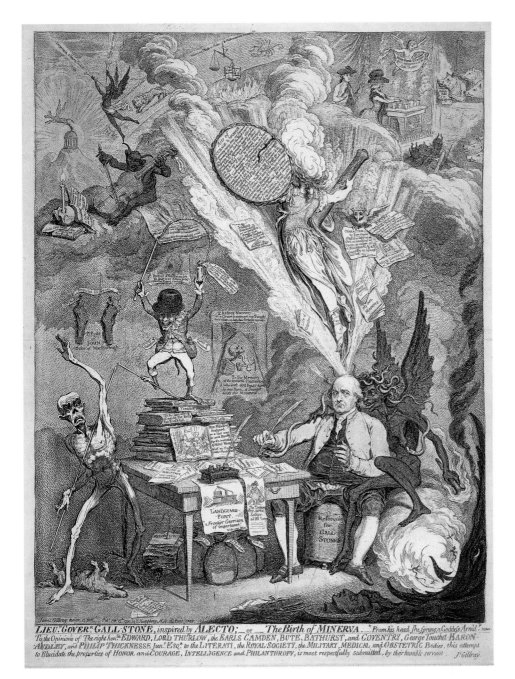

LIEU.^t GOVER^r GALL-STONE, inspired by ALECTO;_or_The Birth of MINERVA.._"From his head, she sprang a Goddess Arm'd." Nato ._

To the Opinions of The right hon^{ble} EDWARD, LORD THURLOW, the EARLS CAMDEN, BUTE, BATHURST, and COVENTRY, George Touchet BARON-
AUDLEY, and PHILIP THICKNESSE, jun.^r ESQ^r to the LITERATI, the ROYAL SOCIETY, the MILITARY, MEDICAL and OBSTETRIC Bodies, this attempt
to Elucidate the properties of HONOR, and COURAGE, INTELLIGENCE and PHILANTHROPY, is most respectfully submitted, by their humble servant. J.^s Gillray.

43B

anonymous verses were published, and
an insulting card was sent out on the
publication of the print. 'This day is Published
– Price five Shillings,' noting with heavy irony
that 'as the Engraving is intended merely as
an attempt to gibbet Meanness, Vive and
Empiricism it cannot possibly allude to
so respectable a Personage as PHILIP
THICKNESSE Esq.'

This print, with *Shakespeare Sacrificed*
and *Titianus Redivivus* (no.47), may be seen
in retrospect as part of a grotesque trilogy,
attacking conceit, greed and self-delusion.
A small but telling detail in the background

is common to all three prints, namely a small
classical temple on a mountain – probably
intended as Mount Helicon. In this print it
is surmounted by a leaping winged ass – a
mock Pegasus. Seven years later the same ass
alights on the rainbow in *Titianus Redivivus*,
and gorges itself on the paints of the
Venetian Secret.

44 Francisco José de Goya y Lucientes (1746–1828)

El Sueno De La Razon Produce Monstruos (The Sleep of Reason Produces Monsters)

Plate 43 from *Los Caprichos*, first edition 1799
Etching with aquatint 21.5 × 15
The British Museum, London

Comparisons between Gillray and Goya have
been made frequently, and in the case of the
eighty plates of *Los Caprichos* are inevitable.
It is doubtful if Gillray knew Goya's prints,
which found few buyers in England, but
English caricatures circulated widely on the
Continent, and, despite the absence of direct
borrowing from the former's work, it is more
than likely that Goya knew at least some
examples.

Both *Lieut Goverr Gall-Stone* (no.43) and
The Sleep of Reason anticipate Romantic art,
revealing a dark inner world, irrational and
dangerous.

45 William Dent (active 1783–93)

The Cutter Cut Up, or, The Monster at Full Length

Hand-coloured etching 42 × 30
Published 15 December 1790 by J. Aitken
The British Museum, London
BMC 7725

Thicknesse was a target for a number of other
caricaturists, including Dent, a crude but
effective and productive caricaturist. The
title refers to a man then at large in London,
known as 'the Monster', who attacked
women with a knife, cutting their clothes,
and sometimes their posteriors.

46 Nathaniel Hone (1718–84)

Philip Thicknesse 1757

Miniature on enamel, oval 2.8 × 2.5
National Portrait Gallery, London

Titianus Redivivus

47 Titianus Redivivus; – or The Seven-Wise-Men consulting the new Venetian Oracle, – a scene in the Academic Grove. No.1

Hand-coloured etching and aquatint 54.9 × 42
Published 2 November 1797 by H. Humphrey
The British Museum, London
BMC 9085

This epic and sublimely comic design, like the earlier *Shakespeare Sacrificed* (no.41), is a devastating attack on the Art Establishment and, more particularly, an exposé of the confidence trick inflicted on numerous Royal Academicians – the so-called 'Venetian Secret'.

In December 1795 a little-known miniaturist painter, Ann Jemima Provis, told the President of the Royal Academy, Benjamin West, of a copy of an authentic early Venetian manual of painting. This was in the possession of her family, the original supposedly destroyed by fire after the copy had been made. By the beginning of 1797 numerous Royal Academicians, anxious that West might obtain a monopoly of the Secret, began clambering and scrabbling for access to Miss Provis and her recipe book. Information seems to have been conveyed by access to the text, and through audiences with Miss Provis in which she demonstrated the method with its emphasis on dark grounds, pure linseed oil, and the 'Titian Shade' with its blending of lake, indigo, and Antwerp and Prussian blues – the last two pigments having been developed in the eighteenth century. Money began to change hands, subscribers paying ten guineas. Once possessed of the Secret they were bound by quasi-masonic ties, and dire threats of swingeing fines if they revealed the secret to foreigners – or Royal Academy students.

Other artists, however, were less credulous, and were suspicious or even downright derisive of the whole affair. These included Paul Sandby, Philippe Jacques de Loutherbourg, William Beechey, Henry Fuseli and the young J.M.W. Turner. For James Barry it was a 'quaking disgraceful imposture'.

Gillray delivered his thunderbolt on 2 November 1797. At the centre, seated on a long wooden bench as if they were students at the Academy life school, are the seven 'wise men', who are busy painting a cast of the Apollo Belvedere – which has lost

44

45

46

its head. Reading from right to left they are clearly identified as Joseph Farington, John Opie, Richard Westall, John Hoppner, Thomas Stothard, Robert Smirke, and J.F. Rigaud. Each is identified, and their characteristics and failings as a painter defined with pinpoint accuracy by the legends on the balloons and the backs of their canvases. Thus Farington, who occupies the chief place of dishonour at the far right of the bench, muses, 'Will this secret make me paint like Claude? – will it make a Dunce, a Colourist at once?' From his pocket protrudes a paper, 'Methods of eating ones way into the Academy', a sly allusion to the fact that Farington's position of eminence in the Academy owed more to politicising and constant dining out than to his very modest talents as a landscape artist. The caricatures of these seven artists are amongst the most brilliant and animated that Gillray ever made; even when their faces are obscured, their excited twitching feet and peculiarities of costume indicate variety of folly and appearance. Behind these seven initiates of the Secret swarm a host of envious artists, tiny and monkey-like, who scramble onto a rainbow, some of them obscured by the peacock feathers at the end of Miss Provis's skirt. Three flying, farting putti, are identified as Sir George Beaumont, amateur and keen 'Venetian', and Edward Malone and Sir Abraham Hume, the critics.

Slinking away furtively at the lower right are Benjamin West, palette in hand, John Boydell in the centre – Gillray's *bête noire* – and Thomas Macklin, another print publisher, who like Boydell was eager to seek profit from the whole affair. Banknotes flutter from Macklin's money bag and drift towards the shade of Reynolds, emerging from the flagstones – an allusion to Reynolds's biographer Edward Malone who had asserted that Reynolds would have embraced the method. Gillray does not forget those artists sensible enough to reject the method. The portfolios of Sandby, Cosway, Bartolozzi, Rooker, Turner, de Loutherbourg, Beechey and Fuseli are arranged at the base of the statue. A monkey figure with a sans-culotte-type bonnet leers horribly, and urinates copiously over the folders.

Miss Provis herself is atop the rainbow daubing a grotesque portrait of Titian onto her dark ground. The magnificence of her train contrasts with her tattered skirt. A winged ass gorges on her overflowing pot

of paint. A putto on a second rainbow blows a trumpet: 'You little Stars, hide your diminished heads', and stars representing Rubens, Corregio, Michelangelo, Raphael and Parmigianino fall towards the building of the Royal Academy – on which a menacing crack has already appeared.

The career of the enterprising Miss Provis did not long survive the publication of this brilliantly devised programme and its swirling but exactly controlled design. Interesting sidelights on its publication are to be found in the diaries of one of its main casualties, Joseph Farington, particularly regarding the probable close connection with the print of George Steevens (1736–1800), Shakespearian

scholar, Hogarth collector, and exposer of the humbug of the earlier Shakespeare forgeries by W. Ireland – which are alluded to in the lines at the top of the print.

The progressive discomfiture of Farington about being thought a dupe begins with an entry on 10 November 1797: 'Bourgeois mentioned a caricature print by Gillray – intended to ridicule those who have recommended Provis's process.' On 23 November things got worse: 'Steevens spoke of Gillray's satirical print – thinks him a clever fellow – attacked the process violently – as another Ireland business. I replied in a way that seemed to touch him. Coombe remarked afterwards on Steevens habit of

TITIANUS REDIVIVUS; – or – The Seven-Wise-Men consulting the new Venetian Oracle, – a Scene in ye Academic Grove

boring people when he had once undertaken to decry a subject'; 27 November: 'Steevens is often at Mrs. Humphrey's Paint Shop, and likely enough supplies the Latin motto's to Gillray's prints'; 4 December: 'Shakespeare Gallery. Steevens there, gave me Gillray's caricature print of Academicians. – Boydell believes Steevens had a hand in the contriving of it'. Farington could not even avoid persecution when he visited the House of Commons on 28 December to listen to a debate affecting Academy matters: 'Canning showed us Gillray.'

Farington returned reluctantly to the subject on 23 June 1800: 'Boydell told me that Gillray, the caricaturist dined lately in company with Bulmer, the printer, & on hearing Bulmer say that George Steevens superintended the letter press of Boydell's Shakespeare expressed his surprise, saying that Steevens was the person who instigated him to engrave the Plate which represented Alderman Boydell as an Usurer etc, etc – he also said that Steevens instigated him to engrave the Plate rediculing the venetian System of Colouring. – All this proves the duplicity & malevolence of Steevens's character.'

This involvement of Steevens cannot otherwise be confirmed and may well have consisted of private conversations in some inner sanctum of Mrs Humphrey's shop. Yet Farington's words have the ring of veracity, albeit partially derived from the tittle-tattle of the Town. However Steevens's celebrated hatred of deceit, forgery and humbug obviously led him irresistibly to the Provis scandal, and Gillray was the obvious conduit for a satirical print – and an obvious ally with his antagonism to Boydell and the Royal Academy. It is interesting also that he is associated with *Shakespeare Sacrificed*, another highly programmatic print.

Gillray's extraordinary inside knowledge of the whole affair also suggests sly conversations with some of those Academicians who recognised the imposture – de Loutherbourg was after all an earlier partner of Gillray. Whatever the involvement of others Gillray's originality is not called into question; but it seems likely that the input of others, not perhaps in images, but sometimes in words or suggested subjects and allusions, was accepted and welcomed.

For a time poor Farington refused to learn. He attended Miss Provis on 27 November with Richard Westall, where, their asses' ears growing by the moment, they listened as she expounded on linseed oil, glazing and other tricks – not merely limited to sixteenth-century Venetian pictures. There was no limit to her knowledge! 'She showed us examples that to imitate the Flemish pictures a ground should be laid with Spanish White & size of the same sort used in the Venetian process – this should be passed twice over, after which by scraping with a knife the ground might be made perfectly smooth & the grain of the wood shown beautifully in parts – on this ground draw the subject with Ivory black or Titian shade and using 2 Whites – Spanish White and Flake White for different degrees of light prepare a Chiaroscuro for finishing with glazing colours.' Thereafter she quietly vanishes from the diary.

This large and complicated etching is comparatively scarce, and must have taken a long time to prepare. It also required particularly careful colouring, since in this case uncoloured impressions were pointless. The present example shows very good, bright early colouring. It seems likely that from the outset the print was intended for a small, highly sophisticated audience conversant with the affairs of the Academy. Gillray's infinite capacity for mischief is revealed in one tiny detail. The title is concluded by the ominous numeral 'No.1'. How many Academicians waited anxiously for a sequel that never came, and was almost certainly never intended?

48 Simon Ravenet, after J. Hamilton Mortimer (1740–79)
An Academy

Engraving 51 × 42.5
Published 1 November 1771 by John Boydell
The British Museum, London

This was the frontispiece to the second volume of *A Collection of Prints* published by Boydell in 1772. It is likely that Gillray knew the engraving, given his admiration for Mortimer, and that it supplied some visual hints for the grouping of the artists, and for the repoussoir effect of the semi-silhouetted foreground groups in *Titianus Redivivus* (no.47).

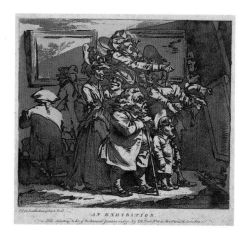

49 Philippe Jacques de Loutherbourg (1740–1812)
An Exhibition

Etching and aquatint, printed in brown ink
22.4 × 24.1 (trimmed within platemark)
Published 29 January 1776 by V.M. Picot
Private Collection

De Loutherbourg was trained in Paris, but came to London in 1771 where he remained for the rest of his life. Best known for landscapes and history paintings, executed in exceptionally pure technique, he was an occasional caricaturist, this satire of ignorant spectators at the Royal Academy being a very good example.

50 Thomas Rowlandson (1756–1827)
A Bench of Artists 1776

Pen and grey and black ink over pencil
27.2 × 54.8
Tate. Purchased as part of the Oppé Collection with assistance from the National Lottery through the Heritage Lottery Fund 1996

This pen sketch was made by Rowlandson two years before Gillray entered the Royal Academy Schools. The curved bench on which the students sit is very similar to that which accommodates the foolish Academicians – 'The Seven Wise Men' – in *Titianus Redivivus* (no.47). Seven students are shown here, the central figure being the portrait painter William Beechey.

51 Thomas Rowlandson
The Exhibition 'Stare-Case' c.1800

Watercolour and pen and ink 44.5 × 29.7
Yale Center for British Art, Paul Mellon Collection
B1981.25.2893

A comic scene at the annual exhibition of the
Royal Academy at Somerset House, where
the impracticality of parts of Sir William
Chambers building, particularly the challeng-
ing nature of the staircase, has led to disaster.
It was this staircase which ultimately deterred
an increasingly stout George IV from visiting
the exhibitions.

Rowlandson and Gillray were probably
not intimate friends, but seem to have been
on good terms. A writer in the *Somerset
House Gazette* (3 April 1824) recorded that
the two artists would sometimes meet and
'exchange half a dozen questions and
answers upon the affairs of copper and
aquafortis, swear all the world was one vast
masquerade and enter into the common
chat of the room'. They should not be seen
as rivals, and in many ways their work is
complementary. Political satire was not a
large part of Rowlandson's output, and he
shared nothing of Gillray's enthusiasm for the
technical possibilities of etching. The greatest
beauty of his work lies in the graceful lines
and fluent washes of his watercolours, of
which this is one of the finest examples.

52 Thomas Rowlandson
Viewing at the Royal Academy

Watercolour and pen and ink over pencil
14.7 × 24
Yale Center for British Art, Paul Mellon Collection
B2001.2.1161

A comic view of the exhibition, with pictures
close packed and hung from ceiling to floor,
occasioning the ridiculous postures of the
figures, their faces eager, their bellies and
bottoms jutting and prominent.

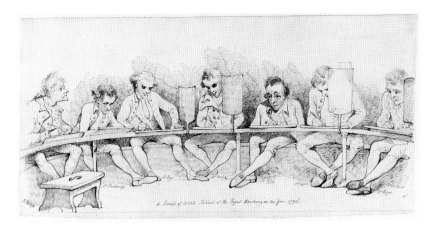

50

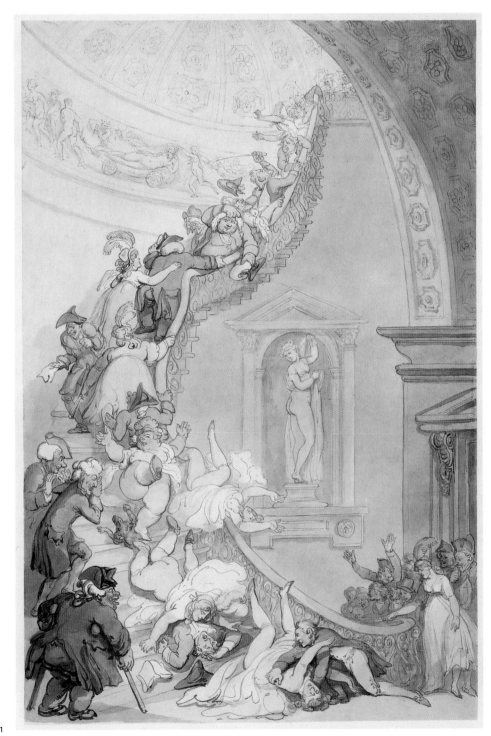

51

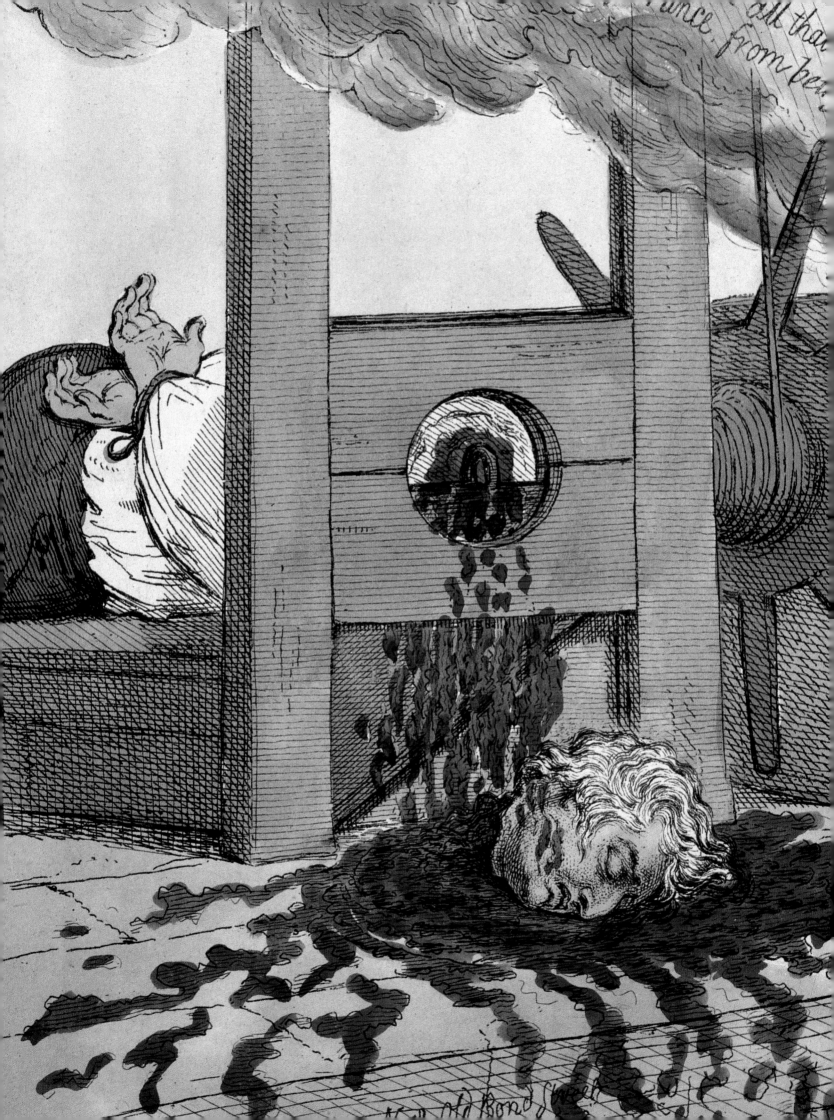

The French Revolution, French Wars, Napoleon

From the outbreak of the French Revolution until the end of his career in 1810, much of Gillray's output, often avowedly propagandist, was concerned with the momentous events of the Revolution and the subsequent long and exhausting wars. Even as Gillray died in 1815, Wellington was preparing to confront Napoleon at Waterloo.

Initially many Britons were sympathetic to the aims of the Revolution, including James Northcote, whose histrionic *Le Triomphe de la Liberté* was engraved by Gillray in 1790. However, as Terror raged and the guillotine began to rise and fall, so did much public opinion begin to turn. Gillray's sub-human sans-culottes tear their victims apart. The blood of Louis XVI, shown as a martyr by Gillray, flows in torrents, as King George and Charlotte shake with fear. Republican sympathisers in Britain are demonised in prints ranging from rapid scrawls to elaborate allegories. Yet some of Gillray's simplest prints, such as *French Liberty. British Slavery* (no.59) are in fact very sophisticated, slyly adapting and simplifying earlier sources.

Although Gillray's etching needle from 1797 was at the service of the Government, he was not neutered. Seen with the perspective of time, as if it was in theatre, Pitt seems as ridiculous as Fox, or as Bonaparte, John Bull and Britannia nearly as foolish as the sans-culottes.

detail, no.61

The French revolution

In the summer of 1789 a rapid succession of events established a revolutionary government in France, beginning with the creation of a National Assembly in defiance of the King (17 June), the fall of the Bastille (14 July) and the Declaration of the Rights of Man (26 August). Church property was nationalised, the nobility abolished, and eventually the King himself arrested (June 1791). At first, many in Britain supported the Revolution, seeing it as a corrective to tyranny. But others were more suspicious. Gillray's *The Hopes of the Party* (no.54) is an extraordinary vision of the potential for political violence among Britain's more democratic elements, and appeared a full eighteen months before the actual execution of Louis XVI. News of atrocities in Paris were taken up by Gillray as the basis of his almost hallucinatory depictions of sexual violence and cannibalism among the revolutionaries (nos.55, 56). The execution of Louis in January 1793 was received with horror by both conservatives and liberals, and by February, Britain and France were officially at war. Characteristically, Gillray distilled these feelings of horror into an image of breathtaking vividness (no.61).

53

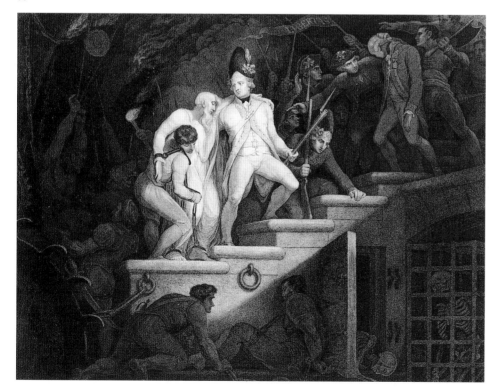

53 James Gillray after James Northcote
(1746–1831)
Le Triomphe de la Liberté en l'élargissement de la Bastille

Etching and stipple engraving 32.5 × 37.5
Published 12 July 1790 by R. Wilkinson
Dedicated 'a la Nation Françoise – par leurs respectueux admirateurs James Gillray
& Robert Wilkinson'
Andrew Edmunds, London

This large and melodramatic print was published two days before the anniversary of the fall of the Bastille, when there were still many British sympathisers for the Revolution in France. It seems likely that it was intended as a companion piece to *The Triumph of Benevolence* (no.39). Northcote's imagination creaks like a pair of old stays, the caged skeletons in particular come straight from the props of provincial theatre. The legend of the liberation of the Bastille is more dramatic than the truth. Only seven prisoners were found, one of them being a patriarchal old

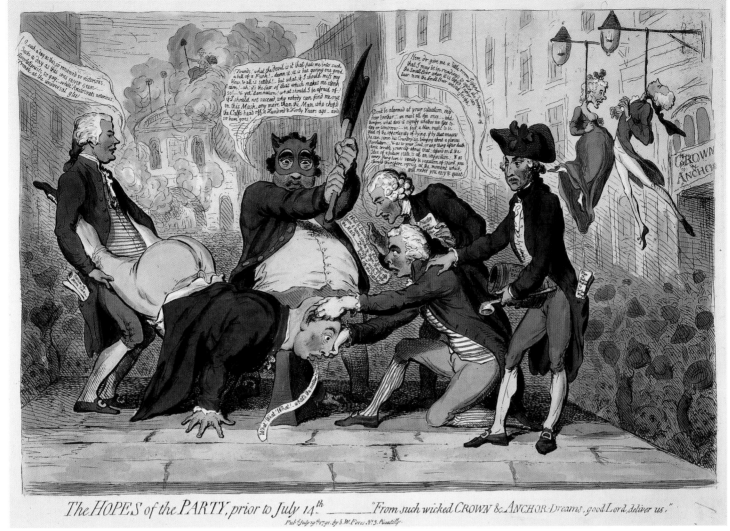

The HOPES of the PARTY, prior to July 14th _____ "From such wicked CROWN & ANCHOR-Dreams, good Lord, deliver us."

Publ. July 19th 1791 by S.W. Fores Nº 3. Piccadilly.

man with a flowing white beard, known as 'Major Whyte', perfect for the imagination of the mob, and it is possible that Northcote had read reports of him. In fact he was a lunatic who was not surprised to be borne through the crowds since he thought he was Julius Caesar.

Northcote had a great reputation in his day, but it has not endured. He and Gillray seem for a while to have been friends. In 1826 in conversation with William Hazlitt (*Conversations of James Northcote, Esq., R.A.*, London 1830, pp.301–2) he said that 'Gillray was a great man in his way . . . why does not Mr.Lamb write an essay on the *Two-penny Whist*?' (no.184). Unfortunately no such essay was written.

This was an expensive print, offered for sale at twelve shillings plain and twenty-six shillings hand-coloured.

54 The Hopes of the Party, prior to July 14th – 'From such wicked Crown and Anchor-Dreams, good Lord deliver us'

Hand-coloured etching 36.7 × 51.5
Published 19 July 1791 by S.W. Fores
Library of Congress
BMC 7892

The Crown and Anchor tavern on the Strand was for a time the dinner venue for radicals celebrating the anniversary of the taking of the Bastille. Such a dinner had been held on 14 July 1791, five days before publication of this print but, prudently, neither Fox nor Sheridan had attended. This was no deterrent to Gillray who shows Fox poised to chop off the King's head, while Sheridan holds his ears to keep him still. They are assisted by three other radical Whigs: John Horne Tooke at the left, Sir Cecil Wray at the right, and Joseph Priestley, uttering insincere words of condolence, who stands behind Sheridan.

It seems likely that the idea for this print

had its origins in the picture of the execution of Charles I, seen behind Priestley in *Smelling out a Rat* (no.63). It is an extraordinary and gross satire, which would not have been possible to publish after the guillotining of Louis XVI in 1793. Enthusiastic crowds raise their hats and cheer as the axe is poised over the King's shaven head. Pitt and Queen Charlotte dangle from a lamp post, their bodies jerking into sexual proximity. The position of Tooke, who spreads the King's legs and thrusts his own body between them is outrageously suggestive. Some of the sting is taken out of the design, however, by the bewildered innocence of the King himself, uttering his habitual words 'What! What! What! What's the matter now'.

This strongly-coloured impression was formerly in the Royal Collection. George III did buy caricatures of himself which he sent to the University of Gottingen (founded by George II). It is unlikely that he bought this. Far more probably it was bought for the enjoyment of his son, the Prince of Wales.

55 A Representation of the horrid Barbarities practised upon the Nuns by the Fish-Women, on breaking into the Nunneries in France

Etching and engraving 27 × 40, with publisher's watercolour
Published 21 June 1792 by J. Aitken
Andrew Edmunds, London
Provenance: Count von Starhemberg
BMC 8109

During Passion week in Paris in 1791 nuns had been scourged by market women. Gillray interprets the event with outrageous licence and self-indulgence, even to the gloating dedication 'to the Fair-Sex of Great Britain, & intended to point out the very dangerous effects which may arise to Themselves'.

The colouring of this impression is applied with great skill and enthusiasm, especially to the rubicund bottoms of the unfortunate nuns. There is no hard evidence with which to identify the hand-colouring of Gillray's prints, but if this is not his own brush then nothing is.

56 Petit souper a la Parisienne; – or – A Family of Sans-Culottes refreshing, after the fatigues of the day

Hand-coloured etching 25 × 35.2
Published 20 September 1792 by
H. Humphrey
The British Museum, London
BMC 8122

The Revolution was at its ugliest in Paris during 2–6 September, with bloody massacres of prisoners, including many priests and political prisoners, as well as prostitutes and common criminals. At least 1,400 people died in scenes of dreadful butchery. The Princesse de Lamballe was cut to pieces with axes and pikes, her body stripped, and her head stuck on a pole to be paraded through the streets. Some early accounts refer specifically to the mutilation and display of her genitalia.

News of this reached London on 8 September and Gillray's response was a print showing a scene of a revolting, bestial, cannibal feast, etched with extreme rapidity and issued with bright elementary hand

colouring. The composition looks dashed off, improvised in a frenzy, but it is in fact a very skilful adaptation of an engraving after Pieter Brueghel, *The Poor Kitchen* (no.57). A peasant boiling a pot in the fireplace is replaced by an old crone basting a dead child; the child being fed turns into a group of demonic children eating intestines, whilst the ravenous peasants become the cannibalistic sans-culottes.

This is also an extraordinary example of Gillray's adaptability as a printmaker. Only six days beforehand he had published *The Reception of the Diplomatique* (no.58), one of his most refined and carefully worked prints, with evidence of careful study of Chinoiserie. For Gillray the printmaker it must have been a relief that his next work was to gouge out this brutal subject and plunge the plate into the acid.

57 After Pieter Brueghel (*c.*1525–69)
The Poor Kitchen 1563

Engraving 22.1 × 29.4
The British Museum, London

55

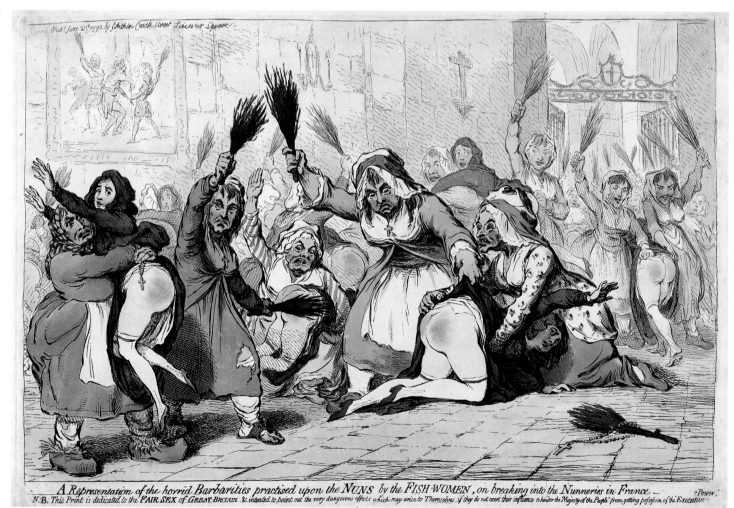

A Representation of the horrid Barbarities practised upon the NUNS by the FISH-WOMEN, on breaking into the Nunneries in France. – 'Power.'
N.B. This Print is dedicated to the FAIR SEX of GREAT-BRITAIN, & intended to point out the very dangerous effects which may arise to Themselves, if they do not exert their influence to hinder the Majesty of the People from getting possession of the Executive –

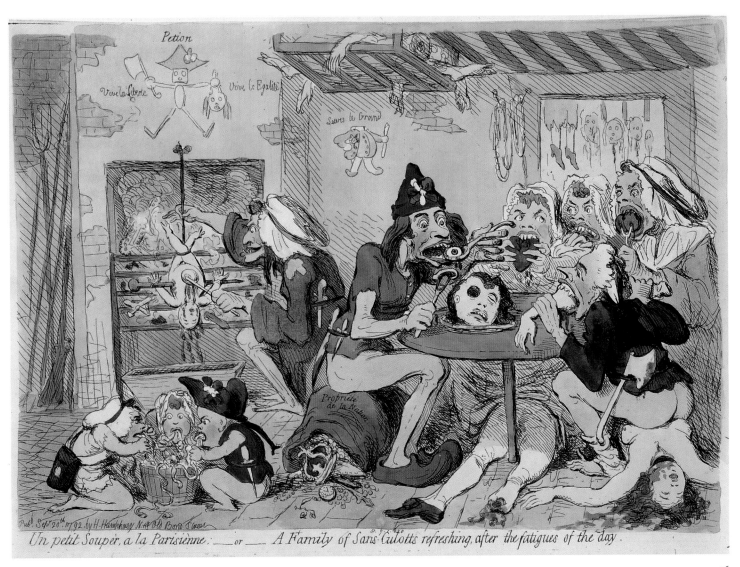

Un petit Souper, a la Parisienne. ___or ___ A Family of Sans Culotts refreshing, after the fatigues of the day.

LA MAIGRE CVISINE. CVLINA TENVIS. DE MAGHER KEVKEN.
Où Maigre dos le pot mouue, est vn pouure comune,
Pource a Grasse cuasine iray, tant que je viue.
Daer Magherman den pot roert is een arm ghasterie
Dus loop ick naer de Veite keuken met herten blije.

58A The Reception of the Diplomatique and his Suite at the Court of Pekin

Hand-coloured etching 31.5 × 39.5
Published 14 September 1792 by H. Humphrey
The British Museum, London, Banks Collection
BMC 8121

Gillray's extraordinary variety as a printmaker is demonstrated by the fact that this very refined and sophisticated print was followed six days later by the crude savagery of the *Petit souper*.

This exceptionally fine print was published a week before George, Ist Earl Macartney embarked for China with an embassy, hoping to persuade the aged Emperor, Qianlong, to permit a permanent English mission to the Court of Peking. Numerous gifts were taken, to show the superior quality of English manufacture and craftsmanship. The mission was not a success. An attaché, Aeneas Anderson, recalled bitterly that 'we entered Pekin like Paupers, remained in it like Prisoners, and departed from it like Vagrants'. The Emperor's letter to George III was massively condescending, proclaiming, 'You,

O King, live beyond the confines of many seas, nevertheless, impelled by your humble desire to partake of the benefits of our civilization, you have dispatched a mission respectfully bearing your memorial . . . I set no value on objects strange or ingenious, and have no use for your country's manufactures' (Sir A.F. Whyte, *China and Foreign Power*, London 1927, p.41).

Gillray's joyous prediction of the embassy's arrival, although exaggerated, highlights the ignorance of the English in assuming that the Emperor of such an ancient civilisation would be impressed by their gifts. The Chinese regard the buffoonery of their visitors with contempt. Even the furniture registers disapproval, a carved dragon's tail puncturing the eye of a British lion on a child's balloon. Macartney goes down on one knee (as he in fact did), but five of his followers perform a farcical kow-tow. The print is drawn with extreme refinement of detail, and with patient and delicate dotwork and short, chopped lines. This impression has the rather pale colouring typical of early examples, allowing a clear reading of the detailed work.

58B The Reception of the Diplomatique and his Suite at the Court of Pekin

Hand-coloured etching 31.5 × 39.5
Published 14 September 1792 by
H. Humphrey
The British Museum, London
BMC 8121

A good example of a slightly later impression, with bright, strong colours which obscure some of the details.

58A

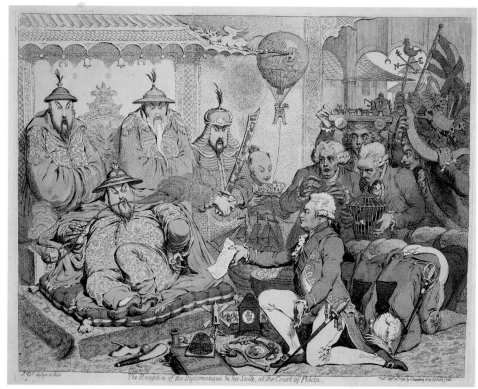

59 French Liberty. British Slavery

Hand-coloured etching 25 × 35.5
Published 21 December 1792 by
H. Humphrey
The British Museum, London, Banks Collection
BMC 8145

The simplicity of this famous print belies the complexity of Gillray's mind. The caricaturist, more than most artists, needed a mind stocked with diverse images culled from whatever source he could find, and suitable for re-cycling and adaptation to new purpose. Sometimes the sources, such as popular prints or paintings, would be well known to Gillray's educated audience. In other cases they were disguised. The national characteristics of the French and the English are here simplified to the point of absurdity. The skeletal Frenchman sits before a pathetic little fire and exults in his freedom, whilst he dines happily on raw onions – with a dish of live snails to follow. The gross Englishman, blotched with drink, gorges on beef and

beer, while complaining that the government is enslaving him and starving him to death. This figure, although he is not John Bull, came to be perceived as the very type of corpulent beef-eating Englishman – indeed, a number of foreign visitors to England were disappointed to find that the English were not generally so gross.

The contrast between the fat and the lean is a very ancient visual joke. It is likely that Gillray's mind was still full of Brueghel's prints *The Poor Kitchen* and *The Rich Kitchen*, which he had utilised in *Petit souper* (no.56). There were also an abundance of earlier English caricatures on the subject, sometimes emblematic, when a Frenchman might be represented by a skinny monkey and the Englishman by a bear. Gillray was also feeding from his own earlier prints and transmuting them into different forms, an activity that may have been a combination of the deliberate and the subconscious. The spectacle of a lean person and a stout one, facing each other, and feasting greedily,

has already been seen in *Monstrous Craws* (no.142). in the shape of the King and the Queen. Gillray's almost pathological loathing of the Queen, of her greed, of her physical ugliness, is one of the most interesting features of his prints from the late 1780s. In her various manifestations she is a serpent and a hag, while Alecto, in *Lieut Goverr Gall-Stone* (no.43) is her near cousin; her mouth is huge, her teeth are filed to points, her nose drips and hairs sprout from her face. She is ugly enough in fact to be a sans-culotte, and the scrawny, disgusting Frenchman in *French Liberty* is her kith and kin – a logical but extraordinary development in Gillray's demonisation of the unfortunate woman.

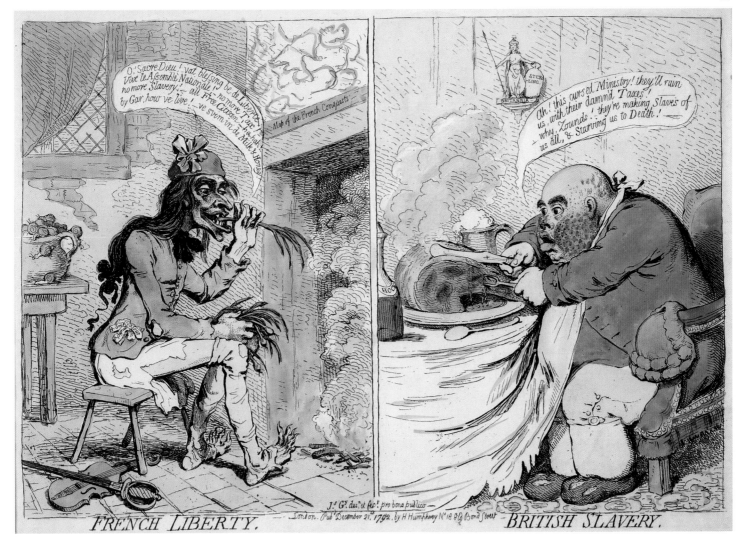

FRENCH LIBERTY. BRITISH SLAVERY.

60 The Zenith of French Glory; –
The Pinnacle of Liberty

Hand-coloured etching 35.5 × 25
Published 12 February 1793 by
H. Humphrey
The British Museum, London
BMC 8300

On 21 September 1792 the French National
Convention abolished the monarchy. During
16–17 January 1793 a vote was taken by
roll-call for the death of the King, the voting
being 387 to 334 in favour. On the morning of
18 January 1793 Louis XVI was guillotined
before a vast crowd, including massed ranks
of soldiers, in the place de Révolution (now
place de la Concorde). This grim sequence
of events culminated in the Convention's
declaration of war against Great Britain and
Holland on 1 February. A state of war had
thus existed for twelve days when this print
was published, and with the exception of one
brief spell in 1802–3 was to remain so for the
rest of Gillray's working life. Inevitably it was
to be one of the central themes of his work.

Gillray did not hurry with his response
to the King's execution. This is a carefully
planned design, and the foreground figures
are highly worked up. The viewpoint is
original and effective, as if the artist had
been peering secretly from a high building.
A bishop and two monks dangle from a
horizontal bar, and the bishop's crozier,
surmounted by a cap of liberty, bisects a
metal strut to form an inverted crucifix. An
actual crucifix in a niche above this has an
attached strip of paper reading 'Bon Soir
Monsieur'. The sans-culotte, his bare behind
balanced on the lantern and his foot on the
bishop's neck, is one of Gillray's most telling
inventions. The scene of execution in the
distance is sketched in with a hurried
shorthand of lines, but the guillotine,
its blade about to descend, is carefully
drawn; a ghoulish English public would
have demanded no less.

60

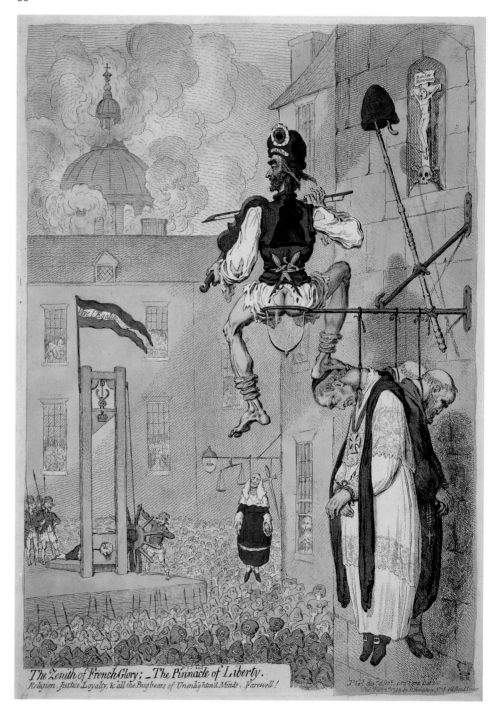

The Zenith of French Glory; – The Pinnacle of Liberty.
Religion, Justice, Loyalty, & all the Bugbears of Unenlighten'd Minds, Farewell!

61 The Blood of the Murdered crying for Vengeance

Hand-coloured etching 35.5 × 25
Published 16 February 1793 by H. Humphrey
The British Museum, London
BMC 8304

Four days after the publication of *The Zenith of French Glory* (no.60) Gillray focuses on the figure of the King, seconds after his head has been severed. Torrents of blood rise heavenwards bearing imagined lamentations of the late King, whose head is idealised. This had not always been the case in some earlier Gillray prints.

The print is deliberately crude, very rapidly etched and highly dependent for its effect on the extensive red colouring of the blood.

62 Jean-Baptiste-Marie Louvion (1740–1804)

Le Neuf Thermidor ou la Surpise angloise aux honnêtes gens de tous les pays

Etching 27.8 × 35.5
The British Museum, London
BMC 8675

French knowledge of Gillray prints is revealed in this print of about 1795, where the gross figure of the Englishman is cleverly adapted from *French Liberty. British Slavery* (no.59). The design is based on an idea by Poirier, a Dunkirk lawyer. France, in the shape of an elegant young man accompanied by an ostrich, holds an ostrich egg, from which emerges a figure of Peace. Behind him a figure of Justice extirpates monsters of the Terror such as Marat, Robespierre and Carrier, signalling a reaction against the violence of the Revolution. The Englishman reacts oafishly, but with interest, 'Goddem! Go on.'.

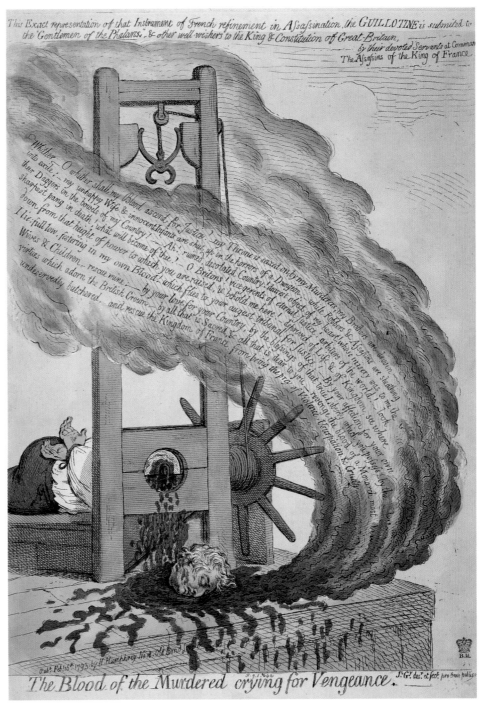

61

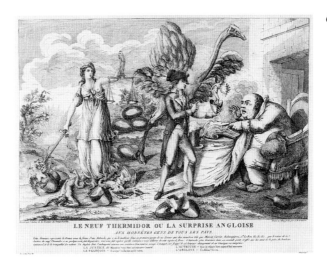

62

Revolutionary and anti-revolutionary ideas

63 Smelling out a Rat; – or The Atheistical-Revolutionist disturbed in his Midnight 'Calculations'

Hand-coloured etching 24.8 × 35
Published 3 December 1790 by H. Humphrey
The British Museum, London
BMC 7686

Burke's famous *Reflections on the Revolution in France* was published on 1 November 1790, and from thence he was a passionate opponent of the Revolution, which he associated with regicide and atheism. He broke with the Whigs, and in 1792 allied himself with Pitt.

This is one of Gillray's boldest and most exaggerated caricatures. Burke's form is reduced to his hands, clutching a crown and a crucifix, glaring eyes behind large spectacles, and a stupendously extended nose, with which he sniffs out Dr Richard Price, a dissenting clergyman who in 1789 had preached a sermon on 'The Love of our Country' to the Revolution Society. He had also moved an address to the National Assembly of France in which they were congratulated on the Revolution. Behind him, significantly, hangs a picture of the execution of Charles I.

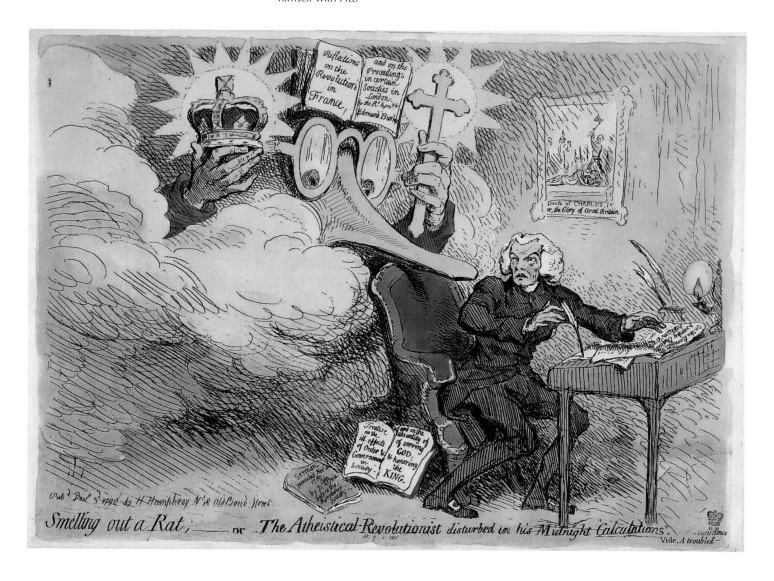

64 The Rights of Man; or – Tommy Paine, the little American Taylor, taking the Measure of the Crown. for a new Pair of Revolution-Breeches

Hand-coloured etching 35 × 25
Published 23 May 1791 by H. Humphrey
The British Museum, London
BMC 7867

The first part of Tom Paine's *Rights of Man*, dedicated to George Washington, was published on 13 March 1791, and was partially intended as a reply to Edmund Burke's *Reflections* (1790). He fled to Paris immediately after, and never returned to England, dying in New York in 1809. His *Common Sense*, published in 1776, had given great impetus to the American Declaration of Independence.

Dressed as a tailor (an allusion to his earlier occupation as a staymaker), Paine takes a measuring tape to a huge crown. His rambling thoughts are packed into a speech balloon, culminating in the words 'I would soon stitch up the mouth of that Barnacled Edmund [Burke] from making any more Reflections On the Flints – & so Flints and Liberty for ever & damn the Dungs'. This is a knowing reference to the division of London tailors into the more radical Flints, who would strike to obtain higher wages, and the Dungs who accepted the going rate. It is reasonable to assume that the press-ganged tailor in his earlier etching *The Liberty of the Subject* (1779) (no.3) was a Dung.

The print is ironically dedicated to the 'Jacobine Clubs of France and England'.

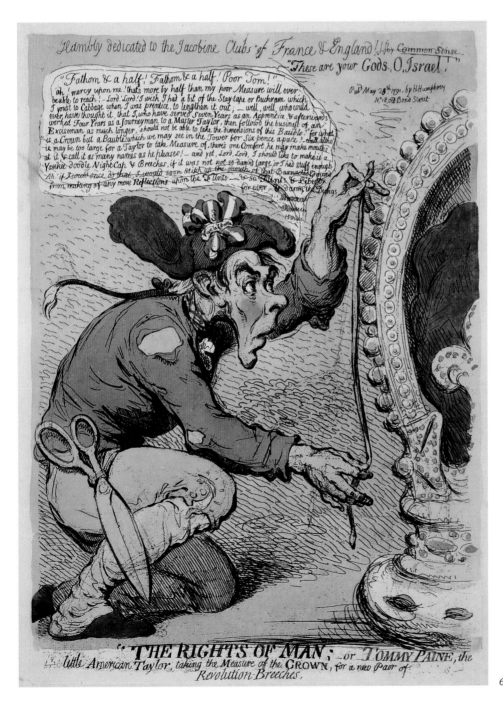

64

65A Tom Paine's Nightly Pest

Etching with aquatint 24.7 × 34.7
Published 26 November 1792 by H. Humphrey
The British Museum, London
BMC 8132

Paine, his face rendered quite naturalistically, with no resemblance to the caricature in *The Rights of Man* (no.64), slumbers uneasily on a straw bed in a ramshackle room. The profiles of his 'Guardian Angels', Priestley and Fox, are drawn on the head of his bed. A number of ludicrous publications, including 'Common Sense or Reason destructive to Free Government', can be seen, indicating his extreme radicalism.

This is etched in very strong assertive aquatint, and the dramatic effect is powerful. However, Gillray was not satisfied and this is a first version that he rejected.

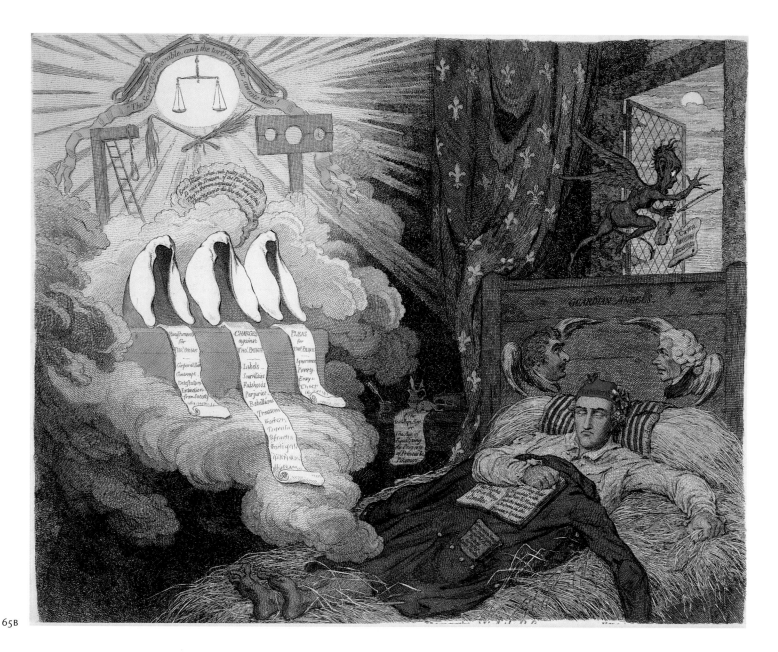

65B

65B Tom Paine's Nightly Pest

Hand-coloured etching 29.3 × 36.4
Published 10 December 1792 by
H. Humphrey
The British Museum, London
BMC 8137

This is the second and definitive version,
which follows the essential elements of
the first, but shows the design in reverse,
and extends the design so that Paine's bare
feet emerge from his makeshift coverlet,
increasing the sense of utter poverty. His

twitching toes now indicate his agitation as
his nightmare reveals the panoply of justice,
the wigs of headless judges, a gibbet and the
scales of justice. An alarmed hobgoblin now
skips out of the window into a moonlit sky.
The nightmares of politicians were to become
a favourite subject of Gillray's.

Paine was scheduled to be sent for trial
on 18 December for publishing *The Rights of
Man*, part II, but he had fled to France, never
to return.

66A Patriotic Regeneration, – Viz. –
Parliament Reform'd, A La Françoise, –
That Is – Honest Men (I.E. Opposition.)
In the Seat of Justice

Trial proof in etching and aquatint, before letters
31 × 42.5
The British Museum, London
BMC 8624

This is Gillray's first attempt, an etching with
aquatint freely applied, giving the effect of a
sunlit interior to the House of Commons.

66B Patriotic Regeneration, – Viz. – Parliament Reform'd, A La Françoise, – That Is – Honest Men (I.E. Opposition.) In the Seat of Justice

Hand-coloured etching, engraving and aquatint, with additional extensive scoring of the plate
31 × 42.5
Published 2 March 1795 by H. Humphrey
The British Museum, London
BMC 8624

Although the composition remains essentially the same, the whole plate has been radically reworked, and the interior is now dark, sombre and menacing. This is one of Gillray's most elaborate and carefully executed prints, and demonstrates how he combined the exigencies of political caricaturing with some of the most daring and innovative printmaking techniques ever attempted. Large areas of the plate appear to have been vigorously scored and textured with

some unorthodox tool or tools. This method, seemingly unique to Gillray, was first used by him a few days previously in *Affability* (no.150), but is more ambitiously deployed.

As the war advanced so were the activities and the proposals of radicals for reform more menacing to the government. Aggressive demands for changes in the electoral system were brushed aside by Pitt. Radical reformers are here identified with the opposition, Fox most prominent among them, as he sits judicially on the Speaker's throne looking at Pitt with complacency and malevolence, the whites of his eyes gleaming against the dark background. Pitt, bound and dishevelled with a noose around his neck, looks dismayed. Charles Stanhope stands beside him holding up a great roll of nonsensical charges adding to those made by Thomas Erskine, who sits with the red-bonneted Sheridan beneath the Speaker's chair. The assembled crowd who fill the background are a nightmarish

congregation of ignorance and malice, the faces of many scarcely human.

Gillray's disposition of the masses of light and dark is greatly enhanced by the dense texturing of the plate, which emphasises the whiteness of Pitt's shirt and the scroll held before him.

66

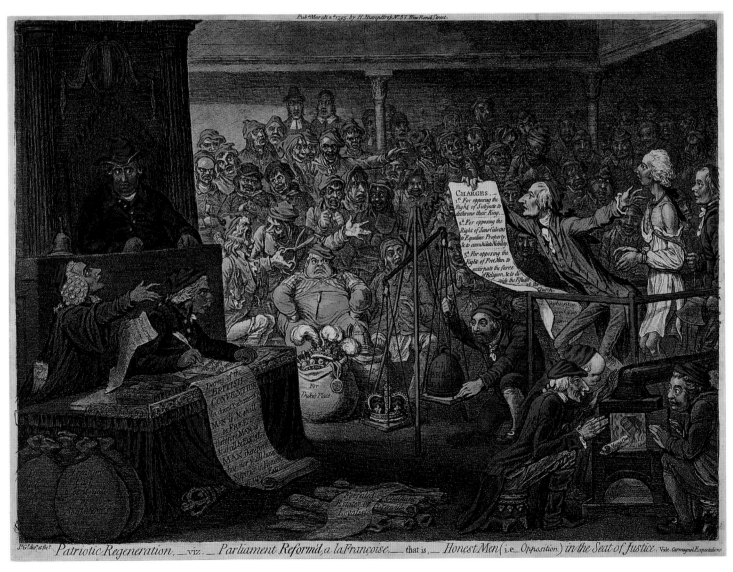

Patriotic Regeneration, – viz. – Parliament Reform'd, a la Françoise. – that is, – Honest Men (i.e. Opposition) in the Seat of Justice.

67 Exhibition of a Democratic-Transparency, – with its Effect upon Patriotic Feelings

Hand-coloured etching with aquatint 36.6 × 45.1
Published 15 April 1799 by H. Humphrey
The British Museum, London
BMC 9369

Transparencies, large designs lit from behind, were a form of street entertainment familiar to Gillray's clients. Rapidly created, ephemeral, they could provide crude but instant celebrations of military or, more likely, naval victories such as the Battle of the Nile (1 August 1798) – thus, the 'Effect upon Patriotic Feelings'. Gillray has made the print as dark as possible to emphasise their illusionism.

On 15 March 1799 Henry Dundas had made an urgent report for the Secret Committee on individuals and societies in England – and more significantly Ireland who, encouraged by the French, planned treasonable activities. The horrors of their possible success are illustrated on the transparencies: the plunder of the Bank, the violation of parliament, the seizure of the Crown, and the establishment of a French Government. Pitt and Dundas, most prominent members of the Secret Committee, are partially concealed by the massive framed transparency, while in the foreground the Opposition, Fox prominent among them, are – as usual in Gillray's propagandist prints – fleeing with alacrity and in terror.

68 Icarus

Engraving, etching with some aquatint
26.8 × 22, with added watercolour (trimmed within platemark)
Andrew Edmunds, London
Not in BMC

This unrecorded print, of which this is probably a unique impression, was clearly intended for the proposed de luxe edition of the *Anti-Jacobin Magazine and Review* which so preoccupied Gillray in 1800. This publication, promoted by the publisher John Wright, was to consist of thirty to forty numbers with highly finished satirical designs by Gillray. Canning and his cronies, including the Rev John Sneyd and John Hookham Frere, were heavily involved, and their interference ultimately led Gillray to abandon the project in disgust. Nonetheless, the few surviving designs are of great interest. He employed a tightly meshed technique of engraved cross-hatching, etching and aquatint, and the colouring has a more miniaturist effect than usual.

The title given here is speculative. The republican sympathiser Sir Francis Burdett, scattering scraps of tri-coloured paper, flutters up towards a diminutive Beelzebub figure who is led in a chariot by asses across a zodiacal path. At the right the ghost of Burke looks on. The identity of the figure crowned with grapes, at the base of a cannon feebly spluttering some ineffectual shots, is unknown.

The figure of Burdett, poised balletically, is clearly a parody of Giovanni Bologna's famous bronze figure of Mercury (*c*.1564, Bargello, Florence). On the evidence of Johann Zoffany's painting *The Life School of the Royal Academy* (1771, Royal Collection), engraved by Richard Earlom in 1773, which prominently shows a large cast of this on a mantelpiece, Gillray would have known it from his period as a student at the Royal Academy.

69 Ode to Lord Moira

Engraving and etching, with some aquatint
25.3 × 19.5 with added watercolour
The British Museum, London
Not in BMC

This is again from the abandoned *Anti-Jacobin* project, and shares the same technique, colouring, and pen inscriptions as *Icarus* (no.68). Lord Moira, seated on a chair adorned with tricolours, had been widely ridiculed for proposing a third party administration that would exclude both Pitt and Fox.

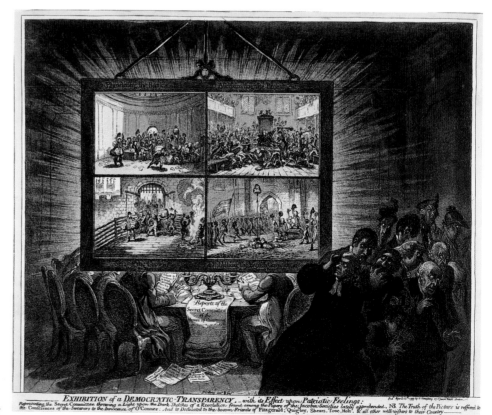

67

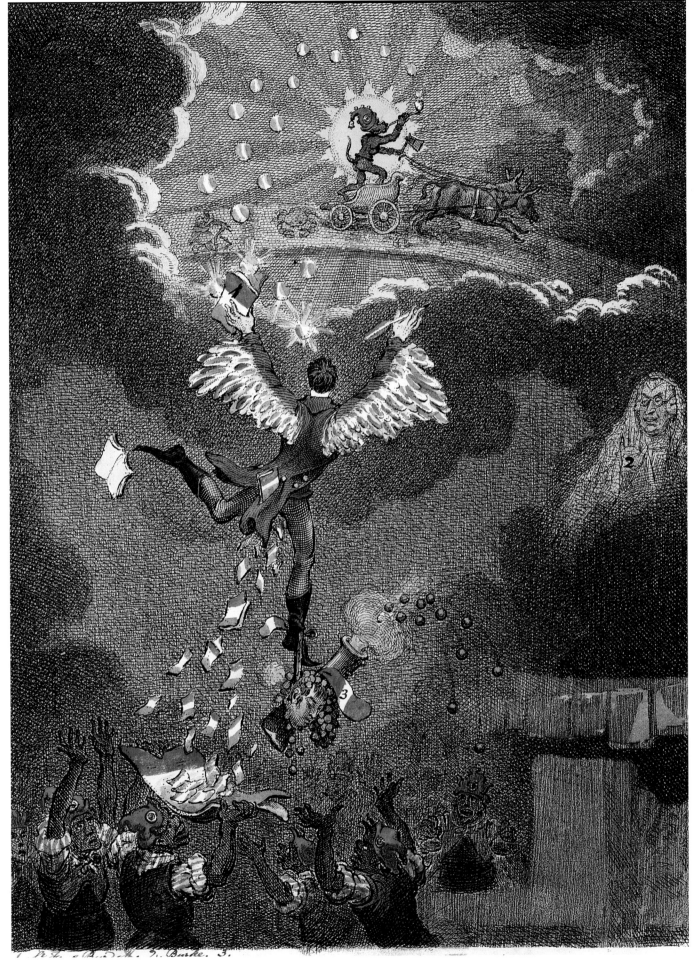

68

70 The Arm of Providence

Engraving, etching and aquatint 28.6 × 22, (trimmed within platemark) with added watercolour
The plate survived, and was published for the first time 2 May 1831, by John Fairburn with the title *The Powerful Arm of Providence*
Andrew Edmunds, London
Not in BMC

This is probably a unique early impression of a print intended for the *Anti-Jacobin*, and like the preceding two examples is likely to have been coloured by Gillray. The design is visionary, ecstatic, but enigmatic, with certain echoes of Fuseli (see no.106).
 A study for the 'cosmic' hand is in New York Public Library.

71 'Two Pair of Portraits'

Etching with engraving 19.5 × 16.3, with publisher's watercolour
Published 1 December 1798 by J.Wright, inscribed 'For ye Anti – Jacobin Review'
Andrew Edmunds, London
Provenance: Count von Starhemberg
BMC 9270

John Horne Tooke, looking cunning, but scarcely caricatured, sits at an easel which holds portraits of Fox and Pitt, their attributes suggesting vice and honesty respectively. Tooke was one of Pitt's most implacable foes, and the purpose of this Tory propagandist print is to mock Tooke's supposed hypocrisy.
 This is an impression aside from the *Anti-Jacobin Review* and was probably sold separately by Hannah Humphrey.

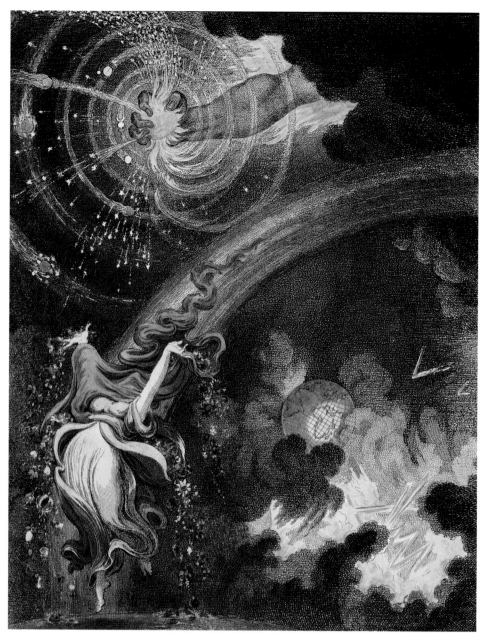

70

71

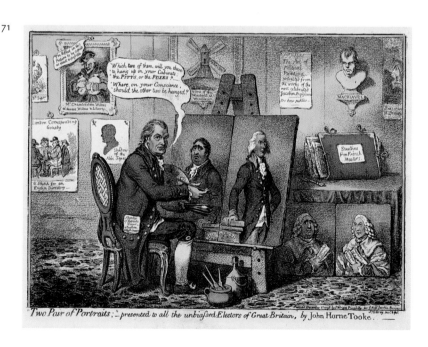

Two Pair of Portraits; – presented to all the unbiassed Electors of Great Britain, by John Horne Tooke.

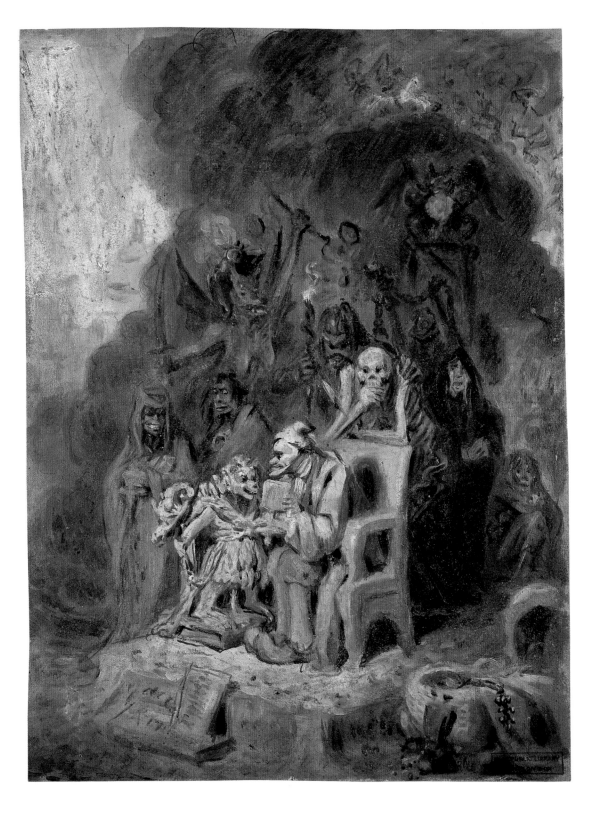

72 Voltaire Instructing the Infant Jacobinism c.1800

Oil on paper 27.3 × 20.3
Print Collection, Miriam and Ira D. Wallach Division of Art, Prints and Photographs, The New York Public Library, Astor, Lenox and Tilden Foundations

This is the most remarkable of the projected works for the *Anti-Jacobin*, but no print apparently survives. However, a drawing on oiled paper (a method used by Gillray for help in transferring a design to a plate) is in New York Public Library, showing that it was near to the etching stage. There are two other oil sketches by Gillray in New York Public Library, both associated with the *Anti-Jacobin* project, but this is the most elaborate, and shows genuine feeling for a medium with which he was unfamiliar.

A collection of devilish figures assemble behind a toothless Voltaire, his wooden sabots upturned, as he gives intimate instruction to the small, eager, sub-human infant Jacobinism.

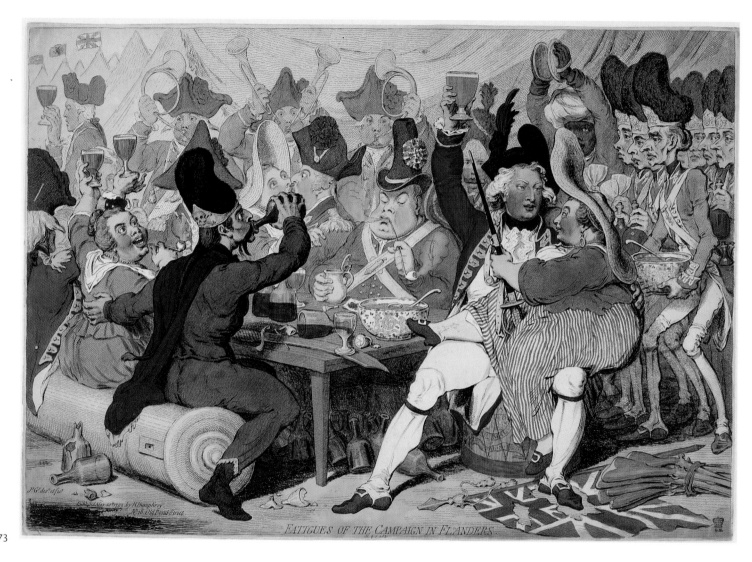

73

73 Fatigues of the Campaign in Flanders

Hand-coloured etching 35.1 × 50.3
Published 20 May 1793 by H. Humphrey
The British Museum, London
BMC 8327

Fired with revolutionary zeal, bloodthirsty and belligerent, France at the beginning of 1793 was at war with Austria and Prussia, and had added England and Holland to her enemies. Having taken possession of the Austrian Netherlands, French armies were poised to invade Holland, whose Stadtholder implored help from the British. A small and ill-equipped British army was dispatched, commanded, at the King's insistence, by the Duke of York. He was by no means an incompetent soldier, but his command was hampered by the government's resentment of his position, and the overall supervision

of the campaign by the cautious Dundas in London.

Rumours quickly reached London that, far from enduring the hardships of the field, the Duke and his entourage were living rather well, dining, wining, while caparisoned Hanoverian mules carried 'cold meats, the service of plate, rich wines and other necessary articles of refreshment'.

In this large print Gillray shows a feast worthy of Rubens or Jordaens. The Duke, his face delicately drawn, not caricatured, raises a bumper of wine as he supports a plump Flemish woman on his knee. She handles his upright sheathed sword suggestively. Her seemingly endless straw hat wiggles upwards, and her fat bottom contrasts with the bony legs of the ranks of gaunt British infantry, their uniforms fitted with corkscrews, who bring in more wine and punch. Next to the Duke is the somnolent

and worthless Stadtholder, the Prince of Orange, and opposite him, seated on a gun barrel and guzzling wine from a bottle, is an Austrian officer.

It is easy to assume that this print was a result of Gillray's excursion to Flanders. In fact it preceded the visit, and perhaps de Loutherbourg's knowledge of it helped persuade him to take Gillray to Flanders.

The present impression is coloured with particular brilliance.

74 William Bromley, after
Philippe-Jacques de Loutherbourg
(1740–1812)

The Battle of Valenciennes

Line engraving 58.4 × 80
Published 1 December 1801 for V. & R. Green, by
R. Cribb and by C. Geisweilers
The British Museum, London

In the first major engagement of the war in
1793, Valenciennes was besieged by the
allies under the command of the Duke of
York, and the French garrison surrendered
on 28 July. This caused great alarm in Paris
since it was believed that the way was clear
for the allies to march on the city. However,
it was a short-lived triumph and by the
beginning of September the French had
gained the advantage and the allies were in
retreat. The initial successes created jubilation
in England and the mezzotint engraver and
publisher Valentine Green and his son Rupert
immediately commissioned de Loutherbourg
to paint a large picture of the scene of
victory, that could subsequently be engraved
to the profit of all concerned. This was
already a familiar pattern in the English print
market. De Loutherbourg rapidly made plans
to visit the scene, and engaged Gillray to
accompany him and make portrait drawings,
and figure and costume studies. The artists
arrived at Valenciennes on 4 or 5 September,
when matters were deteriorating, busied
themselves as best they could, and returned
after about a month. Gillray briefly kept a
diary on this, his only trip abroad.

De Loutherbourg's vast painting, for
which he received '£500 and Mr.Gillray's
expenses' went on show in 1794 in the
Historic Gallery, Pall Mall, but the engraving,
priced expensively at three pounds, did not
appear until the end of 1801, by which time
it was rather dated. A companion piece,
*Lord Howe's Victory, or, The Battle of the
Glorious First of June 1794*, was finished by
de Loutherbourg, again with the help of
Gillray's drawings, in 1795, and an engraving
by Fittler was published in 1799. Joseph
Farington recorded in his diary (24 September
1797) that the engravers were each paid
the enormous sum of £1200 – giving some
idea of the inducements which had led
Gillray to try to establish himself as a serious
reproductive engraver.

De Loutherbourg's choice of Gillray is
interesting and significant, and not without
a sense of fun, since he must, surely, have
been familiar with *Fatigues of the Campaign
in Flanders* (no.73). He evidently wanted
a draughtsman who could work swiftly,
accurately and with character, and whose
drawings would serve as a visual reference
library. The fact that he was a well-known
caricaturist was not a disadvantage – indeed
de Loutherbourg was himself gifted in the
art, and had in 1775 produced a series of
Caricatures of the English, and in 1776,
An Exhibition (no.49). In effect Gillray was
asked to anticipate the functions of the war
artists of the twentieth century, recording not
merely scenes of action, but details of camp
life, clothing and military accoutrements.
These drawings, mainly in pen and water-
colour, constitute the single largest coherent
group to survive. They are little known,
primarily because they have been mounted
in an album in the British Museum (201.C.5)
described as the work of de Loutherbourg,
which has had the result of preserving them
in marvellous, fresh condition.

74

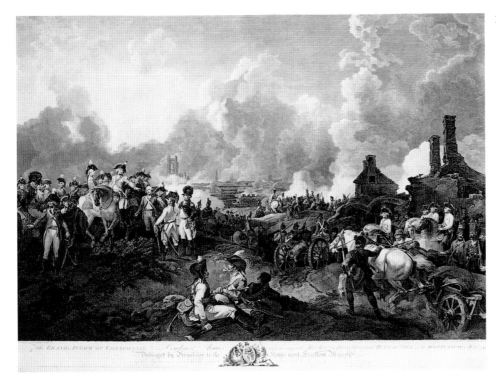

75 Sketches of Military Subjects at Valenciennes 1793

The British Museum, London

A Duke of York's Full Uniform

Pen and ink and watercolour 14.5 × 8.8
Page 9, no.28

It appears from the careful notes by Gillray that he did not have direct access to the Duke's uniform. 'The Uniform of Genl. Lake being taken from the Coat itself is more perfect than this, which . . . only from the Taylor's description . . . the Uniform exactly the same as that of Genl. Lake's except the number of buttons on the sleeve & pocket.'

B Sword of Colonel Congrieve and Moncrief

Pen and ink and watercolour 18 × 13.4
Page 9, no.30

This sheet also shows a careful study of the hat of the Duke of York as a General Officer. Gillray notes, 'The rose at the hind quarters of the Hat has a small tuft of red in the centre.'

C The Mules of the Duke of York

Pen and ink and watercolour, 7.6 × 10.5
Page 15, no.49

D Officer of Artillery

Pen and ink and watercolour
Page 15, no.51

A drawing of the appropriate saddle, inscribed 'White Goatskin . . . 2 White Belts under the Surcingle'. Gillray's attention to detail is no more evident than in these drawings, which are positively Brueghelesque.

75A

76B

76 Naval Subjects for Lord Howe's Victory 1794

The British Museum, London

Gillray took great pleasure in drawing the sea, ships and sailors, and his visit to Spithead, at de Loutherbourg's request, to draw vessels from the Royal Navy, and the prizes they had taken in Lord Howe's victory, produced some of his liveliest drawings. He was as much at home sketching the patched breeches of a lively sailor as he was with the complexities of spars and rigging. The little study of a comical group, including a delighted old lady being wheeled ashore in a small boat, is notable, and could easily be tucked into the more recent sketchbooks of Edward Ardizzone or Ronald Searle.

A Head of a Sailor in a Black Hat

Pen and ink and watercolour 11.5 × 7.6
Page 21, no.63

B Head of a Sailor in a Cloth Cap

Pen and ink and watercolour 10.5 × 7.6
Page 21, no.64

C Sailor at a Tiller

Pen and ink and watercolour 11.5 × 7.6
Page 25, no.85

D Two Seamen

Pen and ink and watercolour 11.5 × 7.6

E Warrant Officer / Master's Mate / Midshipman

Pen and ink and watercolour 12.8 × 16.5

F Mizenmast

Pen and ink and watercolour 20.4 × 13.4

G The Cathead of HMS Queen Charlotte

Pen and ink and watercolour 13 × 20.5

H Front of Sail abast in the Cap

Pen and ink and watercolour

I Furled Rigging

Pen and ink and watercolour 12.8 × 19

J A Woman and Four Men coming ashore in a boat on Wheels

Pen and ink and watercolour 7.6 × 11.8

761

761

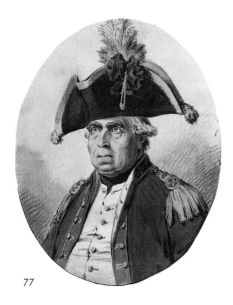

77

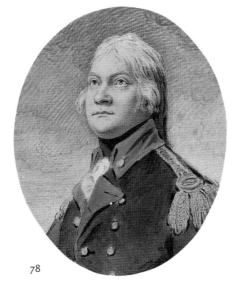

78

77 Field Marshall Freytag c.1793

Pen and ink and watercolour, oval 15.3 × 12.2
Inscribed in ink on verso, possibly by Gillray,
'Field Marshall Freytag By James Gillray', and in
pencil by another hand, 'Field Marshall Freytag'
Private Collection

This highly finished portrait was almost
certainly worked up from a study made in
Flanders in 1793. It was no doubt intended
as a straightforward portrait but the
exaggerated glaring eyes push it to the
verge of caricature.

78 Portrait of an Officer c.1793

Pen and ink and watercolour over pencil,
oval 12.2 × 9.9
Inscribed on verso, possibly by Gillray,
'James Gillray'
Private Collection

The identity of the sitter is unknown, but the
features are markedly Hanoverian. The face,
which is not caricatured, is defined by very
finely drawn brush strokes in a sophisticated
miniaturist's technique, and, like the previous
portrait, probably dates from the Flanders
period of 1793.

79 Studies of Military Subjects in Flanders 1793

Pencil with touches of red chalk 28.5 × 46
Private Collection

This sheet of rough studies, with extensive
notes written by the artist, is a compendium
of subjects from his Flemish trip, including an
outline sketch of Ostend at the lower right,
studies of barrage waggons, encampments
and a group of soldiers at dinner. It thus has
something of the character of a visual diary.
A macabre note is introduced by the 'very
odd formed coffins . . . for British soldiers' at
the centre of the sheet. This seems to have
led Gillray, by morbid association, to sketch at
the left a Grenadier with a face like a skull.

Wars with France and invasion fears

From the beginning of the wars, fear of a French invasion of England, or indeed Ireland, was constant almost until 1805. Some of Gillray's prints depicting the horrors of a successful French invasion are deliberately crude and visceral, the terror of French success being emphasised by their occupation and destruction of familiar landmarks. Fox and the Whigs are shown rejoicing in Revolutionary success, beckoning across the Channel, encouraging the French to land, financing sedition, and attempting to seduce the doltish John Bull, all the while being thwarted by an unexpected British victory, the uncovering of a plot, or the wiles of Pitt.

80 **The French Invasion; – or – John Bull, bombarding the Bum-Boats**

Hand-coloured etching 35 × 25
Published 5 November 1793 by H. Humphrey
The British Museum, London
BMC 8346

Britain goes to war in the shape of George III, transformed into a crude map, his feet Kent and Cornwall, his tasselled nightcap Northumberland. He craps vigorously on the coast of France, dispersing a number of tiny gunboats. This is the first of many prints concerned with the threat of French invasion. The image is gross, but the King's evacuations are heroic, patriotic and contemptuous, expressing the feelings of the brutish but uncensored John Bull, whom he here embodies.

Gillray is here working under the facetious and enigmatic pseudonym of 'John Schoebert', but the publication line of Hannah Humphrey would by this date have made his identity obvious.

The 'British Declaration' emitting from John Bull's backside refers to a royal promise that the port of Toulon, then occupied by the British, would be ceded to France on the restitution of its monarchy.

A map given a figurative and national identity was not a new graphic formula, and it is possible that Gillray knew the large engraved maps published by Claesz Jansz Visscher in Holland at the beginning of the seventeenth century, where the coastline of Holland takes on a patriotic profile.

81 Richard Newton (1777–98)
Treason

Etching 31 × 24
Published 19 March 1798 by 'N at his Original Print warehouse'
Library of Congress
BMC 9188

In his brief life of twenty-one years Newton produced an extraordinary output of caricatures, grotesque, sometimes crude, but always inventive, and in the present case scatological and extremely daring. John Bull, presented as a cheerful species of sans-culotte, farts in the face of an astonished King, while Pitt furiously expostulates. Like most of his prints it is etched with extreme rapidity, with none of Gillray's refinements of printmaking. For Newton the etcher's needle was a blunt implement to be wielded with as much speed and violence as possible.

The Prince Regent seems to have had a partiality for Newton, whose prints are well represented in the Library of Congress, Washington.

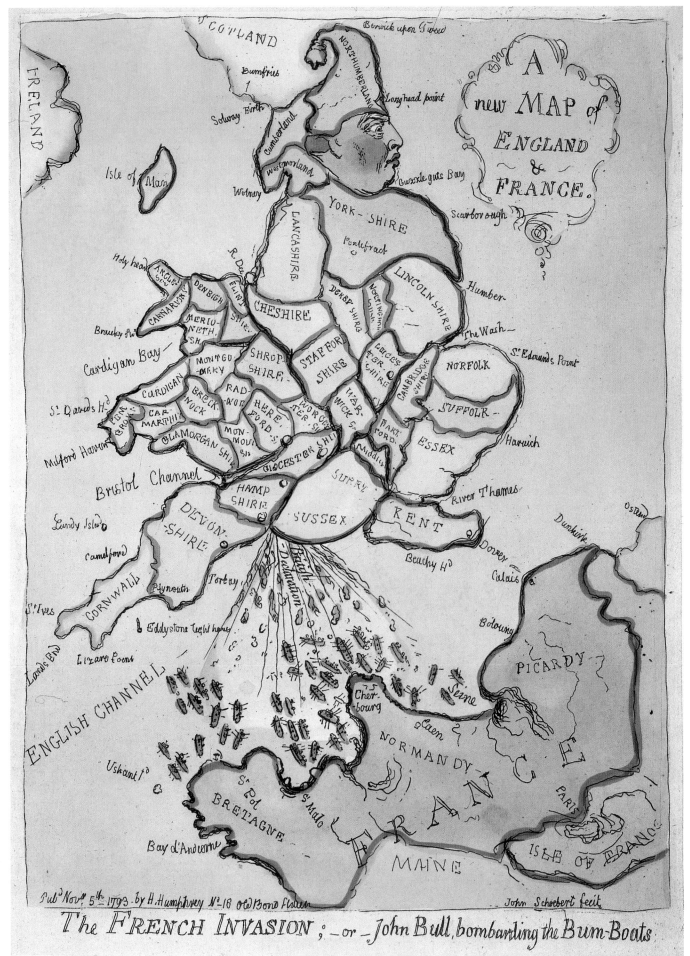

The FRENCH INVASION; — or — John Bull, bombarding the Bum-Boats

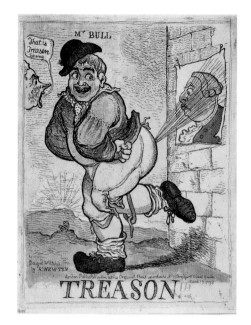

81

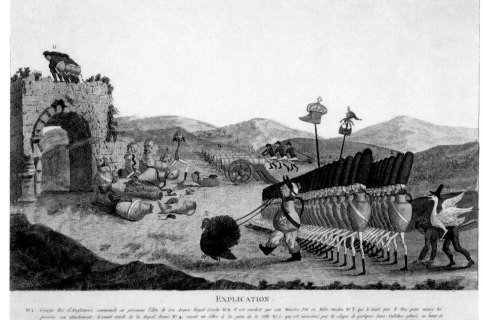

82A

82B

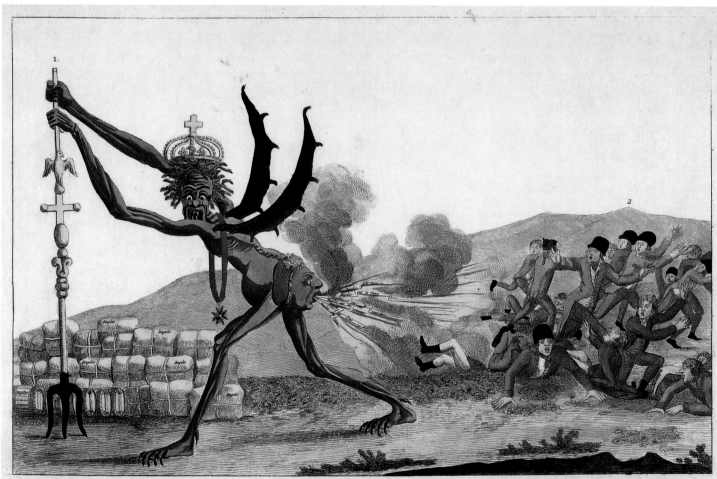

82A After Jacques-Louis David
(1748–1825)
L' Armée des cruches (Army of jugs)

Hand-coloured etching 39.5 × 54.2
The British Museum, London
BMC 8462

82B After Jacques-Louis David
(1748–1825)
Le Gouvernement anglais sous la forme d'une figure horrible et chimérique (The English government in the form of a wild and horrible figure)

Hand coloured etching 33.4 × 44.5
The British Museum, London
BMC 8463

It is remarkable to find David as the designer of these stiff but effective images. He is not best remembered for his sense of fun, and there would be no reason to associate him with their production were it not for a minute of the Committee of Public Safety of 27 March 1794, which recorded that David presented 'two caricatures of his composition, one showing an army of jugs, commanded by George [III], led by a turkey, the other represents the English Government in the form of a wild and horrible figure, dressed in all his royal insignia'. The engraver is unknown but he was presumably following drawings by David, or at the least, ideas transmitted by another hand. French satirical prints of this period are inevitably overshadowed by the more vigorous English tradition, and are usually rather old-fashioned and emblematic in nature. Nonetheless there were a great many of them, and they were known in England, a significant number being collected by the Prince of Wales.

The excretory imagery common to both, and the winged hag figure who spurts bayonets from an anus in the shape of the King's mouth, suggests a knowledge of Gillray prints, particularly *The French Invasion* (no.80).

83 Promis'd Horrors of the French Invasion, – or – Forcible Reasons for negotiating a Regicide Peace. Vide, The Authority of Edmund Burke.

Hand-coloured etching with aquatint
30.5 × 41.5
Published 20 October 1796 by H. Humphrey
The British Museum, London
BMC 8826

St James's Street runs with blood as goose-stepping French troops march into London, detachments swarming into White's Club, a Tory stronghold, and hurling the Duke of York from the balcony, his dice box falling before him. The Prince of Wales is already falling, and the Duke of Clarence is about to be stabbed. The French are aided and abetted by their Whig 'allies', the most prominent being Fox who scourges Pitt, who is tied to a Tree of Liberty planted in the middle of the street. Sheridan, laden with money, skulks into Brooks's – the Whig club – on the balcony of which a guillotine is busy, its blade dripping with blood. Grenville, ignominiously suspended by his trousers, has been beheaded. Outside the entrance to Brooks's, Burke has been tossed in the air by an angry ox – intended for the cattle-raising Duke of Bedford, an implacable foe of Burke's. Atrocities are everywhere in evidence, the vista closed by the blazing St James's Palace.

This print followed closely on the King's speech of 6 October when he had referred to the threat of invasion – a real prospect in fact, but dismissed as fantasy by the opposition. Gillray's propaganda for the Tories is blatant, and his Tory 'tempter' George Canning makes his first appearance, dangling from a lamp-post at the left, back to back with Baron Hawkesbury.

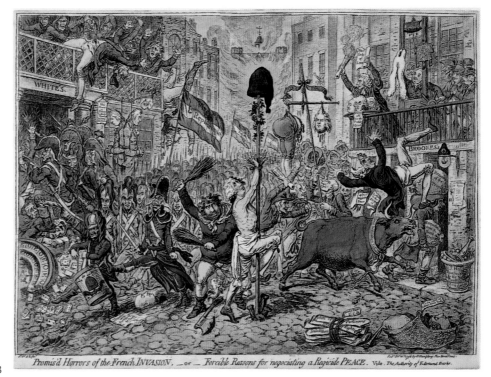

83

Promis'd Horrors of the French INVASION, – or – Forcible Reasons for negociating a Regicide PEACE. Vide. The Authority of Edmund Burke.

84 End of the Irish Invasion; – or – The Destruction of the French Armada

Hand-coloured etching and aquatint 27.3 × 38.4
Published 20 January 1797 by H. Humphrey
Library of Congress
BMC 8979

Fox, portrayed here as the dismayed figurehead of the French warship Le Révolutionnaire, had repeatedly scorned fears of a French descent upon Ireland. However, on 23 December, in an expedition organised by the fanatical and Anglophobe General Lazare Hoche (1768–97), a French squadron with numerous military transports anchored in Bantry Bay in Southern Ireland, but was dispersed by foul weather. The opposition, identified with the Revolution, are destroyed by violent storms, fortified by the gales of wind emitting from Pitt, Dundas, Grenville and Windham.

Gillray's particular delight in representing ships, preferably in stormy seas, is evident, and he was probably making use of the studies he had made at Spithead when collaborating with de Loutherbourg in 1794 on the latter's painting of the *Glorious First of June*.

85 The Apotheosis of Hoche

Hand-coloured etching 50.9 × 39.2
Published 11 January (?) 1798 by H. Humphrey
The British Museum, London
BMC 9156

This is not Gillray's most imaginative composition, but it is certainly the most densely crowded and obviously propagandist of his prints. General Hoche is now largely forgotten, but he loomed large in the pantheon of early revolutionary zealots, reserving his particular bile and hatred for England. In addition to the failed invasion of Ireland in 1796, he intended armed incursions into Wales and Scotland, but died in 1797 from consumption – although rumours of poisoning have never been discounted.

The idea of the print was suggested by John Hookham Frere, a friend of Sneyd and Canning, and one of the prime movers of the *Anti-Jacobin Review*. The print was accompanied by a leaflet (Gillray Collection, House of Lords Library) which parodied the absurd obsequies of Hoche's elaborate funeral in the Champs de Mars in Paris, where a chorus, classically clad, sung his praises to

hymns and music by Chenier and Cherubini. 'The Soul of the Hero arose from the Dust, and reclining upon the Tri-Coloured Bow of Heaven, tuned his soft Lyre whilst myriads of Celestials advanced to meet him and . . . chaunted in Chorus. He rises! The Hero of the new Republic rises.' A host of sans-culottes accompany him; at the right Gillray's hag figure deserts Phillip Thicknesse (no.43) to shower the earth with venom.

The brief description of the print in Thomas McLean's *Illustrative Description of the Genuine Works of Mr. James Gillray* (1830) is typically apt. 'This celebrated French general was deputed by "the great nation" to head the expedition "appointed for the conquest of Ireland". The fates, however, decreed that he should "bite the dust" to use the revolutionary phrase, in another field. This, his Apotheosis, is a true touch of the mock-heroic, or Michal Angelo travestied.'

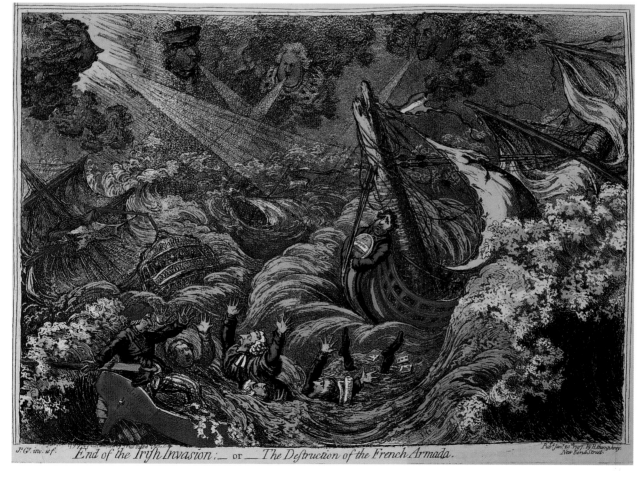

84

J^r G^y inv. & f. End of the Irish Invasion ;_ or _ The Destruction of the French Armada. *Pub. Jan. 20 1797 by H. Humphrey, New Bond Street.*

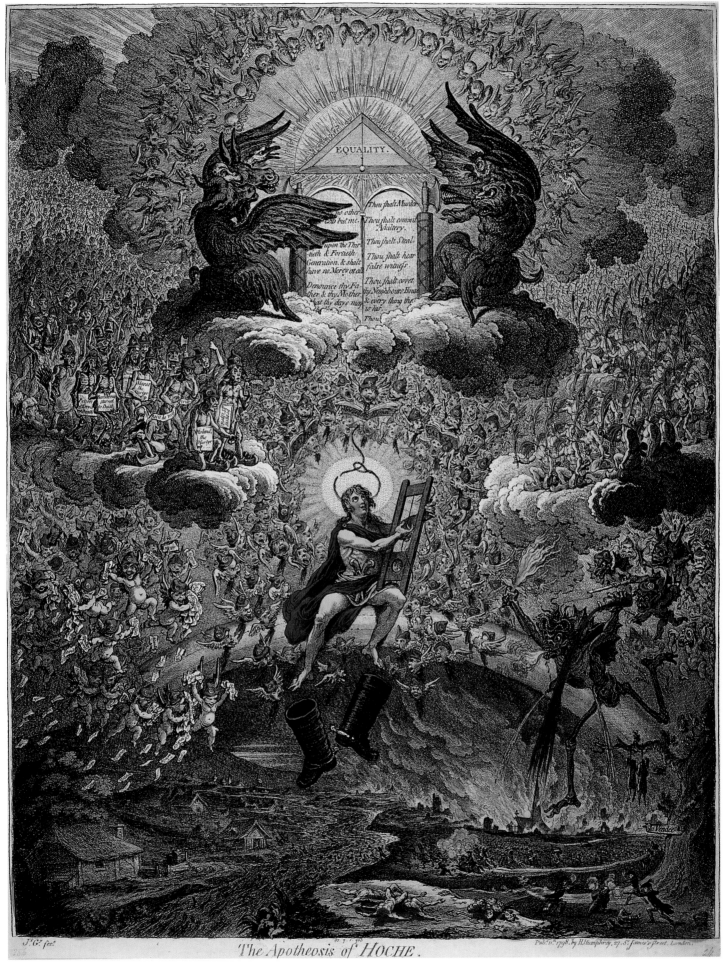

The Apotheosis of HOCHE.

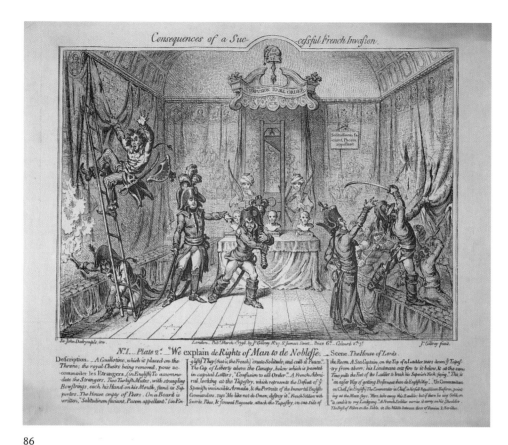

Consequences of a Suc——cessful French Invasion.

CONFUSION TO ALL ORDER

N°.1_Plate 2°_ "We explain de Rights of Man to de Nobleſſe._ Scene The Houſe of Lords.

Deſcription._A Guillotine, which is placed on the Throne; the royal Chairs being removed, pour accommodate les Estrangers. (in Engliſh) To accommodate the Strangers. Two Turkiſh Mutes, with strangling Bowſtrings, each, his Hand on his Mouth, stand as Supporters. The Houſe empty of Peers. On a Board is written, "Solitudinem faciunt, Pacem appellant." (in En-

glſh) They (that is, the French) create Solitude, and call it Peace." The Cap of Liberty above the Canopy, below which is painted in capital Letters, "Confuſion to all Order". A French Admiral, looking at the Tapeſtry, which repreſents the Defeat of ŷ Spaniſh invincible Armada, & the Portraits of the Immortal Engliſh Commanders, says Me like not de Omen, deſtroy it. French Soldiers with Swords, Pikes, & ſcrewd Bayonets, attack the Tapeſtry, on one Side of

the Room. A Sea Captain, on the Top of a Ladder, tears down ŷ Tapeſtry from above, his Lieutenant cuts fire to it below, & at the same Time pulls the Foot of the Ladder to break his Superior's Neck; ſaying, "This is an easier Way of getting Preferment than de Engliſh Way". Un Commandant en Chef, (in Engliſh) The Commander in Chief in ſtylish Republican Uniform, pointing at the Mace, says. Here, take away this Bauble: but if there be any Gold, on, "a, send it to my Lodgings "A French Soldier carries it away on his Shoulder. The Poſt of Ribós on the Table, in the Midſt between those of Roman & Ruſſian.

Sir John Dalrymple, inv.

London, Pub° March 1°1798. by J° Gillray N°.27 S° James's Street. _ Price 6° _ Colour'd 1°6.°

J° Gillray feci.

86

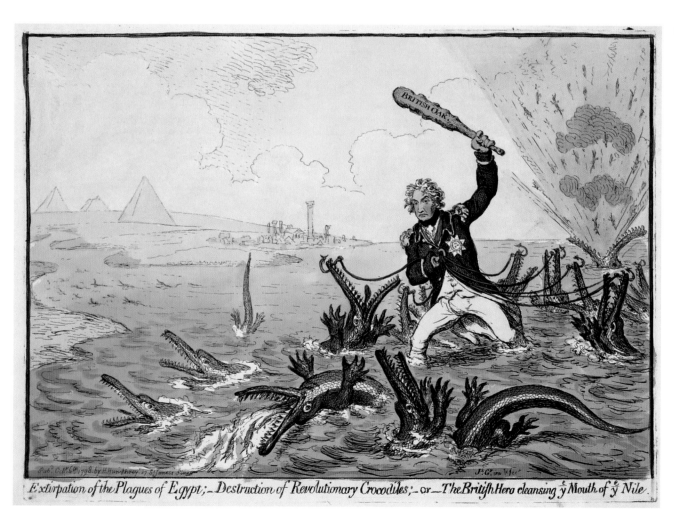

BRITISH OAK

Pub° Oct°. 6°. 1798. by H. Humphrey N°.27 S° James's Street

J°. G°. inv & fec.

Extirpation of the Plagues of Egypt;_Destruction of Revolutionary Crocodiles;_or_The British Hero cleansing ŷ Mouth of ŷ Nile.

87

86 **Consequences of a Successful French Invasion: No. 1 – Plate 2d**

Etching, printed in red 34.9 × 40.3
Published 1 March 1798 by J. Gillray
Library of Congress
BMC 9181

This is the second plate of a series of four illustrating the *Consequences of a Successful French Invasion*, commissioned by a patriotic Scot, Sir John Dalrymple, and intended as popular propaganda against the French. Gillray ultimately became disenchanted with the project, resenting interference with his ideas.

This impression is of particular interest since it is inscribed in ink on the back, in a fine bold calligraphic hand: 'For His Majesty. To the care of G. Troup (?) Esq from G. Humphrey'. This was presumably Hannah Humphrey's nephew, although it is not impossible that the handwriting is Gillray's. Its presence in what was the Royal Collection of caricatures, now in Washington, clearly demonstrates that this must have been an impression mischievously presented to George III – and carefully preserved.

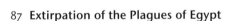

JOHN BULL taking a Luncheon: — or — British Cooks, cramming Old Grumble-Gizzard, with Bonne-Chère.

87 Extirpation of the Plagues of Egypt

Etching and engraving 26.2 × 36.5, with
publisher's watercolour
Published 6 October 1798 by H. Humphrey
Andrew Edmunds, London
Provenance: Duke of Northumberland
BMC 9250

On 1 August 1798 the British Fleet,
commanded by Horatio Nelson, destroyed
the French in Aboukir Bay in one of the most
devastating of all naval victories. The Battle
of the Nile instantly turned Nelson into a
national hero of almost unprecedented status.

His dispatch reached London on 2 October
and was published the same night. Gillray, as
usual, was quick off the mark, and his design
shows close knowledge of the facts of the
battle. The French warships are transformed
into crocodiles, the nine tethered by Nelson
representing those captured by the British,
while in the background another crocodile
stands in for the French flagship, l'Orient,
which blew up. This transformation and the
subjection of the beasts by the diminutive,
maimed but heroic figure of Nelson gives the
design a Herculean, semi-mythological status.

88 John Bull taking a Luncheon; – or – British Cooks, cramming Old Grumble-Gizzard, with Bonne-Chère

Hand-coloured etching 26 × 36
Published 24 October 1798 by
H. Humphrey
The British Museum, London
BMC 9257

Manifestations of John Bull in Gillray's work
are numerous, the most familiar being the
put-upon peasant. Here he is a coarse but
prosperous figure, 'Old Grumble-Gizzard',
complaining gracelessly as he is force-fed
on a surfeit of naval victories, served up
by British Admirals, Nelson prominent at
the right.

89 Siege de la Colonné de Pompée. Science in the Pillory. Etched by Js. Gillray from the Original Intercepted Drawing

Etching and engraving 46.8 × 33.6, with publisher's watercolour
Published 6 March 1799 by H. Humphrey
Andrew Edmunds, London
Provenance: Count von Starhemberg
BMC 9352

Napoleon had made the enlightened decision, before his invasion of Egypt in July 1798, to augment his armies with a large contingent of savants, including surveyors, artists, antiquarians and other learned figures. They included archaeologists who numbered amongst their discoveries the Rosetta Stone (later taken by the British).

Gillray's print follows the publication in London of disillusioned letters from French officers that had been intercepted by the Royal Navy. Gillray extends the disclosure to imagine the savants in desperate straits atop the Colonné de Pompée (in fact it celebrated Diocletian), besieged by the natives. Their precarious abode on the top of the column is not entirely fanciful; in 1781 eight drunken officers of the Royal Navy had held a party there.

89

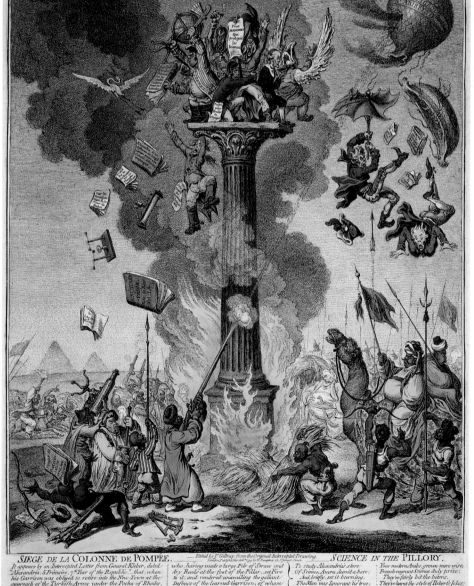

SIEGE DE LA COLONNE DE POMPÉE. ——— *Etched by Js Gillray, from the Original Intercepted Drawing.* SCIENCE IN THE PILLORY.

90 The first Kiss this Ten Years! – or – the meeting of Britannia & Citizen François

Hand-coloured etching with aquatint 35.5 × 25.5
Published 1 January 1803 by H. Humphrey
Library of Congress
BMC 9960

The Peace of Amiens, 1802–3, provided a brief lull of calm in the interminable war. Gillray's cynical view (according to tradition much enjoyed by Napoleon) is another classic juxtaposition of national types, the fat, prosperous and dim-witted Britannia being embraced by a tall, ragged, cunning and treacherous Frenchman. The words are amongst Gillray's best; simple and quickly memorised like a vulgar species of verse. A sub-plot is provided by the little oval portraits of Napoleon and George III, viewing each other with suspicion.

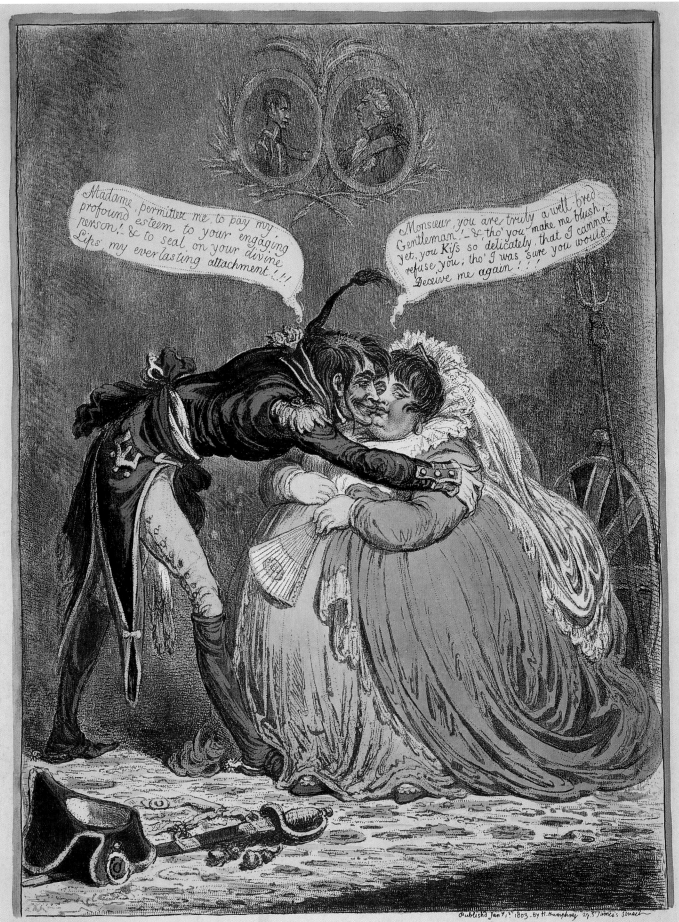

91 German Nonchalance; – or – the Vexation of little Boney

Etching, engraving and aquatint 25.5 × 35.6,
with publisher's watercolour
Published 1 January 1803 by James Gillray
Andrew Edmunds, London
BMC 9961
Provenance: Count von Starhemberg

Count Starhemberg was the Austrian Envoy
Extraordinary and Minister Plenipotentiary to
England, who, late in 1802, was ordered by
Napoleon, at short notice, to leave Paris.

Starhemberg was an avid collector of
caricatures from the moment of his arrival
in London, and thus a major client of Gillray
and Hannah Humphrey. This print, the
subject of which is entirely fanciful, is highly
favourable to Starhemberg, who leaves Little
Boney raging as he trots by in a post-chaise,
nonchalantly taking a pinch of snuff. No
doubt as particular homage to a valued
client, it was doubly marked by being

published on the same day – the first of the
year – as such a major print as *The first kiss
this Ten Years* (no.90), and with Gillray's name
as publisher as well as artist.

This is the first appearance of Gillray's
classic invention of 'Little Boney', described
by Draper Hill as Gillray's 'most enduring
contribution to the history of satire'
(*Fashionable Contrasts*, London 1966, p.151).
Small, but horribly energetic, vain, paranoid,
easily distressed, a guttersnipe aping his
betters, ridiculous, but fearsome nonetheless,
Gillray's conception was immediately imitated
by other English caricaturists. Gillray would,
of course, have had access to idealised French
engravings of Napoleon, but it is slightly
surprising that during the peace Hannah
Humphrey did not dispatch the artist to Paris
to see the original. Gillray perhaps felt that
actual observation might interfere with his
imagination.

91

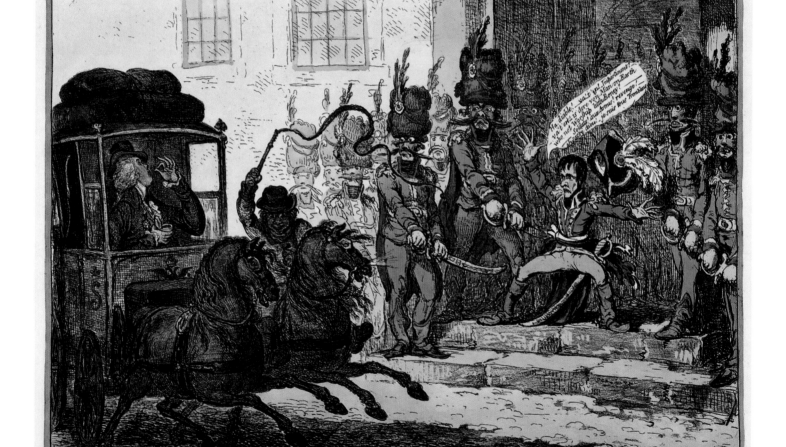

German-Nonchalence; —— or —, the Vexation of little Boney. Vide The Diplomatique's 1st. Journey through Paris.

Napoleon

Napoleon and other French figures were amongst the few of Gillray's subjects whom he had never seen in the flesh. Instead he had to hand only eye-witness accounts, engraved portraits, medals and other secondary sources. His imagination, however, was more than sufficient to conjure up one of the most famous of all caricature creations. The illustrious figure of Napoleon, covered with medals, embodiments of *la gloire*, is transformed into a screaming, raving little guttersnipe, half smothered by his pompous accoutrements, perpetually ranting at Britannia, scheming and threatening, but perpetually discomfited. It was a model quickly taken up by nearly all British caricaturists and immortalised as 'Little Boney'.

92 After Antoine Denis Chaudet

Napoleon 1807–9

Marble bust 58.3 high
The Victoria & Albert Museum, London

Following the form of Imperial Roman models, this official bust was favoured by Napoleon himself. The original plaster model was made in 1799 and it is thought that approximately 1,200 marble versions were produced in the Carrera workshops between 1807 and 1809 on the orders of Napoleon's sister, Elisa Baciocchi. Most were distributed to public buildings in France and it is likely that this bust is such an example. Monumental in scale, this formal bust provides an obvious contrast to Gillray's comic depiction of the French Emperor as the diminutive 'Little Boney'.
RM

93 **The Apples and the Horse-Turds – or – Buonaparte Among the Golden Pippins**

Hand-coloured etching 26 × 36
Published 24 February 1800 by
H. Humphrey
The British Museum, London
BMC 9522

Napoleon, wearing the large plumed hat which Gillray gives him in his earlier caricatures of the First Consul, floats downstream behind the crowned heads whom he aspires to emulate. A great steaming mass of horse turds at the left is composed of members of the opposition, vices, and other attributes of republicanism.

At the end of 1799 Bonaparte had written to George III proposing peace – an insincere offer which was rejected. The question of Bonaparte's status was one obstacle, and the one here satirised.

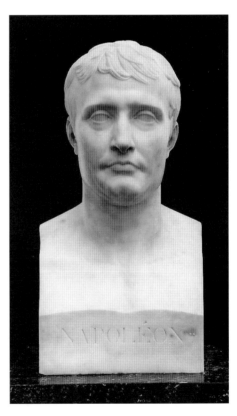

92

94 Maniac-Raving's – or – Little Boney in a strong Fit

Hand-coloured etching 26 × 35.3
Published 24 May 1803 by James Gillray
Library of Congress
BMC 9998

War between France and Britain resumed on 18 May 1803 after the brief peace of Amiens. Little Boney is convulsed with fury, a torrent of words issues from his head, blaming the English, threatening them with an invasion of 480,000 Frenchmen, promising them 'everlasting chains', cursing the English press, and fulminating against 'British Trade and Commerce'. His writing table has toppled and numerous papers are scattered on the floor, detailing his plans and grievances. To the title of the print is the addendum 'Vide Lord W–, account of a Visit to ye Thuilleries', a knowing reference to the intemperate behaviour by Bonaparte when meeting the British Ambassador, Lord Whitworth, on 13 March. War had threatened for some time, and was made inevitable by the British refusal to evacuate Malta (ceded to the French under the terms of the Peace), and by British fears of a French invasion of Egypt.

This is a particularly ebullient example of Gillray's fusion of words with image – there is as much to read as there is to see.

95 The Hand-Writing upon the Wall

Hand-coloured etching 25 × 35.5
Published 24 August 1803 by James Gillray
Library of Congress
BMC 10072

Fears of French invasion are the subject of many caricatures of this period. In June 1803, with large armies massed at Boulogne, Napoleon had boasted that he only needed three days of fog before he controlled London, parliament and the Bank of England.

Chapter 5 of the Book of Daniel provided the text for this print. Belshazzar, feasting in great splendour, was confronted by a hand holding a mysterious message: 'Mene, Mene, Tekel, Upharsin.' This was interpreted for him by Daniel as 'God hath numbered the days of thy kingdom; Thou art weighed in the balances, and art found wanting; Thy kingdom is divided, and given to the Medes and Persians.' Whilst his companions carouse, feasting on such English delicacies as an iced Bank of England, Napoleon starts with alarm, and the three soldiers behind him cast their eyes with dread towards the apparition. Josephine, grossly fat, slurps wine, and behind her are three provocative women, breasts bared, and their salaciousness denoted by face patches. These are almost certainly Napoleon's three sisters, Elisa, Pauline and Caroline. A pair of scales are held above Napoleon, the Crown outweighing Despotism.

Gillray's pictorial source is unexpected, but is unmistakably Rembrandt's painting of *Belshazzar's Feast* (c.1636–8, National Gallery, London), the pose of Napoleon being skillfully adapted from that of Belshazzar, and the hand emerging from the clouds and the laden table being adapted from Rembrandt. It is unlikely that Gillray had seen the original picture, then in private hands, but his design seems closer to it than to the Henry Hudson mezzotint of 1786, which copies what appears to be a studio version or imitation.

This is a particularly original example of Gillray's ability to adapt the work of other artists to his own use, and it is likely that a number of his clients recognised the sophistication of the allusion.

93

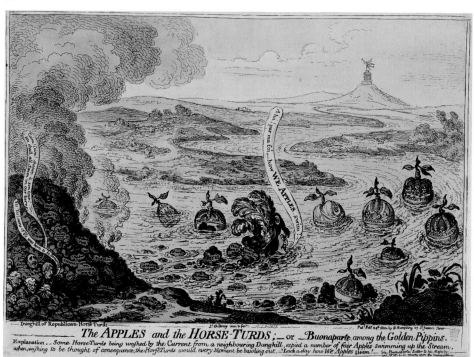

Dunghill of Republican-Horse-Turds
The APPLES and the HORSE-TURDS ;__ or __Buonaparte, among the Golden Pippins.
Explanation __ Some HorseTurds being washed by the Current from a neighbouring Dunghill, espied a number of fair Apples swimming up the Stream, when, wishing to be thought of consequence, the HorseTurds would every Moment be bawling out, _'Lack-a-day how We Apples swim'.

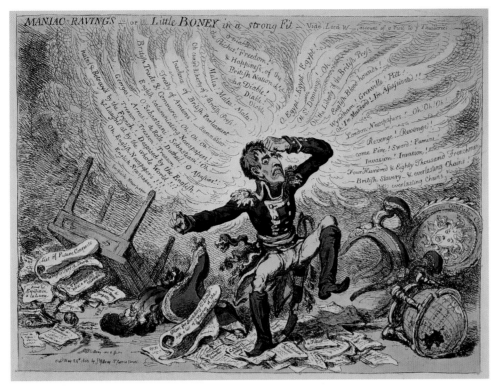

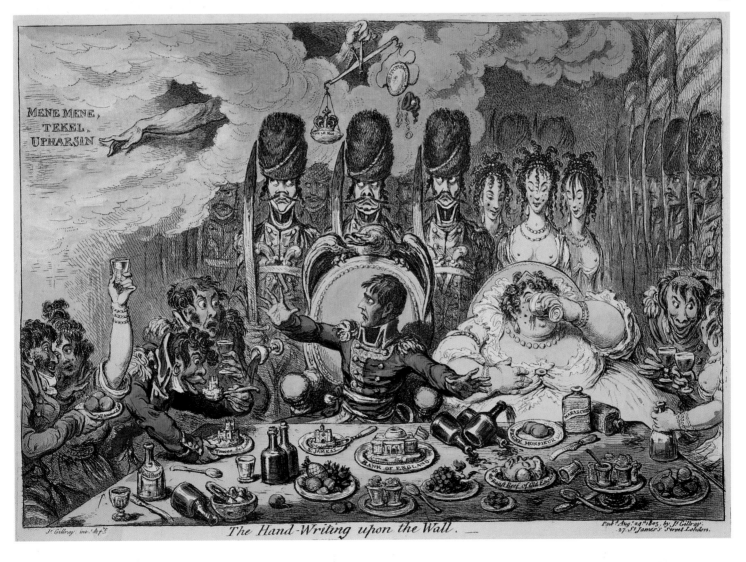

96A The King of Brobdingnag and Gulliver (Plate 2d)

Etching with engraving 35 × 45.2, with publisher's watercolour
Published 10 February 1804 by H. Humphrey
Andrew Edmunds, London
Provenance: Duke of Northumberland
BMC 10227

This is the sequel to an earlier print likening Napoleon to Gulliver (BMC 10019) which was also a design supplied by the same amateur, Lieutenant Colonel Braddyll. Gillray has remained fairly faithful to his design, but has changed the expression of the King's face which is now more serious.

96B The King of Brobdingnag and Gulliver

Pen and grey ink with watercolour 31.5 × 42.7
The British Museum, London

Like most caricaturists of his day, Gillray made extensive use of ideas supplied by amateurs. These could range from the most rudimentary scrawls to the high finish and comparative sophistication of the present example. Gillray's audience was alerted to these partnerships by his omission of the word 'Inven', meaning that the etching was his work but another had supplied the idea or design.

96A

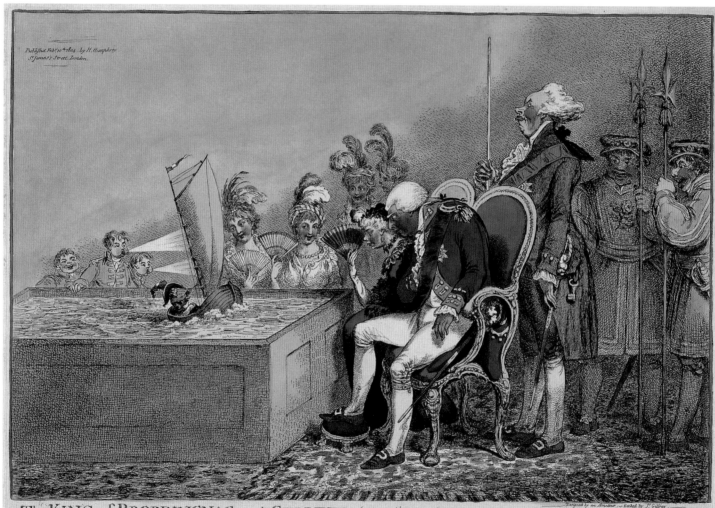

The KING of BROBDINGNAG and GULLIVER. *(Plate 2.ᵈ)* — Scene "*Gulliver manoeuvring with his little Boat in the Cistern*" Vide. Swifts Gulliver

"*I often used to Row for my own diversion, as well as that of the Queen & her Ladies, who thought themselves well entertained with my skill & agility. Sometimes I would put up my Sail and shew my art, by steering starboard & larboard; — However, my attempts produced nothing else besides a loud laughter, which all the respect due to his Majesty from those about him could not make them contain. — This made me reflect, how vain an attempt it is for a man to endeavour to do himself honour among those, who are out of all degree of equality or comparison with him!!!"— See. Voyage to Brobdingnag!*

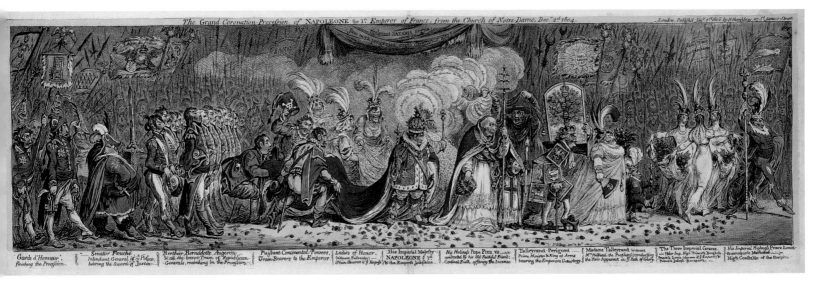

The Grand Coronation Procession of NAPOLEONE the I.st Emperor of France, from the Church of Notre Dame, Dec.r 2d 1804. London, Publish'd Jan.y 1st 1805, by H.Humphrey, 27 St. James's Street.

| Garde d'Honneur, finishing the Procession. | Senator Fouche Intendant General of y Police; bearing the Sword of Justice. | Berthier Bernadotte, Augereau &c all the brave Train of Republican Generals, marching in the Procession. | Puissant Continental Powers, Train-Bearers to the Emperor. | Ladies of Honor. (intimate Favorites) Train-Bearers to y Empress | His Imperial Majesty NAPOLEONE y 1.st the Empress Josephine. | His Holiness Pope Pius vii. conducted by his old Faithful Friend; Cardinal Feith, offering the Incense | Talleyrand-Perigord. Prime-Minister & King at Arms bearing the Emperors Genealogy. | Madame Talleyrand (at dinner) M.rs Halhad, the Prophetess conducting the Heir-Apparent viz, S. Jack of Glory. | The Three Imperial Graces. viz Their Imp. High. Princess Borghese Princess Louis Joseph & y Empress Prince's Joseph Buonaparte. | His Imperial Highness Prince Louis-Buonaparte Marboeuf High Constable of the Empire. |

97 The Grand Coronation Procession of Napoleone the Ist Emperor of France, from the Church of Notre-Dame Decr 2d 1804

Etching, engraving and aquatint 21.2 × 76, with publisher's watercolour
Published 1 January 1805 by H.Humphrey
Andrew Edmunds, London
BMC 10362

Gillray launched the year with an elaborate and ludicrous parody of the ridiculous pomp and ceremony surrounding Napoleon's coronation. Across the Channel his erstwhile 'hero', Jacques-Louis David, was beginning to plan his vast canvas of the Coronation of the Emperor and Empress, completed in 1807, the work of the two artists respectively reaching the furthest extremities of mockery and adulation.

 The momentum of the procession is irresistible, led by a strutting, preening figure, identified in the careful captions beneath the print as 'His Imperial Highness Prince Louis-Buonaparte Marboeuf – High Constable of the Empire'. He literally leads the procession out of the pictorial space –

his foot bisecting the border line. Charles Maurice de Talleyrand, represented with his deformed foot prominent, and his face and costume grotesque caricatures, carries the Bonaparte genealogy. Pope Pius VII, deeply mortified, unwittingly harbours beneath his vestments a little choir boy, who removes his childish mask to reveal the grinning face of the Devil. Cloven hoofs peep from beneath his surplice.

 Napoleon himself, accompanied by a gross Josephine, is little, sulky, half-suffocated by the carnival excess of his robes. A host of courtiers, some evidently reluctant such as Prussia, Spain and Holland who all support his train, follow behind. Equally unwilling are the ranks of generals, some of them shackled. The background is crammed with rank after rank of armed soldiers, making implicit the source of Napoleon's power.

 This impression is a particularly fine example, the brilliant colouring, including gamboge (yellow) overpainted to give a shiny glaze on the gold and yellow silks, showing the great care that went into the earliest examples of Gillray's most important prints.

98 The Plumb-pudding in Danger; – or – State Epicures taking un Petit Souper

Hand-coloured etching 26 × 36
Published 26 February 1805 by H. Humphrey
Library of Congress
BMC 10371

This is arguably the most famous political caricature of all time, with a universal image of the realities of power. The years of caricaturing Pitt and Napoleon are here brought to complete fruition, and the contrast between their faces and physiques is as telling as the contrast between Pitt and Fox. Pitt with a knife and a trident-shaped fork carves from the steaming plum-pudding a great slice of ocean, while a ferocious Napoleon helps himself to Europe – a brilliant illustration of the respective areas of power of the two countries.

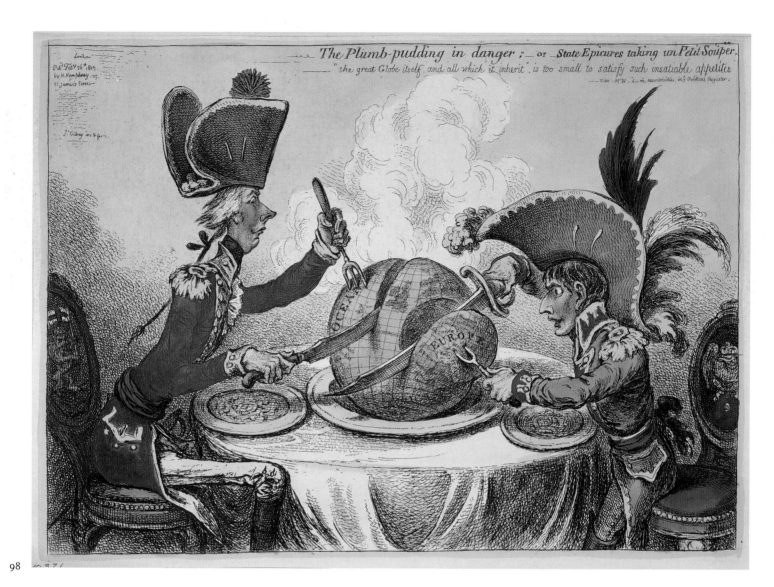

The Plumb-pudding in danger;— or _State Epicures taking un Petit Souper.
— "the great Globe itself, and all which it inherit", is too small to satisfy such insatiable appetites
— Vide M^r W___k's ___ œconomists, in y^e Political Register.

98

99A News From Calabria! Capture of Buenos Ayres! – i.e. – the Comforts of an Imperial Dejeune at St Cloud's

Hand-coloured etching with some aquatint
24.5 × 35
Published 13 Sept 1806 by H. Humphrey
The British Museum, London
BMC 10599

On 4 July 1806 a British army under Sir John Stuart comprehensively defeated a French army at Maida in Calabria, thus gaining much-needed prestige for British arms. Before that, on 27 June, combined British forces captured Buenos Aires from the Spanish; this proved to be a false dawn since the British were catastrophically defeated there in 1807. However it appeared at the time that things were looking up for the British on land, and it is to these events that 'Little Boney' reacts with a violent tantrum. Talleyrand is kicked, assaulted with an urn and held by the ear. The breakfast table and its contents crash to the ground, and a scantily clad Josephine is drenched with boiling water.

99B News From Calabria

Pen and wash, in grey and black ink 29 × 46.5
The British Museum, London

This vigorous preparatory study was followed fairly closely by Gillray in the print, although on the right a twisted column was replaced by a curtain. As in so many of his drawings Gillray was simultaneously drafting captions and speech bubbles, many of them later rejected. Here a number of alternative titles are scrawled into the border, including 'Consequences of a defeat in Calabria'. As is usually the case, nothing could be more perfect than the published words.

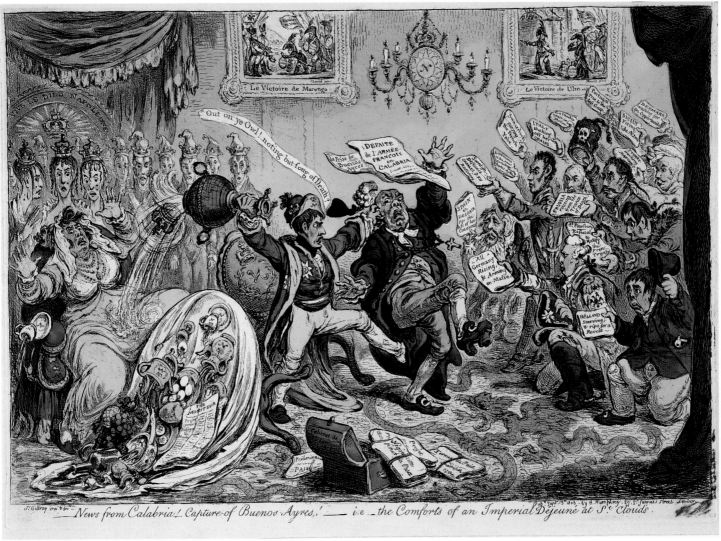

Politics, Royalty and Social Satires

Gillray's art ranged across every aspect of public and private life. Even as revolution and war raged on the Continent, he could turn his attention to the most trivial events involving famous mistresses. Even as ferocious debates in parliament reshaped the nation, he would look comically to the misdemeanours of minor royals. Gillray's great skill was in reducing often complex political issues and passing social fads into comic images which remain appealing. His depictions of Pitt and Fox, George III and the Prince of Wales may relate precisely to a specific event or report, but as characterisations of tyranny, greed or selfishness they still stand up. And ever attentive to the vagaries of fashion and taste, his images of the social world of his time are brilliant documents of an age of change, where new ideas about everything from antique art to breast-feeding were taken up enthusiastically. But they are also commentaries on timeless themes of self-delusion, pretension and desire. At the heart of his satiric vision is an astute grasp of personality and physique. Gillray's greatest gift to the art of caricature is his ability to make his comedy emphatically, even vulgarly, physical, whatever the subject.

100A

Miniatures

100A Self Portrait *c.1795–1800*

Miniature on ivory 7.6 × 6.4
National Portrait Gallery, London
Gift of Charles Bagot 1859

This highly finished miniature, which is
unsigned, was engraved in mezzotint,
greatly enlarged, by Charles Turner and
published by G. Humphrey on 19 April
1819. At Mrs. Humphrey's death in 1818
the miniature passed to the Rev. John Sneyd,
thence to Charles Bagot, by whom it was
given to the National Portrait Gallery, being
amongst the earliest portraits to enter
the gallery (NPG 83).

 Without the mezzotint and the impeccable
provenance there would be little reason to
associate the miniature with Gillray as artist
or sitter. No other such works on ivory
are known. Yet the execution is of an
accomplishment that bespeaks experience
of this very specialised technique, and it
seems likely that other unsigned miniatures
exist (see no.100c).

 The carefully modulated tones are
subdued, defining a grey coat, grey face,
greying hair combed forward to conceal
baldness; nothing could be more restrained,
more distant from the bright colours and
exuberance of his prints.

100B Henry Bone (1755–1834)
Queen Charlotte 1801

Enamel miniature on copper 7 × 5.7
National Portrait Gallery, London

100C Unknown artist, signed in monogram (?JG, possibly James Gillray)
George III

Miniature on ivory, oval 3.2 × 2.2
National Portrait Gallery, London

100D Thomas Day (c.1732–1807?)
Charles James Fox 1787

Miniature on ivory, oval 6.7 × 5.1
National Portrait Gallery, London

100E Richard Cosway (1742–1821)
George, Prince of Wales 1792

Miniature on ivory
National Portrait Gallery, London

100F After James Barry (1741–1806)
Edmund Burke 1774

Miniature on ivory 6.4 × 5.1
National Portrait Gallery, London

100C

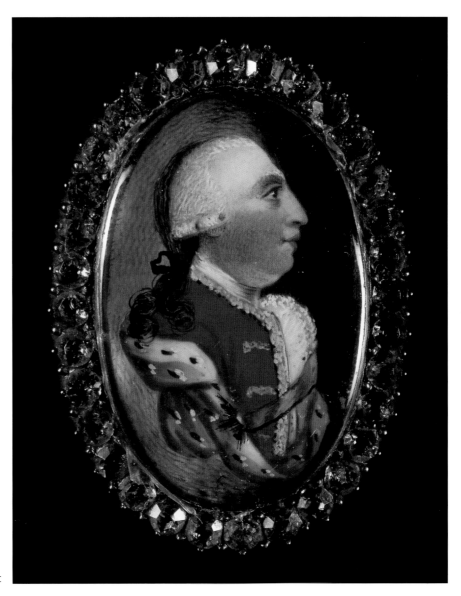

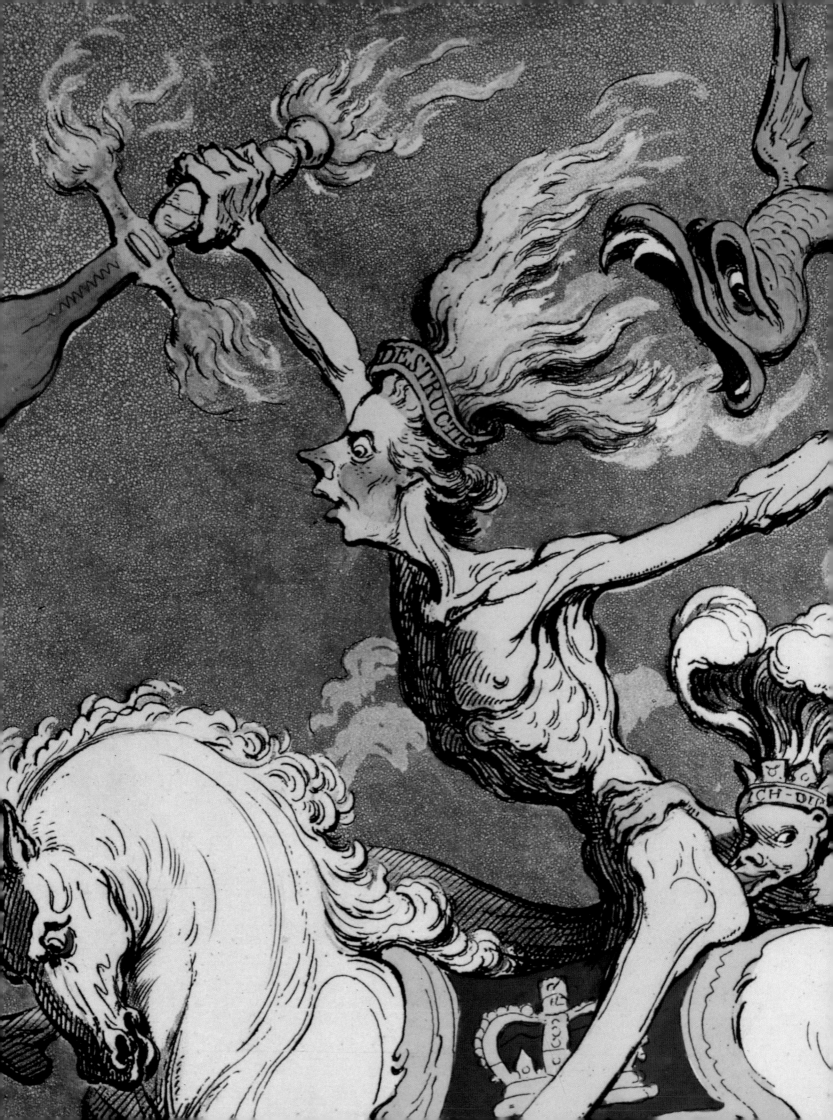

Politics

The rancour and violence of English party politics were meat and drink to Gillray. He regularly attended the House of Commons, little sketching cards in hand – no doubt rather an ominous sight to some posturing minister on the floor of the House. He stalked them in the street; no doubt he observed them on his own ground at Mrs Humphrey's shop. Many politicians knew, however, that their non-appearance or disappearance from his caricatures was a sign of insignificance or political eclipse.

In 1797 Gillray accepted a pension – an annual retainer – from the Tories, and his onslaught on the Whigs became even more relentless, yet the follies and vices of the Tories were never completely pasted over.

detail, no.109

William Pitt

101 Joseph Nollekens (1737–1823)
Bust of William Pitt, after 1806

Marble 71 high
Brooks's

Often paired with the bust of his political
rival Charles James Fox, this portrait bust
of William Pitt the Younger was one of
Nollekens's most famous and popular works.
The Tory Prime Minister would not sit for the
sculptor during his lifetime but, working from
a death-mask of Pitt taken in 1806, Nollekens
created a bust which he and his assistants
continued to execute at least 74 times in
marble and over 600 in plaster cast. Indeed,
in 1806 the sculptor told Farington that 'it
wd. take 4 years to finish all the Marble Busts
of Mr Pitt which had been ordered'.
RM

102 The Right Honorable William Pitt

Line engraving 47.5 × 34.5
Published 20 February 1789 by S.W. Fores
The British Museum, London

Designed and engraved by Gillray without
the benefit of a sitting but based on many
personal sightings of Pitt, this highly finished
print shows Pitt as Chancellor of the
Exchequer, his right hand resting on the
Annual Report of National Debt – not
perhaps a tactful choice of document.

Gillray had entered into an elaborate
contract with S.W. Fores which was to
allow an initial print run of 550 impressions.
He undertook this project with the utmost
dedication and seriousness. On 23 December
1788 he wrote to one Martin, an amateur who
hoped that Gillray would etch his design:
'Jo.Gillray's Compts to Mr.Martin,
is very sorry that he is so circumstanc'd at
present, as not to have it in his power to
oblige him, by executing his admirable
Idea of "The Word Eater" J.G. being now
engraving a *Portrait of Mr. Pitt*, the extreme
urgency of which debars him from engaging
at present in any other work' (Getty Archive,
Los Angeles); and in a letter to Fores of

5 January 1789 he complained that 'The
quantity of work which I find in ye Plate
almost drives me mad' (see Banjeri and
Donald, Cambridge 1999, p.264).

The portrait was not a success. This was
scarcely surprising since despite his best
intentions, and his aggressively vehement
assertions of the faithfulness of the likeness,
Pitt's face with its woodpecker's nose is
practically a caricature. Fores reneged on his
agreement and commissioned a mezzotint
portrait from Henry Kingsbury. Gillray tried
again with a second portrait, published on
9 April by John Harris. This too was a failure.

103 An Excrescence; – a Fungus; - Alias – A Toadstool upon a Dung-hill

Etching 25.5 × 22.5, with publisher's watercolour
Published 20 December 1791 by H. Humphrey
Andrew Edmunds, London
BMC 7936

A caricature of extreme simplicity, perhaps
developing from the crown in *The Rights of
Man* (no.64), in which Pitt is attacked for his
excessive power and closeness to the King.

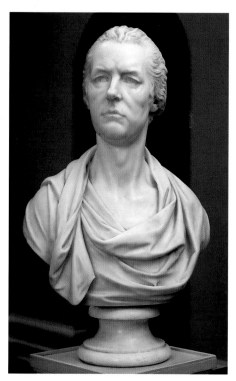

101

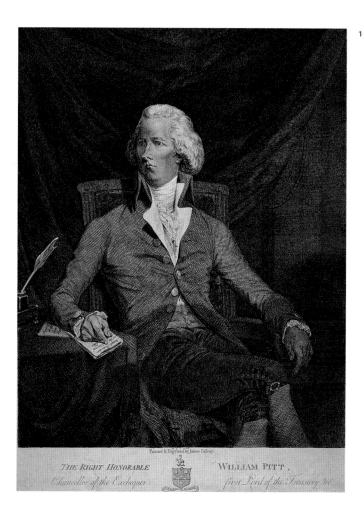

102

THE RIGHT HONORABLE · WILLIAM PITT,
Chancellor of the Exchequer. *first Lord of the Treasury &c.*

103 ▷

An Excrescence;— a Fungus;— alias — a **Toadstool** *upon a* **Dunghill.**

Pub.^d Dec.^r 20.th 1791. by H. Humphrey N.^o 18. Old Bond street.

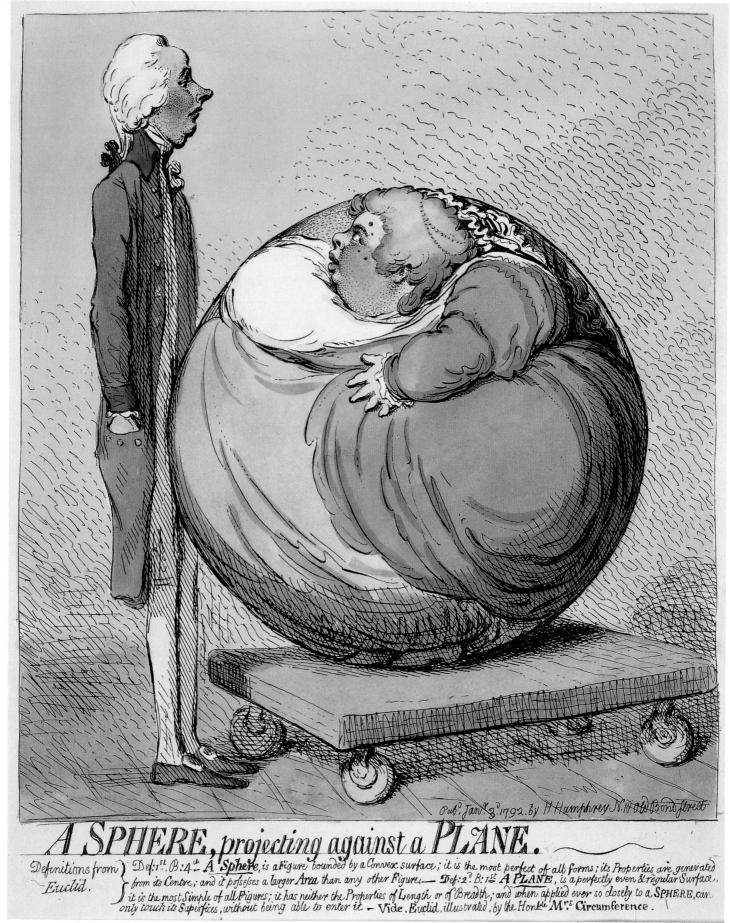

A SPHERE, projecting against a PLANE.

Definitions from } Def: 1.st B: 4.th A Sphere, is a Figure bounded by a Convex surface; it is the most perfect of all forms; its Properties are generated
Euclid. from its Centre; and it possesses a larger Area than any other Figure.— Def: 2.d B: 1.st A PLANE, is a perfectly even & regular Surface.
it is the most Simple of all Figures; it has neither the Properties of Length or of Breadth; and when applied ever so closely to a SPHERE, can
only touch its Superfices, without being able to enter it — Vide. Euclid, illustrated; by the Honble Mrs Circumference.

Pubd Jany 8 1792. by H Humphrey N 18 Old Bond Street

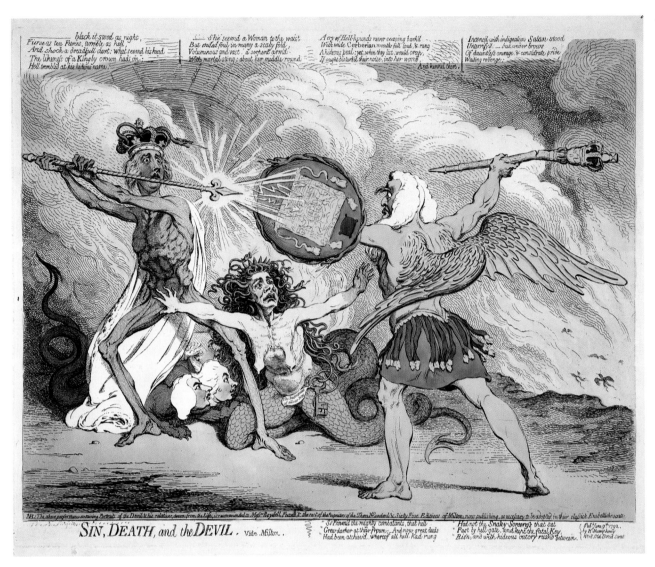

SIN, DEATH, and the DEVIL. Vide Milton.

104 A Sphere, projecting against a Plane

Hand-coloured etching 27.5 × 22.5
Published 3 January 1792 by H. Humphrey
The British Museum, London
BMC 8054

This is caricature at its most elemental, as the skinny Pitt is juxtaposed with the obese Mrs. Hobart. The dry mathematical definitions are an essential accompaniment to the design.

105 Sin, Death, and the Devil

Hand-coloured etching 31.5 × 40
Published 9 June 1792 by H. Humphrey
Library of Congress
BMC 8105

A bitter struggle between Pitt and Thurlow, the Chancellor, culminated in the latter's loss of office, a result believed to owe much to Pitt's influence with the Queen. Gillray has once again plundered Milton's *Paradise Lost*, with Pitt represented as Death, Thurlow as the Devil, and the Queen as Sin. The representation of the Queen as a Devilish hag, half serpent, her breasts withered, is one of the most savage ever sustained by a royal person. She illustrates Milton's lines:

> 'Had not the Snaky-Sorceress that sat,
> Fast by hell-gate, and kept the fatal key
> Ris'n, and with hideous outcry rushed
> between'

She protects Pitt – another manifestation of Gillray's Death figure – with an outstretched

hand, an ambiguous gesture, concealing his private parts but possibly stimulating them as well.

The compositional device of a female Sin separating Death and the Devil was popular in eighteenth-century British art and stems from Hogarth's painting of c.1735–40 (Tate), which was later engraved jointly by Thomas Rowlandson and John Ogborne (see David Bindman, 'Hogarth's *Satan, Sin and Death* and its influence', *Burlington Magazine*, March 1970, pp.153–8). James Barry, William Blake, George Romney and Henry Fuseli (no.106) all drew or etched compositions owing much to this prototype. The central group of Jacques-Louis David's painting *The Intervention of the Sabine Women* (1799) is almost certainly derived from Gillray's print.

Traditionally – and not surprisingly – this print is believed to have given great offence at court. This impression is, however, the one purchased by the Prince of Wales.

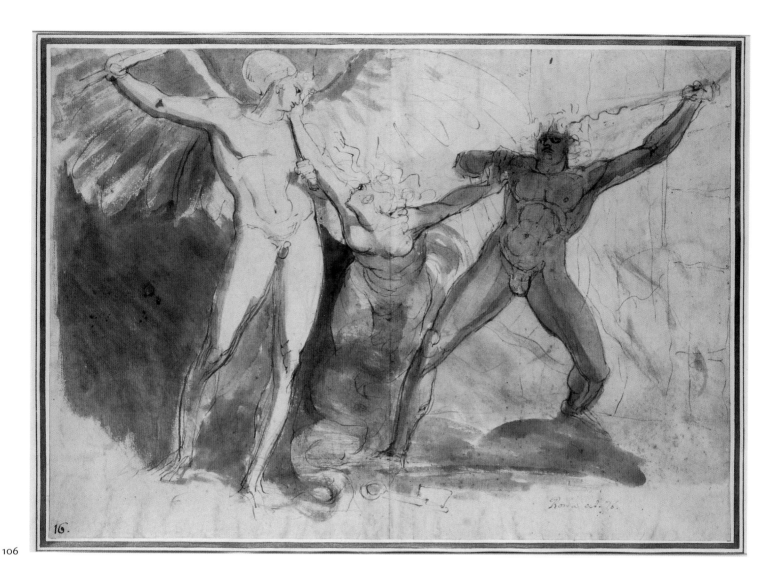

106

106 Henry Fuseli (1741–1825)
Satan and Death Separated by Sin 1776

Pen and sepia with brown and grey wash
26.2 × 37.7
Inscribed bottom right: 'Roma oct. 76'
The Visitors of the Ashmolean Museum, Oxford

107 Thomas Rowlandson and John
Ogborne after Hogarth (1697–1764)
Satan, Sin, and Death

Etching and Engraving printed in sepia ink
31.6 × 36.7 (trimmed)
Published I June 1792 by J.Thane
Andrew Edmunds, London
Provenance: Marquis of Bute.

This was published just eight days before
Gillray's print, and must surely have been
his direct inspiration – an example of the
extreme rapidity with which he could absorb
and adapt an existing image to his own
purposes.

108 **Light expelling Darkness, –
Evaporation of Stygian Exhalations, –
or – The Sun of the Constitution,
rising superior to the Clouds of
Opposition**

Etching, engraving and textured soft ground
33.5 × 44, with publisher's watercolour
Published 30 April 1795 by H. Humphrey
Andrew Edmunds, London
BMC 8644

Pitt, in imperial splendour, is drawn in a
chariot across the skies, pulled by the British
lion and a Hanoverian horse. The opposition,
who merge with a dark and sinister cloud,
are scattered. Their familiar, a naked hag,
rolls her eyes in dismay, her head adorned
with the caption 'The Whig Club'. This epic
print, avowedly Pittite and propagandist
in purpose, was a response to strident
opposition calls for peace overtures to
France. Gillray here combines the comic
and grotesque with genuinely heroic
imagery.

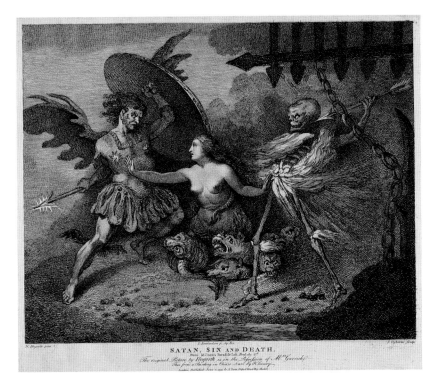

SATAN, SIN AND DEATH.

From Milton's Paradise Lost, Book the 2d.
The original Picture by Hogarth is in the Possession of Mr. Garrick,
This from a Painting on Glass done by R. Livesay,
London, Published June 1, 1792, by J. Thane, Rupert Street, Haymarket.

James Gillray des. et fec. LIGHT expelling DARKNESS, — Evaporation of Stygian Exhalations, — or — The SUN of the CONSTITUTION, rising superior to the Clouds of OPPOSITION. Pub.d April 30.th 1795, by H. Humphrey, N.° 37 New Bond Street.

109 Presages of the Millenium

Hand-coloured etching, engraving and aquatint
32.5 × 37.5
Published 4 June 1795 by H. Humphrey
The British Museum, London
BMC 8655

Pitt in the form of Gillray's familiar Death figure gallops on a white Hanoverian horse, a monkey-like Prince of Wales riding behind greedily kissing his bony backside. Fox, Sheridan and Wilberforce, the last clutching a paper 'Motion for a Peace', are scattered by the horse's flying hooves. The allusion in the inscription to Richard Brothers, the notorious but influential 'prophet', refers to his belief that the revolutionary wars were the fulfilment of the prophecy of Revelation.

Gillray was certainly aware of history painting of the time, and he must have known Mortimer's etching of *Death on a Pale Horse* (1784), but the horse also has its ancestry in his own etching of *The Legacy* (no.26) and the Death figure is his own creation. The open drawing, the grotesquerie and the gruesome figure of Pitt are something of a reaction to *Light expelling Darkness* (no.108).

110 The Sleep-Walker

Hand-coloured etching 34.7 × 24.5
Published 1 November 1795 by H. Humphrey
The British Museum, London
BMC 8682

Pitt, deep in sleep, his candle held aloft, is poised precariously on the stone steps of a Gothic building. The tension is palpable, a reflection of the very anxious mood of the nation in 1795. Gillray has not signed the print, and it was almost certainly drawn from an idea provided to him by Sneyd.

109

Presages of the MILLENIUM; with The Destruction of the Faithful, as Revealed to R:Brothers, the Prophet, & attested by M.B. Halhead Esq
"And ear the Last Days began, I looked & behold, a White Horse, & his Name who sat upon it was Death; & Hell followed after him, & Power was given unto him, to kill with the
"Sword, & with Famine, & with Death; And I saw under him the Souls of the Multitude, those who were destroy'd for maintaing the word of Truth, & for the Testimony

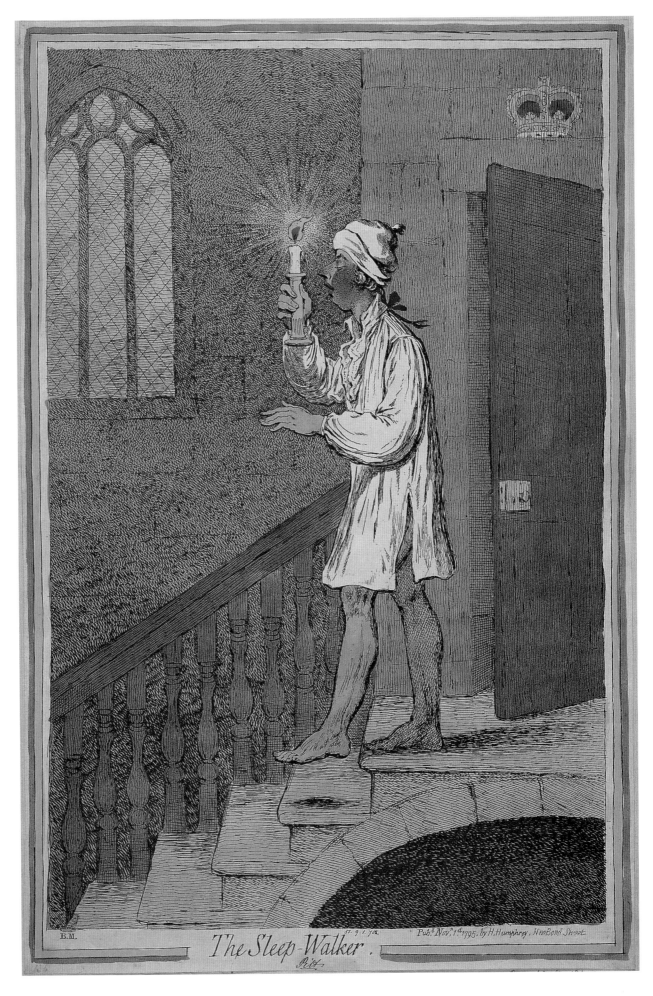

B.M. Pub.ᵈ Novʳ 1ᵈ 1795. by H. Humphrey, New Bond Street.

The Sleep-Walker.

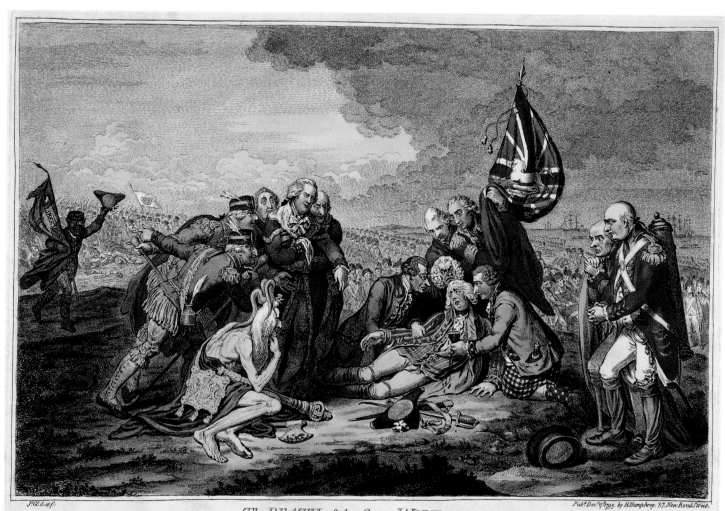

The DEATH of the Great WOLF.

_____ "We have overcome all Opposition!___ exclaimed the Messengers,___ `I'm satisfied`."___ said the Dying Hero, & Expired in the Moment of Victory.

To Beng.ʰ West Efq.ʳ Prefident of the Royal Academy, this attempt to Emulate the Beauties of his unequald Picture, of the Death of Gen.ˡ Wolfe," is most refpectfully submitted, by the Author.

111

111 The Death of the Great Wolf

Etching and engraving 29 × 43.2,
with publisher's watercolour
Published 17 December 1795 by H.Humphrey
Andrew Edmunds, London
BMC 8704
Provenance: Duke of Northumberland

This celebrated print is a very carefully
observed parody of Benjamin West's picture
of 1771, which Gillray would have known
through the best-selling engraving by William
Woollett (no.112). It was published the day
before the Treason and Sedition Bills became
law, and mocks the over-reaction of the
government, symbolised by the massed
ranks of ministerial troops who scatter a
feeble body of sans-culottes. Numerous
ministers and Pitt supporters stand in
ludicrously for West's heroic figures on
the Heights of Abraham.

Dundas does not stop the flow of the
'Wolf's' blood, but instead offers him a
large bumper of port from the bottle in his
pocket – Pitt's fondness for port was well
known. Burke leans over Pitt, his profile much
caricatured. From his pocket projects a paper
labelled 'Reflections upon £3700 Pr Ann' – a
reference to the two pensions he had been
awarded for his famous book.

Sneyd wrote to Gillray after a few days
to praise the work, but with his regret that
'Mr. Canning did not make his debut in Mrs.
H's window in so excellent a print'. George
Canning was desperately anxious to receive
the recognition of significance in affairs that
a Gillray caricature gave. In his case, however,
the artist played distinctly hard to get in
a print which is an assemblage of all the
significant figures in the Tory administration.

112 William Woollett (1735–85) after
Benjamin West
The Death of Wolfe

Engraving with etching 42.7 × 59
Published 1776 by Woollett, Boydell and Ryland
The British Museum, London

West's painting was exhibited at the Royal
Academy annual exhibition in 1771, where
it created a sensation by its calculated
mingling of realism in details of costumes
and portraiture, and idealised religiosity in
the deportment and grouping of the figures.
Woollett's print had vast success and did
much to establish the popular fame of West
in England and abroad.

 This is an impression of the fourth state,
with the officer at the left carrying the French
banner still unfinished.

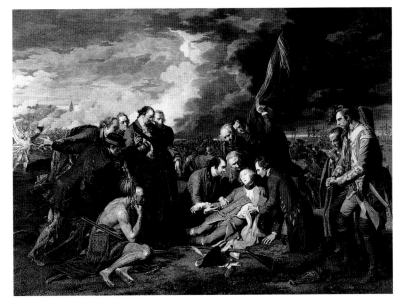

113 **Curing John Bull of his Canine
appetite**, *c.*1796

Pen and ink and pencil 33.4 × 26.8
*Print Collection, Miriam and Ira D. Wallach
Division of Art, Prints and Photographs,
The New York Public Library, Astor, Lenox
and Tilden Foundations*

This vigorous drawing, in which Pitt, horribly
lively and determined, extracts John Bull's
teeth, was never developed into a print, and
the title is based on Gillray's note at the top
of the sheet. A roughly sketched Canning,
annotated as 'Betty Cann', makes one of his
first appearances in Gillray's work as an
assistant, standing behind Pitt. The subject
refers to a tax on dogs, which was imposed
by Pitt on 5 April 1796.

113

114 The Nuptial-Bower; – with the Evil-One, peeping at the Charms of Eden

Hand-coloured etching 25.5 × 35.5
Published 13 February 1797 by H. Humphrey
Library of Congress
BMC 8985

Pitt was a lifelong bachelor, but he had briefly contemplated marriage with Eleanor Eden, daughter of Lord Auckland. However, the amount of his personal debts compelled him to abandon the idea. Fox is portrayed as the Devil, gnashing his teeth and clenching his fists.

115 Midas Transmuting all into Gold [scored through] Paper

Hand-coloured etching 35.4 × 24.8
Published 9 March 1797 by H. Humphrey
The British Museum, London
BMC 8995

The word 'Gold' is conspicuously scratched out and replaced by 'paper'. On 26 February, because of a run on the Bank and the dwindling of stocks of gold, cash payments were suspended and quickly replaced by the issue and circulation of paper money – a move denounced by Fox as ' . . . the first day of our national bankruptcy'. It is a spectacular and Brueghelian image, the pipe-stem limbs of Pitt supporting a monstrous belly stuffed with gold, which from his gullet to his mouth is transformed into a stream of paper. The tiny figures beneath him, and the dwarfish opposition figures in the reeds, increase the sense of Pitt's growing stature and control of events.

114

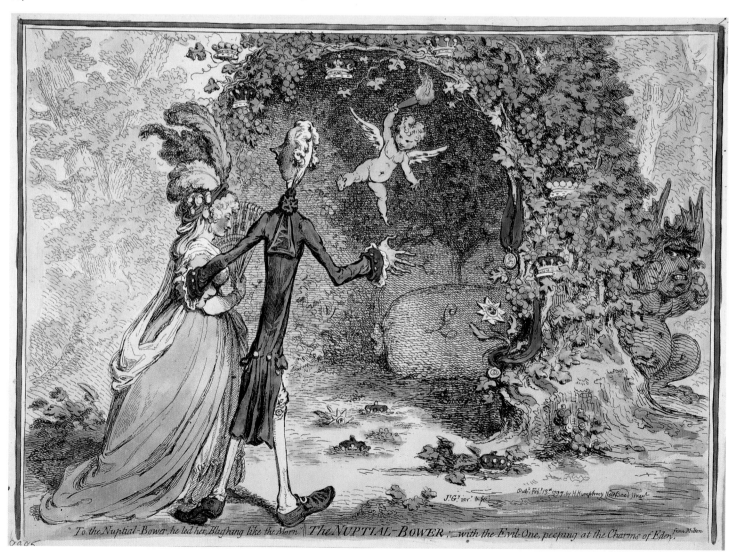

"To the Nuptial-Bower, he led her, Blushing like the Morn." *The NUPTIAL-BOWER; – with the Evil-One, peeping at the Charms of Eden.* from Milton

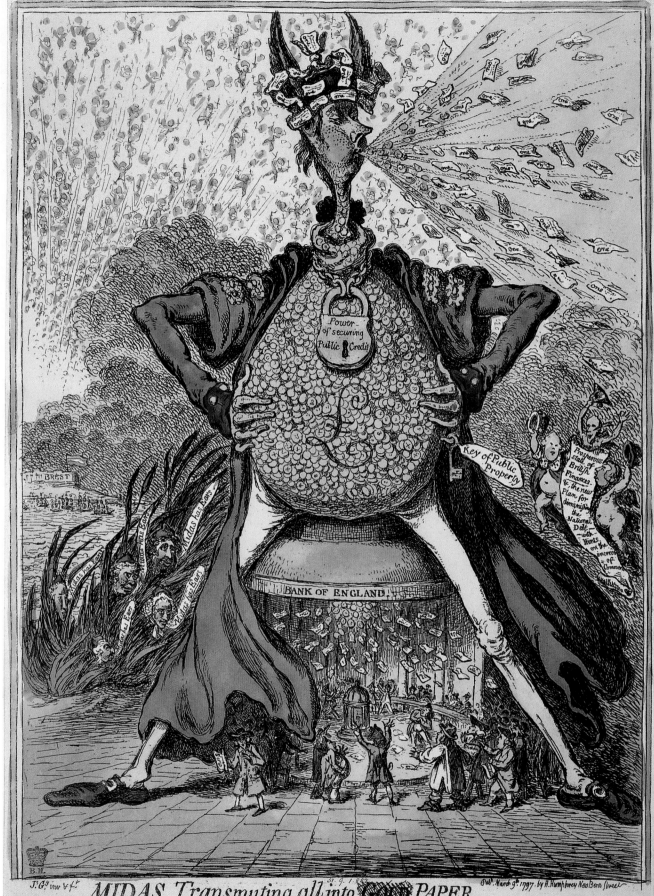

MIDAS, Transmuting all into GOLD PAPER.

History of Midas.— The great Midas having dedicated himself to Bacchus, obtained from that Deity, the Power of changing all he Touched.
Apollo fixed Asses Ears upon his head, for his Ignorance — & although he tried to hide his disgrace with a Regal Cap, yet the very Sedges which grew
from the Mud of the Pactolus, whisperd out his Infamy, whenever they were agitated by the Wind from the opposite Shore.— Vide Ovids Metamorphoses.

145

116 Political-Ravishment, or The Old Lady of Threadneedle-Street in danger!

Hand-coloured etching 25.5 × 36
Published 22 May 1797 by H. Humphrey
The British Museum, London, Banks Collection
BMC 9016

On 3 May the suspension of cash payments was confirmed by parliament. Sheridan spoke of the Bank as 'an old woman courted by Mr. Pitt', and Gillray has seized on this remark and improved it by the insertion of 'Threadneedle Street' in the title. The phrase has entered the language and Gillray is generally credited as its sole inventor.

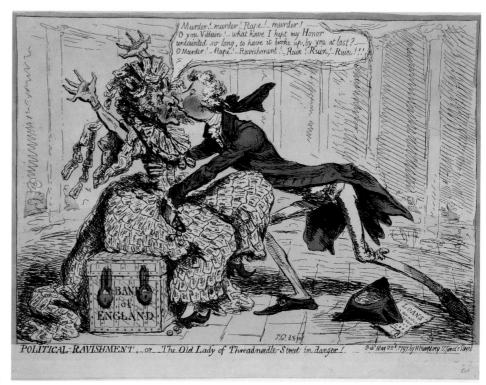

116

117 John Hall (1739–1797) after Reynolds (1723–1792)
Richard Brinsley Sheridan

Engraving, third state of four 52.2 × 38.4
Published 1791 by J. Hall
The British Museum, London

This engraving after Reynolds's portrait is the most ambitious portrait of Sheridan, and, curiously, was the subject of a pencil copy by Gillray (New York Public Library). Sheridan took a keen interest in its progress, and an anecdote by the engraver Abraham Raimbach (*Memoirs and Recollections of the Late Abraham Raimbach*, 1843, p.19) reveals his sensitivity to the blotched and boozy complexion continually lampooned by Gillray:

'Sheridan came twice or thrice . . . during the engraving of the portrait . . . I was however most struck by what seemed in such a man an undue and unbecoming anxiety about his good looks in the portrait to be executed. The efflorescence in his face had been indicated by Sir Joshua in his picture, not, it may be presumed, a bon gre, on the part of Sheridan, and it was strongly evident that he deprecated its transfer to print. I need scarcely observe that Hall set his mind at ease on this point . . .'

118 Integrity Retiring from Office

Hand-coloured etching with aquatint 25.4 × 35.7
Published 24 February 1801 by H. Humphrey
Library of Congress
BMC 9710

In March 1801 Pitt resigned office, a primary cause being the extreme reluctance of some of his colleagues, and more importantly the King, to accept his proposals for the political union of England and Ireland, and the emancipation of Irish Catholics. The King invited Henry Addington to take his place.

Pitt, in declamatory pose and holding a document entitled 'Justice of Emancipating ye Catholicks', leads his colleagues from the Treasury doors, the arched shape of which Gillray had always loved to draw. Dundas holds Pitt's arm and behind him is the Foreign Secretary, Grenville, wearing peer's robes. A riotous rabble of Whigs, incited by Sheridan with a butcher's cleaver, launches a shower of missiles, including a great can of Whitbread's Entire, an allusion to the brewer's rabid Whig sympathies. Fox is notable by his absence. A grenadier (possibly intended for Addington, or even the King) holds them at bay and their missiles fall short. Gillray emphasises Pitt's virtuous conduct by the way he walks into a sunlit open space, in contrast to the cluttered corner occupied by the Whigs.

119 Lilliputian-Substitutes, Equipping for Public Service

Hand-coloured etching 25 × 35.7
Published 28 May 1801 by H. Humphrey
The British Museum, London
BMC 9722

Gillray has given shape to a classic pictorial metaphor for an incompetent administration attempting to elevate itself by donning the outsize garments of its predecessors, the effect being merely to emphasise their own insignificance. From left to right the new administration are Lord Eldon, Baron Hawkesbury, Lord Hobart, and Lord Glenbervie, their predecessors being clearly identified in Gillray's text. Glenbervie, a plump figure, tries on 'Mr. Cng's Old Slippers'. Glenbervie had taken Canning's position as Paymaster General, and the latter greatly resented the loss of the perquisites of office. It has been suggested very plausibly that Canning may have had a hand in designing this print, especially since Gillray has signed the print as made and drawn ('fec & del'), but not necessarily designed ('invenit'), by him.

The speech bubbles, so important a part of Gillray's work, are of especially striking shapes, contrasting with the bureaucratic quill pens held like weapons by the two new Treasury secretaries, the Prime Minister's brother, John Hiley Addington, and Nicholas Vansittart.

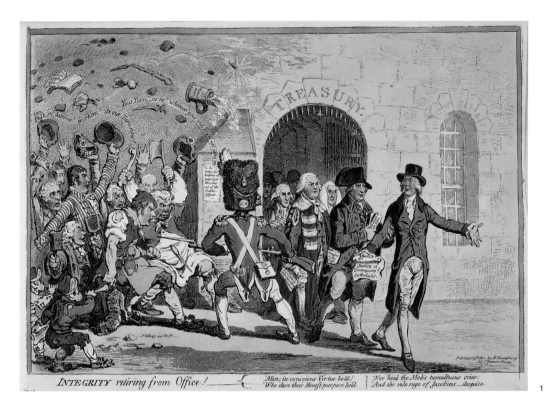

INTEGRITY *retiring from Office!* — *Men, in/conscious Virtue bold,/ Who dare their Honest purpose hold.* — *Nor heed the Mob's tumultuous cries,/ And the vile rage of Jacobins—despise.*

118

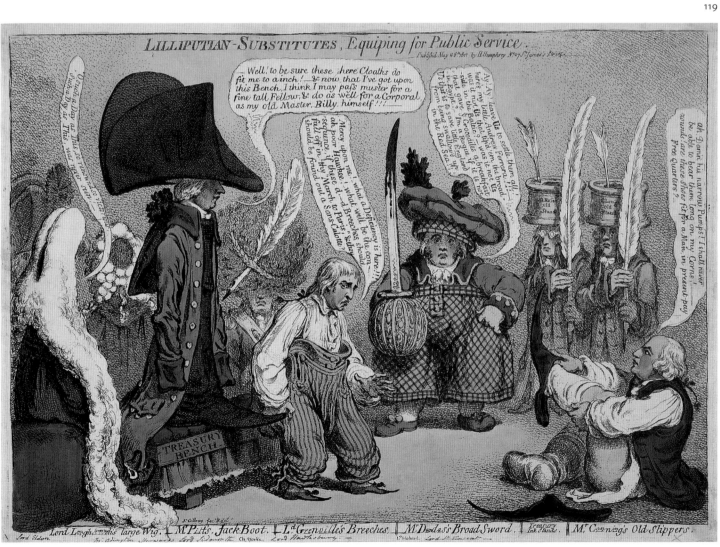

LILLIPUTIAN-SUBSTITUTES, *Equiping for Public Service.*

Lord Loughborough's large Wig. | M.r Pitt's JackBoot. | L.d Grenville's Breeches. | M.r Dundas's BroadSword. | Treasury Ink Stands. | M.r Canning's Old Slippers.

120 Political-Dreamings! – Visions of Peace! – Perspective Horrors!

Hand-coloured etching 26 × 36
Published 9 November 1801 by H. Humphrey
The British Museum, London, Banks Collection
BMC 9735

William Windham (1750–1810) had been Secretary of War in Pitt's cabinet. He was a bitter opponent of the Peace of Amiens, the Preliminaries of which had been made known on 1 October 1801, and which involved the British abandoning many of their overseas possessions. In a characteristic Gillray scene of night-time bedroom torment, Windham sees all his fears realised in the spectres that surround him.

This impression of the print bears a slip of paper stuck to the back with a number of the foreground figures identified in Gillray's handwriting; presumably the collector Sarah Banks asked him to do this when she bought the print at the shop.

120

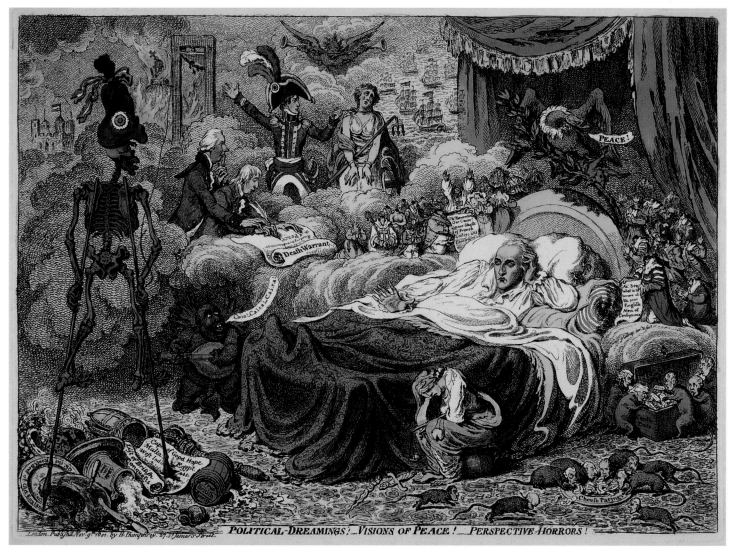

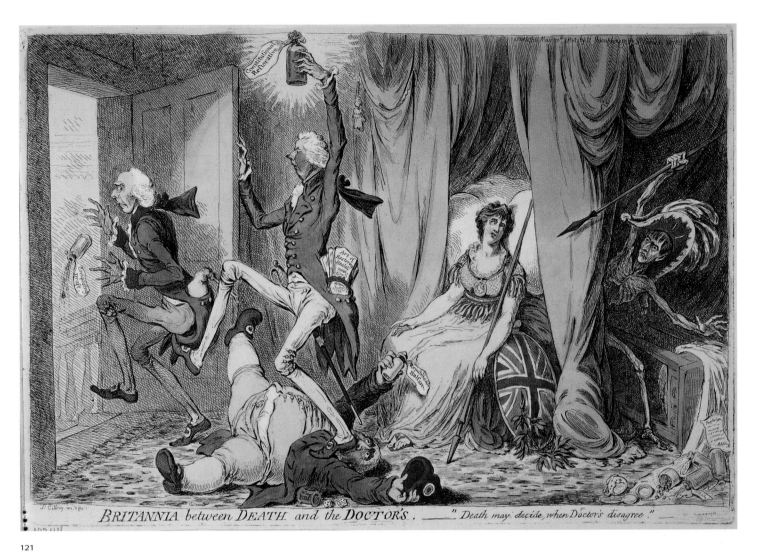

BRITANNIA between DEATH and the DOCTOR'S. ____ "Death may decide, when Doctor's disagree."

121

121 Britannia between Death and the Doctor's

Hand-coloured etching 25.8 × 38.1
Published 20 May 1804 by H. Humphrey
Library of Congress
BMC 10244

Pitt, returned to office on 10 May 1803, kicks Addington out of the door, while simultaneously trampling on Fox, who at the King's insistence had been excluded from any part in the new government. It was widely believed that Addington had neglected the country's defence, and as a consequence the Death figure of Napoleon is able to threaten a distressed Britannia.

The grouping of Addington, Pitt and Fox is one of Gillray's most dynamic configurations, a positive Laocoön of caricature.

122 Uncorking Old-Sherry

Hand-coloured etching 35.8 × 25.5
Published 10 March 1805 by H. Humphrey
Library of Congress
BMC 10375

This famous and striking image reflects Gillray's close attention to parliamentary affairs and speeches. On 6 March Pitt had responded brilliantly to a long and diffuse speech by Sheridan.

According to Thomas McLean, Sheridan bought six impressions of the print (*Illustrative Description of the Genuine Works of Mr James Gillray*, London 1830, p.294).

149

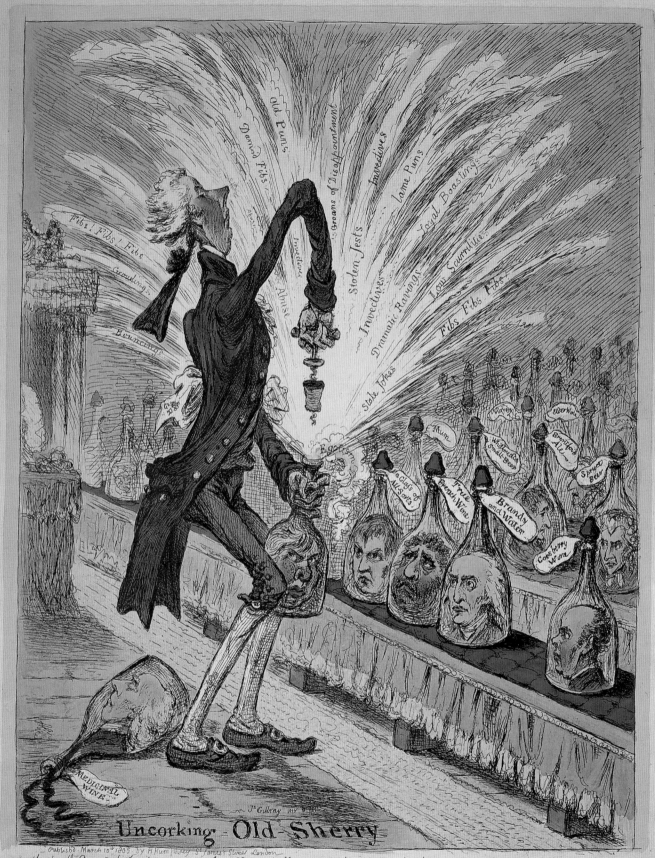

Js Gillray inv

Uncorking-Old-Sherry

Publish'd March 10th 1805. by H Humphrey, St James's Street, London

_ the hon.ble Gent.r tho' he does not very often address the House, yet when he does, he always thinks proper to pay off all arrears, & like
a Bottle just uncork'd bursts all at once into an explosion of Froth & Air; _ then, whatever might for a length of time lie
lurking & corked up in his mind, whatever he thinks of himself or hears in conversation, _ whatever he takes many
days or weeks to sleep upon, the whole common-place book of the interval is sure to burst out at once, stored with
studied Jokes Sarcasms, arguments, invectives, & every thing else, which his mind or memory are capable of embracing
whether they have any relation or not to the Subject under discussion _ See Mr Pitts speech on ye Genl Defence Bill. March 6th 1805

Charles James Fox

123 Joseph Nollekens (1737–1823)
Bust of Charles James Fox, after 1792

Marble 69.8 high
Private Collection

Catherine the Great of Russia is said to have owned no fewer than 12 busts of Fox by Nollekens. After her initial commission in 1791, Nollekens and his assistants produced over thirty further versions. Although fewer than those executed of Pitt, this was Nollekens' most famous bust. Other patrons included Samuel Whitbread II, who appears as a scornful character in Gillray's print *View of the Hustings in Covent Garden* (no.130), describing Sheridan's unsuccessful challenge to Fox's old seat in the Westminster election. Whitbread is said to have composed the verse inscribed on this bust's pedestal:

Live, Marble, to speak the Patriot's Mind
His generous Heart, embracing all Mankind.
His constant Fortitude, unbroken by time
His Thought profound, and Eloquence sublime.
If vain his Toil to save a Venal Age
If Wisdom's Voice be lost in factions Rage,
He fosters Liberty's expiring Flame
Her Champion he acquires a deathless Fame
He pleads Humanity's neglected Cause
And wins from After Ages sure Applause.
RM

124 The Tree of Liberty, – with, the Devil tempting John Bull

Hand-coloured etching 36.4 × 26.2
Published 23 May 1798 by H. Humphrey
Library of Congress
BMC 9124

John Bull, gross and essentially stupid, has enough native sense to resist the blandishment of Fox, represented as a serpent offering the rotten apple of reform, associated by the most obvious of symbols with republicanism. This is not Gillray's only John Bull, but the oft-tempted and abused yokel is the most quintessential. His speech is bucolic but knowing: 'I hates Medlars. they'r so damn'd rotten they'll gee me the Guts-ach for all their vine looks!' His pockets are laden with the golden fruit of constitutional monarchy, enabling him to scorn medlars, a fruit deemed to be disgusting, inedible until it was on the very point of decay.

The twisted oak tree (perhaps a memory of that in *The Village Train*, no.36) is unforgettable – a glorious caricature of a tree – if such a thing is possible.

The serpent's body is no less remarkable, bespeaking direct observation, and this would not have been difficult: on 16 January 1797 Joseph Farington wrote a vivid description of a live South Carolina rattlesnake then exhibited in Bond Street.

125 Shrine at St. Ann's Hill

Hand-coloured etching with aquatint
36.5 × 25.8
Published 26 May 1798 by H. Humphrey
The British Museum, London
BMC 9217

During Fox's temporary 'secession' from parliament he retreated to St. Ann's Hill, where Gillray represents him, hair cropped in the republican manner, worshipping devotedly at the shrine of Revolution.

The use of aquatint is particularly bold and effective.

123

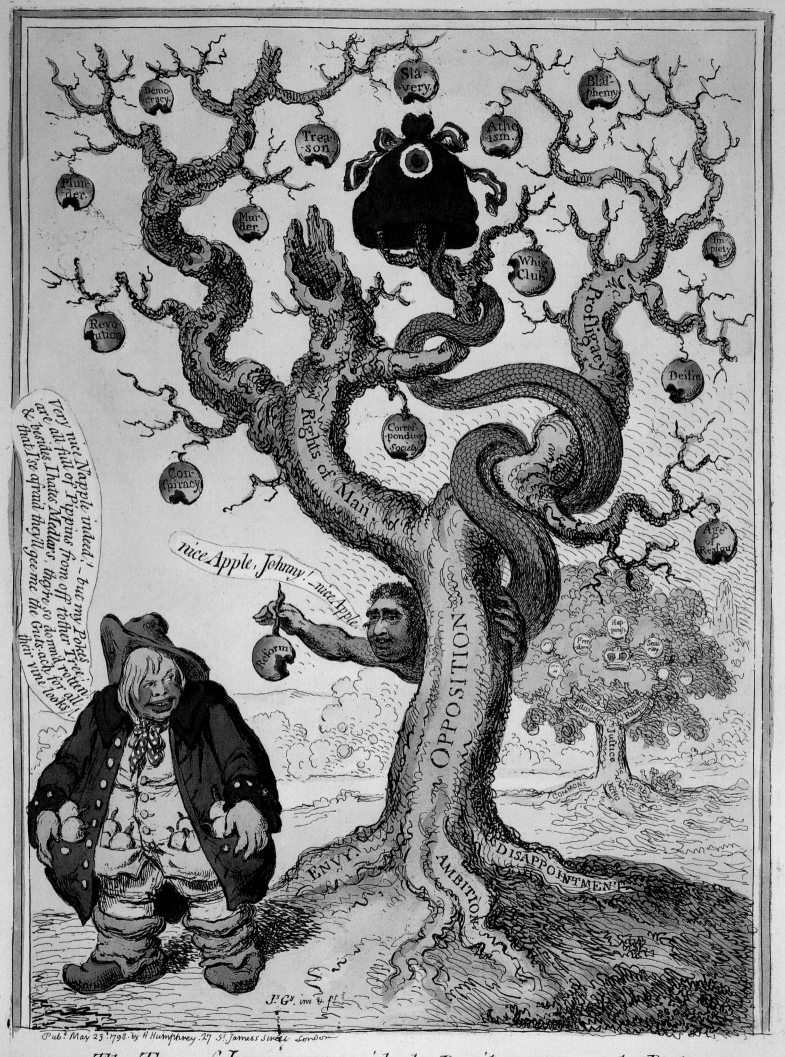

The Tree of LIBERTY, — with, the Devil tempting John Bull.

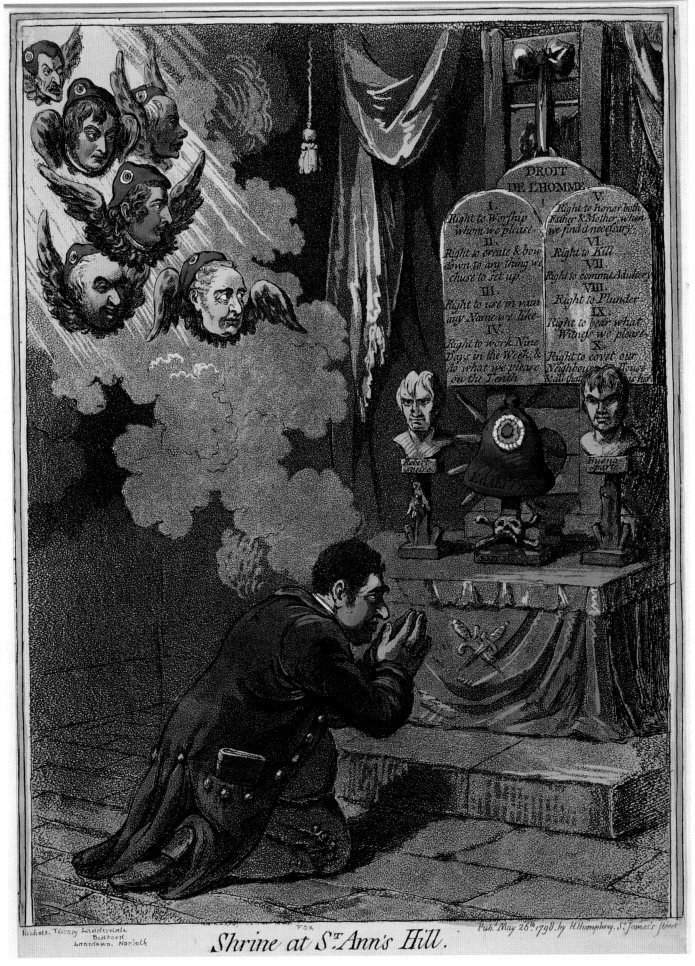

Shrine at St Ann's Hill.

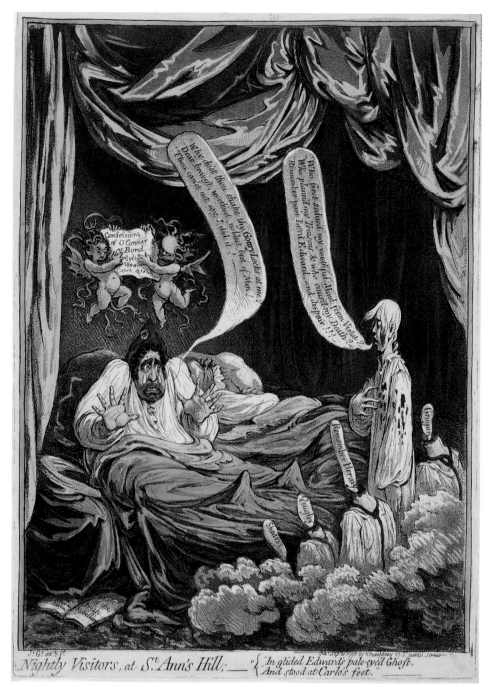

Nightly Visitors, at St. Ann's Hill;— {"In glided Edwards pale-eyed Ghost, And stood at Carlo's feet."

126

126 Nightly Visitors, at St. Ann's Hill

Hand-coloured etching with aquatint
36.5 × 25.8
Published 21 September 1798 by H. Humphrey
The British Museum, London
BMC 9244

This is clearly intended as a sequel to *Shrine at St. Ann's Hill* (no.125). Mrs Fox slumbers, unaware of the apparitions which are tormenting Fox. Fox had been a persistent critic of the government's Irish policy, and whenever possible the Tories painted him as an avid supporter of the most revolutionary Irish activities. He is confronted by the bloody ghost of Lord Edward Fitzgerald who had died when resisting arrest by the British.

127 Stealing off; – or – prudent Secesion

Hand-coloured etching with aquatint 25.7 × 36.2
Published 6 November 1798 by H. Humphrey
Library of Congress
BMC 9263

From May 1797 Fox temporarily exiled himself from the House of Commons (thus 'prudent Secesion'). Gillray depicts him fleeing with great speed for one so stout, the snarling 'opposition greyhound' Charles Grey beside him. In the background the opposition literally eat their words as Pitt, represented only by his papers, declares a succession of triumphs, including the Battle of the Nile. He also holds up 'O'Connor's list of secret traitors'. O'Connor was an Irish patriot acquitted of treason after Fox and others testified on his behalf. He later admitted guilt, greatly embarrassing the opposition.

Stealing off; — or — prudent Secesion: "—— courageous Chief ! N.B. The background contains , a corner of the House next Sefsion ; with the Reasons
The firft in Flight ! " } for Secefion; —also, a democratic Déjeuné : —(i.e. Oppofition Eating up their Words,

127

128A Comforts of a Bed of Roses 1806

Pen and ink, with extensive inscriptions in pen
and ink and pencil
25.3 × 41.6 (irregular)
*Print Collection, Miriam and Ira D. Wallach
Division of Art, Prints and Photographs, The New
York Public Library, Astor, Lenox and Tilden
Foundations*

On 3 April 1806 Lord Castlereagh in a
sarcastic speech told the government, which
then included Fox, that their difficulties were
not really so great, and that they may in fact
'be considered as on a Bed of Roses'. Gillray
at once seized upon the phrase, and in this
very rough draft sheet begins to play with
ideas suggested by it, three times noting
Castlereagh's speech, and also describing
in some detail his notion of a Death figure
emerging from under a bed in the lines at
the upper left of the sheet. This is an excellent
example of Gillray's mind working overtime,
establishing a verbal structure for a print.

On the verso of the sheet is a pen study
for a vast group of political figures at dinner,
given a working title of 'Grande Regime. I.e. a
Broadbottom Ordinary, a Cabanitical Dinner.'
This includes references to Grenville, Sheridan
and many others, and finds some expression
in *Political Mathematician's* of 4 Jan 1807
(no.136).

128B Comforts of a Bed of Roses 1806

Pen and black ink, with grey wash and
red chalk 32.5 × 38
*Print Collection, Miriam and Ira D. Wallach
Division of Art, Prints and Photographs,
The New York Public Library, Astor, Lenox
and Tilden Foundations*

A stout couple, indistinctly represented,
are embracing in a bower. The foliage
surrounding them is threatening and
anthropomorphic, suggesting little
harpy-like figures. This is the idea of the
bed of roses taken one step further, but
far from resolved.

A similar drawing was sold at Sotheby's,
London (15 July 1999), which bore another
draft title 'The Garden of Paradise, – or the
happy pair reposing upon this Bed of R. . . .
[sheet cut] . . . Vide Lord Castler'.

155

128C Comforts of a Bed of Roses

Hand-coloured etching with aquatint
26.2 × 36.5
Published 21 April 1806 by H. Humphrey
Library of Congress
BMC 10588

This represents the culmination of Gillray's musings on Castlereagh's speech; Fox and his wife are in a grand and enormous bed, the former awakened in terror as Napoleon leaps onto the bed, which is covered with a pattern of roses. As suggested in Gillray's early draft an emaciated figure of Death with an hourglass emerges from under the coverlet.

129 Visiting the Sick

Hand-coloured etching with aquatint
26.2 × 36.5
Published 28 July 1806 by H. Humphrey
Library of Congress
BMC 10589

Fox died on 13 September 1806, and this cruel print anticipates his demise as Gillray stalks him to the very edge of the grave. There is some slight mitigation in the fact that at the end of July it was believed there was some hope of Fox's recovery.

Fox, his legs horribly swollen, reclines miserably, scarcely noticing Mrs Fitzherbert, who proffers a rosary and chucks him under the chin. The Bishop of Meath, seen from behind, offers heartless words of warning, and is accompanied by Sheridan. At the extreme left Mrs Fox has swooned away and is attended by Lord Derby, whose mistress she had once been. Other friends and associates of Fox weep and wail in demonstrative fashion. The central figure at the sick bed, and in actuality a frequent and solicitous visitor, is the Prince of Wales, seen from behind, the upper part of his fashionably cut coat covered with flour from his wig.

This is the Prince of Wales's own copy of the print with wonderfully fresh and well-preserved colours.

130A View of the Hustings in Covent Garden

Etching with aquatint, proof impression in brown ink 25 × 35.5
The British Museum, London
BMC 10619

A working proof before the introduction of the crowd beneath the hustings. In general Gillray preferred to print with brown ink, which also had the advantage of blending better with hand-colouring.

130B View of the Hustings in Covent Garden

Hand-coloured etching with aquatint 25 × 35.5
Published 15 December 1806 by H. Humphrey and J. Budd
The British Museum, London
BMC 10619

This was etched by Gillray as a folding supplement to the *History of the Westminster and Middlesex Elections* (November 1806), which explains the addition of two publishers' names to the usual imprint of Hannah Humphrey, who would have sold it separately. The Westminster election, in which Sheridan expected to win Fox's old seat, was the most humiliating experience of his political career. The poll opened on 3 November, and when the vain and over-confident Sheridan attempted to address the crowd he was greeted with such howls of execration that he was forced to leave the platform unheard. It is this moment on which Gillray has fastened, and his caricature of Sheridan is one of his fiercest, enhanced by the fact that the other figures on the platform are scarcely caricatured. William Cobbett, a determined foe of Sheridan, wrote in the *Political Register* (8 November 1806, p.715) that he 'retired from before the people for the first time perhaps in his life, in an agony of mortification and in a rage too violent to admit of concealment'.

The election was a three-horse race: Sir Samuel Hood, a Grenvillite, with whom Sheridan would certainly have been returned had not a third contender emerged in the shape of James Paull, a rich independent radical who firstly outstripped Sheridan, until finally he fell behind allowing Sheridan an ill-tasting victory. It is Paull, a diminuitive figure, who stands besides Sheridan gesturing at him with contempt. At Paull's right stand his supporters, including the plump satisfied figure of William Cobbett. Behind Sheridan stands Samuel Whitbread, his expression sardonic, handing him a tankard of foaming beer. Samuel Hood, in naval uniform, turns away unable to disguise his amusement.

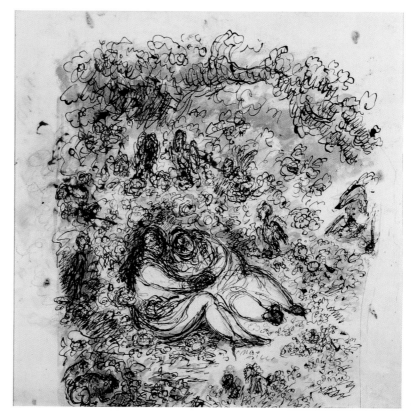

128B

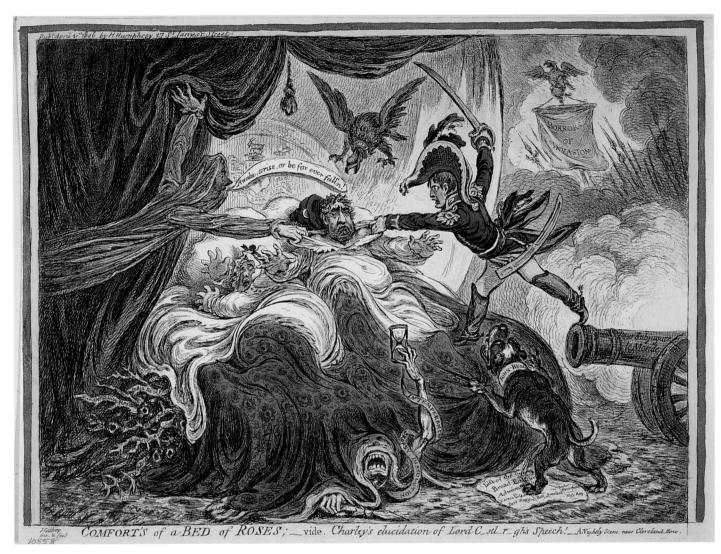

COMFORT'S of a BED of ROSES; — vide. Charly's elucidation of Lord C_stl_r_gh's Speech! — A Nightly Scene near Cleveland Row.

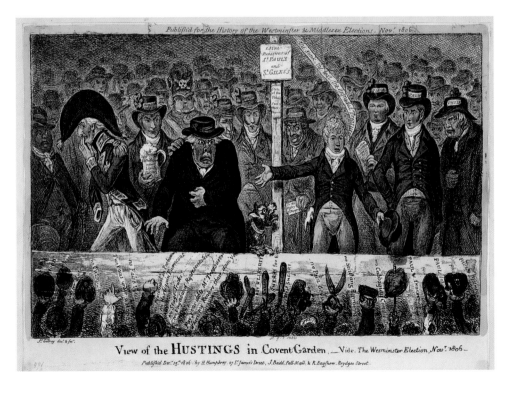

View of the HUSTINGS in Covent Garden, — Vide. The Westminster Election, Nov. 1806 —

131 Twelve Studies from Life 1802

Pencil on card
Each c.9.2 × 6
The British Museum, London

These little scraps of card, of which it is likely
that thousands were used, were vital tools
of Gillray's trade. He could carry them in his
pockets, and draw unobserved with one of
them cupped in his left hand. They were very
useful for getting a first quick impression,
dashed down probably in a matter of
seconds. One of these is a particularly telling
example, a card showing two rapidly
sketched figures, one in a large wig. They
are identified as Speaker and Chaplain of
the House of Commons. This must be a little
relic of Gillray's visit to the House of Common
at the end of February 1802, when a new
Speaker, Abbot, had just been elected – a
new character for Gillray. He rapidly noted
the essentials – small head, big wig, and
quickly used the characteristic in *Sketch of
the Interior of St. Stephens.*

Gillray could pursue his subjects with
remarkable brazenness. Farington wrote that
on 16 March 1806, when Benjamin West
was entertaining the American inventor of
the submarine, Robert Fulton, that 'Gillray
came and stayed some time. He appeared
to come to Fenton.' Unfortunately no print
resulted from this abuse of West's hospitality.

132 Sketch of the Interior of St. Stephens, as it now stands

Hand-coloured etching with engraving
36 × 25.6
Published 1 March 1802 by H. Humphrey
The British Museum, London
BMC 9843

Addington, in oratorical pose, addresses the
House on the subject of a peace treaty. The
Speaker is half hidden by his wig, which had
caused much merriment, and which Gillray
had sketched shortly before this print came
out. The figures on the benches behind
Addington are a mixture of caricatures,
notably a brutal study of Wilberforce, seen
behind Addington, holding a stick, and other
heads represented straightforwardly.
Hawkesbury sits at the left, hand to mouth,
the whole language of his body suggesting
ministerial uncertainty and incompetence.

133 Confederated Coalition; – or – The Giants Storming Heaven

Etching, engraving and aquatint 46.8 × 33.6,
with publisher's watercolour
Published 1 May 1804 by H. Humphrey
Andrew Edmunds, London
Provenance: Count von Starhemberg
BMC 10240

Although Gillray does not seem to have
had any single source, this large print is a
brilliant and sustained parody of the
aspirations, composition and poses of the
most ambitious and serious type of academic
history painting. Addington, armed with a
syringe, is engaged in a hopeless defence of
the Treasury, assailed by a pyramid of naked
'heroic' figures. This unholy alliance has Pitt
at its apex, hurling a packet of 'Knockdown
arguments'; Fox, held aloft at the left firing
a huge blunderbuss, is hairy and obese, in
contrast with the skeletal figure of Windham,
a dog barking at his feet, who holds an
elaborate shield with his left hand, and
prepares to hurl a huge spear with his right
hand. This figure in itself composes a
universal satire of a ridiculous academic type,
and is a remarkable anticipation of Honoré
Daumier's caricatures of certain French
academic paintings. There are numerous
subsidiary figures: Fox is supported by the
obese Marquis of Buckingham, and the
latter's brother Grenville; Canning, in heroic
pose and not caricatured, supports Pitt in
hurling documents at Addington. The day
before this satire was published Pitt was asked
by the King to form a new administration.

131

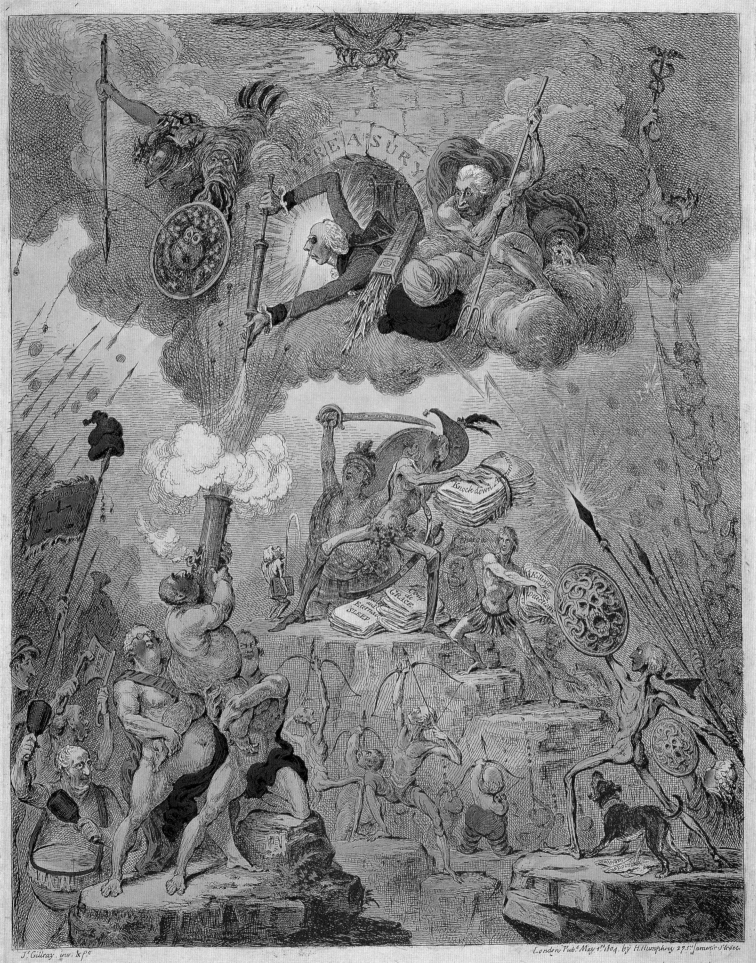

J. Gillray inv. & f.c.

London Pub.d May 1.st 1804. by H.Humphrey 27.5.t James's Street

Confederated-Coalition; _ or _ *The Giants storming Heaven;* _ with the Gods alarmed for their everlasting-
_abodes.

_ "They never complain'd of Fatigue, but like Giants refreshed, were ready to enter immediately upon the attack!"

_ "Not to destroy! but root them out of Heaven". Milton.

Vide Lord Chancellor's Speech
24.th April 1804.

Politics without Pitt and Fox: the 'Ministry of All the Talents'

The deaths of Pitt and of Fox, both in 1806, deprived Gillray of his two greatest targets – although both continue to appear in his work, but as ghosts. He would not leave even their Shades in peace. Yet undeniably although there were still marvellous political prints to come, some of the old snap went out of his work. Henry Addington, or Grenville in the Ministry of all the Talents which followed Pitt's death, were not quite the same thing, and perhaps the best attack on this administration, also nicknamed the 'Broadbottoms' – for the obvious reason that some of them had large bottoms – was that chronicling their demise in 1807, *Charon's-Boat; or the Ghost's of 'all the Talents' taking their last Voyage* (no.138).

134

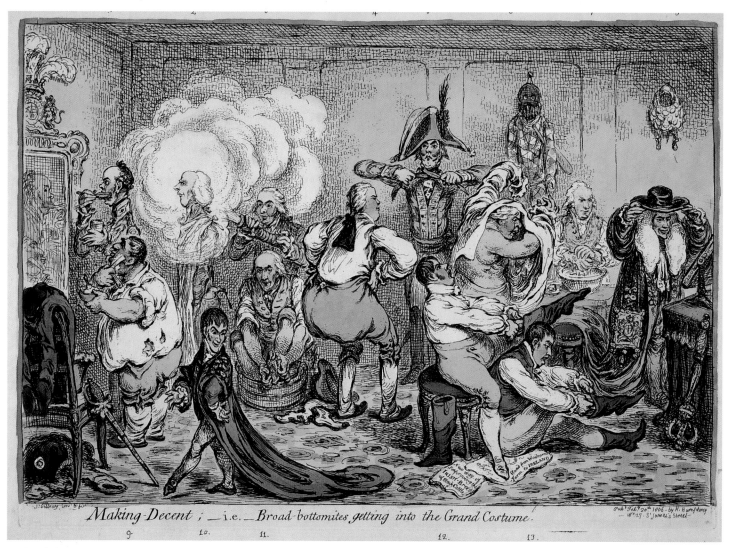

Making-Decent ; —i.e.—Broad-bottomites getting into the Grand Costume.

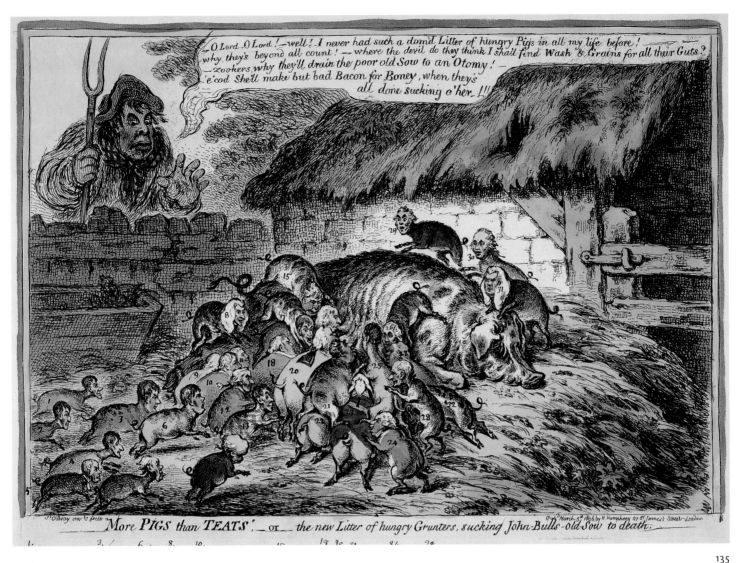

More PIGS than TEATS.' — or — the new Litter of hungry Grunters, sucking John-Bull's-old-Sow to death.

134 Making-Decent; i.e. Broad-bottomites getting into the Grand Costume

Hand-coloured etching 24.9 × 35.1
Published 20 February 1806 by
H. Humphrey
The British Museum, London, Banks Collection
BMC 10531

Members of the new ministry, headed by the central figure of Grenville, preen themselves in new clothes and appurtenances of office. Grenville pulls up his breeches emphasising the ample bottom, which gave another meaning to the 'Broad-Bottomed Ministry' — which in polite parlance meant its varied talents and breadth of individual opinion. Fox, his shirt disreputable, prepares to shave as he assumes the office of Secretary of State in the last year of his life.

135 More Pigs than Teats

Hand-coloured etching 25.1 × 35.3
Published 5 March 1806, by H. Humphrey
The British Museum, London, Banks Collection
BMC 10540

The print contains a multitude of figures, major and insignificant (indeed Sarah Banks felt the need to label them with numbers in this impression), but its central point is simple, and applicable to many governments before and since. The Broad-Bottomed Ministry, by its nature, had many claimants for office – and ensuing perquisites – from politicians of a very different cast from each other. Thus the indecent scramble for the succour available from the exhausted old sow, whose plight is observed by a dismayed John Bull, in a familiar incarnation as an uncouth but decent country yokel.

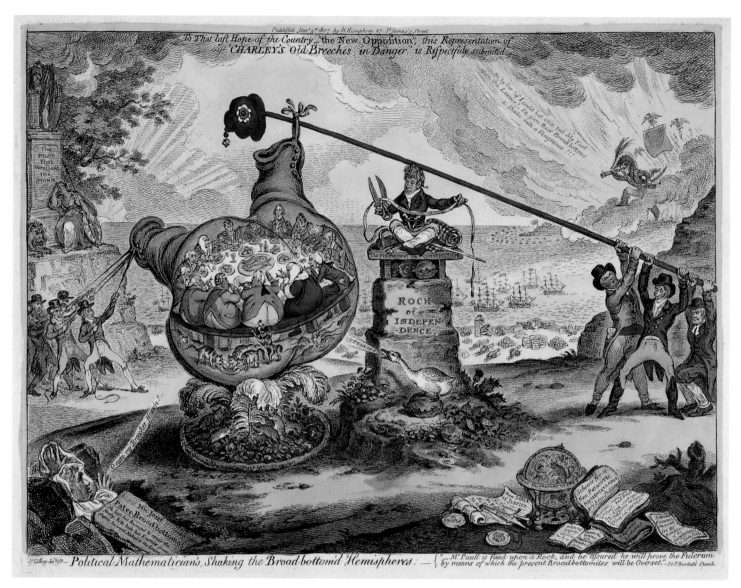

Political Mathematicians, Shaking the Broad-bottom'd Hemispheres: — {"— Mr. Paull is fixed upon a Rock, and be assured he will prove the Fulcrum by means of which the present Broadbottomites will be Overset."—Sir F. Burdett's Speech.

136

137

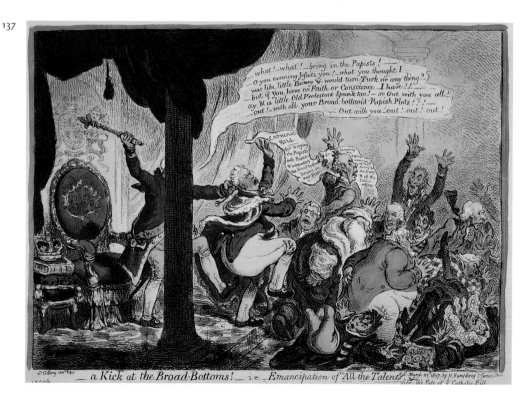

a Kick at the Broad-Bottoms! — i.e. *Emancipation of "All the Talents."*

136 Political Mathematician's, Shaking the Broadbottom'd Hemispheres

Etching and engraving 32.2 × 42.6,
with publisher's watercolour
Published 9 January 1807 by H. Humphrey
Andrew Edmunds, London
Provenance: Duke of Northumberland
BMC 10697

This curiously old-fashioned design,
reminiscent of emblematic Netherlandish
satires of the sixteenth century, centres
around a pair of the deceased Fox's
monstrous breeches – 'CHARLEY'S Old
Breeches', which sit above a rat infested set
of the Prince of Wales's feathers. Within the
interior of the breeches the Ministry of All
the Talents feast on the loaves and fishes of
office, whilst their radical opponents, includ-
ing William Cobbett, Sir Francis Burdett and
John Horne Tooke use poles and ropes to
try and topple them. Across the Channel
Napoleon watches, impatient that only
the sea prevents him from giving 'their
Broadbottoms a shake with a Vengeance'.

After the deaths of Pitt and Fox something
of the old snap disappears from Gillray's
political satires. He frequently has recourse
to showing them as ghosts, or as is the case
with Pitt here, a statue with its head obscured
by clouds. Fox emerges from the ground
below, bewailing the fate of his old breeches.

137 A Kick at the Broad-bottoms! – i.e. – Emancipation of 'All the Talents'

Hand-coloured etching with aquatint 25.8 × 34.6
Published 23 March 1807 by H. Humphrey
Library of Congress
BMC 10709

The so-called Ministry of All the Talents,
headed by Grenville, is routed by the
King, half concealed behind a pillar, who is
consumed by rage as he kicks Grenville and
his cohorts from his presence. Their fall was
precipitated by the King's opposition to the
proposed Army Bill which extended Catholic
Emancipation to the armed forces.

138 Charon's-Boat; or the Ghost's of 'all the Talents' taking their last Voyage

Hand-coloured etching with aquatint
24.5 × 35
Published 16 July 1807 by H. Humphrey
Library of Congress
BMC 10748

Four months after Grenville had fallen foul
of the King and been tumbled from office,
Gillray etched this elaborate epitaph. A
lumbering boat, in imminent danger of
foundering under the gross weight of 'All
the Talents', steers towards Hades, where
Fox and others wait to greet it. Its mast
sports the feathers of the Prince of Wales,
its splitting sail the motto of Catholic
Emancipation. Sheridan is being sick. The
huge bottoms of the Grenvillites, parodying
the mores of history painting, threaten to
capsize the vessel. This is one of Gillray's
last great political satires, for by 1807 his powers
were waning.

138

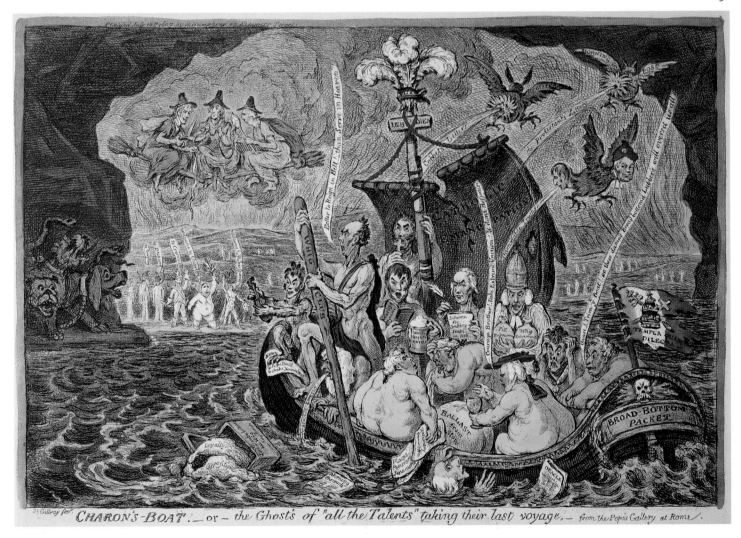

CHARON'S-BOAT. – or – the Ghosts of "all the Talents" taking their last voyage, – from the Popes Gallery at Rome.

139 Phaeton alarm'd!

Etching, engraving and aquatint 34 × 37.4,
with publisher's watercolour
Published 22 March 1808 with accompanying
letterpress
Andrew Edmunds, London
Provenance: Duke of Northumberland
BMC 10972

The highly idealised figure of Canning is
portrayed as Phaeton driving a chariot
across the sky in a semi-heroic composition
reminiscent of *Light expelling Darkness*
(no.108). Aware of his own financial interests
Gillray handles Canning gently, lending his
activity as Foreign Secretary an heroic cast as
he travels across a sky filled with malevolent
opponents, and above an earth set ablaze by
Napoleon and war. The bottom corners are
occupied by the shades of Pitt and Fox.

140 Tentanda via est qua me quoque possim Tollere humo

Etching, engraving and aquatint 51.3 × 39.1,
with publisher's watercolour
Published 8 August 1810 by H. Humphrey
Andrew Edmunds, London
Provenance: Duke of Northumberland
BMC 11570

Grenville was installed as Chancellor of
Oxford on 3 July 1810. The massive posteriors
assigned him by Gillray as a trademark are
seen perched in the flimsy seat of a balloon,
which itself takes the shape of Lord Temple.
The Catholic paraphernalia allude to
Grenville's well-known support for Catholic
emancipation.

139

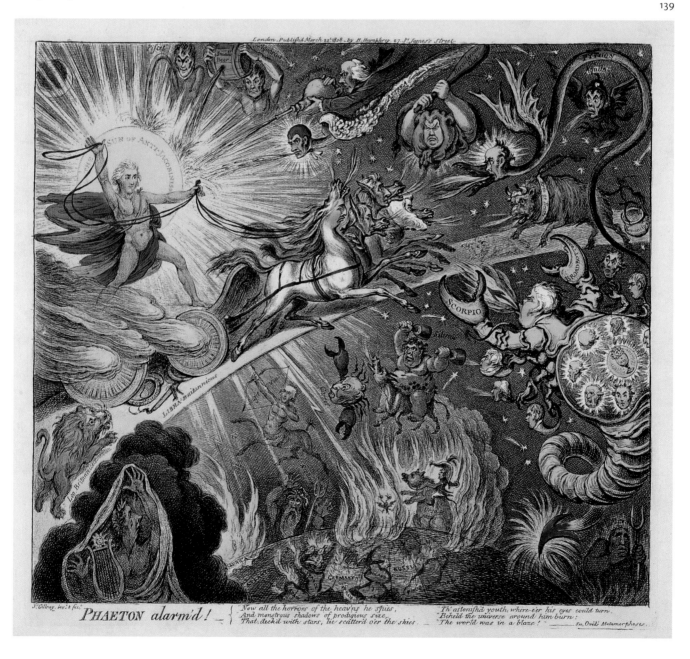

PHAETON alarm'd! — { "Now all the horrors of the heavens he spies, "Th'astonish'd youth, where-e'er his eyes could turn, "And monstrous shadows of prodigious size, "Beheld the universe around him burn: "That, deck'd with stars, he scatter'd o'er the skies. "The world was in a blaze!" _____ *In Ovid: Metamorphoses.*

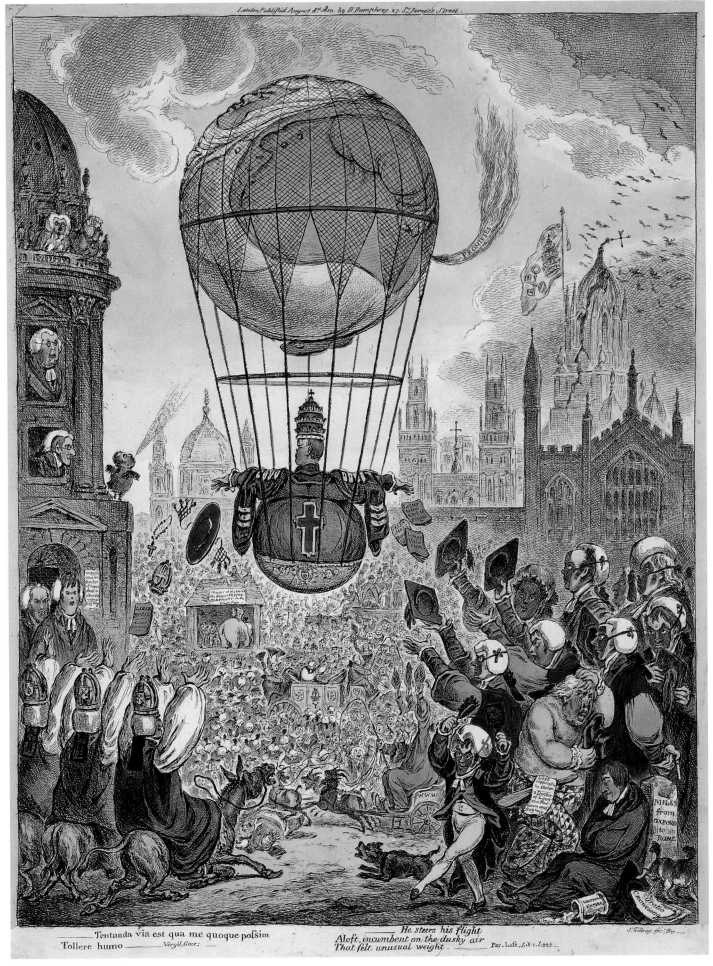

Tentanda via est qua me quoque possim He steers his flight

Tollere humo Virgil, Geor: Aloft, incumbent on the dusky air

That felt unusual weight Par. Lost, Lib. 1. l. 225.

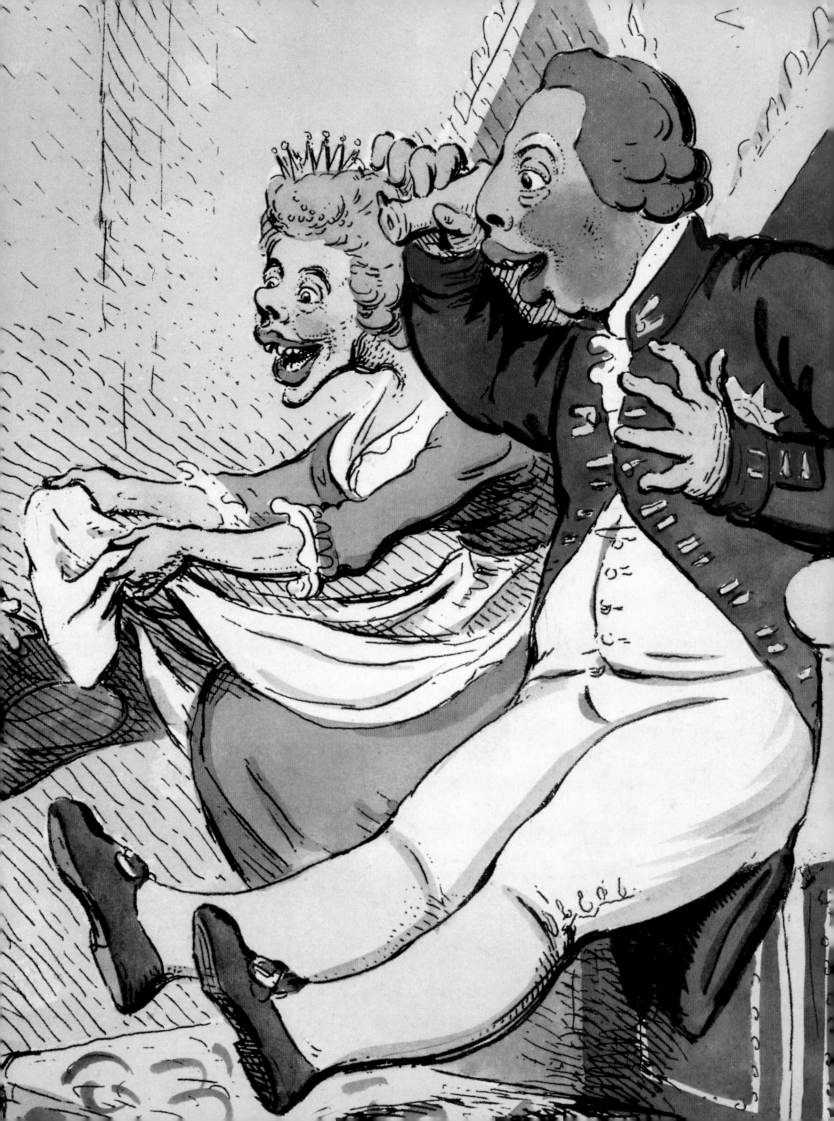

Royalty

Gillray's caricatures of the hapless George III and his family are amongst his most famous and inventive prints. The family and their various foreign appurtenances were targets any caricaturist would have rubbed his hands over. The King was subject to bouts of insanity; he favoured the Tories and hated the Whigs. He detested his son, the Prince of Wales, who reciprocated his loathing with interest. Queen Charlotte was not only foreign and an uncritical admirer of Pitt, she was also as ugly as sin.

The King and Queen were austere and parsimonious, their household of legendary dullness from which their offspring could not escape too soon. The Prince of Wales was dissolute, a voluptuary and a reckless spendthrift. He was egged on in his excesses by Fox and his Whig cronies, who hoped to inherit power when the King was finally certified, and the Prince appointed Regent.

Around these central figures, with Hanoverian goggle eyes and gaudy uniforms, sported the Royal Dukes – happily ensconced with their various mistresses.

detail, no.146

George and Charlotte

141 Studio of John Bacon (1740–99)

A **George III**

B **Queen Charlotte**

Pair of marble busts, each 42.5 high
Private Collection

The brewer Samuel Whitbread (see no. 130)
commissioned this pair of busts of George III
and Queen Charlotte to commemorate the
royal party's visit to his brewery in Chiswell
Street, London on 26 May 1788. A plate on
the back of each bust is inscribed: *The King,
Queen, Princess Royal / and Princesses Augusta
and Elizabeth, / accompanied by/ the Duke of
Montague, Earl of Ailesbury / Duchess of
Ancaster and Countess Harcourt / visited my
Brewery/ XXVI May. MDCCLXXXVII. /
S.Whitbread.*
RM

141B

141A

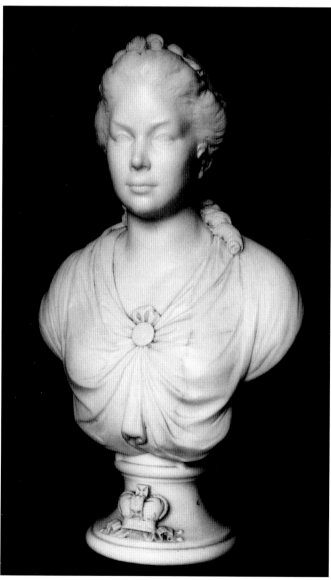
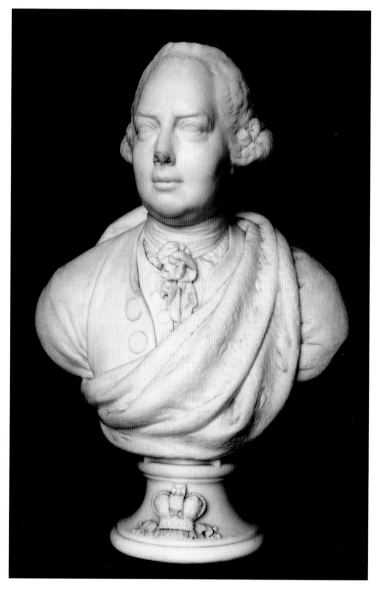

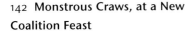

MONSTROUS CRAWS, at a New Coalition Feast.

142 Monstrous Craws, at a New Coalition Feast

Hand-coloured etching with aquatint 37.4 × 47.3
Published 29 May 1787 by S.W. Fores
The British Museum, London
BMC 7166

This superb aquatint, one of Gillray's greatest prints, added a new element of monumentality to his work. The subject is now a familiar one: the greed and miserliness of the King and Queen, and the perpetual need for funds of the Prince of Wales. All three are seated in front of the Treasury gate. They sit gorging themselves on a great bowl of guineas, inscribed 'John Bull's Blood'. The print is a satire on a partial reconciliation between the Prince and his parents after Pitt had recommended the settlement of his debts, and the granting of additional income, including the revenue from the Duchy of Cornwall. The Prince, looking covertly at the Queen, wears a fool's cap with the three ostrich feathers. The King is dressed as an old woman. The full spate of Gillray's venom is, however, preserved for the Queen, who is depicted as a revolting old hag with goggling eyes and a large mouth into which she greedily shovels guineas, using two ladles. The King's figure is placid, but Charlotte thrusts her body forward with almost sexual avidity. For some years, for reasons not entirely clear, she would be the subject of some of Gillray's most brutal personal caricatures.

All three sport 'craws' coming from their necks, that of the Prince being symbolically empty, while those of the King and Queen are like massive breasts culminating in nipple like knots which graze the gold. These unpleasant forms and the title of the print were inspired by the exhibition in London in 1787 of 'three wild human beings; each with a Monstrous Craw, being two females and a male, with natural large craws under their throats, full of big moving glands which astonishingly play all ways within their craws, according as stimulated by either their eating, speaking, or laughing'. It is probable also that Gillray knew Jusepe de Ribera's etching of *A Man with a Goitre*, which is close in appearance to some of his caricatures of the Queen.

The rather crude hand-colouring, typical of Fores's publications, disguises the quality of the aquatint, and flattens out the space skilfully created, particularly by the enlarged hands of the King and Queen which reach forward to the spectator.

143 Jusepe de Ribera (1591–1652)
Large Grotesque Head *c.1622*

Etching, first state of two 21.7 × 14.5
The British Museum, London

Ribera's prints were well known to English artists, and had been used as source material by a number of earlier caricaturists, including George Bickham and Joseph Goupy (see no.29). This revolting face probably helped Gillray develop his image of Queen Charlotte and, later, that of the French sans-culotte.

144A Wierd-Sisters; Ministers of Darkness; Minions of the Moon

Hand-coloured etching 25 × 35
Published 23 December 1791 by H. Humphrey
The British Museum, London, Banks Collection
BMC 7937

Gillray prominently acknowledges his pictorial source: 'To H.Fuzelli Esqr. This attempt in the Caricatura-Sublime is respectfully dedicated'. Fuseli's famous painting of the *Weird Sisters* was engraved in mezzotint by J.R. Smith and published on 10 March 1785 (no.145). The parody, although instantly recognisable, is not that close, the overlapping profiles being the main point of resemblance. The subject of the print, the temporary insanity of the King from November 1788 until February 1789, is seemingly approached by Gillray rather late in the day, although Wraxall in his *Memoirs* (1884, v.291) described the print as appearing during the Regency crisis of February 1789. The moon is composed of profiles of the King, shadowed and with eyes closed, and the Queen, brightly lit and with a sprightly countenance. The three witches from *Macbeth* are Dundas at the left, Pitt and Thurlow. Their expressions and the nervous action of their fingers bespeak tension and anxiety – well justified, since if the King had been declared insane the Whiggite Prince of Wales would have become Regent.

The colouring of Gillray's prints, particularly those published by Mrs Humphrey, can vary significantly. This early impression, probably purchased by Miss Banks at the time of publication, is in very limited, rather cold colour, appropriate to the chilling moonlit scene.

143

To H. Fuzelli Esq.ʳ this attempt in the Caricatura-Sublime, is respectfully dedicated.

WIERD-SISTERS; _MINISTERS of DARKNESS; MINIONS of the MOON."

"They should be Women! _ and yet their beards forbid us to interpret, _ that they are so."

144B Wierd Sisters; Ministers of Darkness; Minions of the Moon

Hand-coloured etching 25 × 35
Published 23 December 1791 by H. Humphrey
The British Museum, London
BMC 7937

This is also an early impression, but the colouring of the faces is much ruddier, and lacks the dramatic effect of the previous example.

145 John Raphael Smith after Henry Fuseli (1741–1825)
The Weird Sisters

Mezzotint 45.5 × 55.5
Published 10 March 1785 by J.R. Smith
The British Museum, London

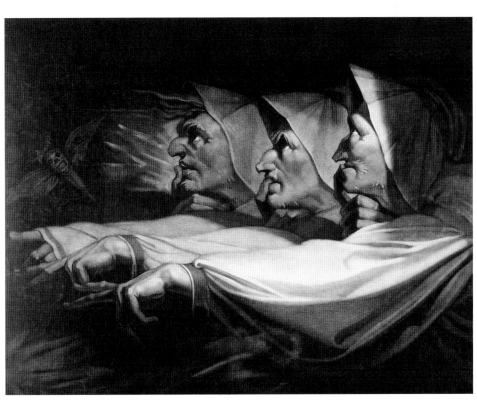

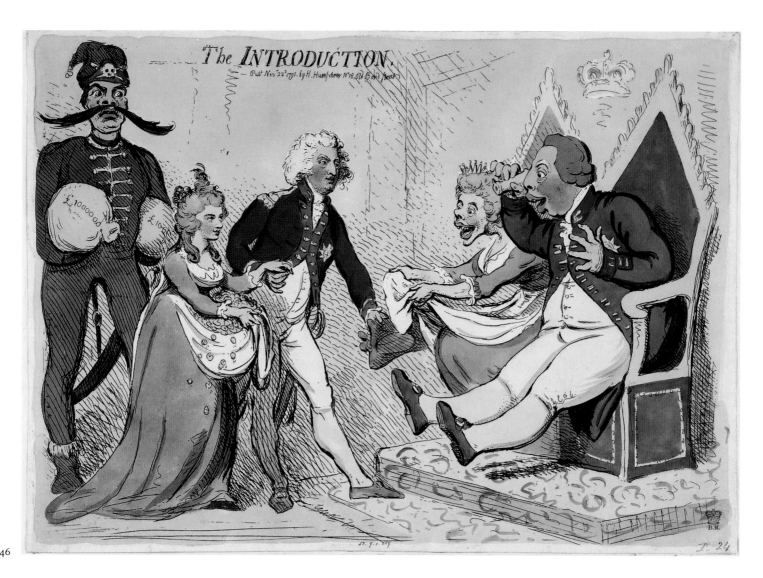

The INTRODUCTION.

146

146 The Introduction

Hand-coloured etching 24.6 × 34.9
Published 22 November 1791 by H. Humphrey
The British Museum, London
BMC 7917

This is one of many satires on the betrothal
of the Duke of York to Princess Frederica,
eldest daughter to the King of Prussia. It was
popularly, but mistakenly, believed that her
dowry was enormous. Ever perceived by
Gillray as being avaricious to the core, the
King and Queen react with delight as the
Duke presents his bride, the couple being
accompanied by a huge Prussian soldier
carrying sacks of money.

147 Anti-Saccharrites, – or – John Bull and his Family leaving off the use of Sugar

Hand-coloured etching 31.4 × 39.8
Published 27 March 1792 by H. Humphrey
The British Museum, London
BMC 8074

The King and Queen endeavour to set a
good example to their dismayed daughters,
advocating giving up West Indian sugar as
a gesture of protest against the slave trade.
Gillray's implication, typical of his approach
to the royal couple, is that it is miserliness
rather than fine feelings that motivates their
economy. This is a particularly telling pair
of royal portraits: Charlotte is bony, eager,
with filed teeth; the King is plump and
amiable – a Royal version of John Bull. He
is represented in profile, which is invariably
the case in Gillray's prints, almost as if he
were parodying the coins or medals that
carried an idealised profile. Many other
caricaturists followed his example.

148A Unknown artist
Medal of George III

Bronze, diameter 5
Private Collection

148B Unknown artist
Medallion showing Queen Charlotte

Bronze, diameter 3
Private Collection

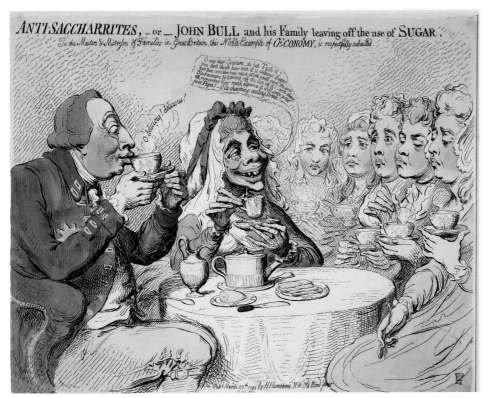

149 **Taking Physick – ; or – The News of Shooting the King of Sweden!**

Hand-coloured etching 24.7 × 35
Published 11 April 1792 by H. Humphrey
The British Museum, London
BMC 8080

Gustavus III of Sweden had died on 29 March after being shot in the Stockholm Opera House on 16 March. The King and Queen, both severely caricatured, are seated side by side on a lavatory, and they react to Pitt's news with grotesque agitation and dismay, the King expostulating 'What? Shot? What? what? what? Shot! shot! shot!'

No doubt Gillray expected his audience to make the link between this print and the earlier *Introduction* (no.146), contrasting the expectant and elated monarchs on their thrones, and this horrified and undignified couple.

147

149

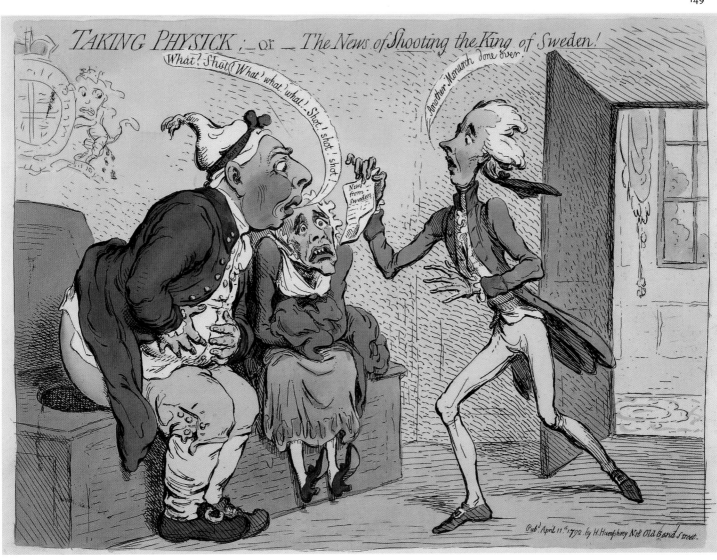

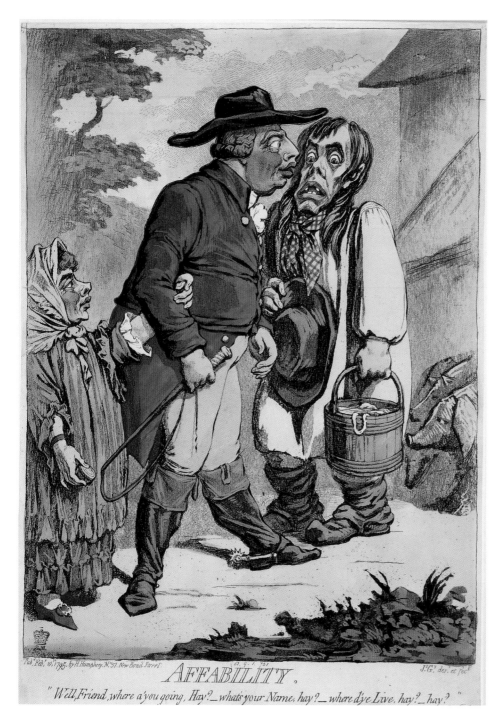

AFFABILITY.

" Well, Friend, where a'you going, Hay? _ what's your Name, hay? _ where d'ye Live, hay? _ hay? "

150

150 Affability

Hand-coloured etching with aquatint 34.5 × 24.5
Published 10 February 1795 by H. Humphrey
The British Museum, London
BMC 8616

The King, popularly known as 'Farmer George', established three farms at Windsor and took the keenest interest in them. He was a familiar figure to the villagers, although his unannounced visits to their cottages must have been alarming occasions, and a number of anecdotes testify to encounters such as that represented here. The agriculturist Arthur Young was given a guided tour by the King and recorded that 'His farm is in admirable order, and the crops all clean and fine . . . I found fault with his hogs; he said I must not find fault with a present to him. The Queen was so kind as to give them from Germany . . . We must not examine them too critically . . . He is the politest of men.'

The juxtaposition of the thrusting, eager profile of the King with the petrified figure of the yokel is a notable grouping, set off by the dumpy little figure of the Queen, ill at ease, clutching the King with one hand and her snuffbox with the other. Nonetheless, this is one of Gillray's kinder portrayals of her, and a certain perverse affection for the couple is evident. The King's peremptory patterns of speech, 'where d'ye Live, hay? – hay?', are a variant on the more usual 'What! What! What!' found, for example. in *The Hopes of the Party* (no.54).

The etching technique is novel and experimental; Gillray, as well as using etched lines and aquatint, appears to have worked the copper with some kind of an abrasive to score the metal with densely textured lines. This anticipates twentieth-century techniques, and was developed further by Gillray in *Patriotic Regeneration* (no.66).

151 C.H. Hodges after Thomas Stothard (1755–1834)
Royal Beneficence

Mezzotint, printed in colour, finished by hand
48.5 × 60.2
Published 20 April 1793 by C.H. Hodges
Private Collection

DIDO FORSAKEN. Sic transit gloria Reginæ.

152A Pierre Conde (active 1795) after Richard Cosway (1742–1821)
George IV as Prince of Wales

Stipple engraving 26 × 19.8
Published 1795 by P. Conde
The British Museum, London

Cosway's idealised simpering portraits are at the furthest possible remove from Gillray.

152B John Conde after Richard Cosway
Mrs Fitzherbert

Stipple engraving 42.4 33.6
Published 1792
The British Museum, London

153 Dido Forsaken

Etching 27.1 × 37.1
Published 21 May 1787 by S.W. Fores
The British Museum, London
BMC 7165

During debates about the Prince of Wales's debts, Fox had denied that any marriage ceremony had taken place between the Prince and Mrs Fitzherbert. Gillray casts her as a semi-heroic Dido, seated on a funeral pyre, watching in dismay as a tiny boat, ironically called 'Honour', crewed by the Prince, Fox, North and Burke, sails away, the Prince announcing, 'I never saw her in my life.' Behind her Pitt and Dundas blow away her worthless royal regalia.

154 Bandelures

Hand-coloured etching 29.5 × 40
Published 28 February 1791 by S.W. Fores
The British Museum, London, Banks Collection
BMC 7829

The Prince of Wales, corpulent and indolent, idles the time away with a bandelure (in modern parlance, a yo-yo), a toy associated in contemporary French prints with useless and frivolous émigrés. Mrs Fitzherbert fondles his belly, but welcomes the attentions of Sheridan, who has his hand on her breast and his raddled face thrust close to hers. Above the fireplace a bust of the Emperor Claudius, who was deceived and humiliated by Messalina, emphasises the theme of cuckoldry – always of interest to Gillray and his clients. From January 1789 it had been falsely rumoured that the bankrupt Sheridan and his wife had been avoiding his creditors by staying with Mrs Fitzherbert.

The faces are carefully worked up in stipple, only marginally caricatured. Few artists could draw hands like Gillray, and they here signal a complicated roundabout of complacency and deceit.

The hand-colouring is rather heavily applied, typical of Fores's publications.

thus sits the Dupe, content!
: Pleases himself with Toys, thinks Heav'n secure,
Depends on Womans smiles & thinks the Man
His Soul is wrapt in, can be nought but true;

BANDELURES.

London Pub^d Feb 18 1791. by S.W. Forer. N°3 Piccadilly.

'Fond Fool, arouse! shake off this childish Dream,
'Behold Love's falshood, Friendships perjur'd troth;
'Nor sit & sleep, for all around the World
'Thy shame is known, while thou alone art blind—

Blackmore

154

155 A Voluptuary under the horrors of Digestion

Etching and engraving, in stipple and line,
printed in brown ink 37 × 29.8
Published 2 July 1792 by H. Humphrey
The British Museum, London
BMC 8112

Sated by his gross meal, his distended belly threatening the security of the one waistcoat button still fastened, the Prince of Wales picks his teeth and reclines in a chair amongst the wreckage of his debauchery. An overflowing chamber pot partially covers unpaid bills, and the dice in the foreground allude to his gambling habits. The unfinished façade of Carlton House, his planned residence, can be seen through the window. Everything is indicative of excess, folly, ill health and debauchery, even to the finest details such as a little pot amongst the jelly glasses, labelled 'For the Piles'. His coat of arms is parodied by the introduction of a crossed knife and fork.

This is a two-sided satire. Although usually seen in coloured impressions, which conceal much of the detail, this uncoloured example, like its pair *Temperance enjoying a Frugal Meal* (no.156) is executed in the most refined technique of dot and line – usually reserved for the most softened and idealised portraits. The point would not have been lost on contemporary collectors, that a highly conventional technique was being deployed to a different and more mischievous end.

J.G. design et fecit.

Pub. July 2. 1792. by H. Humphrey, N° 18 Old Bond Street.

A VOLUPTUARY under the horrors of Digestion.

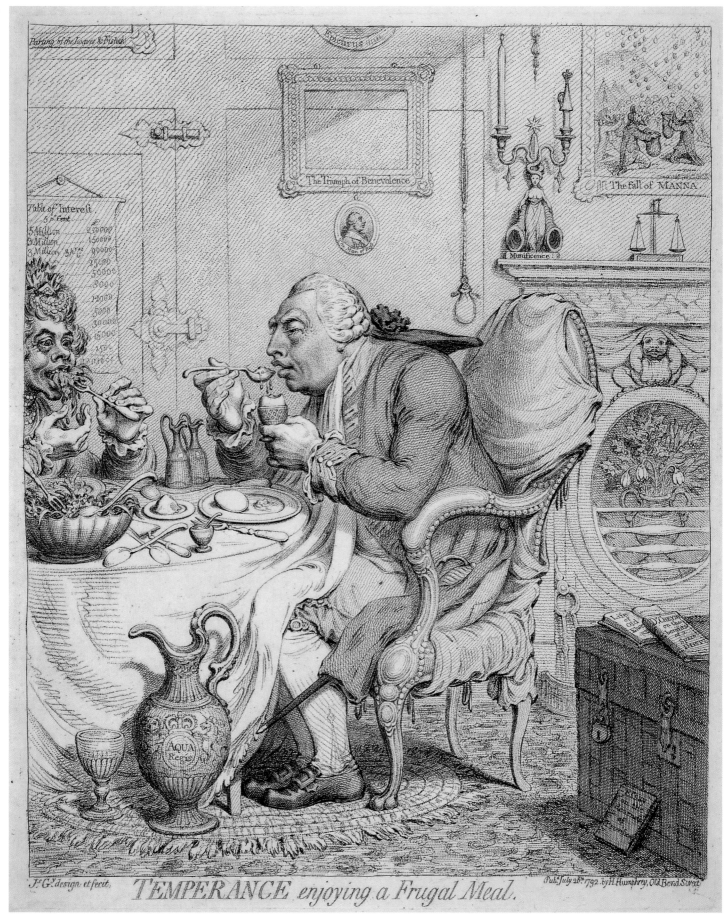

TEMPERANCE *enjoying a Frugal Meal.*

156

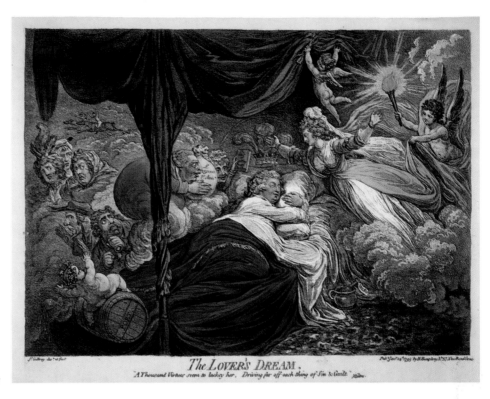

The LOVER'S DREAM.
'A Thousand Virtues seem to lackey her, Driving far off each thing of Sin & Guilt.'

157

156 Temperance enjoying a Frugal Meal

Etching and engraving in line and stipple,
printed in brown 36.8 × 29.5
Published 28 July 1792 by H. Humphrey
The British Museum, London
BMC 8117

This is the inevitable sequel and companion
print to *A Voluptuary under the horrors of
Digestion* (no.155), and engraved in exactly
the same delicate manner. The meanness of
the King and Queen and their self-restraint
at table were well known, and a favourite
subject of Gillray and other caricaturists.
The King is concentrating hard on a slightly
underdone boiled egg, with another to come.
He has dispensed with bread. The Queen
eats oafishly, cramming salad into her mouth.
Everything in the room is indicative of
miserliness, from the King's patched trousers
to the empty fire-grate. His chair is covered
by a cloth, an empty frame on the wall is
ironically labelled 'The Triumph of
Benevolence', and their drink is water.

This pair of prints is amongst the finest of
all royal portraits, the drawing is superb and
not a detail is superfluous.

157 The Lover's Dream

Hand-coloured etching and aquatint 32.1 × 42.6
Published 24 January 1795 by H. Humphrey
The British Museum, London
BMC 8610

For most of Gillray's characters, sleep was
a time for nightmare and the appearance
of ghastly apparitions. On this occasion,
however, the Prince of Wales slumbers
blissfully, his arms wrapped round a pillow
as he anticipates the raptures of his
forthcoming marriage to Caroline of
Brunswick, who hovers above him, attended
by putti. In fact they had never met, and
the Prince had agreed to marriage only
with the condition that his income should
be increased and his debts settled. Behind
him the King emerges from a cloud with a
large bag of money, while the Queen holds
a book, 'The Art of getting Pretty Children'.

The Prince's cronies and mistresses scatter,
dismayed by this royal conversion to virtue.
In ascending order are found Lord Derby as
the infant Bacchus, rolling away on a bottle
of port, Fox and Sheridan, subdued by the
King's vast backside, and three mistresses,

the most prominent being Mrs Fitzherbert,
who clasps her hands in despair.

Caroline's arrival was delayed and when
they finally met mutual antipathy was instant.
He was fat. She stank. The Prince turned to
James Harris, Baron Malmesbury, who had
escorted Caroline to England, and gasped
'Harris, I am not well, pray fetch me some
brandy.'

In January 1796 they somehow managed
to produce a child, Princess Charlotte;
thereafter he abandoned Caroline.

Royal Lovers

The late Georgian public, and later that of the Regency, had an insatiable appetite for scandal, and – plus ça change – Royal dalliances, affairs, and mistresses set up with a coach and four and a mansion without the pretence of concealment. The Prince of Wales, and his brothers, the Royal Dukes, provided ample material for Gillray. His prints, which would have been well known to Royalty, are some of his best, funny and in some cases, such as *Fashionable Contrasts* (no.161), or *Lubber's-Hole* (no.159), outrageous in their gross simplification.

158

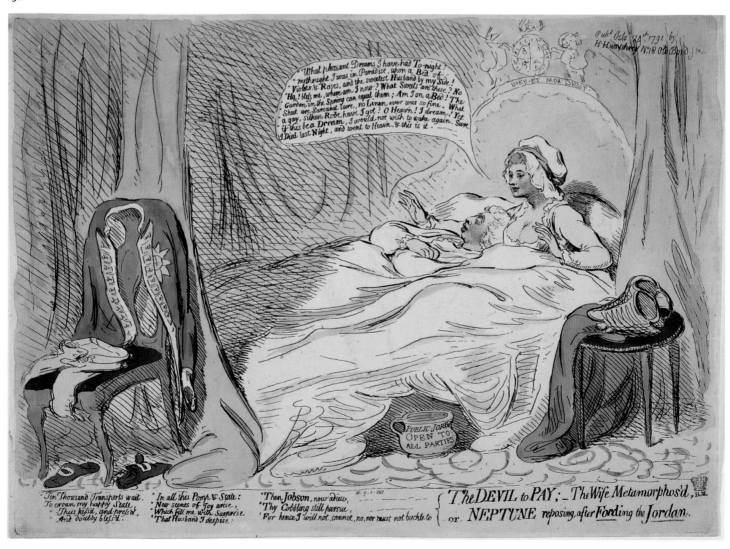

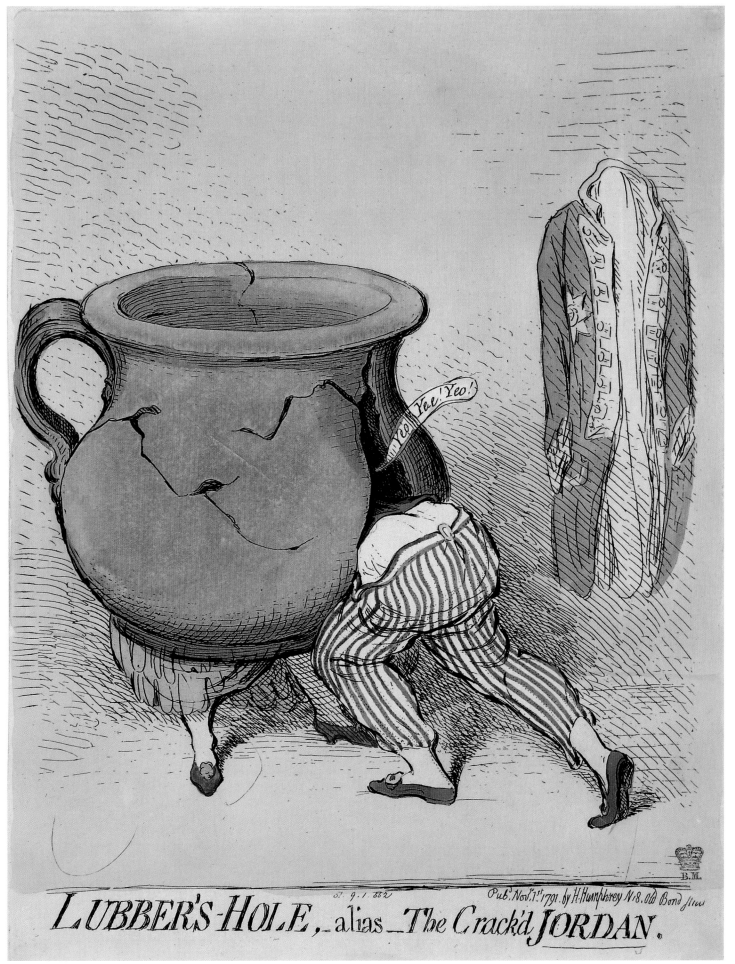

LUBBER'S·HOLE, _ alias _ The Crack'd JORDAN.

158 The Devil to Pay; – The Wife Metamorphos'd, or Neptune reposing, After Fording the Jordan

Hand-coloured etching 25 × 34.5
Published 24 October 1791 by H. Humphrey
The British Museum, London
BMC 7908

The liaison between the Duke of Clarence, third son of George III, and the celebrated actress Dorothy Jordan rapidly became public knowledge and the subject of many scurrilous caricatures. This freely etched plate is not especially unkind, and the actress's sweetness of countenance is acknowledged.

The Duke is deep in post-coital slumber, his head on Jordan's bosom. She sits up alert and exclaims her good fortune. Their clothes, deftly characterised, are carelessly disposed, suggesting the ardour with which they have disrobed and scrambled into bed. A chamber pot beneath the bed is inscribed 'Public Jordan – Open to all Parties'. This was a very obvious pun, since a 'jordan' was the slang word for a chamber pot. A knowing public would also have instantly deciphered the last phrase of the title, 'Neptune reposing, after Fording the Jordan', since the Duke was a serving naval officer, and Dorothy Jordan had formerly been the mistress of the actor-manager Richard Ford.

159 Lubber's-Hole, – alias – The Crack'd Jordan

Hand-coloured etching 27.1 × 21.2
Published 1 November 1791 by H. Humphrey
The British Museum, London
BMC 7909

A week after the publication of *The Devil to Pay* (no.158) Gillray returned to the subject of the Duke of Clarence and Dorothy Jordan, but this time with a brutally explicit image. She has been transformed into a giant chamber pot with a huge fissure, into which the Duke plunges his body, uttering nautical cries of glee, 'Yeo! Yee! Yeo!' His coat, hanging on the wall, and his striped trousers denote his naval calling.

The sexual symbolism of a cracked vase was not new; it had been used in earlier English satires, and also in a best-selling French print after Jean-Baptiste Greuze, *La Cruché Cassée*, but Gillray's use of it is altogether original.

Claire Tomalin (*Mrs. Jordan's Profession*, 1994, p.123) has memorably described the effect this print must have had on its victim: 'It was bad luck for Dora that Gillray was a genius, and that he struck off here a brilliant surreal image that imprints itself on the eye at once, and stays. It must have haunted her: an image to make its victim reluctant to face friends, enemies, family – Fanny (her daughter) was old enough to be aware of written words and pictures – colleagues, servants, or even strangers in the street; that could wake her at two in the morning in a cold sweat of humiliation.'

160 John Ogborne after George Romney (1734–1802)

Mrs. Jordan in the Character of the Country Girl

Stipple engraving 38 × 28.6
Published 24 June 1788 by J. Boydell
The British Museum, London

By all accounts Dorothy Jordan (1762–1816) was a woman of great charm and intelligence. She lived with the Duke at Bushy Park and bore him ten children.

161 Fashionable Contrasts; – or – The Duchess's little Shoe yeilding to the Magnitude of the Duke's Foot

Etching 25 × 35, with publisher's watercolour
Published 24 January 1792 by H. Humphrey
Andrew Edmunds, London
BMC 8058

Frederick, Duke of York, the second son of George III, married Frederica, eldest daughter of the King of Prussia, in 1791, returning with her to London in November of that year. She was not noted for her personal charms. However, the approach of her birthday on 18 January led to a frothy gushing from the press, much of it centring on the delicacy of her feet and her exquisite shoes. Gillray's unsigned response was of devastating simplicity.

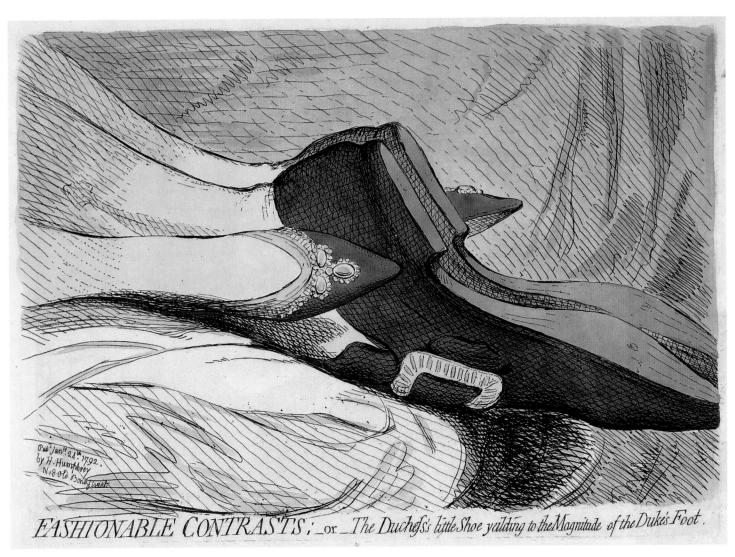

FASHIONABLE CONTRASTS; _or_ The Duchess's little Shoe yielding to the Magnitude of the Duke's Foot.

161

162 Facius after Benjamin West
(1738–1820)
Angelica and Medoro

Stipple engraving 35.5 × 26
Published 1 June 1778 by J. Boydell
Private Collection

The softness of stipple engraving was
ideally suited to sentimental subjects such
as this, which overflowed from the London
printshops, and which were widely
expanded. The effect of Gillray's satires of
sexual scandals would have been much
enhanced by his customers' familiarity with
such prints.

163 Pietro Bettelini (1763–1829)
Aminta

Stipple engraving printed in brown 32.5 × 25
Published 3 September 1788 by Molteno,
Colnaghi & Co
Private Collection

Bettelini was an Italian engraver who,
like others, came to London to train with
Bartolozzi and to take advantage of the
thriving London print trade.

The ORANGERIE; — or — the Dutch Cupid reposing, after the fatigues of Planting. — Vide. The Visions in Hampton Bower.

164

164 The Orangerie; – or – the Dutch Cupid reposing, After the Fatigues of Planting

Hand-coloured etching 25.5 × 35.5
Published 16 September 1796 by H. Humphrey
Library of Congress
BMC 8822

William V of Orange came as a refugee to England from Holland in January 1795. Lord Holland wrote, 'When the Prince of Orange resided at Hampton Court, his amours with the servant-maids were supposed to be very numerous.' He was also noted for his heavy-lidded somnolence, duly depicted in *The Bridal Night* (no.165), and was shown by Gillray in *Pylades and Orestes* (1 April 1797) as slouching down Bond Street, half asleep.

Gillray's continuing fascination with dream and nightmare subjects is again evident, as troops of heavily pregnant women float accusingly through the sky, clutching their bellies, while the portly Cupid sleeps, his spade strategically deployed. The women are drawn with exceptional delicacy, and the group of three on the right shows his predilection for deploying figures in symmetrical groups of three or four, here echoed by the three freshly planted pots of orange trees in the foreground. The little oranges themselves bear the embryonic faces of William, their eyes closed in sleep.

165 The Bridal Night

Etching, engraving and aquatint 30.6 × 45.4,
with publisher's watercolour
Published 18 May 1797 by H. Humphrey
Andrew Edmunds, London
BMC 9014
Provenance: Duke of Northumberland

The Princess Royal and the Prince of
Wurttemberg were married at St James's on
17 May 1797, and the royal party then drove
to Windsor Lodge to dine. Gillray's print was
published the next day, although it is safe to
assume that it had been in the making some
time before that. It is one of the greatest *tours
de force* of group caricature ever produced.

The bridegroom is monstrously stout, his
belly preceding his backside by several feet –
it was rumoured maliciously that he needed

a semi-circle cut out of a dining table to
accommodate it. His face is turned away and
he holds the hand of his bride who looks
winsome behind her fan. The King, his plain
costume in marked contrast to that of the
over-adorned Duke, leads the procession to
the bedroom, his face hidden by a pillar. He
is accompanied by the Queen, half obscured
by a poke-bonnet, and carrying a bowl of
steaming posset. Much of the art of this
caricature lies in the deliberate obscuring of
the features of the main protagonists. The
Prince's belly could speak for itself, and
Gillray's George III was now so well known
that a leg, a hat or a speech bubble could
serve as identification. Pitt holds a sack of
£80,000 as he stands beneath a picture of
'Le Triomph De L'Amour' – Cupid riding on

an elephant – just in case somebody had
missed the point.

On the right ostrich feathers swirl, as
princesses and ladies of the court pay their
respects. Most remarkable of all is the group
of royal dukes at the right, headed by a
corpulent Prince of Wales, his expression
supercilious. His thick legs are in contrast
to the spindly shanks and knock-knees of
Prince William of Gloucester. Behind the
Prince of Wales are the upturned features of
the Duke of Clarence and, beyond him, the
Duke of York, completing a rogue's gallery
of Hanoverian faces. Behind them, seen in
profile, is William V of Holland. He appears
to be asleep.

165

The BRIDAL-NIGHT.

Social, Personal and Observational Satires

Gillray is probably best known for his political prints, or for his unforgettable caricatures of Napoleon. However, throughout his career, and increasingly in his later years, he delighted in the social spectacle of raucous Georgian London, its scandals, faux pas, ridiculous fops and sinful hostesses. It was something of a closed world, and some of his targets were very obscure figures indeed, only known at the time for their taste in shoes, for a particularly juicy affair, or for their sheer ugliness. His main targets were to be found in high life, but he also attended to characters he saw in the streets, probably also within Mrs Humphrey's shop itself. He made little sketches and memoranda; above all he looked – and remembered what he had seen. He also acted as a conduit for the ideas of others, amateurs with an axe to grind, or a frivolous social joke. They sent him a rough sketch or a short memorandum even, and these he rapidly etched into finished form.

detail, no.203

Collectors & connoisseurs

The years of Gillray's career saw a great expansion in British collecting. Old Master paintings flooded in from aristocratic families fleeing from revolutionary France, and were snapped up by British collectors. Their wives or mistresses paraded through the auction houses. Savants and antiquaries returned from abroad laden with treasures, and they were a species in whose excesses and follies Gillray delighted.

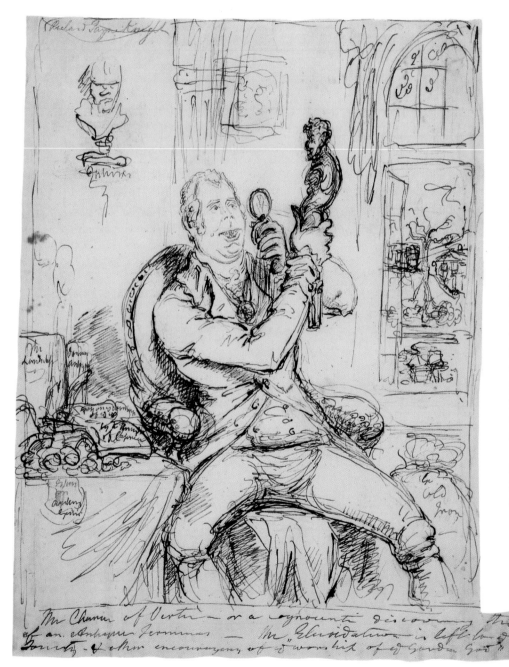

166A The Charm of Virtu – or – A Cognoscenti Discovering the Beauties of an Antique Terminus 1794

Pen and ink 31.1 × 23.1
Print Collection, Miriam and Ira D. Wallach Division of Art, Prints and Photographs, The New York Public Library, Astor, Lenox and Tilden Foundations

It is unfortunate that Gillray never turned this caricature of Richard Payne Knight into a print. Payne Knight was a famous collector and self-appointed arbiter of taste. He is here seen holding a small statue, an 'Antique Terminus', his thumb buttressing the figure's erect member, which he observes with enthusiasm through a magnifying glass. This is a reference to Payne Knight's *Discourse on the Worship of Priapus* which was printed for private circulation in 1786. However, it is likely that the drawing was made in 1794 when an attack on the *Discourse* was published in the *British Critic*. In the same year his portrait by Thomas Lawrence – an especially unctuous performance – was exhibited at the Royal Academy.

A roughly sketched bag at the lower right is inscribed 'Old Iron', an allusion to Payne Knight's grandfather, a famous iron-master and the founder of the family fortune.

166 A

166B

A companion sheet is covered with rough drafts for the planned title. Gillray took immense pains over the wording of his prints, which evolved simultaneously with the pictorial design.

167 After Thomas Lawrence (1769–1830)
Richard Payne Knight

Stipple engraving proof impression 37.8 x 32.5
Private Collection

168

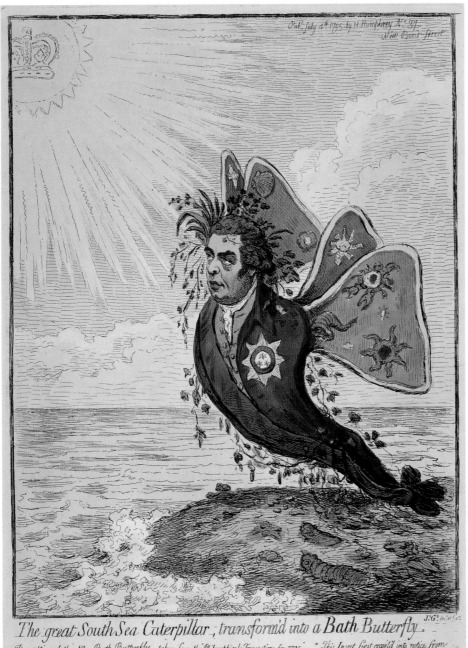

The great South Sea Caterpillar, transform'd into a Bath Butterfly

Description of the New Bath Butterfly taken from the Philosophical Transactions for 1795 — "This Insect first crawl'd into notice from among the Weeds & Mud on the Banks of the South Sea; & being afterwards placed in a Warm Situation by the Royal Society, was changed by the heat of the Sun into its present form — it is noted & Valued Solely on account of the beautiful Red which en.... its Body, & the Shining Spot on its Breast; a Distinction which never fails to render Caterpillars valuable.

168 The great South Sea Caterpillar, transform'd into a Bath Butterfly

Hand-coloured etching 35.1 × 24.7
Published 4 July 1795 by H. Humphrey
Library of Congress
BMC 8718

Sir Joseph Banks (1743–1820) made his name by travelling round the world on Captain Cook's voyage (1768–71). From 1778 until his death he was a somewhat dictatorial president of the Royal Society. Gillray here satirises his elevation to the Order of the Bath on 1 July 1795.

169 A Peep at Christies; – or – Tally-ho, & his Nimeney-pimmeney Taking the Morning Lounge

Etching, engraving and aquatint 35.5 × 25.3, with publisher's watercolour
Published 24 September 1796 by H. Humphrey
Andrew Edmunds, London
Provenance: Duke of Northumberland
BMC 8888

The Earl of Derby, accompanied by his mistress, the actress Elizabeth Farren, takes a 'Morning Lounge' in the exhibition rooms of the auctioneer James Christie. He examines a painting of the culmination of a fox-hunt called *The Death*. This is a cruel reference to the illness and impending death of his wife, following which he married Elizabeth Farren. She uses a quizzing glass to look at a painting of *Zenocrates and Phrynne*, an imaginative grouping of an austere and virtuous Greek philosopher (396–314 BC) with a courtesan of the same period. The libidinous theme is reinforced by three fashionable figures who are looking at a painting of Susannah and the Elders. Elizabeth Farren had scored a particular success in 1786 playing the role of Niminey-Piminey in General Burgoyne's play *The Heiress* – which had been dedicated to Lord Derby. This was ten years before the publication of this print, an indication of the sophistication of allusion that Gillray expected his public to recognise. 'Tally-Ho' refers to Lord Derby's enthusiasm as a sportsman. A prominent Whig, he was a favourite target of Gillray's, invariably represented as a stunted little figure shaped like a dumpling.

James Christie started his business in 1766, and from 1770 until 1823 he was established at 125 Pall Mall. He was well connected, being friendly with Joshua Reynolds, David Garrick and Richard Sheridan, and his portrait was painted by Thomas Gainsborough, who was his next-door neighbour. By 1796 his auction rooms had become a fashionable gathering place – thus the 'Morning Lounge' – and the French Revolution ensured a constant supply of important paintings consigned by penniless émigrés. In the absence of public galleries it was also an important place for artists and the public to look at a constantly changing exhibition of paintings, drawings and prints, and Gillray signalises his familiarity with the inscription 'Ad vivum'.

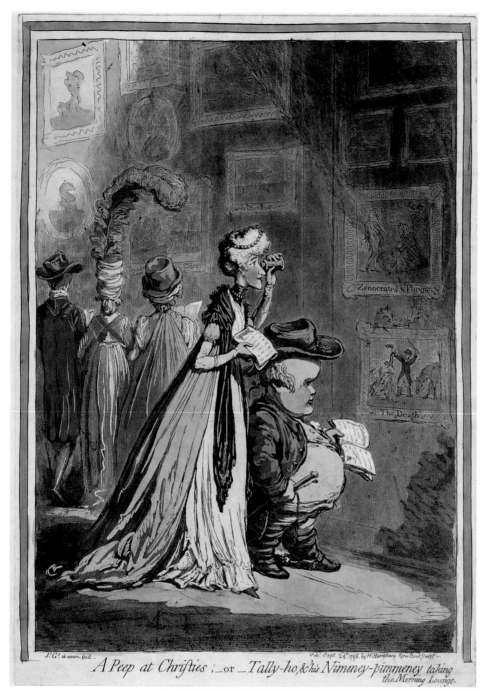

A Peep at Christies ;_or _Tally-ho, & his Nimeney-pimmeney taking the Morning Lounge.

169

170 Contemplations upon a Coronet

Hand-coloured etching with aquatint 35.8 × 25.8
Published 25 March 1797 by H. Humphrey
The British Museum, London, Banks Collection
BMC 9074

Lady Derby died on 14 March 1797. Almost immediately Gillray rushed into print with this caricature showing Miss Farren contemplating the delights of marriage with Lord Derby now awaiting her. The objects with which she intends to adorn herself include, on the chair, one of the then fashionable belly pieces. With indecent haste the wedding took place on 1 May.

When this print was published Hannah Humphrey was evidently in the course of moving her establishment from Bond Street to St James's Street, as both addresses are given.

171 The Marriage of Cupid & Psyche

Hand-coloured etching with aquatint 26 × 36.5
Published 3 May 1797 by H. Humphrey
The British Museum, London
BMC 9076

Gillray was unable to keep away from the subject of Miss Farren and the Earl of Derby. Two days after their marriage he produced this inspired travesty of the then celebrated cameo known as the Marlborough Gem, after its owner. The rear-most putto wears a red bonnet, indicative of Lord Derby's supposed republican sympathies. His small stature is again compared to his new wife's height. The torch of Hymen held before the couple has been extinguished.

172 Francesco Bartolozzi (1727–1815) after G.B. Cipriani
Cupid and Psyche

Stipple engraving printed in red. A proof before lettering 27.3 × 20.8
Published in *Geminarum antiquarum delectus, ex praestantioribus desumptus quae in dactyliothecis Ducis Marburiensis conservantur*, 1790–1.
The British Museum, London

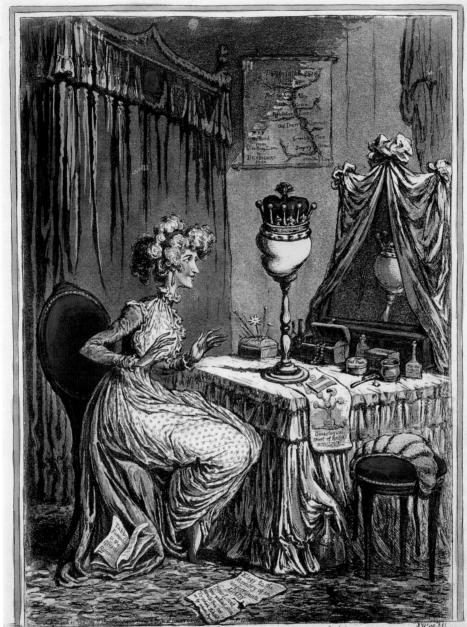

CONTEMPLATIONS *upon a* CORONET; ___ "A Coronet!_o bless my sweet little heart!_ ah, it must be mine, now there's nobody left to hinder!___ and then,_hey, for my Lady Nimminimmey-pimmimmey!_O, Gemmini! no more Straw-Beds in Barns; no more scowling Managers! & Curtsying to a dirty Public!_but a Coronet upon my Coach; Dashing at the Opera! shining at the Court; O dear! dear! what I shall come to!

170

171

The MARRIAGE of CUPID & PSYCHE.

173 Francesco Bartolozzi and Charles Knight after Thomas Lawrence (1769–1830)

Miss Farren

Stipple engraving printed in colours 55.4 × 35.3
Published 25 February 1791
The British Museum, London

Lawrence's painting, one of his most beautiful early works, is in the Metropolitan Museum, New York. This is the sixth and published state of the print. Most of the engraving was in fact done by Bartolozzi's pupil Charles Knight, but Bartolozzi put his name to it before publication.

174 Anne Seymour Damer (1749–1828)
Portrait bust of Miss Farren *c.*1789

Marble 59.7 high
National Portrait Gallery, London

174

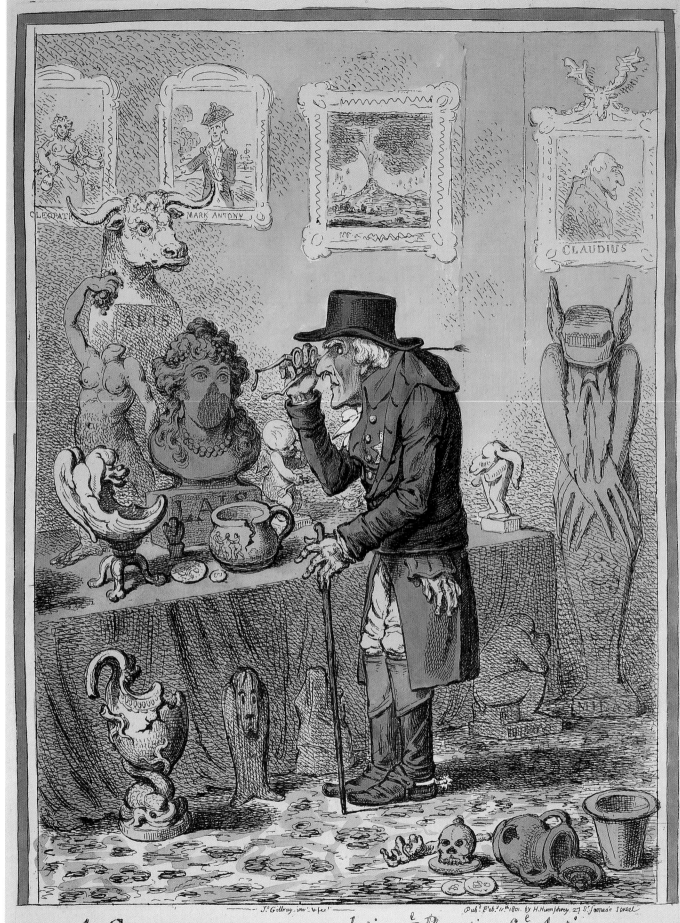

A COGNOCENTI contemplating y̆ Beauties of y̆ Antique.

175A A Cognocenti contemplating ye Beauties of ye Antique

Hand-coloured etching 36 × 35.2
Published 11 February 1801 by H. Humphrey
Library of Congress
BMC 9753

Sir William Hamilton (1730–1803), antiquary, collector, British Minister to Naples, and author of *Observations on the Volcanoes of the Two Sicilies* (1776 and 1779), is one of the most famous cuckolds in British history. Emma Hart, whom he had met in London when she was the mistress of his nephew Greville, arrived in Naples in 1786 when she was 21. Against his better judgement Hamilton soon fell in love with her, and married her in London in 1791, supposedly because 'she only of the sex exhibited the beautiful lines he found on his Etruscan vases'. Horace Walpole noted cattily that he had 'married his gallery of statues'.

The Hamiltons first met Nelson when he landed at Naples in 1793. At the time of his return in 1798 he was the Hero of the Nile. He saw much of Emma and a close attraction soon formed. At the time of issue of this print in November 1800 the Hamiltons were back in England, by which time Emma was pregnant with Nelson's child.

Old and spent, Hamilton views his collection myopically, almost every object indicating the indignity of his situation. The bust of Lais, half-broken, represents Emma, who is also shown in a picture on the wall as Cleopatra, whilst Nelson is shown as Mark Antony.

175B A Cognocenti contemplating ye Beauties of ye Antique

Pen and dark brown ink over pencil, with brown and pink watercolour washes 19.5 × 16.2
The British Museum, London

This preliminary drawing for the print of 11 February 1801 is drawn with great agitation and vehemence, the jagged pen lines scoring the paper, into which in places the corrosive iron gall ink has eaten. Gillray has concentrated mainly on the face and posture of Sir William Hamilton, and the ludicrous ancient statues which are so prominent in the print are only indicated by scrawled lines. A few crossed out words indicate the theme of antiquity, but he has not yet decided on a title.

175B

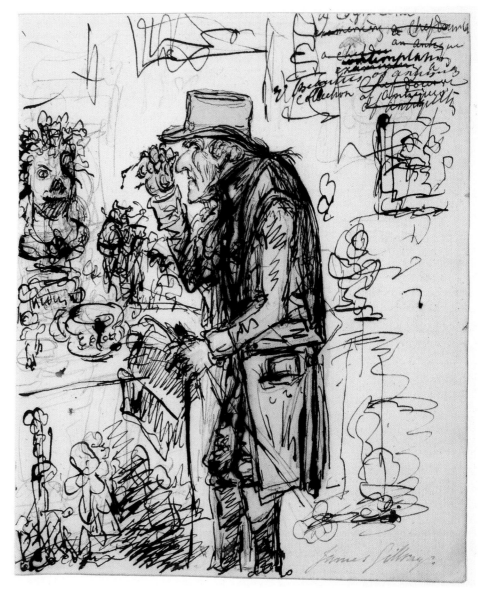

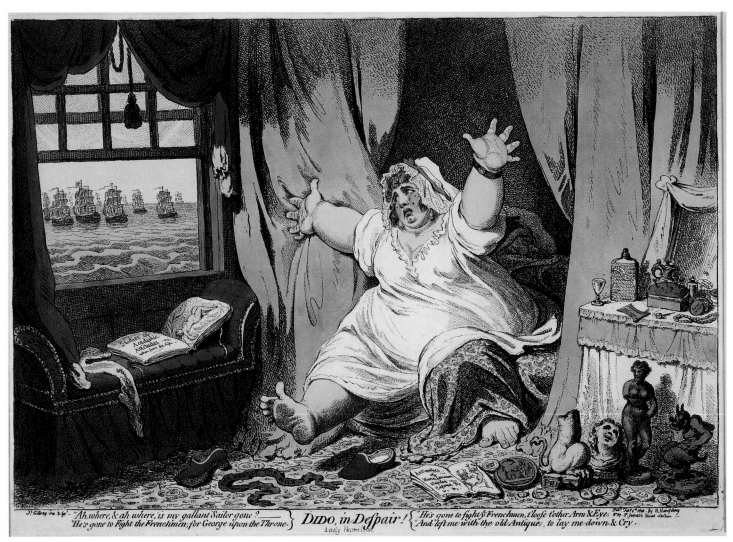

"Ah, where, & ah where, is my gallant Sailor gone?____
He's gone to Fight the Frenchmen, for George upon the Throne.} DIDO, in Despair! {He's gone to fight ye Frenchmen, t'loose t'other Arm & Eye:
And left me with the old Antiques, to lay me down & Cry.

Lady Hamilton

176

176 Dido, in Despair!

Hand-coloured etching 25.3 × 35.9
Published 6 February 1801 by H. Humphrey
The British Museum, London
BMC 9752

Emma Hamilton in an attitude of great
distress, parodying her famous 'Attitudes',
bewails the departure of Nelson and his fleet.
Sir William slumbers by her side; ridiculous
objects from his collection are scattered on
the carpet. Many artists, notably George
Romney, had portrayed her youthful beauty,
which with Hamilton's encouragement she
had put to good use in performing a series
of Attitudes, illustrations of which are in a
book on the window seat. She later turned
to fat, although to do her justice she was
pregnant when Gillray designed this print.
His conception is unforgettable and as
sober a scholar as T.S.R. Boase was moved
to write that her 'vast ungainly limbs have
the monumental forms of Picasso's
neo-classical phase' (*English Art: 1800–1870,*
Oxford 1959, p.57).

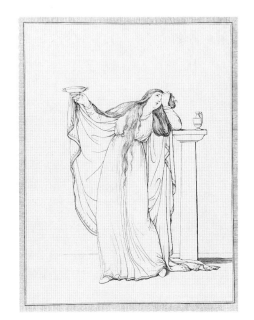

177

177 Thomas Piroli (1752–1824) after
Frederick Rehberg (1758–1835)
**Drawings Faithfully Copied from
Nature at Naples** 1794

Plate 4. *A Woman in Despair*
Line engraving 26.5 × 20.3
The British Museum, London

Emma Hamilton's dramatic performances
of the Attitudes were one of the sights of
Naples, and also attracted fashionable
throngs when she travelled. They were
much admired by Goethe. Other spectators
admired the poses, but confessed their
disillusion when they heard her plebeian
accent.

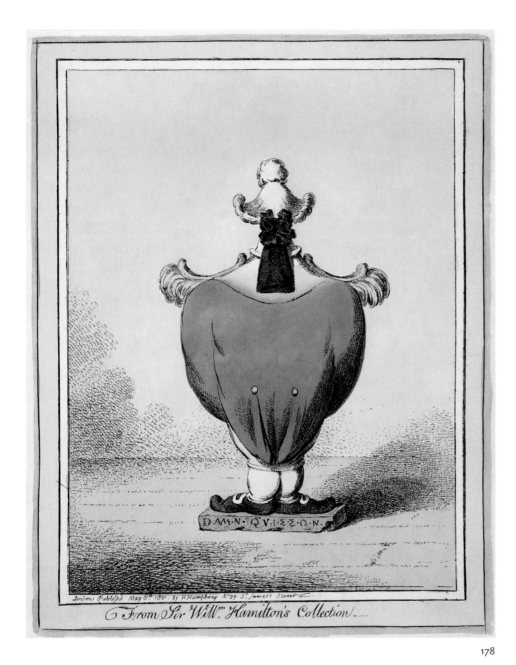

From Sir Willm. Hamilton's Collection

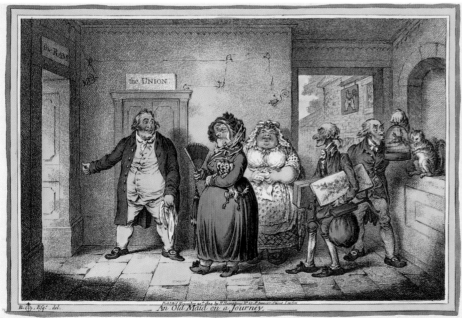

An Old Maid on a Journey

178 From Sir Willm. Hamilton's Collection

Hand-coloured etching 25.5 × 20
Published 8 May 1801 by H. Humphrey
The British Museum, London
BMC 9754

Hamilton, viewed from behind, has been transformed into a vase with a chipped base, his wig forming its lid. Gillray, in his most simple and effective mode, thus identifies a character with his most obvious interest and attribute.

179 An Old Maid on a Journey

Etching and engraving 25.2 × 38, with publisher's watercolour
Published 20 November 1804 by H. Humphrey
Andrew Edmunds, London
Provenance: Count von Starhemberg.
BMC 10300

This design by Brownlow North was published on the same day as *Company shocked at a Lady getting up to Ring the Bell* (no.203). The old lady has traditionally been identified as Miss Sarah Sophia Banks (1744–1818). The only sister of Sir Joseph Banks (see no.168), she was one of the most remarkable and innovative collectors of her time. She collected books, coins, medals and prints, but most originally she was an insatiable collector of every conceivable kind of printed ephemera. After her death her sister-in-law, Lady Banks, gave the collection to the British Museum, and the Department of Prints and Drawings possesses more than 19,000 items, more material being housed in the British Library.

She was a keen collector of caricatures, and many of her Gillray prints, frequently annotated, are to be found in this catalogue. She seemingly did not own this print, but if it caused offence it did not prevent her continuing to be a customer of Hannah Humphrey.

180A An Amateur Going a Picture-Hunting on a Frosty Morning c.1808

Pen and brush with grey and blackish brown ink
22.6 × 22.2
The British Museum, London

In the print resulting from this carefully blocked-out drawing, the title has been changed to *Maecenas in pursuit of the Fine Arts*. Gillray's target was the Marquis of Stafford (1758–1833), a noted collector and patron of the arts, here seen in profile approaching the entrance of Christie's. His movement is comical, with his waist thrust forward and his posterior projecting backwards in a manner beloved of low comedians. His green spectacles protect his notoriously weak eyes. Stafford later became the 1st Duke of Sutherland. He owned the great Titians, Raphaels and Poussins now on loan from the present Duke to the National Galleries of Scotland.

Gillray's first idea for a title, 'Going to British Institution on a frosty morning', seems to have been quickly changed. The words British Institution have been crossed out, and Stafford's destination changed to Christie's. The British Institution, founded in 1805 to exhibit publicly pictures from British collections, was only a short distance from Christie's in Pall Mall. This is another example of Gillray's simultaneous use of words and images to define his subject.

180B Maecenas, in pursuit of the Fine Arts – Scene, Pall Mall; a Frosty Morning

Hand-coloured etching 26 × 20
Published 9 May 1808 by H. Humphrey
The British Museum, London
BMC 1106

Gillray's drawing has now been developed to target Christie's as well as Stafford. On the pillar by the entrance hangs the customary catalogue, here announcing the sale of '800 Capital Pictures to be Sold by Mr. Christies in Pall Mall, February 1st 1808'. There was never any such sale and Gillray was slyly drawing attention to the puffery and exaggeration of auctions for which James Christie and others were notorious.

This was brilliantly summed up by Sheridan in *The Critic* (first performed at Drury Lane Theatre in 1779), where Puff, a hack, is given the following lines in Act 1, Scene 2: 'Even the Auctioneers, now – the auctioneers, I say – though the rogues have lately got some credit for their language – not an article of the merit theirs: take them out of their pulpits, and they are as dull as their catalogues! (With growing enjoyment of his own eloquence) No, sir; 'twas I first enriched their style – 'twas I first taught them to crowd their advertisements with panegyrical superlatives, each epithet rising above the other, like the bidders in their own auction rooms! From me they learned to inlay their phraseology with variegated chips of exotic metaphor; by me too, their inventive facuklties were called forth – yes, sir, by me they were instructed to clothe ideal walls with gratuitous fruits – to insinuate obsequious rivulets into visionary groves – to teach courteous shrubs to nod their approbation of the grateful soil; or on emergencies to raise upstart oaks where there had never been an acorn; to create a delightful vicinage without the assistance of a neighbour; or fix the temple of Hygeia in the fens of Lincolnshire.' Little has changed.

180A

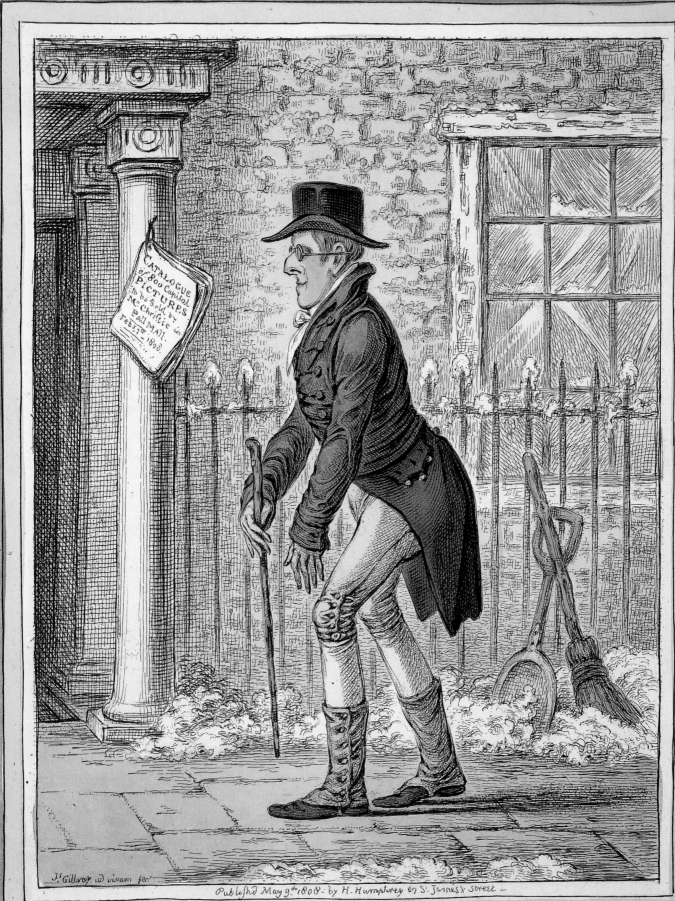

MÆCENAS, *in purfuit of the Fine Arts:* — Scene, Pall Mall; a Frosty Morning.

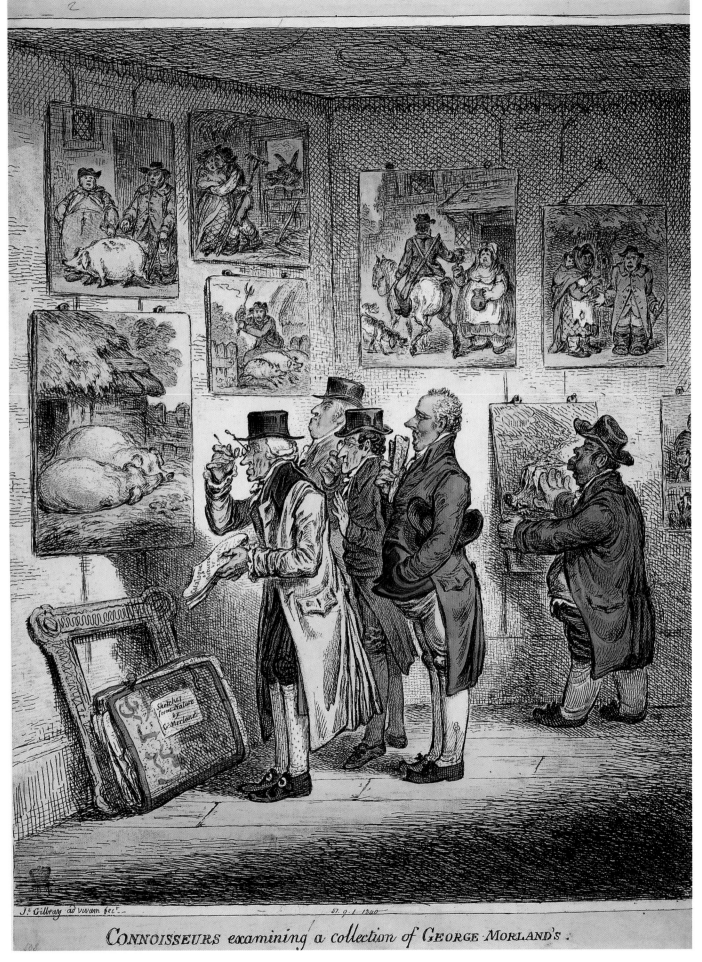

CONNOISSEURS *examining a collection of* GEORGE·MORLAND'S.

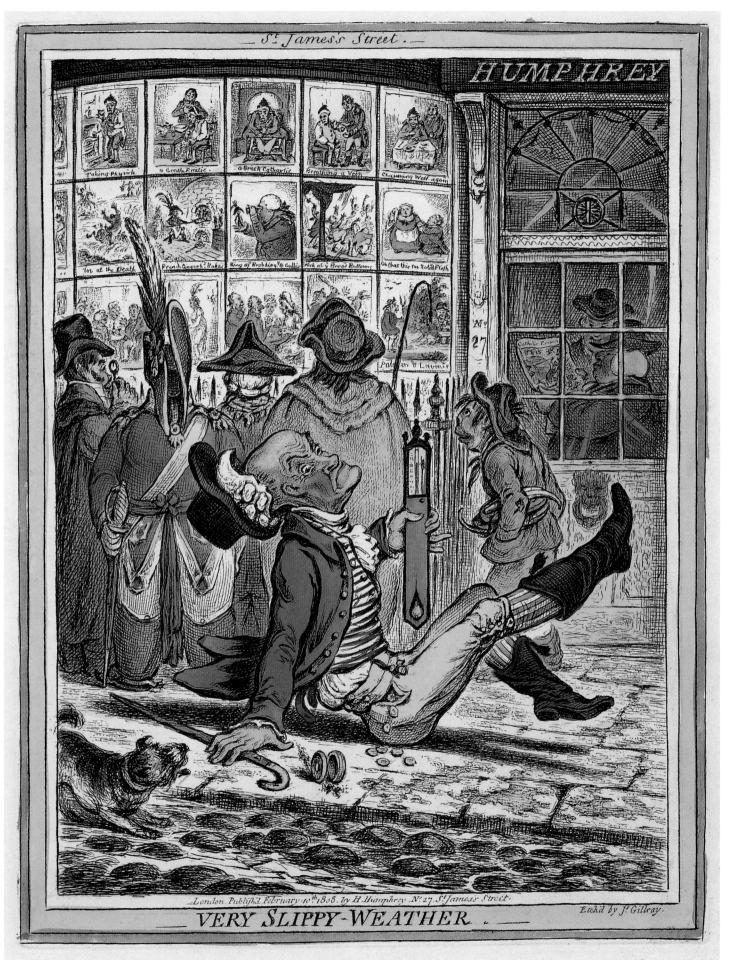

181 Mr George Baker c.1807

Red and black ink over pencil 23.2 × 18.3
The British Museum, London

George Baker was a well-known print
collector, and Gillray's numerous draft titles
allude to his passion: 'a remarkable choice
impression indeed . . . pure etching'; 'a
collector viewing a collection at King's (an
auction house); 'just returned from making
a purchase', etc.

 Like a number of Gillray's later drawings
this has been squared up for possible transfer.
It seems likely that he originally intended this
as an independent print.

182A Connoisseurs examining a collection of George Morland's

Etching with aquatint 47 × 31
The British Museum, London
BMC 10791

A proof impression before all letters.

182B Connoisseurs examining a collection of George Morland's

Hand-coloured etching with aquatint 47 × 31
Published 16 November 1807 by H. Humphrey
The British Museum, London
BMC 10791

There was an almost insatiable demand for
George Morland's (1763–1804) sentimental
rural scenes, which he satisfied by turning
out innumerable pot-boilers, burlesqued
here by Gillray. In the background a fat,
coarse man, identifiable as a picture dealer
and restorer called Mortimer, spits onto a
picture of a large pig. Four collectors are
entranced by the carelessly hung paintings.
Baker, at the centre, has been adapted from
the print collector in Gillray's drawing. In
front of him is Captain Baillie, a collector and
engraver, and the two other enthusiasts have
been identified as Caleb Whiteford, with a
glass, and a banker named Mitchell.

 There is an unusually large number of
drawings for this print, a group being in
the Victoria and Albert Museum.

183 Very Slippy Weather

Etching and engraving 25.8 × 19.8,
with publisher's watercolour
Published 10 February 1808 by H. Humphrey
Andrew Edmunds, London
BMC 11100

This celebrated print, one of the most
memorable from Gillray's final two years of
work, shows an incident outside the front of
Mrs Humphrey's shop at 27 St James's Street,
where she and Gillray had been established
since the summer of 1797.

 In the foreground an elderly man has
come a cropper on the icy pavement, his
smartly booted feet in the air as he hits the
ground. The sense of sharply arrested
motion is emphasised by his hat and wig
which tumble to the ground. His braces
have snapped and a snuff box and coins
cascade from his pockets. With his left
hand he clutches a barometer at a precisely
vertical angle.

 Behind him, oblivious of his disaster, is
a group of five figures, engrossed by the
window display. They are of varying social
rank, a formulaic kind of grouping common
to caricatures featuring print shop windows
by other artists. They range from a dandified
gentleman at the left with a quizzing glass,
to an urchin at the right, a pair of skates
beneath his arm, his nose seemingly
destroyed, perhaps by hereditary
syphilis. In the shop itself are two contented
clergymen who are admiring Gillray's print
End of the Irish Farce of Catholic Emancipation
(17 May 1805).

All but one of the prints set into individual
window panes are identifiable, and at least
seven of them, including the top row, *Taking
Physick* and four others, are based on designs
by his old friend the Rev. John Sneyd
(1763–1835), who was an indefatigable and
highly valued contributor of ideas for Gillray
to etch. In 1805 Gillray had written to Sneyd
to tell him of the success of *Taking Physick*
and asking for more sketches. *Very Slippy
Weather* itself is based on a set of seven draw-
ings on the theme of weather which he sent
Gillray in 1807. The depiction of the window
display is not an accurate record of the shop
at a given moment of time; the prints shown
are of different shapes and sizes, and Gillray
has trimmed them to fit the space neatly.

 Numerous foreign visitors to London
marvelled at the peculiarly English
phenomenon of the caricature shop window
and its attendant crowds – in St James's
Street and Bond Street perhaps attracting
rather fewer proletarian onlookers than
Gillray implies – and their inclusion is
perhaps intended as a manifestation of
British Liberty.

 There is perhaps more to this design
than meets the eye. A distinct focal point is
provided by the vertical of the barometer –
not unphallic in its disposition – which is
terminated visually by the downward curve
of the herdsman's whip, seen above the
caricature of *Paloma and Lavinia*. The third
part of this visual meeting is the thrusting
face of the noseless boy. There is perhaps
a hidden meaning there, known only to
Sneyd and Gillray.

184A

184A Two-penny Whist

Pen and brown ink 11.1 × 17.5
Private Collection

This is a study, drawn at break-neck speed,
almost certainly from the life, for *Two-penny
Whist*. The verso is inscribed by the artist in a
sprawling, slightly incoherent hand: 'A sheet
of White Paper / I am as [illegible] a sheet of
white paper, you may write upon / me what
you will / a Sixpenny Slop / Canning and
Jenkinson.'

184B Two-penny Whist

Etching, engraving and aquatint 18.5 × 30.5,
with publisher's watercolour
Published 11 January 1796 by H. Humphrey
Andrew Edmunds, London
BMC 8885

The woman at the centre is Hannah
Humphrey, sitting next to Betty, her assistant,
who triumphantly holds out the ace of
spades. The two men have been identified,
but not certainly, as the German Tholdal,
who sits next to Betty, and Mortimer, a
picture dealer and restorer.

This print, inscribed 'ad vivum', gives a
rare glimpse into the sometimes cosy
domestic environment that Mrs Humphrey
gave to Gillray here in Bond Street and,
shortly after, in St James's Street.

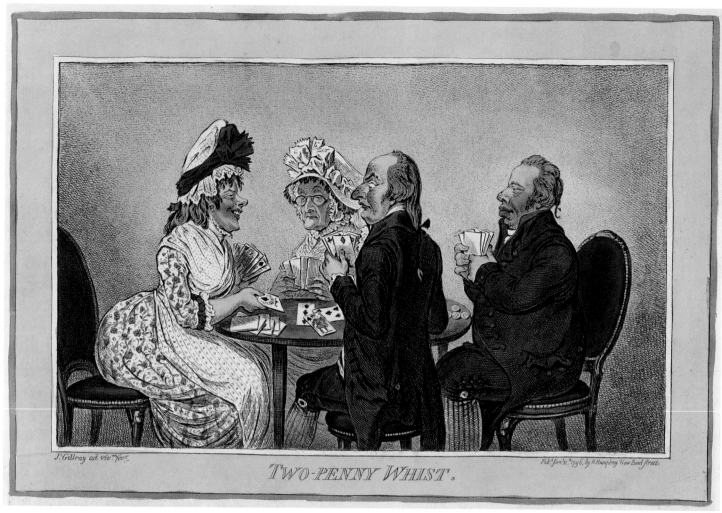

J. Gillray ad viv.^t foc^t.

TWO-PENNY WHIST.

Pub.^d Jan.^y 11.th 1796, by H. Humphrey New Bond Street.

184 B

185A Anacreontick's in full Song

Etching, engraving and aquatint 24.4 × 31.5,
with publisher's watercolour
Published 1 December 1801 by H. Humphrey
Andrew Edmunds, London
BMC 9764

The Anacreonticks were a modish musical
society who regularly sang the Anacreontic
Song after the supper which followed the
concert. Gillray, however, represents them
as a set of coarse plebeians. The song is best
remembered for its musical score, which
later served as the basis for the Star-Spangled
Banner.

185B Anacreontick's in full Song 1801

Pencil, black ink and watercolour 20.5 × 26.6
Private Collection

Most unusually this vigorous preparatory
drawing has been worked up in watercolour.
Possibly Gillray did this for presentation to a
patron such as Sneyd.

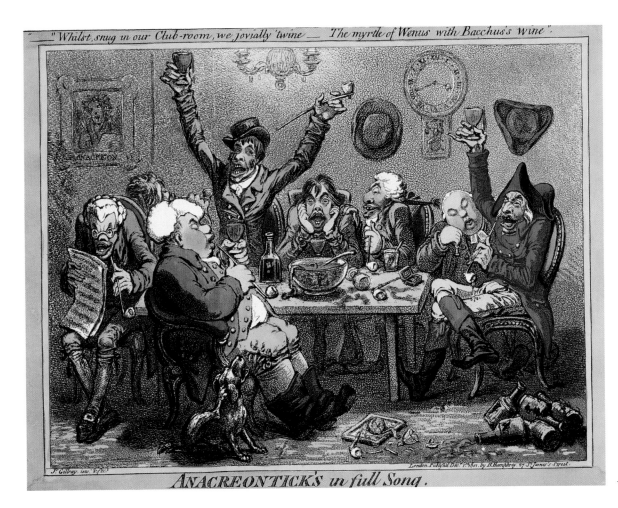

"Whilst, snug in our Club-room, we jovially 'twine ___ The myrtle of Wenus with Bacchus's wine".

ANACREONTICK'S *in full Song*.

185A

185B

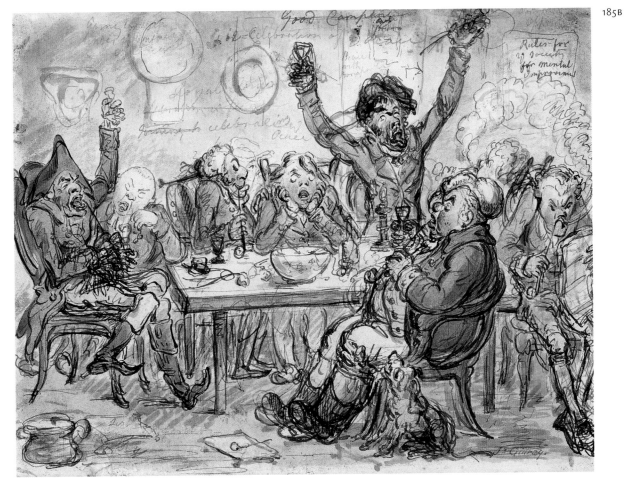

Scientific Researches! — New Discoveries in PNEUMATICKS! — or — an Experimental Lecture on the Powers of Air

186

186 Scientific Researches! – New Discoveries in Pneumaticks! – or – an Experimental Lecture of the Powers of Air

Hand-coloured etching 25.5 × 35.5
Published 23 May 1802 by H. Humphrey
The British Museum, London, Banks Collection
BMC 9923

This elaborate print is a very knowing satire of the lectures at the Royal Institution which had become fashionable since its charter in 1800. Between January and May in 1802 Thomas Young, the Professor of Natural Philosophy, delivered a series of thirty lectures. He here experiments on Sir J.C. Hippisley, a leading member of the Institution, the result being explosive. The faces of the men in the direct path of this monstrous fart are wonderful studies in dismay and amusement. The amusement shown by the man at the top of this group appears to be shared by Humphrey Davy, who stands behind the table with a pair of bellows.

Many of the figures can be identified. The standing man at the right with a bulbous nose is Count Rumford the inventor. Lord Stanhope looks earnestly with the aid of a quizzing glass. In front of him Lord Pomfret, vastly fat, appears to have dozed off. At the extreme left, a palette protruding from his pocket is Peter Denys, a failed artist who had been a fellow student of Gillray's at the Royal Academy. Gillray's observations are inexhaustible and extend to the smallest details. A book open on the green bench at the right reads, 'Hints on the nature of Air required for the new French Diving Boat', a reference to Fulton's recent experiments with a prototype submarine at Brest.

187 Dilettanti Theatricals; – or – a Peep at the Green Room

Hand-coloured etching 30 × 47.5
Published 18 February 1803 by H. Humphrey
The British Museum, London
BMC 10169

A host of the fashionable members of the Pic Nic Society prepares to indulge in amateur dramatics. This short-lived society, founded in 1802, was by February of the next year coming to an end, little mourned, especially by actors and playwrights such as Sheridan, who considered it to constitute unfair competition.

 A screen, decorated with heroes and heroines of the Society, divides the room. The principal figures prepare themselves and cavort before it. The large woman in the centre is Lady Buckinghamshire, her face covered with patches. Matching her bulk at the left is Lord Cholmondely, grotesquely attired as Cupid. Sir Lumley Skeffington capers as Harlequin, faced by the misshapen little Lord Kirkcudbright. Lady Salisbury, seductive, pulls on her boot, displaying her legs.

 The correspondent for London and Paris perceptively noted Gillray's probable debt to Hogarth's engraving, *Strolling Actresses Dressing in a Barn.*

188 Blowing up the Pic Nic's

Hand-coloured etching with aquatint
35.2 × 25.2
Published 2 April 1802 by H. Humphrey
The British Museum, London, Banks Collection
BMC 9916

Sheridan, dressed as Harlequin, accompanied by a gang of histrionic actors, leads an attack on the amateur performers of the Pic Nic Society, whose performances at a little theatre in Tottenham Street concert rooms were much resented by the professsionals. Directly behind Sheridan, ranting and raving in his role as Hamlet, is Charles Kemble. Gillray loved to draw ghosts rising from the floor; here it is Garrick who emerges from the floorboards.

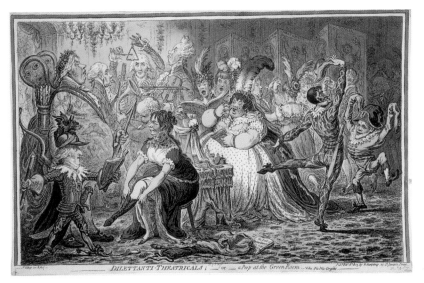

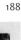

187

188

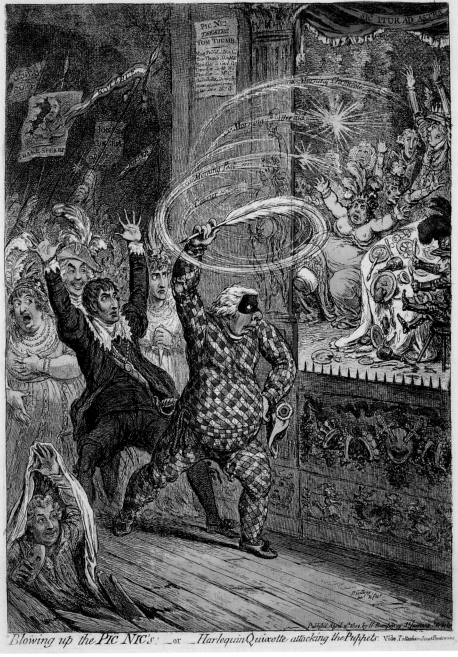

Blowing up the PIC NIC's; _ or _ Harlequin Quixotte attacking the Puppets. Vide Tottenham Street Bombazine.

189 The Theatrical Bubble; being a new specimen of the astonishing Powers of the great Politico-Punchinello, in the Art of Dramatic-Puffing

Hand-coloured etching and aquatint 36 × 26
Published 7 January 1805 by H. Humphrey
Private Collection
BMC 10459

William Henry Betty (1791–1874), the Young Roscius, or Master Betty, was one of the great phenomena of the Georgian Theatre. He first appeared at Drury Lane, whose proprieter was Sheridan, in 1804, when his popularity was much resented by Kemble in particular. Here Sheridan, dressed as Punch and caricatured with especial cruelty, blows bubbles from which Roscius emerges. The enthusiastic crowd includes Fox, Lord Derby, holding up a hunting cap, and the Duke of Clarence, seen with Dorothy Jordan. Sheridan is attacked for his insolvency and the lack of dignity of his theatrical doings.

This impression has been finished with gum arabic on the coins to give them a greater effect of glitter.

189

190A Harmony before Matrimony

Hand-coloured etching 25.7 × 35.9
Published 25 October 1805 by H. Humphrey
Library of Congress
BMC 10472

190B Matrimonial-Harmonics

Hand-coloured etching 25.4 × 35.9
Published 25 October 1805 by H. Humphrey
Library of Congress
BMC 10473

The subject of lust and harmony before marriage, followed by lassitude and disillusion in matrimony, is an age-old favourite of caricaturists. Gillray accumulates detail after detail to make the point.

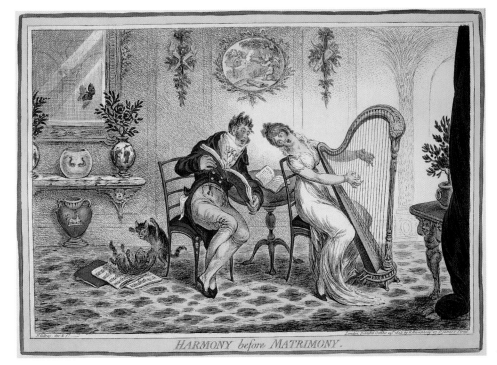

HARMONY before MATRIMONY.

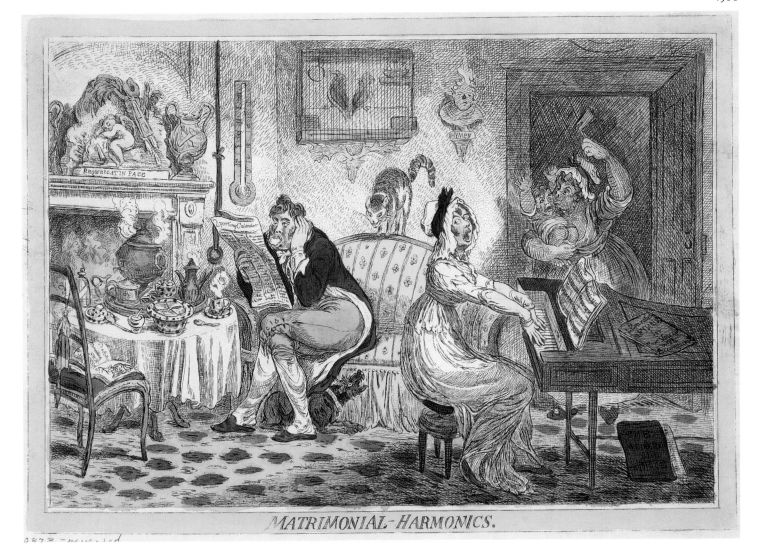

MATRIMONIAL-HARMONICS.

191

191 The Piano Recital, *c.*1807

Pen and ink on oiled paper 24.1 × 35.6
*Print Collection, Miriam and Ira D. Wallach
Division of Art, Prints and Photographs, The New
York Public Library, Astor, Lenox and Tilden
Foundations*

New York Public Library possesses a number
of drawings on oiled paper, mainly from
after 1800. The paper, thus made semi-
transparent, allowed Gillray to see his design
in reverse, as it would appear in the resulting
print. In this case, unfortunately, no print
resulted. After 1800 Gillray produced an
increasing number of social satires, here
observing the bored audience of an old
maid at the piano.

Fashion

Gillray was a keen and observant student of high fashion – indeed of clothes generally. From the windows of his studio, firstly in New Bond Street and then in St James's Street, he could not have had a better view as fops and fashionable women paraded past in search of pleasure. The 1790s and the beginning of the 19th century were perfect years for his purposes, with the exotic costumes, some imported from France, monstrous collars and tight breeches for the men, and ostrich feathers and semi-transparent dresses, breasts peeping out, for the women.

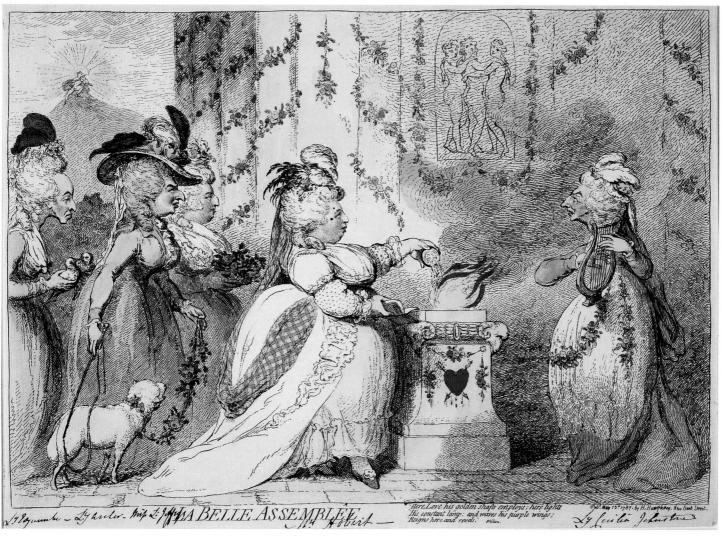

192

192 La Belle Assemblée

Hand-coloured etching 24.8 × 35.1
Published 12 May 1787 by H. Humphrey
The British Museum, London
BMC 7218

Gillray had a real loathing for vain, elderly, posturing, painted ladies of fashion, and here assembled five prime specimens in an absurd frieze. They were well known on the Town. Mrs Hobart pours incense onto the flames of an altar of love. To her right, plucking at a lyre, is Lady Cecilia Johnston. Behind Mrs Hobart are Lady Archer, leading a lamb, Miss Jefferies, and bringing up the rear is the decrepit Lady Mount-Edgecumb. All are

represented in profile with exaggerated and repellent noses. They are very close in type to the two old hags beneath the canopy in *Ancient Music* (no.28), the one at the right indeed being Miss Jefferies, which had been published only two days before by Mrs Humphrey's rival, S.W. Fores.

Gillray, besides caricaturing individuals, is also parodying conventions of idealised portraiture, and it seems likely that the concept of this print, if not the design, is derived from Reynolds's full-length portrait of *Lady Sarah Bunbury Sacrificing to the Graces* (engraved by Edward Fisher in mezzotint in 1766), which shows an altar and a statue of the Graces – the latter being aped in the relief

on the rose-garlanded wall. Another possible source is John Hamilton Mortimer's caricature print *Iphigenia's Late Procession from Kingston to Bristol – by Chudleigh Meadows* (15 July 1776). The title of the print, heavily ironic, is probably a reference to a mid-eighteenth-century institution known as La Belle Assemblée, where people paid admission to hear ladies debate on abstract topics.

This impression has been coloured selectively, some areas of the paper being left blank to enhance effects of colour – particularly the roses.

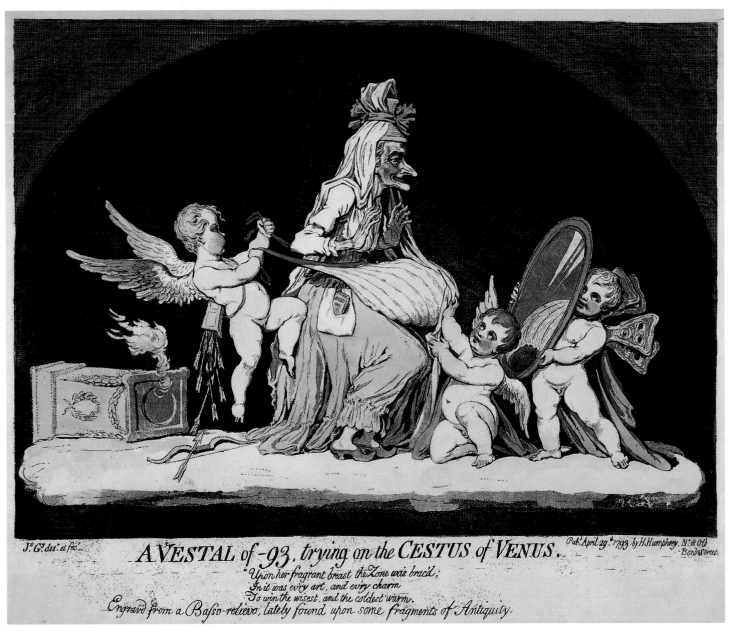

194

193 Edward Fisher after Reynolds
(1723–1792)
**Lady Sarah Bunbury Sacrificing to
the Graces (C.S.6)**

Mezzotint 58.8 x 36.3
Published 8 November 1766
The British Museum, London

**194 A Vestal of – 93, trying on the
Cestus of Venus**

Hand-coloured etching and engraving, with
some aquatint 31.2 × 37.6
Published 29 April 1793 by H. Humphrey
The British Museum, London, Banks Collection
BMC 8389

Modelled with mock solemnity on an
antique bas-relief, this very original design
shows an old hag, attended by smirking
putti, being fitted with one of the stomach
pads which became fashionable in 1793.
She admires herself in a mirror; a copy of
Ovid's *Art of Love* is in her pocket, but the
arrows which tumble from the rearmost
putto's quiver reveal the futility of her
desires. Gillray's visceral loathing of vain,
self-deluding old ladies is nowhere more
evident than here. The satire is as savage as
anything later produced by Goya.

Gillray devoted great technical pains to
this print. It relies for its effect on the contrast
between the lighting of the figures and the
dark background which, uniquely for Gillray,
has been worked up by an infinity of ruled
lines, etched and engraved.

The identity of the old lady is uncertain,
but Miss Banks has written the initials 'P.M'
on the back of this impression.

195 Francisco José de Goya y Lucientes
(1746–1828)
Hasta La Muerta (Until Death)

Plate 55 from *Los Caprichos*, first edition 1799
Etching with aquatint 21.5 × 15
The British Museum, London

Goya shared Gillray's distaste for vain old
ladies, and expressed it in a number of prints,
drawings and paintings.

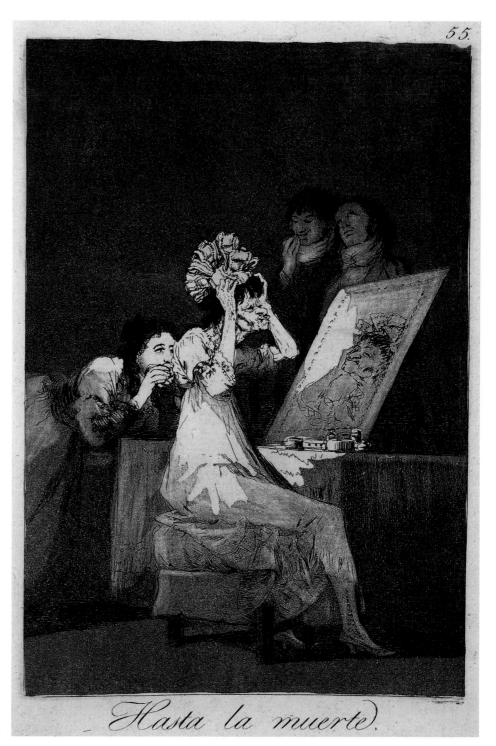

195

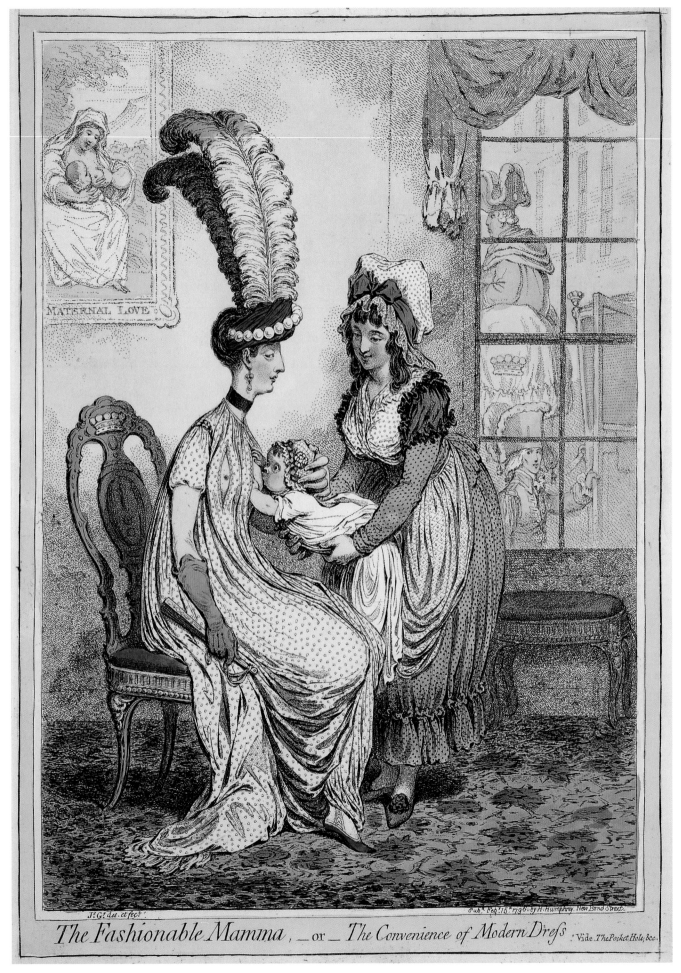

MATERNAL LOVE.

The Fashionable Mamma, _ or _ The Convenience of Modern Dress

Vide. The Pocket Hole, &c.

J.G.^y des. et fec.^t.

Pub.^d Feb.^y 15.th 1796. by H. Humphrey, New Bond Street.

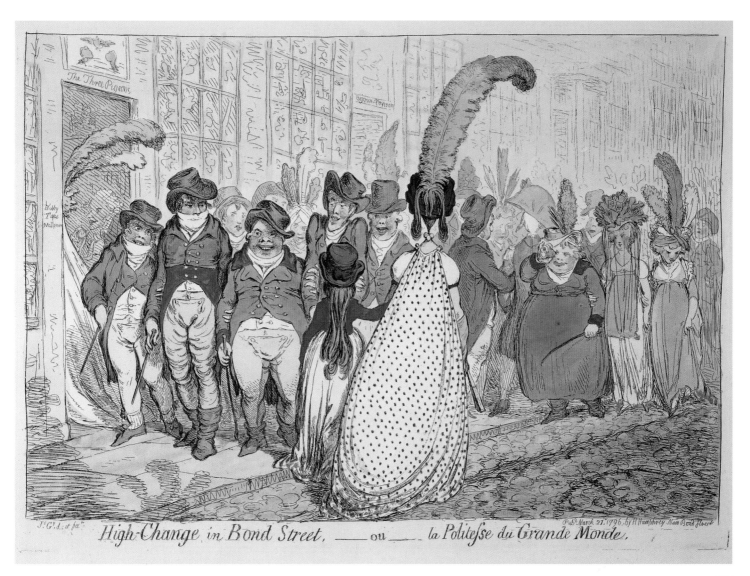

High-Change in Bond Street, ___ ou ___ la Politesse du Grande Monde.

196 The Fashionable Mamma, – or – The Convenience of Modern Dress

Hand-coloured etching, with extensive stipple
engraving 35 × 24.3
Published 15 February 1796 by H. Humphrey
The British Museum, London
BMC 8897

In keeping with the doctrines of Jean-Jacques
Rousseau it was natural, and indeed *à la
mode*, for a fashionable mother to suckle
her own child, aided here by the 'pocket
holes' for her breasts, allowing the greedy
infant easy access. The mother, her vast
ostrich feathers inclining towards a
sentimental picture, eyes the spectator
knowingly, the fan in her right hand
suggesting frivolity and the impermanence
of her affections. She represents high fashion
from tip to toe, her feathers giving her the
ascendancy over the bonneted maid. Gillray
has taken particular delight in the dotted,
speckled dresses worn by both.

197 High-Change in Bond Street, – or – la Politesse du Grande Monde

Hand-coloured etching 23.2 × 34
Published 27 March 1796 by H. Humphrey
Library of Congress
BMC 8900

Five swells, dressed absurdly in the height
of fashion, advance down Bond Street,
monopolising the pavement. The women,
sporting veils, turbans, huge feathers and
expensive dresses, are not to be outdone.
The print is sardonically given a smart French
sub-title, emphasising the frivolity of those
partaking in the 'Bond Street lounge', in
which one fashionable activity was no
doubt to buy this print.

198A 'What can little T.O do? Why Drive a Phaeton and Two!! –

Etching, engraving and aquatint 26.1 × 67.7, with publisher's watercolour
Published 1 May 1801 by H. Humphrey
Andrew Edmunds, London
Provenance: Duke of Northumberland
BMC 9759

The title continues 'Can little T.O do no more? Yes, drive a Phaeton and Four!!!!'. The eccentric Thomas Onslow (1755–1827) is represented full of self-importance, atop his phaeton, with two cynical attendants riding behind him. Gillray's words suggest that his attainments are not as important as he thinks.

Phaetons were carriages with a very high seat for two, with the rear wheels much larger than those at the front. They were as a consequence impractical, very difficult to drive and extremely dangerous. This endeared them to young bucks – preferably accompanied by a daring young woman – who wished to show their pluck and their driving skills. They were generally harnessed to two horses, and Onslow's handling of four shows great ambition. Phaetons were very expensive, custom built, decorated, painted and emblazoned to the owner's requirements. An additional expense could entail commissioning a painting by George Stubbs, such as that painted for the Prince of Wales in 1793 (Royal Collection).

198B What can little T.O do? 1801

Pencil, black and brown pen and ink, with grey wash, on two joined sheets of paper 25.5 × 60.5
Print Collection, Miriam and Ira D. Wallach Division of Art, Prints and Photographs, The New York Public Library, Astor, Lenox and Tilden Foundations

A preparatory drawing, executed with great verve, which Gillray followed closely in the print, although he added a dog and defined the two grooms more closely.

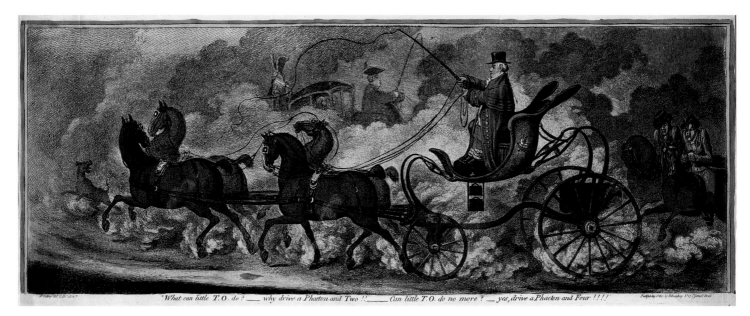

"What can little T.O. do? ___ why drive a Phaeton and Two !! ____ Can little T.O. do no more ? ___ yes, drive a Phaeton and Four !!!!"

198A

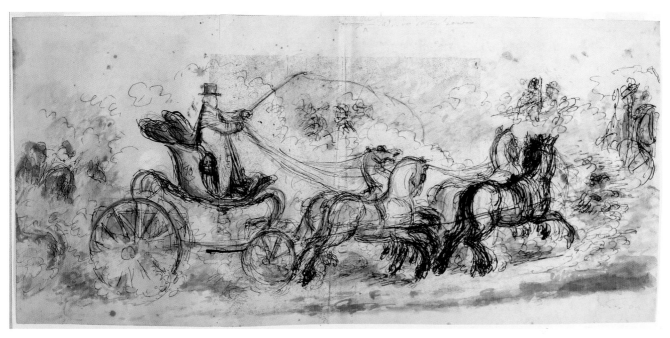

198B

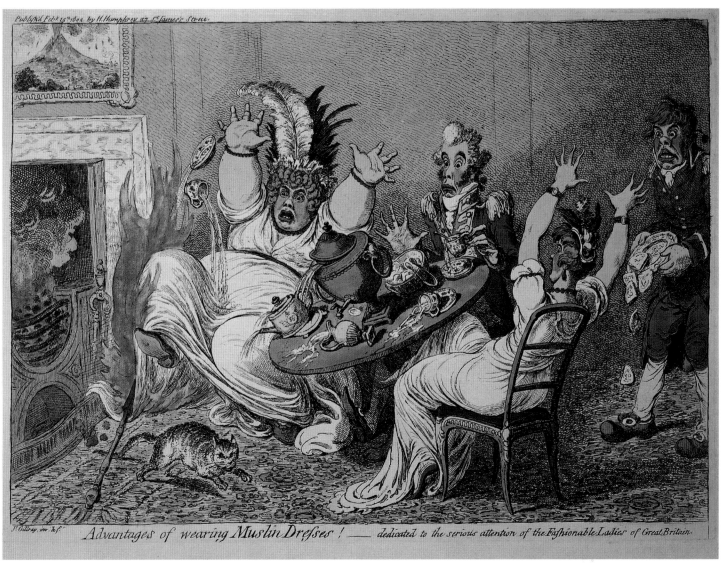

199

199 Advantages of wearing Muslin Dresses!

Hand-coloured Etching 25.5 × 35.7
Published 15 February 1802 by H. Humphrey
Library of Congress
BMC 9933

The calamity of a grossly fat woman's muslin
dress catching fire, with a consequence of
related disasters, is sarcastically dedicated
by Gillray to 'the serious attention of the
Fashionable Ladies of Great Britain'.

200 "all Bond Street trembled as he Strode"

Etching and engraving 25.9 × 20.5,
with publisher's watercolour
Published 8 May 1802 by H. Humphrey
Andrew Edmunds, London
BMC 9909

James Duff (1776–1857), afterwards 4th
Earl of Fife, modishly dressed, his pumps
of ladylike delicacy, minces down Bond
Street on an aimless promenade; even his
shadow is pale and formless. The humour
is accentuated by the sonorous words
of the title.

"_all Bond-Street trembled as he strode._"

J.$ $Gillray del.& f.$

Pub.$ $May 8.$ $1802 by H. Humphrey, St James's Street.

Leering and lechery

The themes of lust and frustrated desire were hardly new, or unique to Gillray. His contemporary Rowlandson specialised in depicting dirty old men, cuckolds and luscious young girls, often indulging in frank pornography. But Gillray brought his special sense of cynicism to the subject, the absurdity of his impotent old fools equalled only in his satires of ageing hags. And his superb control of the medium is always apparent. His depiction of feminine grace, especially *Lady Godiva's Rout* (no.201) and *A Corner, near the Bank* (no.205) equal the very finest fashion plates in technique and beauty.

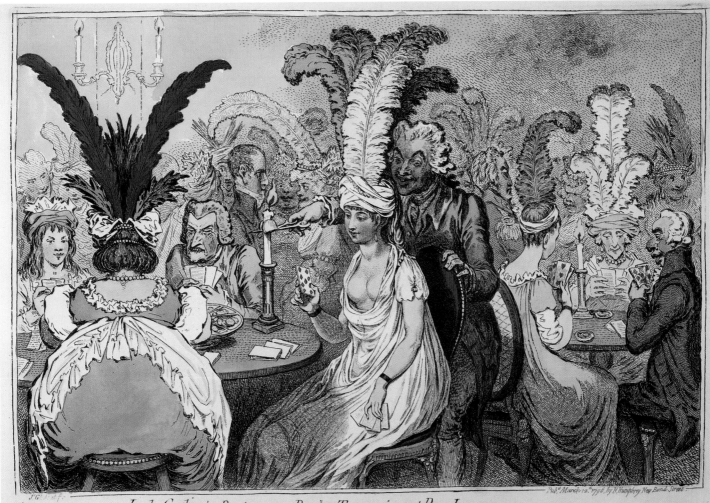

Lady Godiva's Rout; — or — Peeping-Tom spying out Pope-Joan. Vide *Fashionable Modesty*.

201

201 Lady Godiva's Rout; – or – Peeping-Tom spying out Pope-Joan

Hand-coloured etching 23.9 × 35.2
Published 12 March 1796, by H. Humphrey
Library of Congress
BMC 8899

The air is stirred by a multitude of feathers as a fashionable throng plays cards. The central figure, her breasts nearly bared, is almost certainly Lady Georgiana Gordon (1749–1812) wearing the flimsy and revealing costume introduced from France in 1793. A leering man trims a candle, using the opportunity to peer down her cleavage. The stout lady at the left is probably Lady Georgiana's mother, the Duchess of Gordon.

The title is a play on words, suggesting the resemblance between Lady Georgiana and Lady Godiva. Pope Joan is the card game being played.

202A Philanthropic Consolations, after the Loss of the Slave Bill

Etching and engraving printed in brown ink
25.8 × 36
The British Museum, London
BMC 8793A

An unfinished trial proof before the lettering, much of the shading and other features.

202B Philanthropic Consolations, after the Loss of the Slave Bill

Hand-coloured etching with engraving 25.8 × 36
Published 4 April 1796
Library of Congress
BMC 8793A

Not only is this extremely cynical print unsigned by Gillray, but the publisher's name (presumably Mrs Humphrey's) has been omitted, perhaps a sign that even these two considered its publication a slightly clandestine undertaking. However, only an innocent would have failed to make his way to New Bond Street to buy the print, since Gillray's style is so distinctive.

William Wilberforce and Horsley, Bishop of Rochester and Dean of Westminster, console themselves with two fetching black women, who are attired – or semi-attired – in fashionable muslin dresses and turbans. A few weeks before, on 15 March, Wilberforce's Bill for the Abolition of the Slave Trade had been narrowly defeated by 74 to 70. Most unusually Pitt and Dundas joined Fox and Sheridan in voting for the measure, the Prime Minister being especially vehement in his support of total abolition. Opponents of the Bill cited loss of revenue and, in particular, damage to the commerce of Liverpool as reasons to reject it. Wilberforce (1759–1833), a close friend of Pitt and Horsley, had long been a dedicated abolitionist.

The execution of the print is refined, delicate even. The breasts and arms of the black women are engraved in a highly formalised, old-fashioned method, at odds with the light etching elsewhere. Wilberforce is slight and bony, puffing cheroots with the fatter woman. Horsley is stout, all surplice and wig, his profile just visible as he kisses and hugs the more lissome of the two women.

202 B

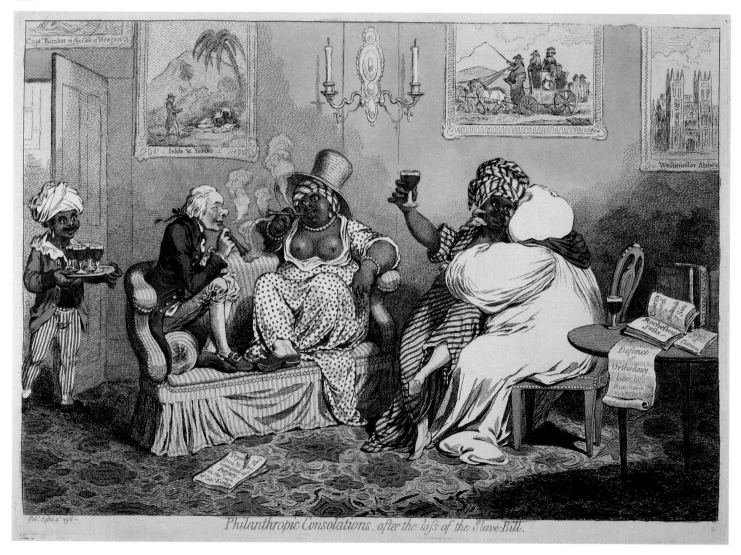

Philanthropic Consolations, after the loss of the Slave-Bill.

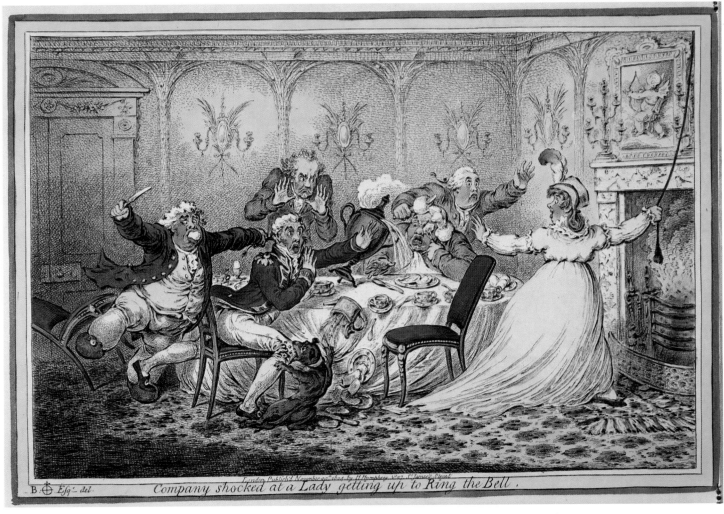

203 Company shocked at a Lady getting up to Ring the Bell

Hand-coloured etching 25.2 × 37.4
Published 20 November 1804 by H. Humphrey
Library of Congress
BMC 10303

The imprint 'B, Esqr – del' identifies the designer as Brownlow North, an amateur who supplied Gillray with a number of designs. In the later part of his career Gillray made increasing use of designs supplied by amateurs, a source of income to many other caricaturists.

The five elderly men who have created such havoc are presumably suitors of the rich widow who is reaching for the bell-pull.

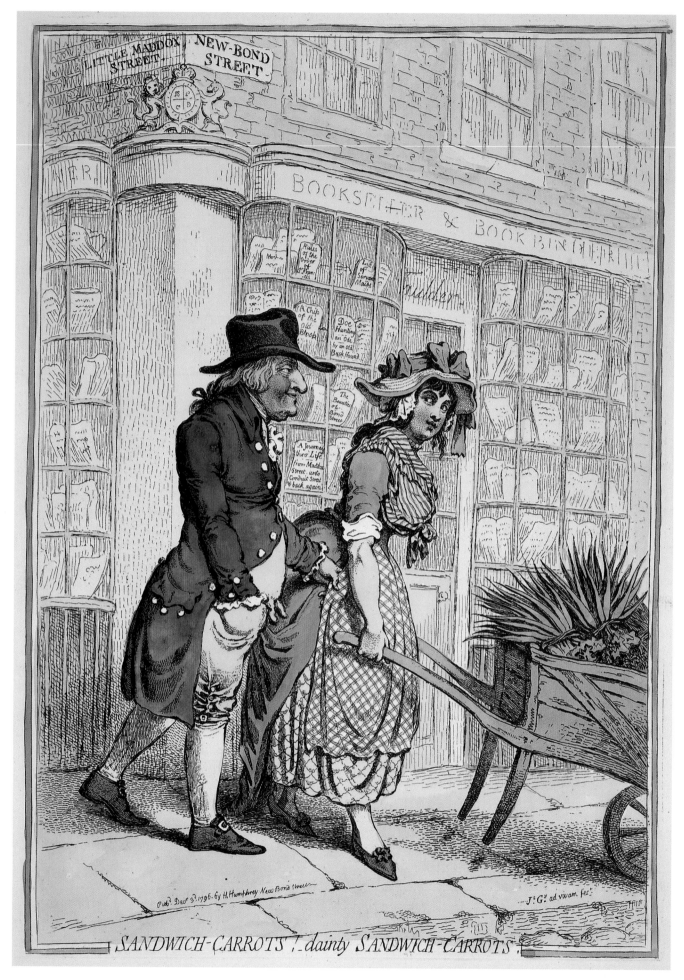

204 Sandwich-Carrots! dainty Sandwich-Carrots

Hand-coloured etching 36 × 25.5
Published 3 December 1796 by H. Humphrey
Library of Congress
BMC 8886

A buxom and compliant barrow girl is approached and fondled by Lord Sandwich, his face a study in brazen lechery, while with his right hand he makes suggestive gestures from within his breeches. They are at the corner of Little Maddox Street and New Bond Street, with Hannah Humphrey's shop only about ten yards away. Behind them is a bookshop, a number of the titles displayed being appropriate to the subject, such as 'A Journey through Life from Maddox Street into Conduit Street'. Conduit Street is twenty yards away at the other end of Little Maddox Street, and alludes to the frivolous nature of the area, then as now, with its fashionable, expensive shops, and abundance of monied loungers. The title at the top, 'Rules of the Order of St. Francis', is an allusion to Lord Sandwich's father, the notorious 4th Earl, who had been a member of Sir Francis Dashwood's infamous 'Franciscan order' at Medmenham Abbey – the Hellfire Club.

Dorothy George wrote that the girl's 'elegant shoes and clocked stockings are inconsistent with her occupation' (*Catalogue of Political and Personal Satires, British*). However, this is Bond Street and the German pastor Carl Phillip Moritz who visited England in 1782 had noted that 'fashion is so generally attended to among the English women, that the poorest maid servant is careful to be in the fashion'.

205 A Corner, near the Bank; – or – An Example for Fathers

Etching and engraving 36.3 × 27.2,
with publisher's watercolour
Published 26 September 1797 by H. Humphrey
Andrew Edmunds, London
BMC 9083

A decrepit, stumbling old man, supporting himself on a knobbly stick, follows two streetwalkers with lecherous intent. The black colouring of his hat and coat indicate that he is a Quaker. From his pocket protrudes a volume lettered 'Modest Prints'. In 1830 Thomas McLean identified him as 'Old P . . . , a notorious debauchee, too well known in the city for his depravity. He

was a clerk at the Bank of England, and made himself infamous by his constantly associating with the frail ones of Elbow-lane. The resemblance of this hoary sinner was too striking not to be recognised by all the frequenters of Lloyd's, the Bank, and the Exchange' (*Illustrative Description of the Genuine Works of Mr. James Gillray*, London 1830).

One of the two streetwalkers raises her skirt to show him her legs, and it seems likely that the position of her fingers is a coded sexual invitation. Streetwalkers they may be, but they are splendid girls, not so far away from *The Morning Walk* (1785, National Gallery, London), and it is easy to imagine Gainsborough waving at them from his studio window. The figures are drawn with great care. Easy to overlook but just as skilled are the short dashes and curves that

indicate the pavement and the brick walls.

It is possible that the man may be identified with one Isaac Pilau, a clerk in the Bank of England who was left a thousand pounds in the will of the famous English print collector John Barnard, who died in 1784. The title of the catalogue in the man's pocket, 'Modest Prints', may well be an allusion to this bequest.

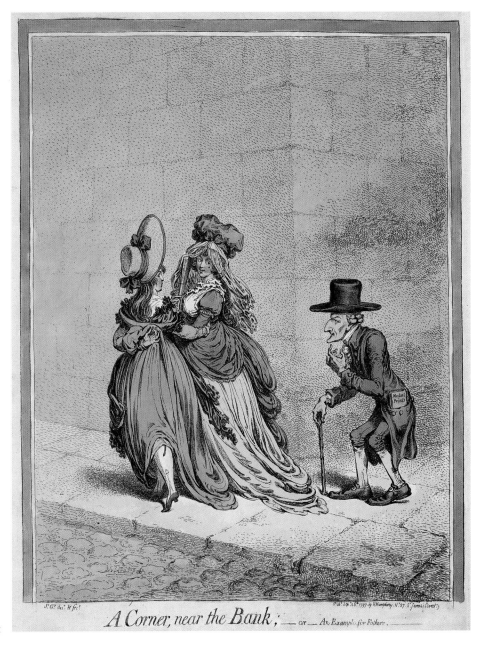

J.Gy. del. & fec. Pub.d Sep.r 26.h 1797 by H.Humphrey N.o 27 S.t James's Street

A Corner, near the Bank; — or — An Example for Fathers.

207 Thomas Rowlandson (1756–1827)
A Worn-Out Debaucher 1790–5

Watercolour with pen and ink 30 × 19.8
Yale Center for British Art. Paul Mellon Collection

Rowlandson, like Gillray, was a connoisseur of the lecherous and clapped-out old roués who snuffled their way around the West End of London. This emaciated and raddled specimen has been identified as the 4th Duke of Queensberry (1725–1810), otherwise known as 'Old Q'.

This is one of Rowlandson's finest watercolours, the fine penwork defining Old Q's legs and contrasting with the delicate washes of the girl's skirt. On the evidence of her skirts it is not a cold day, but her hands are encased in a large fur muff, often understood as one of the appurtenances of a streetwalker.

In 1794 Queensberry was mocked in telling verses by Thomas Mathias:

> And there, insatiate yet with Jolly's sport,
> That polish'd sin-worn fragment of the court,
> The Shade of Q . . . nberry with Cl-rm-nt meet
> Ogling and hobbling down St. James's Street

(*The Imperial Epistle from Kien-Long unto George the Third . . . in the Year 1794*, p.16)

206 B. Smith (active 1786)
Street Walkers

Hand-coloured etching 28 × 19.8
Published 28 April 1786 by B. Smith
Library of Congress
BMC 7080

Smith records a charged encounter between an elegant courtesan and a fashionable lecher, possibly intended for George Hanger, at the junction of Old Bond Street and Piccadilly. This impression has the publication line altered in pen and ink to 'S.W. Fores, No 3, Piccadilly', showing how the ownership of a plate could change, this subject being more suitable to Fores's Piccadilly address.

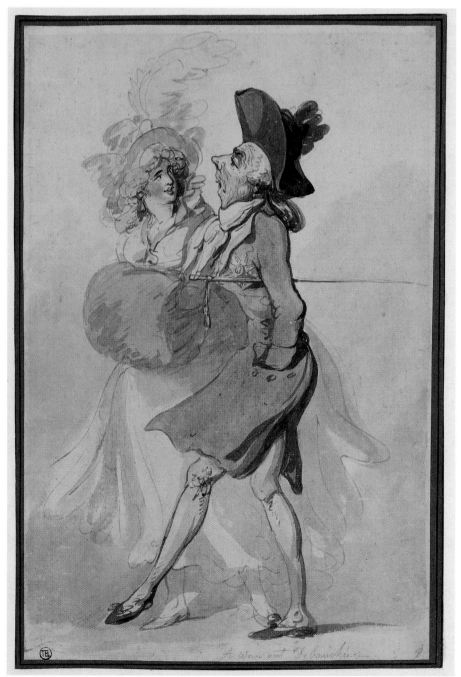

Everyday subjects

Gillray was an urban creature, only really at home in the crowded streets and buildings of London. Yet the countryside was only a walk away from the centre of London, and although he had little interest in picturesque scenes his work reveals shrewd observation of the countryside's inhabitants, farmers – including the King as 'Farmer George' – the peasants, and gloriously comic farm animals, sheep, grunting porkers, ducks, geese, chickens, and monstrous overfed cows. His most memorable rustic creation however is the yokel who stands in for John Bull, stupid, but not without some native cunning, perpetually exploited and tempted.

Rustic themes were a stock subject among artists in Gillray's time. Combining straightforward realism with cheap sentiment and sometimes the titillating presentation of country girls, subjects of everyday life by artists such as George Morland found a ready audience (see no.182). Stipples and mezzotints showing sickly-sweet visions of life in the country and flower-sellers in the city always sold well. Gillray's few drawings and sketches in this line show that, although justly famous for his comic art, he was also a sensitive observer of nature.

208

208 A Cottage Interior with an Old Woman Threading a Needle

Pen and ink and watercolour 22.8 × 17.9
Inscribed on verso by Gillray, 'Sept 1795'
Private Collection

Gillray made a number of finished watercolour genre scenes, evidently intended for sale as individual items and unrelated to prints. They mainly date from the mid-1790s, and although they are not large in number they have a distinct and individual quality.

The cottage interior is humble but not destitute. The old crone, carefully threading a needle so that she can mend her stocking, is not ill provided. A side of bacon and onions hang on the wall and a bed warming pan hangs by the window. The drawing of the hands and the concentration of her expression are characteristic of the artist.

209

209 A Flower Girl Sitting on a Doorstep

Watercolour over pencil 26.3 × 19.3
Stamped with two German collectors' marks:
H.K. and B. Moser
Private Collection

The subject is intended to be sentimental, in the manner of countless English prints after Francis Wheatley and others, but the girl's expression, intent but unsmiling, hints rather at the watercolours of Richard Dadd, and the door knocker above her head is distinctly menacing.

210 A Drunk Barrow Woman *c.1795*

Pen and ink and watercolour 17.1 × 11.5
Private Collection

A drunken woman, her features debased, her glass empty – probably of gin – slumps on her barrow which holds some sad-looking buns. The observation is direct and Hogarthian.

This drawing is probably from one of the sketchbooks given to Gillray's friend the Rev. John Sneyd, which were sold at Sotheby's on 1 December 1927, Lot 375, described as 'Three Notebooks'.

211 A Coat Hung Over the Back of a Chair

Pen and ink and watercolour 15.5 × 9.5
Signed in ink by the artist
Private Collection

This drawing is evidence of Gillray's capacity to suggest character not merely by features, but also by clothes which are shaped by the nature of their owner. This is probably also from one of the sketchbooks given to Sneyd.

210

211

212 Studies of a Calf and Sheep

Pen and ink and watercolour 18.1 × 22.8
Signed by the artist
Private Collection

This, like other sketchbook studies, is likely
to have been drawn when the artist was
staying at Elford, Staffordshire, as the guest
of Sneyd in the autumn of 1795 – one of
his few rural excursions. Gillray was a fine
draughtsman of animals – a prime
requirement of a caricaturist.

213 Fat Cattle

Etching, printed in brown ink 36 × 25.5
Published 16 January 1802 by H. Humphrey
The British Museum, London
BMC 9912

The short-lived Francis Russell, 5th Duke
of Bedford (1765–1802), was a pioneering
breeder of cattle and sheep, and is depicted
by Gillray gripping the side of a monstrous
ox. It is likely that he was making use of
earlier drawings of animals, such as those
in his sketchbook of *c.*1795 (no.212). This is
a proof before letters, printed in the brown
ink preferred by Gillray.

212

213

Appetite

214 Hero's recruiting at Kelsey's; – or – Guard-Day at St. James's

Hand-coloured etching 36.3 × 26
Published 9 June 1797 by H. Humphrey
Library of Congress
BMC 9068

Hannah Humphrey moved her premises
from New Bond Street to St James's Street in
April 1797, some prints of that month giving
both addresses as the transition was made.
This satire of the military, a lean officer and
his counterpart – a commissioned infant –
consuming sweetmeats in a fashionable
St James's Street shop is a witty confirmation
of the move.

215 The Gout

Hand-coloured, soft-ground etching 26 × 35.5
Published 14 May 1799 by H. Humphrey
The British Museum, London
BMC 9448

The painful affliction of gout, mainly affecting
the big toe, was traditionally associated with
heavy-drinking men of superior social rank.
It was a frequent subject for satirical artists,
a notable sufferer being Earl Squander in the
first subject of Hogarth's *Marriage à la Mode*
series, engraved and published on 1 April
1745. Most caricaturists preferred to depict
the victim in a social setting, his plight
emphasised by the contrast with healthy
young women, or mocking companions.
Gillray eliminates such props and focuses
brutally on the inflamed toe, and the
ferocious demon who assails it with fire,
teeth and forked fingers – a vicious tail
being reserved for even greater agonies.

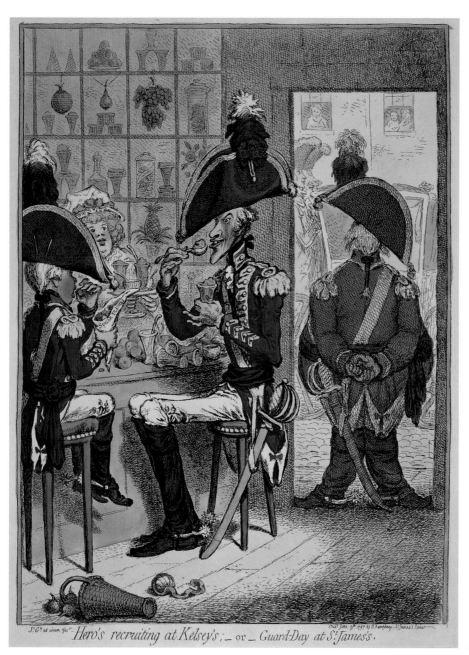

Hero's recruiting at Kelsey's; – or – Guard-Day at St. James's.

214

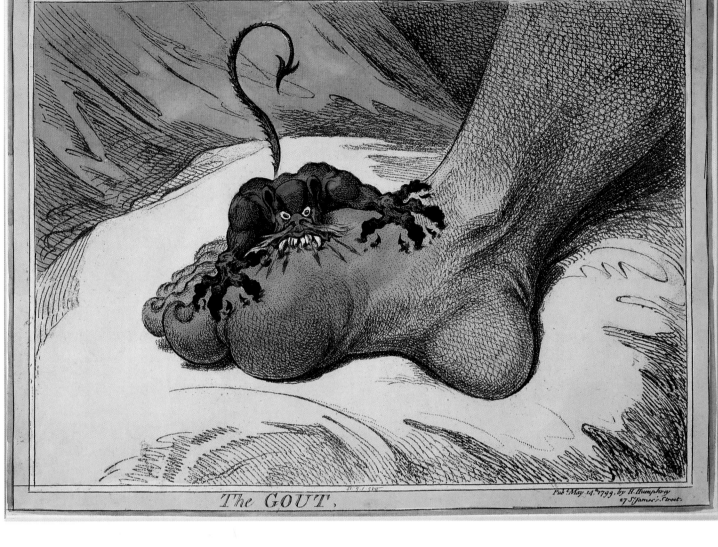

The GOUT,

Pub.d May 14.th 1799. by H. Humphrey 27 S.t James's Street.

216 Germans Eating Sour-Krout

Hand-coloured etching 26.1 × 36.4
Published 7 May 1803 by H. Humphrey
The British Museum, London
BMC 10170

The plates and massive tankards are inscribed 'Weyler Castle Street', thus identifying the eating-house as that of Weyler, a Viennese, whose establishment in Castle Street, Leicester Square, was noted for its sausages and sauerkraut. An heroic plateful is carried through the door to reinforce the already laden plates of the guzzling Germans. There is little to distinguish them from the English, save for the menu; indeed the porker at the right of the table is a very close cousin to 'Old Grumble Gizzard' in *John Bull taking a Luncheon* (no.88). Gillray frequently returned to the subject of people gorging themselves at table, which he viewed with dyspeptic distaste.

GERMANS EATING SOUR-KROUT.

Pub.d May 7.th 1803 by H.Humphrey, S.t James's Street.

Late Drawings

Gillray was an enormously prolific draughtsman. The auction of the final stock of Mrs Humphrey's in 1835 lists many sketchbooks and drawings lotted up in bundles, and sold for next to nothing. Most of these have disappeared and probably been destroyed as being of no interest to collectors. As a consequence the limited number of drawings that have survived have until recent years been neglected. Particularly in his final years Gillray was a highly original and varied draughtsman, but one whose work is not ingratiating or elegant but frequently uncomfortable and sometimes disturbing, particularly when his mind was beginning to collapse, and his squiggles and staccato bursts of line become semi-coherent.

A unique feature of his drawings is the interdependence of words and images, for he expressed himself in both simultaneously as he struggled to give form to the ideas with which his mind was teeming. Many of these battered sheets of paper are, in fact, more written memoranda than drawings.

detail, no.221

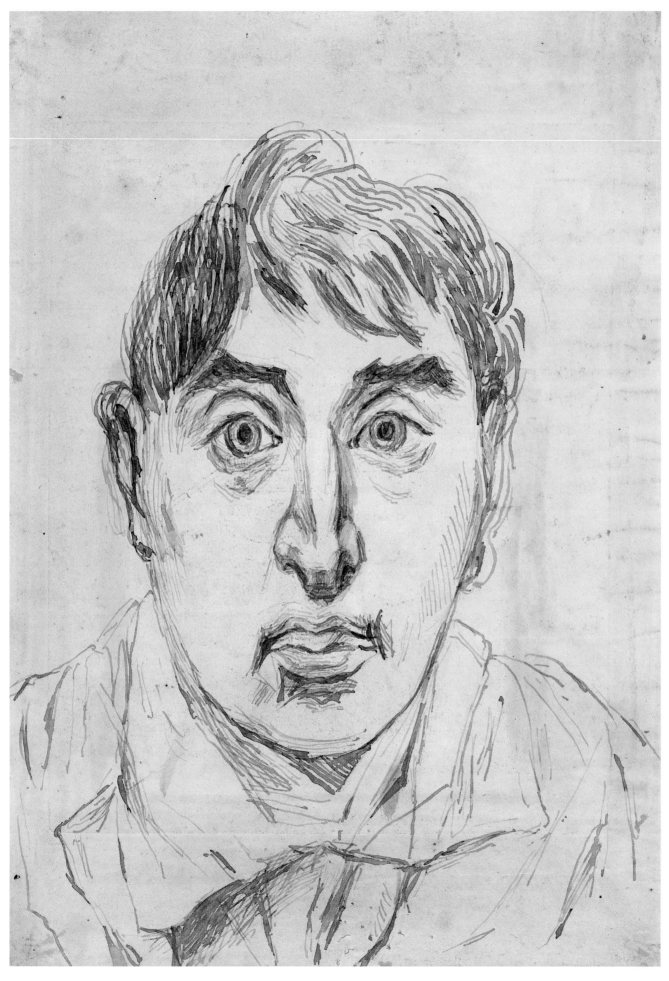

217 A Young Man with Staring Eyes

1809

Black and grey ink, with touches of graphite and
white body colour 34.7 × 24.4
The Pierpoint Morgan Library, New York
Peel Collection vol.8, no.6, verso p.3

The sitter is not identifiable, but the drawing
gives every appearance of being a study from
life and, despite hesitant passages, one that
is compelling and even disturbing.

 The drawing was recently removed from
one of the Peel Collection albums, which
contain very fine Gillray prints, especially
from his early period. This revealed that it is
drawn on the verso of a minor Gillray print,
*Cambridge Commencement Sermon 2 July
1809* (BMC 11403), after a design by an
amateur. The print was published on 18
October 1809, allowing us to establish an
unusually precise date for the drawing. By
1809 Gillray's mind was fast disintegrating,
and his career was coming to a pitiful close.

218 John Bull Roasted *c.*1808—10

Pen and black ink, graphite, red wash and traces
of red chalk 35.2 × 27.3 (irregular)
*Print Collection, Miriam and Ira D. Wallach
Division of Art, Prints and Photographs, The
New York Public Library, Astor, Lenox and Tilden
Foundations*

This late drawing, possibly made between
1808 and 1810, was never converted into a
print. It is an agitated and confused design
in which John Bull is shown as an ox being
basted by a stout cook, while a little man
turns the spit. There are a number of
inscriptions, notably 'Lord Castlereagh
convincing John Bull that he will be ruin'd
if his plan of finance be not adopted'.

 The drawing is covered with incoherent
indenting (a method of preparing a drawing
for transfer to a print by indenting the lines
with a metal stylus), which in this case can
have had no practical purpose.

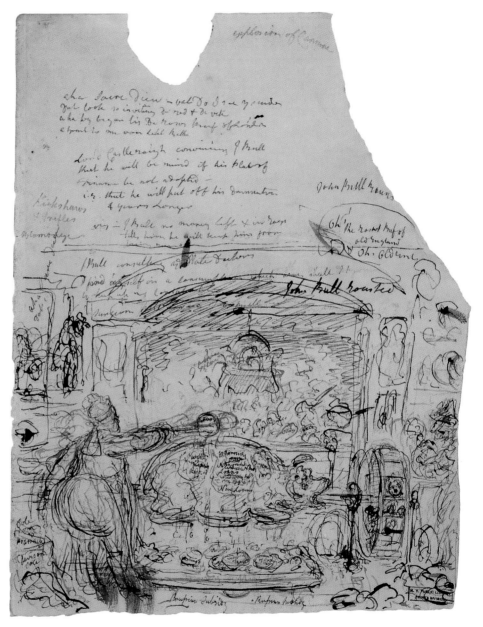

218

219 Overthrow of the Republican Babel
1809

Pen and ink with white body colour 47.3 × 27.6
(squared up for transfer)
*Print Collection, Miriam and Ira D. Wallach
Division of Art, Prints and Photographs, The New
York Public Library, Astor, Lenox and Tilden
Foundations*

This confused drawing, which nonetheless
conveys a tremendous sense of momentum
as a crowd of people are sent tumbling, is a
study for a print of May 1809 (BMC 11327).
Mary Clarke, formerly a mistress of the Duke
of York, had accused him before the House
of Commons of financial irregularities in his
position in the army. He was acquitted, and
it is this event that Gillray glorifies, with the
troublesome radicals who supported her
being scattered by the Speaker.

220A The Duke of Cumberland Assaulted by his Italian Valet 1810

Black ink and wash over red chalk, with some
white body colour 23 × 37.2 (squared for
transfer)
Private Collection

220B The Duke of Cumberland Assaulted by his Italian Valet 1810

Black ink with wash over red chalk 25 × 36.3
(squared for transfer)
Private Collection

220C The Duke of Cumberland Assaulted by his Italian Valet 1810

Grey wash and white body colour over red chalk
20 × 31.8
Private Collection

219

220A

220D The Duke of Cumberland Assaulted by his Italian Valet 1810

Black and grey wash body colour over red chalk and pencil 20 × 31.7
Private Collection

On 31 May 1810 a rumour quickly circulated around London that the Duke of Cumberland (1771–1850), a particularly unpopular member of the royal family, had murdered his valet. This was a canard. In fact the Duke's valet, one Sellis, had attempted to kill him, inflicting severe injuries on his master before cutting his own throat with a razor. Sellis was a Corsican and a Roman Catholic, the Duke the most robust of Protestants, and it is possible that the latter's insensitive remarks about Catholicism had led to the outrage.

Gillray's drawings are wild and scarcely controlled, the squaring up of two of them, presumably for intended transfer to a print,

providing a semblance of order. Three of them show the Duke assaulted in bed, Sellis wielding the Duke's own sabre; in the fourth Gillray has used his brush with decreasing order, representing the Duke rising from bed to defend himself – the figures are blob-like, scarcely human.

The last drawing is inscribed by Gillray in pencil on the verso, with the usual crossings out and corrections. The message is xenophobic: 'Sellers the Italian valet attempting the assassination of a prince of ye Blood Royal in the Palace of Royalty this representation of extreme Danger attendant upon employing Foreign Servants in place of British Domestics is submitted to the serious consideration of all those who prefer (?) Italian French & other Charlatans & cut throat adventurers'.

Gillray never translated this idea into a print, but Isaac Cruikshank seems to have

either known these drawings, or discussed them with Gillray or Hannah Humphrey, since he issued a caricature on 4 June (BMC 11561) clearly indebted to Gillray's ideas – particularly the denigration of foreign servants.

221 George Humphrey 1811

Pen and brush and black ink 36.6 × 49.1
The British Museum, London

This large and incoherent drawing in which not a trace of the artist's skill remains is inscribed by the sitter, Hannah Humphrey's nephew, 'This Portrait of George Humphrey Junr was Drawn by James Gillray on the 1st July 1811 he being at that time Insane.'

221

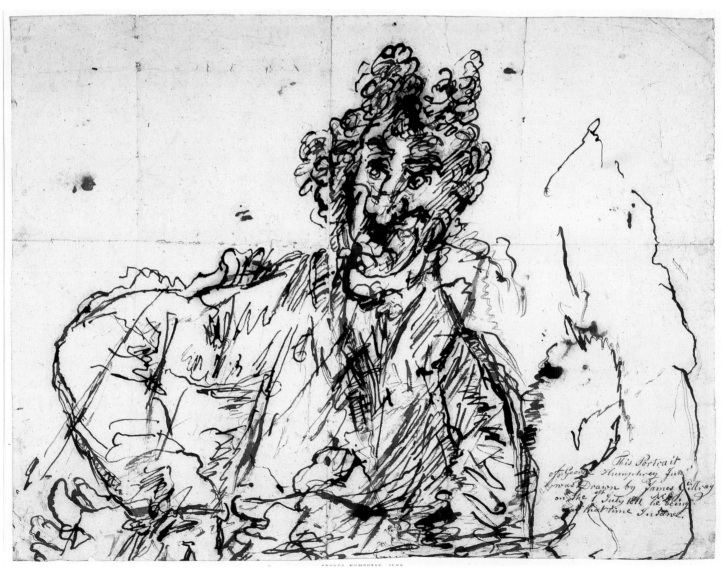

Technical notes

Aquatint

A tonal method of etching, designed originally to imitate the effect of a wash drawing. It was still quite a new technique when Gillray began his career, having been developed in France in the 1760s and introduced to England at the beginning of the 1760s. Powdered resin is fused by heat to a copper plate; the tiny spaces between the grains of resin are then bitten by acid, which the resin repels. On printing this results in a fine granular texture. Areas of white are retained by the brushing on of acid-resistant varnish. A method pioneered by Thomas Gainsborough and Paul Sandby was the lift-ground or sugar-lift technique, whereby marks were brushed onto the plate with a mixture of Indian ink and sugar and then covered with varnish. On its immersion in water the solution will rise, lifting off the varnish and exposing the brush marks, which are then etched by acid.

Aquatint is a technique which tends to wear out quickly, yielding a limited number of good impressions.

Engraving

A term loosely applied to a variety of printmaking techniques, but most accurately describing line engraving, the most difficult and prestigious technique in the 18th century. Lines or flicks are incised into a copper plate by the use of a burin, a steel instrument with a lozenge-sectioned pointed end, and a mushroom-shaped wooden handle. This is pushed forward on the plate, forcing out a shaving of copper in its path. Depending on the angle at which the burin is held, the line can vary in width. The engraver's free hand holds the corner of the plate, which rests on a leather pad, and turns it in harmony with the action of the burin.

Gillray frequently combined engraving with etching.

Etching

This was Gillray's basic technique. A copper plate is covered with stopping-out varnish, or with a wax ground which has been smoked to a dark hue to make the lines scratched through to the copper appear more clearly. This can be drawn upon with great freedom with a steel etching needle. On the plate's immersion in a solution of nitric acid, the lines exposed by the needle will be bitten down by the acid, while the wax or varnish will protect the rest of the plate from its corrosive action. The basic principles of etching can be quickly learned – unlike engraving – and provided the perfect outlet for a draughtsman as vigorous as Gillray.

Intaglio Process

Printmaking methods where the action of a heavy roller press forces the paper into lines or marks beneath the surface of the copper plate, squeezing the ink from them so that they stand out in slight relief from the surface of the paper. Etching, engraving, mezzotint and stipple are all intaglio techniques.

Soft-ground etching

Tallow is mixed in equal proportion with an etching ground, and a sheet of paper is laid upon the plate, upon which a drawing is made with an ordinary lead pencil. When the paper is lifted off, the ground will have stuck to it wherever the pencil has been applied. The lines thus exposed exactly reproduce the character of the pencil marks and the texture of the paper.

Stipple engraving	This method utilises special tools such as a roulette, a tool with a revolving wheelhead containing spikes or other protuberances, or other tools that will perforate the surface. It was a technique particularly associated in England with works of a decorative or sentimental nature, and could be printed in colour or soft shades of brown or red. Gillray often used it to particular effect, particularly in the depiction of faces. Etched line was frequently combined with the technique.
Hand Colouring	When Gillray began his career, hand colouring was very much the exception; by 1810 it was almost invariable. In a number of his earlier prints a rather heavy opaque colouring was used, but later he made use of lighter watercolour, sometimes enriched in places by gum arabic. Colouring was crucial to Gillray's prints, but we have remarkably little knowledge of the *modus operandi* of his studio. It is to be presumed that Gillray coloured at least one impression himself as a model, which was then followed by one or more professional colourists. It was skilled work, requiring a combination of finish and breadth. It is probable that a number of impressions were coloured for issue on the day of publication, and that thereafter colouring was made for successive batches or upon demand. Prints continued to be coloured after Gillray's career finished in 1810, usually with a decrease in quality.
Printing and Publishing	Gillray's copper plates were the stock-in-trade of Mrs Humphrey's shop. Only a handful now exist, but the great majority survived his death and were reprinted, notably in a great folio of uncoloured impressions issued by H.G. Bohn in 1851. These can be easily recognised by the fact that they were printed on both sides of a plate. They were never printed as editions in Gillray's lifetime, but either singly or in batches according to commercial demand.
	Details of printing are limited, and it should be presumed that access to Gillray's workshop was very restricted – a number of unscrupulous artists would have been very happy to purloin his ideas before he published them. For this reason alone, the heavy printing press was almost certainly on Mrs. Humphrey's premises, first in New Bond Street, and then at St James's Street, where she must have employed professional printers.
Collectors and Collecting	Gillray's clients were from a moneyed, educated and sophisticated class. His prints were priced on average at two shillings and sixpence in his mature career, placing them outside the reach of most, and they should not be considered – as they often are – as so-called popular prints. His most elevated collector was The Prince of Wales, an avid collector of English caricatures of all periods and types, the bulk of whose collection was de-accessioned by Windsor Castle in 1921, and purchased by the Library of Congress.
	His prints were not generally intended to be framed – when the colours would have quickly faded. The most usual way of conserving the prints was for collectors, or their agents, to paste them into large albums, often of blue paper, and keep them as a form of library entertainment. Over the years many such albums have been dismantled.
	The largest public collection of his prints is that in the Department of Prints and Drawings in the British Museum.

Select Bibliography

The literature on caricatures and satirical art is international, vast and growing. This list is confined to the most fundamental works needed for the study of Gillray.

Catalogue of Political and Personal Satires in the Department of Prints and Drawings in the British Museum

This epic publication in eleven large volumes catalogues satirical prints from 1537 to 1832, when the tradition of the single print peters out. It was commenced in 1870 and completed in 1954. It contains no less than 17,391 catalogue entries. Since 1954 the Department has acquired hundreds of prints not in the catalogue.

The first five volumes were compiled by Frederick George Stephens, a minor Pre-Raphaelite in his youth, and a prolific writer thereafter. The fifth volume goes up to 1783. Not all the entries are adequate, and those on Hogarth have been completely superseded. The remaining six volumes, covering the greatest and most prolific period, are the work of Dr Dorothy George. They are greatly superior to the previous volumes, with a formidable amount of detail on every figure and incident in the prints. The entries on Gillray are excellent, although it should be noted that Dr George was elucidating the imagery, and had little concern with technical matters. Without the use of these volumes the student of Gillray and English caricature generally cannot even begin. Dr George's volumes can be safely considered as amongst the greatest print catalogues in the English language.

Modern scholarship was pioneered by Draper Hill, an American writer and cartoonist, who organised the ground-breaking Arts Council exhibition in 1967. His publications include, besides the Arts Council catalogue:

Mr. Gillray: The Caricaturist. A Biography, London 1965

This is especially strong in discussing Gillray's political connections, and is the standard biography.

Fashionable Contrasts: Caricatures by James Gillray, London 1966

The Satirical Etchings of James Gillray, New York 1976

These three works, which are complementary, well written, detailed and well illustrated, are the fundamental basis of the study of Gillray.

Standard Gillray works

H. G. Bohn, *The Works of James Gillray*, 2 vols, London 1851 (reprint 1968)

Thomas McLean, *Illustrative Description of the Genuine Works of Mr James Gillray*, London 1830

Thomas Wright and Robert E. Evans, *Historical and Descriptive Account of the Caricatures of James Gillray*, London 1851 (reprint 1968)

Thomas Wright, ed., *The Works of James Gillray with the History of his Life and Times*, London 1873 (reprint 1970)

Eighteenth-century caricature

Herbert M. Atherton, *Political Prints in the Age of Hogarth: A Study in the Ideographic Representation of Politics*, Oxford 1974

David Bindman, with contributions by Aileen Dawson and Mark Jones, *The Shadow of the Guillotine: Britain and the French Revolution*, British Museum, London 1989

John Brewer, *The Common People and Politics 1750–1790s*, Cambridge 1986

Timothy Clayton, *The English Print 1688–1802*, New Haven and London 1997

H.T. Dickinson, *Caricatures and the Constitution 1760–1832*, Cambridge 1986

Diana Donald, *The Age of Caricature: Satirical Prints in the Reign of George III*, New Haven and London 1996

Michael Duffy, *The Englishman and the Foreigner*, Cambridge 1986

M. Dorothy George, *English Political Caricature*, 2 vols, Oxford 1959–60

M. Dorothy George, *Hogarth to Cruikshank: Social Change in Graphic Art*, London 1967

Richard Godfrey, *English Caricature: 1620 to the Present*, Victoria and Albert Museum, London 1984

Ernst Gombrich and E. Kris, *Caricature*, London 1940

Katherine W. Hart with Laura Hacker, *James Gillray: Prints by the Eighteenth-Century Master of Caricature*, Hood Museum of Art, Dartmouth College, Hanover, New Hampshire 1994

Max Hasse, *James Gillray 1757–1815: Meisterwerke der Karikatur*, Willhelm-Busch Museum, Stuttgart 1986

Michel Jouve, *L'Age d'Or de la Caricature Anglais*, Paris 1983

F.D. Klingender, *Hogarth and English Caricature*, London 1944

David Kunzle, *The Early Comic Strip*, Los Angeles 1973

David Low, *British Caricaturists, Cartoonists and Comic Artists*, London 1942

Ronald Paulson, *Representations of Revolution (1789–1820)*, New Haven and London 1983

Nicholas Robinson, *Edmund Burke: A Life in Caricature*, New Haven and London 1996

J.A. Sharpe, *Crime and Law in English Satirical Prints 1600–1832*, Cambridge 1986

Peter D.G. Thomas, *The American Revolution*, Cambridge 1986

Credits

Copyright Credits

Steve Bell © The Artist 2001

Photographic Credits

Figure Illustrations

The British Museum, London

The Metropolitan Museum of Art, Purchase, Mr. and Mrs. Charles Wrightsman Gift, in honor of Everett Fahy, 1977.

Louvre Musée / Réunion des Musées Nationaux / R.G.Ojeda

Steve Bell

Catalogue Illustrations

Ashmolean Museum, Oxford

The British Museum, London

Photographic Survey, Courtauld Institute of Art

Andrew Edmunds, London / Tate Photography

Fitzwilliam Museum, Cambridge

Library of Congress

National Portrait Gallery, London

Print Collection, Miriam and Ira D. Wallach Division of Art, Prints and Photographs, The New York Public Library, Astor, Lenox and Tilden Foundations

The Pierpont Morgan Library, New York. Peel Coll. Vol.8, no.6, p.3v / Joseph Zehavi

Tate Photography / David Clarke / Andrew Dunkley / David Lambert / Marcus Leith/ Rod Tidnam

The V&A Picture Library

Yale Center for British Art, Paul Mellon Collection

Lenders

Private Collections

Brooks's 101

Andrew Edmunds, London 7a, 8, 18, 36, 38, 53, 55, 68, 70, 71, 87, 89, 91, 96a, 97, 103, 107, 108, 111, 133, 136, 139, 140, 161, 165, 169a, 179, 183, 184b, 185a, 198a, 200, 205

Private Collection 5, 7b, 31, 39, 49, 77, 78, 79, 123, 141a, 141b, 148a, 148b, 151, 162, 163, 167, 184a, 185b, 189, 208, 209, 210, 211, 212, 220a, 220b, 220c, 220d

Public Collections

Cambridge, The Fitzwilliam Museum 17

Connecticut, Yale Center for British Art 6, 51, 52, 207

London, British Museum 2, 3, 4a, 10, 11, 14, 15, 16, 20, 22, 23, 24, 25, 26, 27, 28, 29, 30b, 32, 33, 34, 35, 37, 40, 41a, 41b, 41c, 42, 43a, 43b, 44, 45, 47, 48, 56, 57, 58a, 58b, 59, 60, 61, 62, 63, 64, 65a, 65b, 66a, 66b, 67, 69, 73, 74, 75a, 75b, 75c, 75d, 76a, 76b, 76c, 76d, 76e, 76f, 76g, 76h, 76i, 76j, 80, 82a, 82b, 83, 85, 88, 93, 96b, 99a, 99b, 102, 104, 109, 110, 112, 115, 116, 117, 119, 120, 125, 126, 130a, 130b, 131, 132, 134, 135, 142, 143, 144a, 144b, 145, 146, 147, 149, 150, 152a, 152b, 153, 154, 155, 156, 157, 158, 159, 160, 170, 171, 172, 173, 175b, 176, 177, 178, 180a, 180b, 181, 182a, 182b, 186, 187, 188, 192, 193, 194, 195, 196, 202a, 213, 215, 216, 221

London, National Portrait Gallery 12, 46, 100a, 100b, 100c, 100d, 100e, 100f, 174

London, Tate 5, 50

London, Victoria & Albert Museum 4b, 92

New York, New York Public Library 72, 113, 128a, 128b, 166a, 166b, 191, 198b, 218, 219

New York, The Pierpont Morgan Library 217

Oxford, The Ashmolean Museum 106

Washington, Library of Congress 1, 9, 13, 19, 21, 30a, 54, 81, 84, 86, 90, 94, 95, 98, 105, 114, 118, 121, 122, 124, 127, 128c, 129, 137, 138, 164, 168, 175a, 190a, 190b, 197, 199, 201, 202b, 203, 204, 206, 214

Index

Page numbers in **bold** type refer to biographical entries; catalogue numbers in **bold** type refer to main entries.